19th Century Realist Art

19TH CENTURY
REALIST ART

Gerald Needham

ICON EDITIONS

1817

HARPER & ROW, PUBLISHERS, New York

Cambridge, Philadelphia, San Francisco, London

Mexico City, São Paulo, Singapore, Sydney

For

LAURA ANDREW

and

BILL BUSBY

FIRST EDITION

Designer: Ruth Bornschlegel

Copy editor: Ann Adelman

Indexer: Maro Riofrancos

Library of Congress Cataloging-in-Publication Data
Needham, Gerald.
 Nineteenth-century realist art
 (Icon editions)
 Bibliography: p.
 Includes index.
 1. Realism in art. 2. Art, Modern—19th century.
I. Title.
N6465.R4N44 1988 760'.09'03 86-46092
ISBN 0-06-435913-1
88 89 90 91 92 DT/MPC 10 9 8 7 6 5 4 3 2 1
ISBN 0-06-430156-7 (pbk.)
88 89 90 91 92 DT/MPC 10 9 8 7 6 5 4 3 2 1

Contents

List of Illustrations

The author and publisher would like to thank the museums, galleries, libraries, and collectors who provided photographs of their works and permitted their reproduction. Photographs of works in French museums were provided by the Documentation Photographique de la Réunion des Musées Nationaux and the Archives Photographique des Monuments Historiques.

Works are in oil unless otherwise indicated; dimensions are given in centimeters, height first.

Acknowledgments

This book is the result of a number of years looking at and thinking about nineteenth-century art, and is indebted to a great many people; teachers, colleagues, and students. Particularly I would like to thank for their exchange of ideas and/or practical help, Dennis Cate, Anne Coffin Hanson, Roald Nasgaard, Linda Nochlin, Theodore Reff, Robert Rosenblum, Kirk Varnedoe, Gabriel Weisberg, Carol Zemel, Henri Zerner, and Daria Darewych in North America. In Norway, Oscar Thue and Jan Askelund went out of their way to increase my knowledge of Christian Krogh's art. In France, I benefitted from conversations with Robert Coustet and Marie-France Paulin, and the latter's practical help. In England, I am indebted to John House, John Murdoch, and Richard Thomson. The Bibliography is a guide to the many scholars whose writings have vastly expanded my own researches and ideas.

The seminar students whom I have asked—without first inflicting my own ideas on them—to analyze paintings and prints, in order not only to sharpen their abilities but to provide a correction to my own assumptions, have been a valuable resource. Brenda Hicks has been an intelligent and able typist in the face of my demands.

The Faculty of Fine Arts of York University, Toronto, has provided fellowships that have enabled me to do research in Europe, and I have also benefitted from travel grants from the Social Sciences and Humanities Research Council of Canada.

Finally, I would like to thank my editor Cass Canfield, Jr., for his patience, and my wife Peggy for her encouragement, and her unflagging enthusiasm in visiting so many museums and collections.

Foreword

"Realism" is a word, unlike "Romanticism" with its myriad meanings, that at first seems easy to define and to apply to art. Courbet, generally recognized as the leading Realist painter, said that "the art of painting can only consist of the representation of objects which are visible and tangible for the artist." In laying down these principles, Courbet rejected an enormous amount of the painting of the nineteenth century that busied itself with recreating events from past history, depicting religious subjects and allegories of all kinds, or with illustrating scenes from world literature. In clearing away so much and presenting an apparently straightforward approach to art, he nevertheless created a great many ambiguities.

Questions about Realism immediately spring to mind. Is there a Realist style or is a variety of styles possible? Are certain kinds of subject matter more important, or are all subjects that can be observed by the artist equally Realist? Having chosen a subject, does the artist need to be selective in reproducing it on canvas? Where does meaning lie in a Realist picture? Then there are the questions about different media. What is the relation of Realist art to photography? Is not a photograph more Realist than any painting? Courbet was thinking of painting, but what is the role of magazine and book illustration depicting contemporary life, which was such an enormous part of nineteenth-century picture production? Was there such a thing as Realist sculpture?

The question of which art forms belong to Realism also leads us to ask about its historical limits. Can we apply the term to many periods of art, or does it apply in a special way to the nineteenth century when there was a self-proclaimed Realist movement in literature and art, and when the word "Realism" became a slogan or an insult that was violently debated in the press?

The purpose of this book is to examine these kinds of questions and

to analyze the issues of Realism in the context of their chronological development, and to provide an outline but not a detailed history of the movement, which would require at least two volumes and would obscure the issues. It has been necessary to omit several interesting artists, and I have included some less well-known artists from Scandinavia at the expense of artists working in France and England like J. S. Cotman, Alfred Stevens and James Tissot, in order to compensate in part for our usual imbalance towards France and England. In exploring the bounds of Realism, I shall also investigate kinds of pictures often omitted from histories of art. The inventive genius of the Industrial Revolution created new visual media like the Panorama, the Diorama, and photography, and expanded the print media with lithography and wood engraving. Prints, in their turn, combined with the new mass-circulation popular press, inundated the world with images. Meanwhile numerous visionaries, in order to achieve yet greater verisimilitude, struggled to set pictures in movement with picturesquely named devices like the Kinetoscope and the Phenakistiscope. Their efforts took almost the whole century before the Lumière brothers in France, Edison in the United States, and Max Skladanowsky in Germany almost simultaneously invented cinema, for many people the most Realist of all art forms.

I have stressed these new media because too often while proclaiming our modernity, we have unconsciously retained eighteenth-century concepts of the hierarchy of art even today. The insignificant place given to prints in many histories of nineteenth-century art, even though a superficial study reveals their importance, is an obvious example of this conservatism.

This book looks briefly at the origins of Realism at the beginning of the century, but the main period covered runs from the 1830s to the 1880s. The 1830s saw the flourishing of the popular illustration, the invention of photography, and the development of the Barbizon School of painting. The middle years of the century are the high point of Realism as a self-proclaimed movement, led in painting by Courbet, though independently finding expression in England, Germany, and Italy. Impressionism is presented here as a second phase of Realism, lasting from the mid-1860s to the 1880s. The Impressionists followed Courbet's dictum quoted above, yet created a quite different art with a remarkably different content. While Impressionism was developing in France, Realism spread more intensely through the rest of Europe, and we find important contributions from artists in Scandinavia and Russia. The "crisis" of Impressionism in the 1880s marks the end of Realism as a creative movement, though numerous young artists, inspired by their predecessors, tried to continue its aims into the early twentieth century.

American art is a distinctive phenomenon standing at a tangent to European art. It is marked by the American response to what is tangible and down to earth (the pragmatic tradition), but also by the equally strong strain of idealism. Thus many painters of the Hudson River School studied nature carefully, but in order to find a transcendental meaning in it. Thomas Eakins adopted almost scientifically objective methods to build up his paintings, but then only too frequently he inundated them with a chiaroscuro that gives a "poetic" effect at odds with the initial impulse. American art is thus omitted from this book, though certain individual painters and sculptors are discussed as they illustrate particularly well dilemmas of Realism and of nineteenth-century sculpture.

Many scholars and critics have made contributions to our knowledge and understanding of Realism, and their work has provided much of the documentation for this book beyond my own research. The annotated Bibliography will indicate my debts, and provide the reader with a guide to penetrating further into the work of so many remarkable artists.

1

THE DILEMMAS OF REALISM

Light is thrown on Realism by artistic developments in the second half of the eighteenth century. Though rather neglected in histories of art, this period was a time of an enormous variety of styles, media, and subject matter, when artists tried out new ideas with exceptional freedom. As is the case with many aspects of society and culture, major themes of nineteenth-century art find their first statement between 1750 and 1800. They appear in a simple, initial form which makes the issues clearer than they become when fully elaborated in the complexities of the nineteenth century.

In the art world two enormous changes begin to assert themselves. Firstly, all allegorical and religious art that depended on established systems of symbolism and belief lost its persuasiveness. The most important area of Western art ceased to have meaning. Very few people realized this until much later, and, of course, orthodox religious art has continued up to the present, although allegorical works of the *Time Unveiling Truth* type have been abandoned. We may admire the attempts of artists to paint religious subjects but the subsequent pictures do not move us. The situation was expressed eloquently by Hegel at the beginning of the nineteenth century—"however nobly and perfectly we may find God the Father, Christ or Mary represented, it is no use: they will not force us to our knees." Curiously, this death of a whole genre of art has often failed to be noticed, and many books have been written on nineteenth-century art that fail to point it out. They discuss religious paintings in terms of the failure of the individual pictures rather than the impossibility of the type. After the eighteenth century, successful religious art could only be a personal vision like William Blake's creation of a new religion with all its ambiguities, or Caspar David Friedrich's substitution of landscape for Christian iconography. The result in Friedrich's case is that we still argue violently today about the meanings in his paintings.

This fading away of symbolic systems did not preclude imaginative works, but it did encourage art based on direct visual experience. Enormous problems were created for sculptors, whose figures, apart from portrait busts, were necessarily based on traditional religious and allegorical types. Their difficult predicament can be seen in the fact that if all the sculpture of the first seventy-five years of the nineteenth century were destroyed overnight, most art lovers would scarcely feel the loss. This is a startling statement, but I believe it to be accurate.

The second change in the eighteenth century, probably but not clearly connected with the first, was the end of rhetorical gestures and compositions. The dramatic expressiveness that had dominated Baroque art began to look "stagey" and absurd. This development was not clearly recognized either, and we are all familiar with the paintings of saints with outflung arms and eyes rolled up to the heavens, the whites showing prominently, that were produced by the thousands in the nineteenth century. Today we find these paintings embarrassingly comic, even when painted by an artist as great as Ingres. Again it was not a question of good or bad artists, but of a kind of art that had become impossible.

The consequences of this change were enormous, much greater than might at first appear. It meant that all attempts to give meaning to sculpture or paintings by making the figures expressive failed. It was not until the transformation of the basic principles of representation at the beginning of the twentieth century that a new kind of expressiveness became possible. Furthermore this change in the eighteenth century meant that not only gestural expression but the whole notion of how an artist puts meaning into a work of art was called into question. Gotthold E. Lessing, in his remarkable essay *Laocoön* (1766), half grasped this problem when he pointed out that a work of art does not unroll in time like a literary work, and that many of the comments made on art were irrelevant. Horace's *ut pictura poesis* (in painting as in poetry) had been so widely accepted and so ingrained that Lessing's cogent remarks did not succeed in entirely demolishing it, and in the nineteenth century it lived on in the popular saying "Every picture tells a story." This belief shared by the artist and public led to innumerable misguided paintings, a few of which we will analyze to bring out the qualities of the successfully Realist works.

This problem of meaning also has not been sufficiently discussed in histories of nineteenth-century art, which too often have accepted the aims of the artists unquestioningly. In the past few years an extremely influential school of art historians led by T. J. Clark has concentrated on

interpreting nineteenth-century paintings. They have analyzed developments in nineteenth-century society, and have judged the artworks by their success in expressing the trends that the scholars regard as significant. I find that this method, though it has been pursued with great confidence, even arrogance, has misunderstood the way in which meaning is created in a modern picture, and what kinds of meanings can be expressed in visual art as opposed to, say, the novel, the other great art form of the period.

The problem of expression in eighteenth-century art can be illustrated in paintings by two of the leading French artists, Greuze's *The Ungrateful Son*, 1777 [1], and Chardin's *Young Student Drawing*, 1738 [2]. Greuze was very much part of the Enlightenment, one of that group of men and women who turned to the everyday problems and experience of ordinary people as a fully worthwhile subject of art. We think of the English "middle-class" novelists like Fielding, Richardson, Sterne, and Austen, and dramatists like Diderot in France and Lessing in Germany. Greuze was a founder of the genre painting that became so popular in the nineteenth century, just as Chardin's still lifes with their resolutely ordinary earthenware pots instead of silver platters and glass goblets

1. *The Father's Curse (The Ungrateful Son).* By J.-B. Greuze, 1777. The Louvre, Paris.

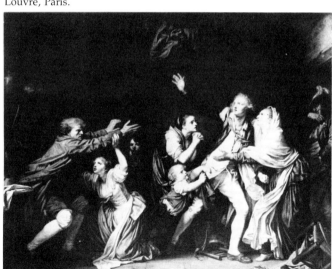

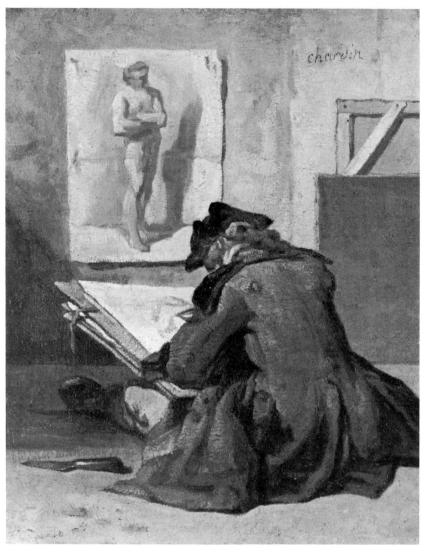

2. *Young Student Drawing.* By J.-B.-S. Chardin, 1738. Kimbell Art Museum, Fort Worth.

were copied by the Realists, and inspired the early still lifes by artists like Claude Monet.

Greuze had painted in 1769 *The Emperor Septimus Severus Reproaching His Son Caracalla*, a very similar theme to *The Ungrateful Son*. To many artists of the time, like Sir Joshua Reynolds, who reaffirmed the traditional hierarchy of subject matter in art, the former was a very desirable theme, while *The Ungrateful Son* was a trivial one. We get no sense at all that Greuze would have agreed with Reynolds. He presents the plight of the village folk as no less important than that of the Roman Imperial family. His conception of picture making is, however quite different, from Chardin's. Greuze's message is immediately clear. The son, the necessary support of the family with an aging father and many small children, is abandoning them for the army, represented by the sardonic recruiting sergeant at the right. We have a common theme of family relations set in modest circumstances that make it even more universal. The message is obvious because it is signaled to us by arms flung out in all directions, frantically clasped hands, eyes rolled up, expressive movements of the bodies, all the faces turned to us so that we can see their expressions.

Today this potentially moving scene strikes us as humorous. We seem to be looking not at a scene from life, but a tableau staged by actors, and bad actors at that. The theatrical is simply not convincing to us, even though it pleased some of Greuze's contemporaries, for whom it represented a new ideal of ordinary life presented with insight and feeling. Indeed, Greuze's painting was the prototype of thousands of subsequent pictures—for example, Antigna's *The Fire*, 1850 [102], which we find equally posed. Yet works like Antigna's were considered Realist works in the nineteenth century, and many people regard them as such today because they deal with commonplace incidents. — *Understatement.*
Social
implica-
tion

To find a precursor of the convincing works of the nineteenth century, we can turn to Chardin. His *Young Student Drawing* contrasts sharply with the Greuze although it is equally a picture of the banal. Chardin gives us no action, no dramatic situation, simply an awkwardly seated art student so intent on his drawing that he seems unaware of his discomfort. All the elements that were central to Greuze's picture, arms, faces, eyes, are concealed. Chardin has even enveloped his artist in a thick, voluminous coat which almost entirely buries him. Nothing in the painting tells us what to feel or think. There is no moralizing message, no revelation about society in the eighteenth century. Yet the majority of us feel that Chardin is one of the very great artists and that this picture, with so much omitted, is an entirely satisfying one. The draughtsman, in contrast to Greuze's characters, who almost turn themselves inside out in their eagerness to tell us their emotions and

how we should respond to them, is totally absorbed in his drawing and unaware of possible spectators. We feel that Chardin has crept up behind him unobserved to capture his intent pose, that we have a real "slice" of life, a kind of snapshot.

Chardin's picture is not, of course, a simple slice of life. He may have begun from a drawing of an art student copying, but he has built up a beautifully complex pyramidal structure dramatically sliced by the diagonal plane of the white paper on the drawing board. Any potential monotony in the basic geometrical forms of rectangles and pyramid that compose the picture is offset by the play of irregularities in the hat, collar, boots, and the folds of the coat. Through these internal movements, Chardin brings to life the painting, which is quite static and is drab in color. Comparing the two pictures, we can see that Greuze created drama and movement through the people and their predicament while Chardin has created the same effects through compositional elements alone.

These characteristics make it very easy to write about a painting like the Greuze. We can discuss the rise of the literature and art in the eighteenth century using ordinary people as subject matter, and of the expansion of the bourgeois audience that helped make this possible. The Enlightenment stress on compassionate feelings is equally embodied in the painting, and we are reminded of Mackenzie's novel *The Man of Feeling* (1771), whose protagonist cultivates compassion almost to excess, bursting into tears several times a day on encountering different kinds of human suffering. When we look at Greuze's composition, perspectives open up on the relation of theater and art at this time, and not only the theatrical nature of the painting but also the popularity of representations of actual scenes from plays in paintings. It would be tempting to write a booklet about *The Ungrateful Son*. When we turn to the Chardin we are silenced. Apart from a visual analysis there is very little to say about it that would not seem forced and distracting. In the mid-nineteenth century, too, the best Realist paintings offer equally little scope for the kind of interpretation outlined above, and when scholars do attempt extensive commentaries, however intelligently done, they usually appear irrelevant.

These two works encapsulate the dilemma of subsequent artists. How is meaning expressed in a picture, and what meanings can be successfully expressed? Most artists of the nineteenth century were unaware of this problem and went on happily producing pictures in the tradition of Greuze, whether they chose religious subjects, allegory, or modern realities. It was only a minority of artists who consciously, or as often seems the case, partially aware and partially instinctively, abandoned the idea of creating meaning through the expressiveness of the

people in their canvases. Today we have still not fully grasped this change, and as this book progresses I shall be referring back to these two pictures by Greuze and Chardin as guides in disentangling the complications that developed in nineteenth-century art.[1]

[1] Michael Fried's book on eighteenth-century French painting, *Absorption and Theatricality* (Berkeley, California, 1980), gives us two words that exactly define these characteristics of the pictures by Chardin and Greuze. Fried develops his ideas in a different direction from that in this book, but these words express a distinction important for Realist art. Chardin painted many pictures of activities that demand total absorption from the protagonist (e.g., building a house of cards, blowing a very large bubble), so that we feel that he or she is completely unaware of the artist or the audience.

I know no subject more elevating, more ready to awake the poetical enthusiasm, the philosophical reflection, and moral sentiment than the works of nature.

James Thomson, preface to *The Seasons,*
1726

Whatever gave us the disastrous idea of trying to bring back the art of the past? Since Raphael's time there has been no true history painting. All beautiful compositions now tend toward landscape.

Philipp Otto Runge, 1802

For these two past years I have been running after pictures and seeking the truth at second hand . . . I shall shortly return to Bergholt where I shall make some laborious studies from nature.

John Constable, 1802

Of all the imitations of nature, I find landscape the most moving. . . . Of all the categories there is none in which the artist needs to do less composing than in landscape. Everywhere the lines of the horizon, the effects of the clouds, the least thicket of woods furnish, at every moment of the day, sufficiently picturesque accidents of light and perspective.

Adolphe Thiers, 1822

Realism: A literary doctrine which would lead not to the imitation of artistic masterpieces but of the originals that nature offers us. This might well emerge as the literature of the nineteenth century, the literature of truth.

Le Mercure français, 1826

2

THE ORIGINS OF REALISM,
ca 1800–1830

We often think of Realism as beginning with a bang in 1850 in France when Courbet exhibited his very large paintings the *Burial at Ornans, The Peasants of Flagey Returning from the Fair,* and *The Stonebreakers* at the Salon in Paris. The three pictures created a sensation, and while defended by a group of admirers, they were vigorously attacked in the newspapers by a much larger number of appalled writers. Courbet was able to exhibit without passing through the jury system because he had been awarded a medal at the previous Salon. That jury had been a liberal one, a result of the Revolution of 1848. It is thus easy to see Realism as intimately linked with midcentury political developments. Though there is a connection in Courbet's case, his spectacular debut has obscured a long evolution. In addition, the fact that we usually consider only oil paintings significant works has eliminated important steps in the growth of the movement.

Our concept of art in France after the end of the Napoleonic wars, 1814, until 1848, for example, is generally of the prevalence of neoclassical painting as taught by the Ecole des Beaux-Arts, with a few dissidents gathered around Delacroix under the banner of Romanticism. This picture will be considerably modified if we read the critics of the period and try to reconstruct what was actually painted. It will be even more changed if we examine all the forms of art that flourished then, which requires even exhuming forms of art like the Panorama and the Diorama that have disappeared and are scarcely known today. We also have to consider these developments in both England and France, as the artistic exchange was considerable and significant.

From the beginning of the nineteenth century a drive was launched to subvert the academically enthroned belief in the nobility of art and the superiority of the Grand Style and the idealized subject. This undermining had begun less consciously in the eighteenth century, and Sir Joshua Reynolds's *Discourses* was an attempt to reestablish "the rules

and precepts of our art on a more firm and lasting foundation." He stressed that "all the arts receive their perfection from an ideal beauty, superior to what is found in individual nature."

Reynolds admitted that all branches of painting had some merit, but he warned the students of the Royal Academy School against spending their lives "in the meaner walks of painting." These included "the French Gallanteries of Watteau, and even beyond the exhibition of animal life, to the landscapes of Claude Lorrain." The lowest of these subjects was, of course, still life. Reynolds was fighting a losing battle. Posterity came to regard Watteau and Chardin, a still-life painter, as two of the very greatest artists, while landscape became the basis of the most important nineteenth-century art.

The rejection of Reynolds's aims can be seen in the publication in 1806 in London of a book filled with illustrations entitled "*Microcosm* or a Picturesque Delineation of the Arts Agriculture and Manufactures of Great Britain in a series of above a Thousand Groups of Small Figures for the Embellishment of Landscape" [3]. This mass of illustrations was "accurately drawn from nature, and etched by W. H. Pyne" (a leading watercolorist and writer on art) so that amateur and professional artists specializing in landscape could animate their pictures with people engaged in occupations that the artists could not necessarily observe for themselves. We have to remember that there existed a large number of amateur women artists of the upper classes for whom mingling with the workers was difficult. Pyne's endeavor contrasts vividly with the French view that landscape painting was justified only if groups of mythological or biblical figures were included to dignify the scenes.

Pyne did not only intend to be helpful to other artists. He wanted to create a picture of contemporary English life, and there were explanations of the plates that set the occupations in a historical context to show the changes that had come about. When *Microcosm* was reprinted (a sign of its success), the following was added to the title page: "Picturesque groups . . . comprising the most interesting accessories to rural and domestic scenery; shipping and craft; rural sports, pastimes and occupations; naval, military and civil employments; implements of trade, commerce and agriculture; etc." When we realize that Pyne also wrote, "It is strict real nature, that has the principle of attraction, and of course, of vitality in it. All the rest is, at best, but trash, more or less splendid, and sooner or later must die," we see that we have a potential program for Realism in art written at the beginning of the nineteenth century; but it was an ambiguous challenge. In *Microcosm*, at least, he envisaged small groups of working people within what might be conventional landscapes, and these people were intended to be "picturesque." We see this in the delightful play of light and shade in the

illustrations themselves, which softens the harshness of the labor, otherwise accurately recorded.

Pyne is thus a precursor, though basing his work on many eighteenth-century predecessors, introducing new concepts into a corner of a painting, suggesting in his comments that the achievements of modern England throughout the realm were worthy of celebrating in

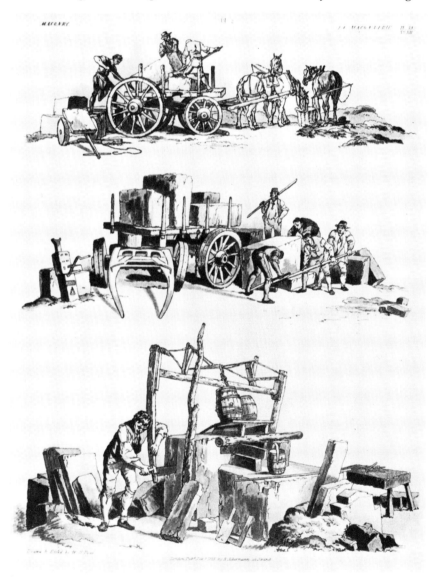

3. *Masonry* from *Microcosm*. By W. H. Pyne, 1806.

art directly without allegorical dressing up. He did not preach a revolution, but his own work in watercolor and prints tells us where to look for the roots of Realism. After 1800 there came a steadily increasing flood of illustrations of every aspect of life. A concept of Realism that confined itself to painting and sculpture would not only be limited, but it would be based on a misunderstanding of the movement. This book has begun with Pyne's aquatinted etchings because the public also had different expectations from a print than they did from a painting. The latter were expected to embody moral lessons, to be uplifting, or to transcend everyday reality, while prints were thought of as illustrations of interesting events, places, or people. This function of prints had existed ever since the Renaissance, but it became vastly expanded in the late eighteenth and early nineteenth century. The popular enthusiasm for science that had developed in the Enlightenment also resulted in an increased importance of factual illustration.

The public was also much larger, as the steady expansion of trade had created a much more numerous middle class, especially in England. We remember Napoleon's gibe about England being a "nation of shopkeepers." (It was a strange mistake for a man born on an island to misunderstand the importance of seapower, for he should have said a "nation of merchant venturers," a fact which we will see had a bearing on English art.) These "shopkeepers" could frequently not afford oil paintings, but they did buy prints, which were of enormous diversity in subject and style. There were the elaborate and expensive engravings after popular paintings, portraits of public figures, landscapes and city views, humorous and grotesque caricatures, topical events, book illustrations, and, a consequence of England's political freedoms, the late eighteenth-century surge of political caricature in the hands of brilliant artists like Rowlandson and Gillray.

This increase in the public was matched by the development of new print media. In 1798 Senefelder in Germany invented lithography, and at this time Thomas Bewick perfected wood engraving which permitted far more detail than the traditional woodcut. The aquatint used to reproduce Pyne's watercolors had been introduced into England in the 1770s. At the beginning of the nineteenth century artists were thus armed with a whole battery of weapons: oil paint, watercolor, drawing, steel engraving, etching, aquatint, mezzotint, woodcuts, wood engraving, lithography, and, to be discussed later, the camera lucida.

In this chapter I want to look briefly at a number of these media and at some new art forms in which are expressed new attitudes to the purpose and content of art. These include the Panorama and Diorama, prints, watercolors and landscape painting, and finally the contribution of the great individual Romantic artists to Realism.

It is an oddity of history that we know the art of the first half of the nineteenth century much less well than that of the previous two centuries. The reason is that a large segment of the art was destroyed, and it was the kind that could not be reproduced in prints so that we have little record. The Panoramas and Dioramas were gigantic canvases displayed in specially constructed buildings, usually of wood, and most of the buildings and pictures were eventually destroyed by fire, as they were lit by candles or gas.

Because some of the Panoramas reproduced biblical scenes or battles, it is easy to imagine them as the Cecil B. de Mille epics of a past age, crudely effective but not really part of the history of art. This idea would be wrong—certainly some of them must have been hack works, full of pseudo-Romantic melodrama, but many were painted under the supervision of first-rate artists, and their aim was the detailed and faithful reproduction of an actual scene.

The Panoramas were huge circular paintings, the logical extension of Renaissance perspective, which presents a vista from the viewpoint of the spectator and which theoretically could continue right around him. In panoramic views of cities, which were extremely popular, the perspective was carefully constructed to give a convincing bird's-eye view. Panoramas could be viewed in two ways: the circular wall with the painting might revolve on rollers around a centrally seated audience, or the latter might walk around a circular platform to examine a static painting. The first Panorama was created in 1788, and after 1800 they multiplied rapidly. Each city in Western Europe and North America had a special building to exhibit them and frequently several. Sophisticated lighting effects were developed to enhance the spectacle. A modern historian has described

> the astonishing illusion of reality. Placed in semi-darkness, and at the centre of a circular painting illuminated from above and embracing a continuous view of an entire region, the spectator lost all judgment of distance and space, for the different parts of the picture were painted so realistically and in such perfect perspective and scale that, in the absence of any means of comparison with real objects, a perfect illusion was given.[1]

It is striking that so many Panoramas depicted the city in which they were exhibited. The first, shown in Edinburgh, created by Robert Barker, was a view of that city. Two Panoramas were created simultaneously in Paris in 1800, which showed "A view of Paris from the roof of the Tuileries" and "The evacuation of Toulon by the English in 1793." The latter had obvious patriotic appeal in the middle of the Napoleonic

[1] M. and A. Gernsheim, *L. J. M. Daguerre.* New York, 1968, p. 6.

wars, but the former scene could be observed by anyone willing to climb a Parisian church tower. However, it is clear from the popularity of these cityscapes that people at this time were fascinated by the detailed recreation of actual places. The fact that they were familiar seems to have increased rather than diminished the interest. It enabled spectators to check the fidelity of the painting, and be even more astonished by it.

An imposing building, the Colosseum, so called in spite of its resemblance to the Pantheon in Rome, was built in Regent's Park in London in 1829 for an enormous Panorama of London. Thomas Hornor, the artist, had taken advantage of scaffolding erected on the lantern of St. Paul's Cathedral to spend a summer, starting at 3:00 a.m. each day,

4. Interior of the London Colosseum with a Panorama of London completed 1829 by T. Hornor.

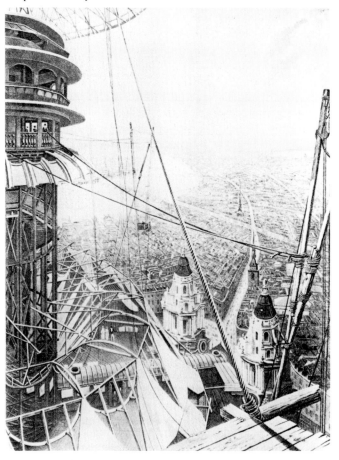

making 300 drawings of the city from this exceptional vantage point. Figure 4 gives an idea of the sheer size of the Colosseum (though the drawing seems to exaggerate somewhat), with the painting itself reputedly occupying more than an acre of canvas. A guidebook of the time said that the realism of the lighting effects and the amount of minute detail "amounted to deception."

The year that the Colosseum opened, it is claimed a million visitors came to marvel at the aerial view of the city. This enormous popularity is evidence of the public's hunger for verisimilitude in pictorial art. The most famous name connected with the Panoramas is that of the man who gained immortality by being the first to demonstrate a practical method of photography, Louis-Jacques-Mandé Daguerre. He was an assistant to Prevost, the leading French painter of Panoramas, before becoming a stage designer in 1816. The combination of this experience of illusionistic painting with Daguerre's own inventive genius led him to create such spectacular and naturalistic effects that apparently quite a number of the audience, including the critics, believed he had introduced a real stream onstage in one play. Finally, plays were mounted especially for his dazzling settings and effects, and the plot and actors became secondary.

Daguerre abandoned the theater in 1822 to launch an invention, the Diorama, that embodied the developing visual interests of the time, and was as a result highly successful. The Diorama combined the persuasive illusion of the Panorama with movement [5]:

> The Diorama, to which the public has been flocking in crowds since the opening day, is one of those inventions which constitute an epoch in the history of painting.
>
> The most striking effect is the change of light. From a calm, soft, delicious, serene day in summer, the horizon gradually changes, becoming more and more overcast, until a darkness, not the effect of night, but evidently of approaching storm—a murky, tempestuous blackness—discolours every object, making us listen almost for the thunder which is to growl in the distance. . . . This change of light upon the lake is very beautifully contrived. The warm reflection of the sunny sky recedes by degrees, and the advancing dark shadow runs across the water—chasing as it were, the former bright effect before it.
>
> (The Diorama of *The Valley of Sarnen,* 1822)
>
> At first it was daylight, the nave full of empty chairs; little by little the light waned; at the same time candles were lit at the back of the choir; then the entire church was illuminated and the chairs were occupied by the congregation who had arrived, not suddenly as if by scene shifting, but gradually—quickly enough to surprise one, yet slowly enough for one not to be too astonished. The midnight mass

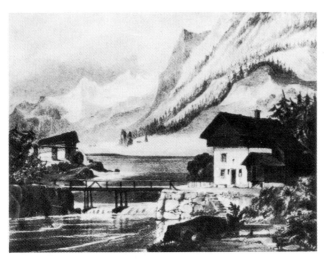

5. Two views of a Diorama scene: an Alpine village in the morning with mist, and at night, ca 1836. Gernsheim Collection, University of Texas.

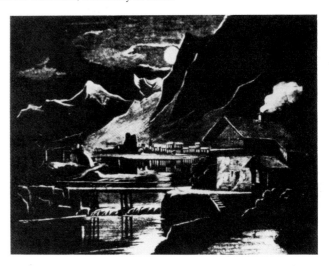

started, and in the midst of a devotion impossible to describe, organ music was heard echoing from the vaulted roof. Slowly dawn broke, the congregation dispersed, the candles were extinguished, the church and the empty chairs appeared as at the beginning. This was magic.
(*A Midnight Mass at Saint-Etienne-du-Mont*, 1834)[2]

The astonishment and delight of both critics and public ("a new marvel of M. Daguerre," "the Diorama is a new conquest," "the greatest achievement ever in pictorial art," "the Diorama has excited universal curiosity, and obtained the approval of all artists and people") was

[2] *Ibid.*, pp. 17 and 34.

created by a skillful combination of painting and lighting. The audience was seated and looked through a proscenium arch. Daguerre painted the two aspects of his scene on the two sides of a sized transparent white calico canvas. The change from front to back lighting and the use of color screens to bring up or eliminate details enabled the illusion to change from day to night, or from empty to filled building. Objects in the picture did not move, but lighting, as we have seen, could give the impression of scudding clouds, running water, and the coming and going of people. The pictorial illusion was aided by music and narration to give a total experience that concealed the limitations of the Diorama. Church interiors were particularly popular, as they combined the new enthusiasm for Gothic architecture, a certain gloomy light which aided the illusion of three-dimensionality, poetic effects of the changing light seen through stained-glass windows and sonorous organ music rolling through the building.

Dioramas remained popular for many years, even though, in spite of all the effects, they could not really tell a story. Daguerre opened a Diorama in Regent's Park in London in 1823 where he showed his Dioramas when they had finished their showing in Paris. Dioramas were then sent on to other cities like Liverpool, Dublin, and even apparently to the United States to be toured there. An idea of the popularity of illusionistic art is given by Daguerre's biographers, the Gernsheims:

> At the time of [the Regent's Park Dioramas] closing down [1851] no fewer than five rival Dioramas were competing with each other in London, not to mention the panoramas and a host of other "oramas" which had sprung up during the 1820s, '30s, and '40s under grandiose titles leaving one guessing about the form of entertainment, ranging from peepshows of prints to geological models: Betaniorama, Cosmorama, Cyclorama, Europorama, Georama, Hydorama, etc.[3]

As we see from this quotation, the Panoramas were not driven out by the Dioramas. While the latter had the advantage of a greater degree of illusion and of the elements of time and motion, it could not present the detailed, all-encompassing vision of the Panorama stretching around the spectator on all sides. These two ideals of representation were so widespread in Europe in the first half of the century that there were innumerable inventions combining drawing or painting with mechanical means on a smaller scale, with the same aims. The recreation of movement in a simple way was achieved by Professor Plateau of Brussels and by Professor Stampfer of Vienna in 1832. Working separately the two men adopted similar means. Plateau's Phenakistiscope

[3] *Ibid.*, p. 43.

was based on a wheel with slots and painted images of successive positions of a wheel or a person in movement. The disc was revolved rapidly and the viewer peered through the slots into a mirror, where the persistence of vision caused the separate images to fuse into a continuous movement. The principle was developed in different ways in the Zoetrope by W. G. Horner of England, 1834, and the Praxinoscope, 1877, of Emile Reynaud, Paris.

These devices were household entertainment like the magic lantern and the stereoscopic viewer rather than works of art, but they challenged artists. It became progressively harder in the nineteenth century to conceive the world only as static, or to accept conventionalized images like the "flying gallop" as representing motion satisfyingly. It is significant that the inventors listed above came from several countries —Belgium, Austria, England, and France. As in the case of photography, inventors throughout Europe worked simultaneously on a development for which there was clearly a widespread need. The enormous popularity of the cinema, the climax of this research which combined photography, movement, and projection, is evidence of this need. I will discuss the specific impact of the problem of movement on art in Chapter 4.

The enthusiastic public response to the Panoramas and Dioramas, as well as the critical praise, suggest a public hunger for representations of the world with which they were familiar, even if it were a very ordinary one. The popularity of the numerous series of prints documenting the cities, ancient monuments, rivers, coasts, and picturesque spots throughout Europe reveals the same enthusiasm.

The beginning of the nineteenth century saw a turning point in the history of printmaking. Senefelder's invention of lithography provided a medium in which the artist could draw directly on the stone, and large numbers of prints could be run off. Until then, engraving had demanded a skilled craftsman to translate the artist's drawing into an inflexible medium. The etching was a complicated method and yielded a limited number of prints. It is interesting to note in the middle of the century the Etching Revival, a deliberate rejection by a group of chiefly amateur artists of the democratizing effect of the mass-production lithograph.

Bewick's development of wood engraving had a similar expansive result as the lithograph, but in the field of book and magazine illustration. As opposed to the woodcut, which involves cutting the design onto a plank of wood, Bewick worked on the end grain of a block of hardwood like boxwood. The cutting was more difficult but it permitted much finer detail. The block with its raised printing lines and its small size could be locked into a frame with type, and text and illustration

printed together. The one disadvantage of lithography was that the printing surface was flat, and it could not be printed simultaneously with type. To include writing, the lithograph had to be printed twice, which was expensive and time-consuming for a magazine, or the text had to be written backwards, very neatly, onto the lithographic stone— a skill that was developed to include captions on caricatures.

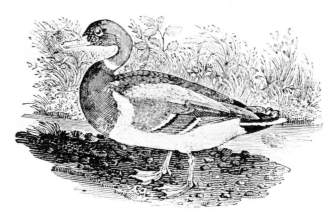

6. *Mallard Duck* from *History of British Birds.* By T. Bewick, 1804.

Wood engraving came into its own with the appearance of the mass-circulation press in the 1830s, but we can see in Bewick's *Mallard Duck* [6], from his *History of British Birds,* the remarkable qualities that he achieved. Bewick prided himself on not using regular cross hatching to suggest different textures, but inventing appropriate gougings, stipplings, lines, for each texture of his subject. This emphasis on technique, not for virtuoso effect but in order to shed conventions and to render the artist's subjects more forcibly, is, as we shall see, an important aspect of Realism.

The steady increase in the population of Europe in the eighteenth and nineteenth centuries, together with the increased wealth brought by the Industrial Revolution, meant that the number of people able to afford prints increased at the same time as lithography brought down the price. The number of prints issued in the early nineteenth century was enormous, and lithographs were published not only as single sheets but also in sets, either in a portfolio or bound as a book. Artists could draw fine detail or evoke atmospheric plays of light and shade, and the versatility of lithography led artists to experiment with both styles and subject matter. We find Charlet's and Raffet's dramatic chiaroscuro dramatizing recreations of Napoleonic scenes, more gentle shad-

ing to suggest the dappled light of woodlands in the numerous landscapes, and the detail of Boilly's and Bonington's street scenes.

The implications of the popularity of the new media are complex and not easy to estimate accurately. On the one hand we can say that people became fascinated by the factual description of the world around them, both the familiar and the exotic. This enthusiasm affected young men and young women turning to art as a vocation as well as the art public. On the other hand the desire for a moving, inspiring, or poetic art remained equally important. Neither artists nor spectators tried to analyze the significance of the new art forms or their relation to the inherited ideas of art. A handful of people like Pyne rejected all that was not real, but most people were open to every kind of art. Increasingly they expected both ideal and actual subjects to be rendered with the concrete detail of the Panorama or, later, the photograph. We are all familiar with the resulting trend in nineteenth-century art that made fortunes for artists like Landseer and Meissonier.

A group of painters did turn to genre pictures of different kinds, just as many chose landscape. In France the proliferation of these works upset some critics, who saw the great tradition of David disappearing rapidly and who found in the Salon an eclecticism with no particular direction. The scenes of everyday life that were acceptable in prints seemed inappropriate for oils.

These artists have been relatively neglected. At the time, critics tended to disregard their work as trivial, and recently we have been more interested in rescuing the great Romantic figures from the attacks of the same critics. Yet the interior scenes of French artists like Boilly and Drolling, or of German artists, are frequently delightful pictures. They are small and unpretentious but possess an attention to light and composition that makes them more satisfying in the long run than the ambitious attempts to prolong the Grand Style. These pictures owe a great deal to seventeenth-century Dutch art, the taste for which steadily increased with the changes we have been documenting. In Germany the term "Biedermeier" used for this art often carries a pejorative quality, suggesting cozy, sentimental, unchallenging characteristics, but some artists escaped these while developing a charming simplicity that was part of the style [7], and which differentiates it from the Dutch models.

Boilly's *Moving Day*, 1826 [8], though an outdoor scene, exemplifies the loving care with which the everyday was approached. He avoids the temptation to create anecdotes, and delights in all the trivia which would have horrified a dedicated student of David. In contrast to his interiors, Boilly sets himself a problem in complexity, brilliantly handled, though with the help of a traditional pyramidal composition. Very

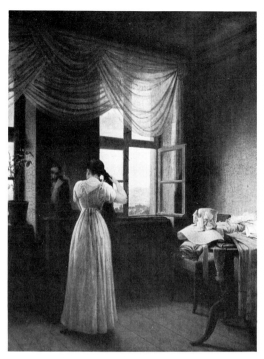

7. *Before the Mirror.*
By G. F. Kersting, 1827.
Kunsthalle, Kiel.

8. *Moving Day.* By L.-L. Boilly, 1826. Collection Jane Voorhees Zimmerli Art Museum, Rutgers, The State University of New Jersey.

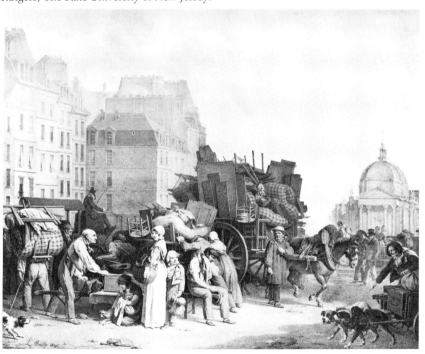

few pictures, after all, give such an important role to old mattresses. This mixture of the new and the old not surprisingly dominates the art of this period as artists struggled toward fresh ideas.

The great Romantics are sometimes thought of as turning away from immediate experience in the present to an idealized past, to exotic Oriental visions (Delacroix's *Sardanapalus)*, or to imaginary worlds like those of Blake. These are important aspects of Romanticism, but an escapism from "real life" is more characteristic of the minor artists and writers of the period who produced absurd Gothic horror novels or the paintings of an Orient that has never existed. The majority of the leading Romantic artists were deeply involved in transforming contemporary experience into art, and the originality of their vision, which led them to abandon prevailing conventions of representation, paved the way for Realism. A remarkable statement in literature appears in Wordsworth's 1800 Preface to *Lyrical Ballads,* one of the earliest Romantic works: "The principal object, then, proposed in these Poems was to choose incidents and situations from common life, and to relate or describe them, throughout, as far as was possible in a selection of language really used by men."

Wordsworth's emphasis on a commonplace subject matter and the appropriate style was paralleled two years later by John Constable's statement that "there is room enough for a natural painture." Constable coined his own word for painting/painter to underline his rejection of established formulas. Both men helped lay a basis for later Realist methods, but neither can be called a Realist. Wordsworth continued in his Preface: "and, to throw over them [the incidents from common life] a certain colouring of imagination, whereby ordinary things should be presented to the mind in an unusual aspect." Similarly, Constable wrote that the skies in his paintings were "the chief organ of sentiment." This concern for feeling, as we would express Constable's "sentiment," embodies his need for a personal expressive vision to accompany the carefully observed rendering of light and atmosphere. One of our tasks in deciphering Realism is to follow the later artists in their attempt to be "truthful" or "objective" by abandoning the seductive imaginative or personal aspects of Romantic art. Constable's "natural painture," like Pyne's "strict real nature," became a goal that was more easily proclaimed than achieved.

Constable's work itself inspired many later artists, and when it crossed the Channel to be shown at the Paris Salons of 1824 and 1827 he achieved greater fame in France than in England. French landscape painting was largely mired in historical landscape, based on the pictures of Claude and Poussin from the seventeenth century. Indeed, when the French recognized the growing significance of landscape art, their re-

sponse was to create a special Rome Prize for historical landscape in 1817. Thus in France Constable stood out much more than in England, where he was competing with a large group of accomplished landscapists. In France several young artists whose instincts led them to reject the clammy antique hand of the Academy found immediate inspiration in Constable's work (so much so that later he was even called the Father of French landscape). The Englishman's observation of specific weather effects in an actual locale could not have been further removed from the imaginary scenes completely bereft of weather, even atmosphere, that prevailed in France.

When French artists painted landscapes of particular places, they were often called *paysages ajustés* to indicate that the painter had reworked the site to conform to the ideals of landscape composition. A startling example of this method can be seen in the two landscapes of the *Bridge at Narni* in Italy by Corot [9 and 10]. At first there hardly seems any resemblance between the sketch and the painting, which was exhibited at the Salon of 1827, as was Léopold Robert's *The Return from a Pilgrimage to the Madonna dell'Arco* [11], which is discussed in connection with Millet's work.

Corot's oil sketch possesses light and atmosphere, and the casual composition that seems to guarantee the truth of the view in spite of the broad treatment, which omits all the particularities that would help identify Narni. The painting at the Salon is reorganized according to the approved formulas, and the trees are beautifully shaped and polished as if the artist were a topiarist clipping a hedge into an ideal form. We could believe that the trees were painted by Claude himself. At the same Salon Constable's *Cornfield* hung as a mute rebuke to the ludicrously cavorting peasants in Robert's picture and to the disappointing conventionality of Corot's "adjusted landscape."

Artists who would play a prominent role in the Barbizon School of landscape painting in the 1830s and 1840s responded directly, either by copying Constable's pictures, like Huet, who made a sketch of the *Haywain* in 1824, or by even more direct contact, like Dupré, who traveled to England and visited Constable. Dupré admired Constable's dramatic skies, and his *Near Southampton* consists of a very broad band of turbulent clouds and sky, with a thin strip of land and water at the bottom of the canvas. It breaks with the French landscape tradition and resembles very much Constable's *A Summerland* [16] discussed below. It lacks "composition," and Dupré's only concession is the inclusion of a tiny white horse, as in Constable's print, and a small white sail to mark divisions across the landscape. Dupré painted his own *Haywain*, but with a stormy sky, more like Constable's sketch than his finished painting. However, he did admire the tranquil scenes of the Suffolk country-

9. *Bridge at Narni.*
By C. Corot, 1826.
Musée d'Orsay, Paris.

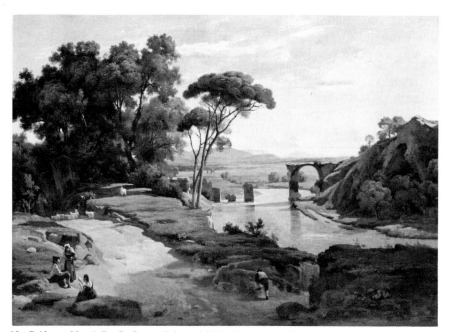

10. *Bridge at Narni.* By C. Corot, Salon of 1827. National Gallery of Canada, Ottawa.

side and his *The Dam* [12], with its stagnant pond showing a boat decaying away, half-hidden in the reeds like the boat in Constable's *Haywain*, reminds us of the latter's words. "The sound of water escaping from mill-dams etc., willows, old rotten planks, slimy posts and brickwork, I love such things."

Constable brought to French landscape painting a respect for the actual location chosen by the artist, a belief that the most ordinary scene was worth painting, that skies, light, atmosphere, and weather were an essential part of landscape, and not least, that the brushstroke needed

11. *The Return from a Pilgrimage to the Madonna dell'Arco.* By L. Robert, Salon of 1827. The Louvre, Paris.

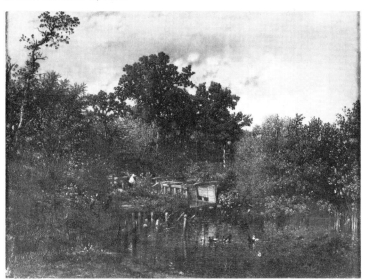

12. *The Dam.* By J. Dupré, 1840s. Musée d'Orsay, Paris.

to be varied in order to capture all the effects observed. The comparison with Constable's finished paintings and oil sketches made it clear that the prevailing French belief in smooth surfaces and invisible brush-strokes was particularly unsuitable for landscape. This was something less easily learned from the English watercolors that were also admired.

Much less well known than Constable's successes in France are those of the group of landscapists with one foot in England and one in France. They traveled back and forth across the English Channel once the Napoleonic wars were over, and they also became a presence in the

Salon, where they were known as the Anglo-French School and some-times as the Anglo-Venetians because of their preference for color and atmosphere. These artists had grown out of the English watercolor tra-dition, and most of their work was in watercolor or in prints, which again accounts for their neglect. The group included Richard Boning-ton, who was born and grew up in England until the age of fifteen, when his family moved to France, and the Fielding brothers, Copley, Thales, Newton, Theodore, and Frederick.

Bonington has always been enormously admired by connoisseurs of watercolor (achieving perhaps in addition a Romantic prestige from his early death at twenty-eight, but the Fieldings have been not at all known from their work but solely from references to them in Delacroix's *Journal* of the 1820s and his description of them as "great artists" in a letter later in his life.

This association with the great Romantic figure painter should not obscure the fact that these artists' greatest significance was in land-scape. Their qualities of light and atmosphere had already impressed French artists before the Salon of 1824, at which not only Constable but also Bonington and Copley Fielding received gold medals. The French artist Regnier, who owned a Constable sketch (seen in his studio by Delacroix in 1823, who described it as "an admirable and unbelievable piece"), was another exhibitor at the 1824 Salon. The critic Auguste Jal, discussing Regnier's pictures, accused him of drifting away from his master Bertin, who was one of the driest practitioners of French histor-ical landscape, and of adopting "this English method."[4]

French connoisseurs enthusiastically collected Bonington's paint-ings, watercolors, and drawings [13], though the paintings were criti-cized by the same Jal because although they looked very naturalistic viewed from a distance, they were only rough sketches. Similarly Jal and the novelist Stendhal, who also wrote about the Salon, used the word "truth" in connection with Constable, but both criticized the painter for the unfinished style of his pictures. These comments re-vealed that two elements essential to the creation of Realist art had been established: the desire to reproduce actual scenes convincingly, and the evolving of new styles necessary to recreate the fluid qualities of atmo-sphere.

A different aspect of Realism can be found in the work of one of the great French painters. Géricault, like Constable, was able to express an

[4] A French critic, P.-A. Coupin, wrote, "A crowd of young people has rushed after the English, and even while the exhibition is still on, they have done landscapes and views where they have sought, above all, to be true and simple."

Cited in H. Honour, *Romanticism*, Harmondsworth, Middlesex, England, 1981, p. 338. See also note 2, Chapter 6.

13. *View of the Normandy Coast.*
By R. P. Bonington, ca 1824.
The Louvre, Paris.

intense personal vision through the transformation of the everyday. In doing so he made the ordinary a valid subject for art for subsequent French artists. Géricault astonishes us by the way he was able to express the whole gamut of human emotions through his pictures of horses: a hypersensitive anguish in the *Horse Frightened by Lightning* (National Gallery, London), the eternal struggle with overwhelming passions in his many pictures of men attempting to restrain rearing plunging animals, and the plodding chained feelings of the carthorses. These latter canvases still surprise us by their originality.

The Lime Kiln, ca 1822 [14], is a particularly remarkable example of his depictions of workhorses. Eighteenth-century English painters like George Morland had painted carthorses, but these had always been part of a picturesque rural scene. Géricault's horses in *The Lime Kiln* belong to the industrial era: the landscape is a desolate, blasted heath, obscured by smoke. As in *The Wine Cart*, ca 1820 (Rhode Island School of Design Museum), the composition appears almost unorganized— simply the view we get as we approach the kiln, some horses in the lower left, the kiln itself to the right, but most of the building out of the picture, with nothing in the center. This sense of the uncomposed will form a major aspect of later Realism.

Géricault's application of paint also strikes us. As in Constable's paintings, we feel the thickness of the medium, the irregularities where the white or cream highlights have been laid on top of the local color. Géricault has splintered the smooth surface prized by French artists, and where they rendered their brushstrokes invisible, we not only see

14. *The Lime Kiln.*
By T. Géricault, ca 1822.
The Louvre, Paris.

his brushstrokes but can sense the movement of his hand. The established attitude can be seen in the comments put in the mouth of an artist by Auguste Jal in his review of the Salon of 1824, discussing Constable's paintings: "This work in relief, these masses of brown, yellow, green, grey, red and white, thrown upon each other, worked with a trowel, cut with a palette knife and then glazed . . . those things, I say, are less art than technique; and further, this technique is without grace."[5]

During his stay in England Géricault produced some lithographs as remarkable as his paintings. His album of prints (1821), "drawn from life" as the title page claims, is remarkable for both the subjects, slices of London life, and the composition. He depicted the poor of London, capturing the grimy, desolate aspects of the sprawling city, as in *Pity the Sorrows of a Poor Old Man*, and, of course, horses. As in *The Lime Kiln*, Géricault concentrates on horses in the industrial world, far from the cavalry horses and the wild horses of his early work. In *Entrance to the Adelphi Wharf* [15], Géricault startles us with the blankness of the subject, the rear views of the horses and drover disappearing into the black arch, the entire upper part of the print filled with uninteresting brickwork. He must certainly have been inspired in part by Hogarth's engravings of dismal London scenes, but Hogarth's repellent subjects like *Gin Lane* are stuffed with lively incidents. Hogarth's energy and invention make his prints fascinating, while Géricault eliminates anecdote. Géricault and his publisher must have thought that these "unappealing" prints would sell, another indication of the growing public taste for unglamorized reproductions of the everyday.

Interestingly, in a letter to a friend, Géricault apologized for these

[5] Cited in E. Holt, *The Triumph of Art for the Public*. Washington, D.C., 1980, p. 257.

prints: "as soon as the real connoisseurs have come to know me, they will use me for work worthier of myself."

We do not know exactly how to interpret this letter. Géricault, like many Romantic artists, may have been torn between the appeal of new possibilities and his admiration for the great art of the past, or he may have been trying to placate his correspondent, whom he suspected of disapproving of his descent from the ambitions of his Salon paintings to popular art. Whatever the case, the prints were not casually tossed off, but stand among Géricault's major works, and once in circulation helped spread the new ideas in art. In the 1860s, the critic Thoré, the defender of Realism, singled out these prints for praise.

Certainly in England, with its less categorical approach to art, painters did not despise prints. Constable had prints made after his paintings

15. *Entrance to the Adelphi Wharf.* By T. Géricault, 1821.

and oil sketches in order to demonstrate more widely the possibilities of landscape art as a medium of expression. He collaborated enthusiastically with a talented young mezzotinter, David Lucas, taking great pains to reproduce tonal effects, what Constable called the "chiaroscuro of Nature." *A Summerland,* 1830 [16], typifies Constable's more original achievements with its horizontal sweep of landscape that lacks all of the framing devices such as trees or hills usually considered essential. What looks to us like a very ordinary picture was part of the revolution in landscape painting in England around 1800. As artists spent more time sketching out of doors they began to complain that while nature always looked right whatever viewpoint was chosen, a picture needed to be

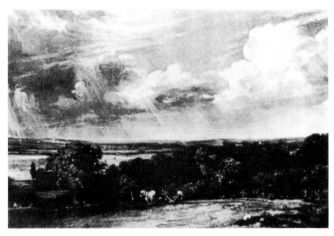

16. *A Summerland* from *English Landscape Scenery*. By J. Constable, 1830.

composed. Constable not only eliminated framing elements but also any prominent motif in the center, which was also customary. The English artists, especially the watercolorists, began to choose slices of nature, and they simply let rivers and field flows off the sides of the paper. This apparently trivial development was one of the major changes in the idea of what constituted a proper picture in the nineteenth century. The "compositionless" painting becomes a cornerstone of Realist art. Needless to say, what we have is a new concept of composition designed to look uncomposed. Doubtless one of the reasons that Constable's *Haywain* was such a success in France was the fact that it followed more traditional models, with the anchoring cottage and trees on one side of the painting. Constable clearly derived the composition from Rubens's *Château de Steen*, which he had admired in Sir George Beaumont's collection.

He was not surprisingly more conservative in his big paintings, intended for the Royal Academy exhibitions, than in his sketches and prints. In *A Summerland* the only distinct compositional device is the tiny horse and plowman in the center. The characteristically Romantic feature of the print is the sky, with its turbulent clouds that transform the placid countryside below with the dramatic chiaroscuro that Constable saw as the vital force of nature. For later artists the inexpressive landscape was sufficient to make a picture.

In his Pelican history of nineteenth-century European art, Fritz Novotny wrote, "One might therefore suggest, as a concise definition of the art of the nineteenth century, that it was a century of great landscape painting."[6] This definition may be too concise, too exclusive, but

[6] F. Novotny, *Painting and Sculpture in Europe, 1780–1880*, Harmondsworth, Middlesex, 1978, p. 15.

it puts the emphasis on the major element. The huge number of figure paintings produced in that period are, for the most part, much less significant than the landscapes. Attempts to treat the art in a balanced way will inevitably distort the significance of what we are discussing. Landscape, in fact, plays a crucial role in making possible what we might regard as figure paintings: Impressionist close-ups like Claude Monet's *Luncheon on the Grass*, Renoir's *The Swing*, or Manet's *Argenteuil*, and later some of the most important paintings by Gauguin and Seurat.

The comprehensive treatment of landscape art in the early nineteenth century has still to be written. The writers on art at that time tended to take the hierarchy of subject matter for granted, giving a minor place to landscape just as they did to watercolors and prints, and we have until recently followed their interests. Pyne advertised *Microcosm* as providing groups of figures for the embellishment of landscape, and we have to realize how widespread this genre was. It has been shown by an analysis of the Salon catalogues in France that even at the height of neoclassical enthusiasm, landscapes were a major category of painting.[7]

The quotation from James Thomson that heads this chapter sounds like a Romantic outpouring from the early nineteenth century that we might attribute to Wordsworth or Shelley, but it was written a century earlier. Thomson's nature poem *The Seasons* remained very popular throughout the eighteenth century and was read and reread by Turner and Constable. His sentiments were not the new ideas of avant-garde poets, but the common currency of educated people throughout Western Europe. This observation brings us to the most neglected group of artists in the histories of art. When we read the lives of artists in this period, apart from the very successful painters in London or Paris, we discover that the innumerable artists in the country towns made their living not only by painting portraits of the local squires, their wives and children, and of their horses and dogs, but as drawing masters. These professional artists taught the middle and upper classes to draw and paint, and they created a numerous body of amateur artists who have largely slipped out of history. Yet these artists are significant in the history of art. Some of them were extremely able; we have only to think of the pictures painted by Queen Victoria or the etchings made by her husband, Prince Albert, the landscape etchings by Sir Seymour Hayden, Whistler's brother-in-law, or, across the Channel, the prints of the Goncourt brothers and the paintings of Princess Mathilde. Even more important than the question of their artistic accomplishment is the fact

[7] See J. Leith, *The Idea of Art as Propaganda in France, 1750–1799.* Toronto, 1965.

that these men and women were rarely interested in composing neo-classical themes, religious subjects, or allegories—apart from some portraiture, they were chiefly interested in painting landscapes. It was for them that Pyne's *Microcosm* and the numerous textbooks on drawing and painting in the early part of the century were written. These amateurs were also the patrons of art. Their interest in landscape led them to buy landscapes. It became possible for a large number of professional artists to paint nature and find patrons. Because the genre was officially despised, prices were not high, and artists often had to struggle, as the large number of artists anxious to paint landscapes led to keen competition, but a successful landscapist like Bonington found his drawings fought over, while Turner became rich. To understand the significance of the amateur artist is to see why landscape painting and its associated genre, animal painting, developed so quickly. It is no coincidence that John Ruskin, the enthusiastic defender of Turner, was also a very gifted amateur landscapist.

In this chapter we have explored the byways of art in the first three decades of the nineteenth century. We will end by looking at the main thoroughfare. In 1824 the two greatest living French artists finished large canvases that embodied the prevailing beliefs in the purpose of art. David executed the last testament to his belief in the neoclassical style and subject as the vehicle of inspiring moral allegory, *Mars Disarmed by Venus and the Three Graces* [17]. Ingres created a history painting taken from the French seventeenth century, *The Vow of Louis XIIIth* [18], the king dedicating his country to the Virgin and Christianity, a subject designed to arouse devotion to the restored Bourbons. His sources were Raphael and the French seventeenth-century royal portraitist Rigaud. The two paintings are complementary, one derived from the classical tradition, the other from the Christian, both painted by outstanding geniuses, yet we regard them as failures. David's posed figures gleaming in confectionary colors appear taken from the lid of a chocolate box, not from the lustful and brutal but profound mythology of ancient Greece. We remain unmoved by the meaningless gestures. Ingres attempted to synthesize the power of history and religion, but his picture seems assembled from the parts of two different kits.

These two paintings by the greatest masters and Constable's *Haywain*, which a visitor to the 1824 Salon would have seen together with Ingres's huge canvas, encapsulated the history of nineteenth-century art. The allegorical, historical, religious painting, with its smooth surface and elegant forms, however distinguished the artist who produced it, was dead, still-born, while the trivial cart in the banal landscape, "coarsely" painted, not much more than a sketch, held the key to the future.

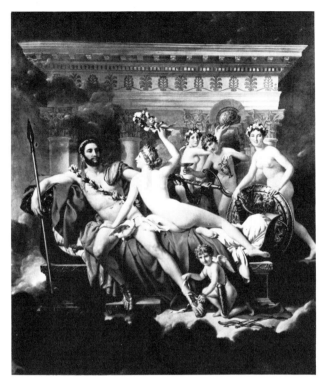

17. *Mars Disarmed by Venus and the Three Graces*. By J.-L. David, 1824. Musées Royaux des Beaux-Arts/Koninklijke Musea voor Schone Kunsten, Brussels.

18. *The Vow of Louis XIII*. By J.-A.-D. Ingres, Salon of 1824. Cathedral of Notre-Dame, Montauban.

Inasmuch as modern art, in the beginning of its career, held commerce almost exclusively with the spirits of dead men of bygone ages, it had set itself in opposition to all the great epochs that had gone before. Whoever wishes to know how the men of the time lived and moved, what hopes and sorrows they bore on their breasts, whoever seeks for works in which the heartbeat of the century is alive and throbbing, must have his attention directed to the works of the draughtsmen, to the illustrations of certain periodicals.

<div align="right">R. Muther, The History of Modern Painting, 1896</div>

It is necessary to be of one's time.

<div align="right">Honoré Daumier</div>

Our art is capable of achieving the expressive force which we are seeking, through the sincerity of the portrayal, through exact truth to life.

<div align="right">Théodore Rousseau</div>

M. Rousseau falls into the frequent modern error, which is born of a blind love of nature, of nothing but nature, he mistakes a simple study for a picture.

<div align="right">Charles Baudelaire, Salon of 1859</div>

And since we adhere closely to nature, we no longer separate a person from the setting of the apartment or of the street. In life a person never appears against a neutral, empty or vague background, but around him are the furniture, the mantelpiece, the wallpapers, the environment which expresses his fortune, his class, his occupation.

<div align="right">Edmond Duranty, 1876</div>

3

THE DESIRE TO RECORD
THE WORLD, 1830–1850

The decade of the 1830s stands out as one of the most remarkable in history for the multiplication of images. There was an "image explosion" created by the foundation of the popular illustrated press, and by the invention of photography. Until this time pictures had been relatively rare for most people, and were objects to be treasured whether paintings or prints. Now they were readily available by the hundreds of thousands, and they could be torn out of magazines to be stored in files, pinned up on the wall, or simply thrown away. They were in almost everyone's possession, and people came to learn about the world through pictures rather than through words.

The rapidity of the spread of cheap newspapers and magazines is still astonishing today. A series of inventions came together: the steam press, cheap newsprint that would go through high-speed presses without tearing, cheap ink that would not smear, and mechanized typesetting. The simultaneous spread of railroads provided a rapid means of distribution for the magazines, further increasing circulation and reducing prices.

One of the most famous and most characteristic of the new publications was *The Penny Magazine,* founded in 1832 by Charles Knight and published by his Society for the Diffusion of Useful Knowledge. The title advertises its democratic intent, and the name of the Society, its educational purpose. The opening editorial attacks those who want to keep literature for those who are wealthy, and makes an interesting parallel between freedom of travel and of communication: "What the stage-coach has become to the middle classes, we hope our Penny Magazine will be to *all* classes—a universal convenience and enjoyment." The magazine was filled with short articles on every conceivable subject, almost all of them factual, and most illustrated. We find world history, architecture from the entire globe, and there seemed to be

particular interest in animals, whether different breeds of cows, or even more frequently exotic creatures like kangaroos and boa constrictors. The aim, though not always the result, of the illustrations was factual descriptive accuracy.

Magazines like this one, which inspired numerous imitators, fed the public appetite that we have already noted for visual information about the world, and increased that appetite. The variety of magazines was considerable, from those like *The Penny Magazine,* which was a miniature encyclopedia, to satiric and comic weeklies like *La Caricature* and *Punch.*

Illustrated books too became widespread, and both novels and poetry contained pictures, often by major artists. Moxon, for his edition of Tennyson's poems, commissioned illustrations from the whole group of the Pre-Raphaelite painters, and Millais became a major illustrator of Trollope. Many painters, such as Daubigny, Meissonier, and Menzel, got their start as illustrators, while Claude Monet helped finance his early studies by his caricatures. The illustrations of novels became particularly important, even though the brilliant descriptions that were part and parcel of the Realist novel seemed to make illustration superfluous. The novels, though, were frequently issued in weekly or monthly parts, and had to compete with the magazines on the bookstalls. A few old established and conservative periodicals held out against pictures as "popular," and some books were not illustrated, which, of course led to *Alice's Adventures in Wonderland:*

> Once or twice she peeped into the book her sister was reading, but it had no pictures or conversations in it; "and what is the use of a book," thought Alice, "without pictures or conversations?"

Not distracted by the book, she noticed the White Rabbit, and her subsequent adventures were illustrated twice before they were even published, once by Lewis Carroll himself and then by Tenniel.

The types of illustration varied enormously, from crudely hacked woodcuts to superbly executed wood engravings and lithographs. They comprised not only individual pictures but fold-out concertinas that reproduced panoramas of cities or the detailed facades of major streets. In studying this outpouring from the point of view of the development of Realism, there is much to interest us. Though the majority of illustrations are just that, with no particularly striking artistic qualities, there are still many of significance.

Most illustrations portrayed contemporary life and phenomena. The public and the artists were interested in the new: the engineering wonders, the bridges, tunnels, railways, and steamships, the growth of the cities and the life in the streets, the terrible social problems that

accompanied industrialization, and the news from all over the world (the latter, as always, famines, wars, and disasters). In the 1830s, '40s, and '50s, painters turned more and more to rural subjects, the landscape itself, the life of the peasants, imaginary or real, and to farm animals, but the magazine artists drew the urban. Another important difference is the approach to the material; painters preferred the static and the monumental (the storms of early Barbizon painting grew fewer and fewer), but the magazines were fascinated by the movement and crowding of the city. The street itself becomes a major theme, not as an architectural entity, except in the fold-outs, but as a swarming mass of people, in which all classes meld together in a struggle for right of way, a microcosm of existence [26 and 168]. It has become a commonplace that all the themes that seemed revolutionary in Impressionist painting —railway stations, trains, cafés, milliners' shops, outdoor entertainments, swimming at Bougival or boating at Argenteuil—had been the stock-in-trade of the periodicals for years.

In England, Frith created a sensation with his painting *Derby Day*, 1858 [19], which had to be protected by a rail at the Royal Academy exhibition, yet a similar idea, with the carriages of the wealthy in the foreground with a picnic spread and the grandstand in the background, had appeared in the *Illustrated London News* in 1843 [20].

The latter journal, founded in 1842, immediately established a reputation throughout Europe for the quality of its pictures. The pupils of Bewick had created a profession of wonderfully skilled engravers who were the backbone of the *ILN*, and who were in demand abroad, where a number of them went to settle and founded their own schools. Many of the blocks from the first year of *The Penny Magazine* were sold to France, and we find these illustrations in the *Magasin pittoresque*, which was founded the following year, in 1833.

The *ILN* with its emphasis on news provides examples of the problems and achievements of the wood engraving. Favorite, and apparently frequent, disasters like the explosion of steamships, locomotives, and powder magazines, meant that artists had to imagine a good deal, and they fell back on existing formulas to represent debris and people being flung through the air. With subjects that could be studied, the shared passion for factuality meant that artists went to considerable lengths to bring back accurate pictures. The pictures of events during the June days in the 1848 revolutions in Paris show these different approaches. The magazine explained that the artist had been at great personal risk in reporting the battles. He himself said that in order to examine the barricade at the entrance of the rue du Faubourg St. Antoine [21], he had been obliged to help build it. No doubt his drawing benefitted from this first-hand experience. The sign "Complet," the

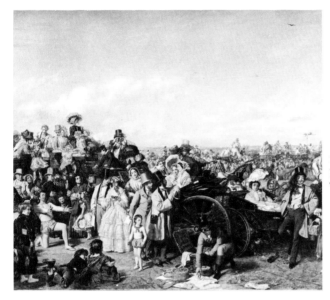

19. *Derby Day*, detail.
By W. Frith, 1858.
Tate Gallery, London.

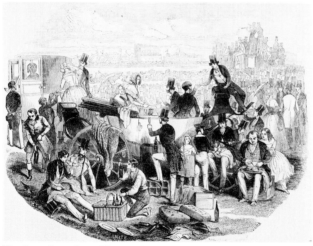

20. *Ascot Races* from *Illustrated London News*, 1843.

artist explained, came from a Paris omnibus, and that it was a charac-
teristic example of the wit of the French people to mount it on the
finished barricade.

The illustration of the women on the barricade near the Porte St.
Denis [22] is another matter. The banners billow, or flatten for us to
read in a manner familiar to us from previous art, just as the gestures
of the women recall earlier heroic poses. The artist insisted that
"Though this scene appears to be too melodramatic to be true, still it is
the very drama of reality. . . . Mounted on the barricade are two

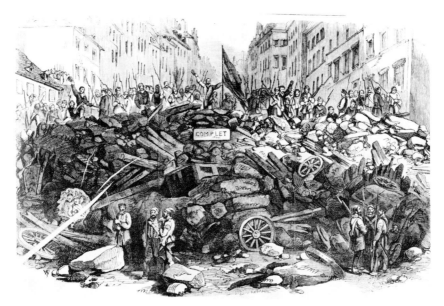

21. *The Barricade—Complet* from *Illustrated London News*, 1848.

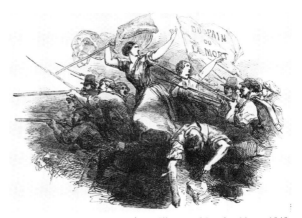

22. *The Barricade—Women* from *Illustrated London News*, 1848.

women heroically calling upon the insurgents to follow their example of self-devotedness. The foremost was well known in the Quartier St. Denis; she was a fine woman, with black hair, and wore a light blue silk dress; her head and arms were bare. She and her companion were shot whilst in the attitudes indicated in the Illustration."

The text is more moving than the picture, which reminds us of Delacroix's *Liberty Leading the People* from the Revolution of 1830 and many other illustrations in this tradition. Meissonier's *The Barricade* [23], an incident from the 1848 uprising, with no heroic gestures, has much

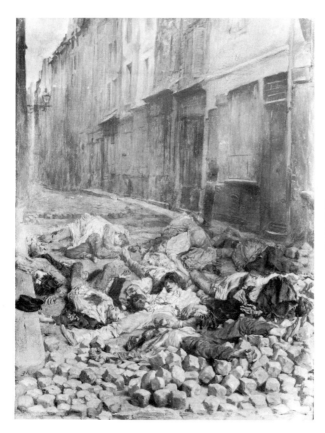

23. *The Barricade*.
By J.-L.-E. Meissonier,
1849. Musée d'Orsay,
Paris.

greater power. The same contrast of text and "recreated" picture can be seen in the *ILN*'s coverage of the coup d'état by Louis Napoleon in 1851. A special correspondent describes men found in a café, suspected of being insurgents, being "dragged out into the passage, and, despite their prayers for mercy, or at least for a trial, were deliberately shot upon the stones there and then." The illustration has a contrived air that reduces the horror of the event. The *ILN* under its founder, Herbert Ingram, seems to have been appalled by the eagerness of the French government to shoot down its own citizens, and the uprisings are covered very sympathetically from the viewpoint of the people on the barricades, though the magazine was opposed to their political ideas. Similarly there were exposés of the horrors of child labor, and the conditions under which many people lived [24]. For a respectable, middle-class journal, the *ILN* pulled surprisingly few punches.

When we look through a number of issues, we can be struck by the breaking down of any idea of a hierarchy of subject matter. As we might expect, the major events in which Queen Victoria participated are shown, but the dreadful conditions of the London slums appear fre-

quently. Views of impressive engineering works are placed beside technical cross sections. Sporting life and work, disasters and the commonplace are of equal interest. We get a sense of an enormously wide curiosity in the Victorian audience, prepared to accept technicalities more than we are today—they were also offered a picture and description of the press which printed the *ILN* at "2,000 perfect impressions per hour."

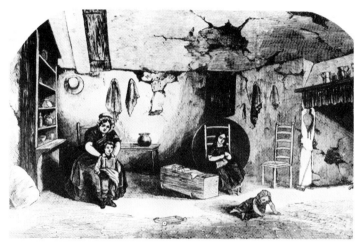

24. *Interior of a Poor Agricultural Cottage* from *Illustrated London News,* 1846.

We also feel, as occurred with the Panorama and the Diorama, an absence of questioning about the nature of art or the role of the new media within it. People seem to have accepted the categories that were handed down to them, and to have put the new forms into a kind of limbo in their mind. When we think of the huge popularity both of pictorial images and of art in the nineteenth century, it is surprising what a tiny number of artists and critics challenged these categories.

It is not as if the illustrations were entirely divorced from the world of art, as one might consider handbills advertising quack medicines of the day as quite different from the world of literature. Not only did accepted artists draw some of the illustrations, but the new subjects often challenged the artists to come up with new ways of presenting them adequately, and we find very sophisticated pictures. Degas was so impressed that he sent a drawing to the *ILN* hoping to have it published. Today many of the double-page spreads in the *ILN* seize our interest much more than the eternal, interchangeable pretty shepherdesses from the academic exhibitions. Two illustrations can demonstrate different achievements of the *ILN* artists and engravers.

The view of the rebuilding of the London Embankment [25] must

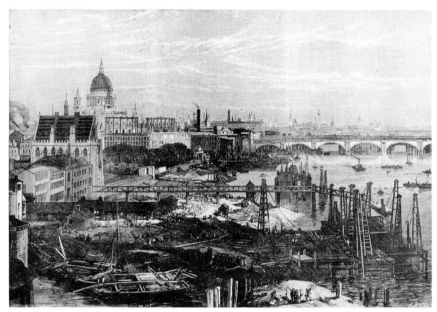

25. *The Victoria Embankment Under Construction* from *Illustrated London News*, 1864.

have been drawn from a photograph. The overwhelming amount of detail could not have been copied on the spot, but the final print is not simply a photograph in drawn form. The translation into wood engraving, from tone to line, means a rethinking of the light and shade of the photograph, and of the representation of the scene. The result is a new kind of picture, which goes beyond the detailed representation of a city, like Canaletto's views of Venice. The Italian had used the camera obscura to achieve detail and perspective, but he started with a specific idea of composition, and pointed his camera accordingly. The photographer of the London docks under construction had a much greater amount of the unorganized inescapably present, and it was in fact the point of his picture—the sheer complexity of modern industrialism. A painter would not have thought of putting on canvas such a panorama of the unfinished and the chaotic. (He would have painted ruins where the broken fragments were overgrown by bushes and trees to form a new picturesque unity.) The aesthetic of disorder expresses one aspect of modern experience that can be found only in the illustrated magazines.

A Thaw in the Streets, 1865 [26], sets out to capture the chaos of the world in motion. The photographer could not really help so we have the imaginative reconstruction of the artist's observations. The result is not a masterpiece, but the composition offers some surprises. We find figures cut off by the edges of the picture, including the top, elements we expect to find only later, in the paintings of Manet and Degas. A

street full of people of different social classes, the engraving can be compared with Ford Madox Brown's *Work* [98] discussed in Chapter 5. Brown's figures are all in a semicircular composition that parallels the curve of the frame, and none of them are cut off. Brown, highly original in many respects, felt the obligation to subordinate the melée of the street to traditional compositional concepts. The artist of *A Thaw* did understand the need for a new concept of picture making, even if his linear style did not entirely capture the movement. (We can suspect that there was a difference in technique between artist and engraver.) These two large prints are typical of the riches to be found in the *ILN*, and of the freedom of the magazine illustrator to innovate, providing that he met the expectation of a satisfying amount of factual detail.

In England, the *ILN* dominated the magazine field for thirty years through the quality of its engravings, but in the 1870s *The Graphic*, trying to replace the *ILN* as the foremost magazine, introduced a more dynamic concept of composition which will be discussed in the final chapter.

When we look at the illustrations produced in France, the overall interest of the work is even greater than that of England. The range and variety is particularly striking, as in addition to the material comparable to that we have seen in the *ILN*, the French caricaturists quite outdid the English. After the brilliance and savagery of Rowlandson and Gill-

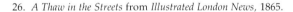

26. *A Thaw in the Streets* from *Illustrated London News*, 1865.

ray, Victorian "good taste" took not only the bite but also the artistic inventiveness out of the English cartoonists.

The French also went much further than the English in studying their contemporary life systematically. The love of classification led not only to excellent dictionaries and encyclopedias but also to the *Physiologies* which categorized all the types of French men and women. They were a kind of primitive sociology, based on observation rather than investigation, but usually fascinating because they were well illustrated. The most famous is *Les Français peints par eux-mêmes*, 1840–42 (*The French Depicted by Themselves*), a series of volumes to which many famous writers and artists contributed. It consists of hundreds of descriptions of professions and roles in society. We not only find, as might be expected, the Actress and the Peer of France, but also the Actress's Mother and the "Rapin," an artist's young studio assistant.

Each article runs from four to eight pages and several vignettes are included in the text. I have an English translation, published in London in 1840 with the original wood engraving, in which the names of the engravers are given with those of the artists in the list of contents, an indication of the importance of the engraver in translating the drawings, especially the beautiful little sketches by Gavarni. The fact that the first volumes were published in England in the same year as in France shows again the closeness of the artistic links between the two countries.

Les Français can be seen as a pivotal work in the growth of Realist attitudes, both from its approach to contemporary life and in certain aspects of the illustrations. Jules Janin wrote in the Introduction:

> though humanity remains unaltered, its forms vary and change to infinity. . . . Society modifies its vices and follies as a fashionable lady changes the form of her dresses and trinkets; and since milliners have their Sybiline leaves to explain the oft occurring revolutions of their empire, why should not the French—the most fickle and frivolous people in the world—keep a register in which to write down the daily transformations of their manners, with all their shades and peculiarities? . . . Neglecting to describe mankind, historians have wasted their talents on dry and minute accounts of battles and sieges, bloody wars and treaties of peace. They have told us of how our forefathers fought, but not how they lived.

Janin goes on to say how interesting it would be to have accounts of daily life from the beginning of history, and he mentions La Bruyère and his *Characters*. The reference to the latter points up the origin of the portraits in the *Français* in the traditional "characters" where a type was described who stood for all country doctors or all gamekeepers. At the beginning of each article in *Les Français* is a full-page engraving of the

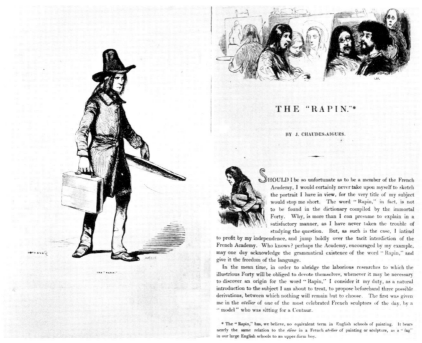

THE "RAPIN."*

BY J. CHAUDES-AIGUES.

SHOULD I be so unfortunate as to be a member of the French Academy, I would certainly never take upon myself to sketch the portrait I have in view, for the very title of my subject would stop me short. The word "Rapin," in fact, is not to be found in the dictionary compiled by the immortal Forty. Why, is more than I can presume to explain in a satisfactory manner, as I have never taken the trouble of studying the question. But, as such is the case, I intend to profit by my independence, and jump boldly over the tacit interdiction of the French Academy. Who knows? perhaps the Academy, encouraged by my example, may one day acknowledge the grammatical existence of the word " Rapin," and give it the freedom of the language.

In the mean time, in order to abridge the laborious researches to which the illustrious Forty will be obliged to devote themselves, whenever it may be necessary to discover an origin for the word " Rapin," I consider it my duty, as a natural introduction to the subject I am about to treat, to propose beforehand three possible derivations, between which nothing will remain but to choose. The first was given me in the *atelier* of one of the most celebrated French sculptors of the day, by a " model " who was sitting for a Centaur.

* The " Rapin," has, we believe, no equivalent term in English schools of painting. It bears nearly the same relation to the *élève* in a French *atelier* of painting or sculpture, as a " fag" in our large English schools to an upper-form boy.

27–28. The "Rapin," from Les Français peints par eux-mêmes (The French Depicted by Themselves), 1840. Illustrations by Gavarni.

particular subject with very little setting [27], but there is a head piece on the opposite page above the text which shows the person in his or her environment [28]. We can see the transition from the abstract type to the idea that the setting is necessary to fully describe someone.

Balzac wrote some of the texts, and we are reminded of his famous description of the boardinghouse of Mme Vauquer at the beginning of Le Père Goriot. He vividly evokes its rundown, moldy condition, pervaded by what he could label only as "boardinghouse smell." Then, with the entrance of Mme Vauquer, Balzac points out in the celebrated phrase, "everything in her person explained the boardinghouse, just as the boardinghouse implied her person." The independent Romantic hero, outside society, was dead. For the Realists, the environment and the person were inseparable. The vignette had begun in the Romantic era as Friedrich Schlegel's "fragments," piercing flashes of insight. The Realist vignette has become a "slice of life"; it is a fragment with no beginning and no end, and no story [29].

Another type of Physiologie can be found in Le Diable à Paris (1845–46), whose title is somewhat misleading. It suggests a racy account of

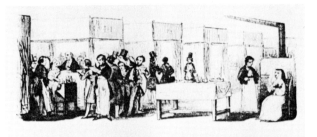

THE HOSPITAL ATTENDANT.

BY P. BERNARD.

Ubi non est mulier, ingemiscit æger.

C'est cœur de la femme qui approche de plus près le mortel aux prises avec la douleur; c'est sa main qui le touche avec plus de douceur.—PERCY ET LAURENT.

ENTURE to look into that long narrow room, bordered by iron bedsteads, with scanty but clean white curtains, and watch that little man who glides rather than walks, in an old pair of slippers, along the polished floor. He appears, then disappears; he is here one moment, and gone the next. Observe, however, that he is perambulating from one bedside to another, to inquire if there is anything new, and to wish good morrow. Do you know to *whom*? To——mere numbers; for the man of whom we are speaking has no fellow-beings in the place where we find him: there, the world is composed only of himself, and Numbers One, Two, Three, Four, &c.

29. *The Hospital Attendant*, vignette from *The French Depicted by Themselves*, 1840. Illustration by Gavarni.

the devil visiting Paris, but this idea is submerged by the factual information provided. The publisher Hetzel was a republican who wanted to emphasize the poverty and suffering in Paris, and he included numerous statistical tables in the book. Modern social statistics begin in the 1830s and '40s and are another sign of the obsession with facts. The illustrations in *Le Diable à Paris* vary a great deal in type. I have selected just two, which show what was achieved in graphic art that was outside the realm of painting. The page of drawings by Bertall of "How People Greet Each Other" [30] attempts to capture life in movement, the small expressive gestures of everyday life. The drawings are humorous but not caricatured; we can identify with the people. Because they are not the exaggerated, emotional gestures of painting, they persuade us of their reality. *Le Diable à Paris* was published simultaneously with Bau-

variété, et la plus habile dissertation mathématique ne pourrait les reproduire.

Le salut est comme les caractères, il est altier, simple.

bonhomme, insultant, bienveillant, froid, humiliant. . . . bas. . . .

. . . . naïf, gourmé. orgueilleux, triste.

. . . . inquiet, misérable. audacieux.

Tel salut irrite, tel autre touche et émeut. — Les rapports sociaux et les nuances des positions s'y dessinent d'une manière éclatante, mais rapide. Avant que les deux salutateurs se soient raffermis sur leurs

30. *How People Greet Each Other* from *Le Diable à Paris (The Devil in Paris)*, 1845–46. Illustration by Bertall.

cits et des confidences y est nue, comme ceux qui en parlent; tous posent,

les uns avec faste, les au-
tres avec orgueil, plusieurs
sans le savoir. Les gros
ventres, les têtes énormes,
les petites jambes, les ge-
noux gros, cagneux et ren-
trants, les épines dorsales
tordues, les tailles sans fin,
les bras maigres, les pieds

longs et vilains, engendrent des caricatures à réjouir Gavarni et Daumier.

L'homme est laid dans l'eau et, au sortir de l'eau, tout son être est gre-
lottant, mouillé et souffreteux; on ne croirait jamais que tant d'heur et
tant de félicité pussent se cacher sous ces piteuses mines de nageurs. Ce
qu'il y a de plus amusant ce sont ceux qui, sur le pont ou sur l'escalier en

spirale construit au
côté droit de l'am-
phithéâtre, pour les
gens qui aiment à
tomber de haut, font
la parade au dehors.
Ces statues aérien-
nes ne se jettent ja-
mais; c'est une ex-
hibition à l'usage des
beaux yeux des da-

mes qui cheminent sur le quai en traversant le pont Louis XV; on a com-
paré ces gens à des dindons qui font la roue sur un perchoir.

31. *Swimmers* from *Le Diable à Paris,* 1845–46. Illustration by Bertall.

delaire's Salon reviews asking for a "painter of the heroism of modern life." The poet wanted painters to show us "how great and poetic we are in our cravats and our patent leather boots." Bertall's figures may not be poetic or heroic (a demand Baudelaire soon dropped), but they possessed the contemporaneity that the critic sought. Furthermore they expressed the momentary gesture, what was fleeting, an aspect of modern life that Baudelaire was to formulate only later, under the influence of these graphic artists on whom he often wrote.

The vignettes lack the environment we have just been stressing, but I would like to claim that they become part of a new form, in which an accumulation of vignettes is given context literally by the text which accompanies them [31]. The *Physiologies* permitted this integration, which did not occur in the magazines. Today we do not usually read and look at these books, and we simply overlook this achievement. It belongs neither to literature nor to art as we generally conceive them, and the *Physiologies* have slipped out of our consciousness like the Panoramas. The fact that the modern descendants, the photo-novel and the comic book, rarely have enough visual originality to excite us with the idea of the mixture of picture and word has further diminished our interest in these earlier examples.

Included as examples of the range of illustration of public and private life from the innumerable books and magazines of the period are the people in a café [32], the man in his bath [33], and the group of umbrellas in the rain [34]. The café scene, the forerunner of so many Impressionist paintings, like the vignettes from the *Diable à Paris*, tries to reproduce the liveliness and the casualness of an everyday event, foregoing storytelling or drama. The man taking a bath is a comic comment on the nymphs busy bathing at the Salon, a contemporary experience as the Industrial Revolution brought the tin bath that transformed the cleanliness and health of Europe, and a precedent for later paintings by Caillebotte and Degas. *Rainstorm* belongs to the way of looking at the world as fragmented experience, and of delighting in these fragments, and is part of the repertoire of compositional motifs handed on to the Impressionists.

Manet's etching of umbrellas [35] and Renoir's painting *The Umbrellas* [91] are frequently reproduced in comparison with Japanese prints, as the umbrella was also a motif that attracted Japanese artists as a formal device. Its existence earlier in French nineteenth-century art provides further evidence that a major reason for the Impressionists' enthusiasm for *ukiyo-e* prints was that they reinforced existing examples of Realist depictions of French life. Japanese prints were thus not simply an exotic new experience, but they showed how to incorporate formally inventive fragments, like the umbrellas, into a complete composition.

32. *A Café* from *La Grande Ville (The Big City)*, 1844.

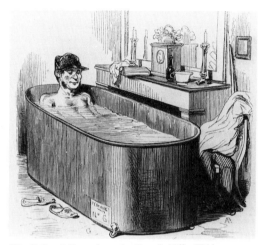

33. *Baths at Home* from *La Grande Ville*, 1844.

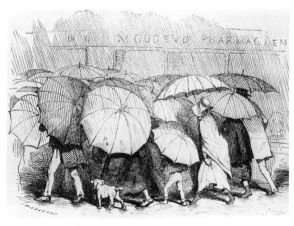

34. *Rainstorm* from
Le Diable à Paris,
1845–46.

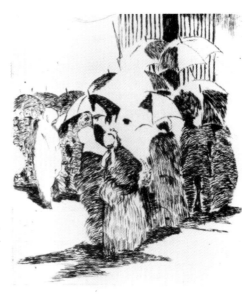

35. *Line in Front of a Butcher's Shop.*
By E. Manet, 1870–71.

When we turn from dipping into this enormous amount of what one might call proto-Realist material, to caricature, we encounter the first great Realist artist, Honoré Daumier (1808–1879). Recognized as a great artist in his lifetime by some of his fellow artists and critics, Daumier has still not been widely accepted as unsurpassed in his century. There were a few equally great artists, but none that were superior. Daumier has even been described as not a Realist because of a few of his imaginative works like the *Don Quixote* series, and because the distortions of his caricatures are seen as incompatible with what is regarded as the verisimilitude necessary in Realism.

Daumier's work, in fact, makes clear the nature of Realism. We see in most of his drawings, lithographs, paintings, and sculptures the essential characteristics. His works are based on actual experience and his almost superhuman powers of observation. Secondly, Daumier did not pose his people—they are all caught in the middle of an action, and we feel that we are observing life on the wing, never an artistic convention. Finally, he created a style to express the nature of his characters and their actions. In almost all great Realist works we see that a photographic rendering of form and precise detail has to be subordinated to the style, whether it is Millet's coarse painting that eliminates detail and sensitive rendering of textures, or the Impressionists' dissolution of form in favor of movement.

Daumier came from a working-class family made poorer by his father's poetic ambitions. The latter probably encouraged his son's choice of an artistic career, but their poverty obliged the young man to become an apprentice lithographer. This is turn led to caricature. It has often

been regretted that Daumier had little time and money for painting, which he pursued as a sideline. On the other hand, Daumier's talents were so perfectly fitted for caricature that had he been able to become a full-time art student and study painting, his work might not have been so exceptional. Daumier produced outstanding paintings, but he was not a colorist, and his style would not have developed so easily in painting. He carried over the exaggerations of form that were a natural part of caricature into his painting, but it would have been much harder to have developed it in a painting context. Caricature also enabled Daumier to eliminate the inessential and to suggest the setting rather than to detail it. He was thus able to avoid the unsatisfactoriness of a blank background, but he did not overwhelm the figures.

Just as Courbet's career was launched by the Revolution of 1848, so Daumier's was made by the Revolution of 1830, even though he spent time in prison. His association with Philipon, the editor of *La Caricature* and *Le Charivari,* and the possibilities opened up by the freedom of the press after the Revolution gave a stimulation that ordinary caricature would not have provided. His art was sharpened by working with the other outstanding artists Philipon attracted, whose fame was subsequently eclipsed by Daumier's incomparable brilliance. It is only recently that they have begun to receive their due again.

It was in 1832, at the age of twenty-four, that Daumier's real artistic breakthrough occurred, thanks to Philipon. The well-known story is evidence of Daumier's unbelievably powerful visual insight and memory. Philipon provided him with clay and suggested that he model small caricatural busts of the members of the French Parliament, in the manner that had been popularized by Jean-Pierre Dantan. Daumier went to the Public Gallery to observe the deputies, and then returned to his room to model the busts. He then drew them for his lithographs. Daumier gave the statuettes to Philipon, and it was only many years later that the dried-out clay was cast in bronze.

Because they are small, 5 to 7 inches high, and not often seen, it is easy to overlook Daumier's originality, but these busts are extraordinarily expressive and formally inventive. He savagely caricatures most of the deputies: some are pompously arrogant, some stupidly self-satisfied, other sunk in lethargy, a few are lively, and Guizot, the historian, with his head twisted and pulled down on his shoulder, seems lost in self-doubt and anguish.

Without any previous sculptural experience, Daumier created masterpieces that overshadowed all such previous works. The figures are all dressed in the same clothing of the period, coats with heavy lapels, collars, stocks and cravats, but Daumier varies them in each case to suit the personality he is creating. Barthe's collar is pressed against his fat

cheeks, extending his grossness into his clothing so that we are forced to imagine an equally gross body. In contrast, the points of Sebastiani's collar jut out forcefully from his face, and his stock projects like the sharp prow of a ship. His clothing thus has an aggressive quality which embodies the toughness of his expression, but at the same time his features are shrunk behind this armor and suggest a man impervious to new experience [36]. Each of the sculptures could be analyzed separately, as Daumier reworks the same few elements in a score of different ways, varying also the manner in which the head is pushed down into or pulled up out of the clothing.

Daumier is even more inventive in the treatment of the heads themselves. The richness of shapes defies description; the tilts and bendings are subtly varied, the artist manipulating the size and shape of the features to an extraordinary degree. Noses can be huge beaks (d' Argout) or tiny buttons, foreheads can be extensive plains (Lefebvre and Delort) or nonexistent as in the case of Fulchiron [37] and of Kératry, whose head recedes back horizontally from his huge arched eyebrows. Etienne's upper lip from the nostrils to the lip itself is as long as his nose, so that his face is composed almost entirely of the lower half and we can think of nothing but his jowls. Pataille has no upper lip, as his pointed nose and pursed lips thrust out sourly at the world. The pinching of the cheek bones into a sharp edge and his equally assertive chin intensify his nasty expression.

A lesser artist distorting features in this way would have ended up with grotesques, but Daumier always retains a sense of the relationship of the parts to the whole, and the actual weight and movement of the parts of the face. Each head remains a specific person, and they are all the more powerful because they are convincing as individuals. Crucial in this creation of a whole is Daumier's gouging of the clay so that he balances out the bulging and projecting elements with deep hollows and incisions, as in the head of Fulchiron. Negative space plays a positive role. Daumier's artistic instincts led him to destroy a basic principle of sculpture since the Renaissance: that of the integrity of the surface of a form, but he does so to create a new type of whole. The implications of this concept were not, could not be, developed until the early twentieth century when Archipenko, Picasso, and Tatlin expressed a new understanding of the material world. Daumier's greatest originality as an artist lies perhaps in this reformulation of sculptural mass.

Though *La Rue Transnonain, 15 avril 1834* [38] is frequently reproduced, its composition is usually neglected in favor of a discussion of the people and the incident itself. The lithograph is large (11¼ by 17⅜ in.), one of a series of individual prints brought out by Philipon for subscribers to help pay the fines to which *La Caricature* was continually

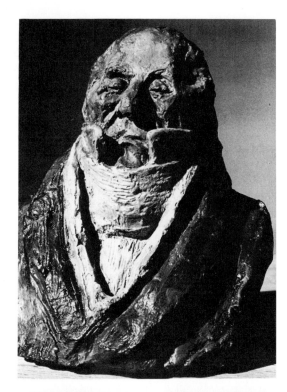

36. *Sebastiani.*
By H. Daumier, 1832.
Musée d'Orsay, Paris.

37. *Fulchiron.*
By H. Daumier, 1832.
Musée d'Orsay, Paris.

38. *La Rue Transnonain, 15 Avril 1834*. By H. Daumier, 1834. The Baltimore Museum of Art.

subjected. It is natural to stress the lack of idealization, the dwarfish and lumpish forms of this working-class family, innocent victims of the military's revenge, but the composition of the print is equally remarkable. Cutting off the picture at the level of the bed, Daumier creates a claustrophobic atmosphere that permits no sense of tragic grandeur. A comparison with David's *Death of Marat* reveals the change in art and Daumier's achievement. Marat, stabbed in his bathtub, shares the ordinariness of Daumier's family, but not only has David composed the plain objects to give a dignified atmosphere, but also the large bare wall behind Marat is crucial to David's wish to create a secular martyrdom. It implies a dimension of meaning beyond the physical scene. In Daumier's print, the looming bolster in the upper part echoes the body of the man, a grotesque invention that presses down on the picture with a sagging, lifeless weight which finalizes the hopeless banality of these deaths.

Linda Nochlin has written brilliantly of death as a subject in Realist art and in nineteenth-century thought, pointing out that everything that in the past had made death a significant subject had evaporated. It had become impossible to suggest heroism in the dead individual, or a redeeming vision of life after death—the dead person had become simply a cipher. Daumier in this early work created one of the great Realist pictures in which the meaning resides in the bolster—that is, in its meaninglessness. Death becomes more awful because it has no redeeming quality.

The savagery and the vulgarity of the campaign that Daumier and his associates waged helped bring political caricature to an end, as they provided the government with an excuse to ban them entirely. Philipon continued *Le Charivari* with its non-political caricature, and Daumier went on to draw the thousands of lithographs that poked fun at the daily life of the Parisians. He avoided both the upper classes and the lower depths, concentrating on the middle classes, especially the lower end, where underpaid clerks and actors and musicians in cheap theaters struggled to maintain respectability. His men almost always are wearing top hats, but top hats that are threadbare and losing their shape. We are reminded of Charles Dickens, Daumier's almost exact contemporary. Dickens in the sweep of his novels included the aristocracy and sometimes the very poor, but his most memorable characters come from the same milieu as Daumier's, like Reginald Wilfer in *Our Mutual Friend*.

> R. Wilfer was a poor clerk. So poor a clerk, through having a limited salary and an unlimited family, that he had never yet attained the modest object of his ambition; which was, to wear a complete new suit of clothes, hat and boots included at one time. His black hat was brown before he could afford a coat, his pantaloons were white at the seams and knees before he could buy a pair of boots, his boots had worn out before he could treat himself to new pantaloons. . . .

Like Dickens, Daumier sees all the ridiculousness in his characters, but also what is human and appealing, and the two men both created styles to express these qualities. It can also be pointed out that it was these same lower-middle-class and working people who bought Dickens's novels in the cheap serial parts, and *Le Charivari*.

Daumier's characters are the people of Paris, and the streets of Paris the place where he finds them most often, though he follows them into their homes, schools, and the law courts. A surprising number of the caricatures do not present dramatic or comic situations between people, as is usually the case in caricature. The Daumier characters are simply walking along the street battling the snow, the rain, the wind, the mud, the traffic. Though the captions are frequently quite elaborate, as many people have remarked, they are unnecessary. Daumier gives us all we need with the hunching of the shoulders, the wincing of the face, the pressing together of the knees. When these people are not walking, they are often riding, in an omnibus or in a train. All Daumier needs is a large person squeezing into a small space between two unwilling and apprehensive passengers. Again, no caption is needed, and the idea is commonplace, but Daumier creates such individualized people that each lithograph is fresh and vivid.

As the artist with probably the most acute visual powers in his

century (rivaled only by Degas), Daumier was fascinated by the idea of looking, and after the street, the greater number of the prints are set in the theater and the art gallery, where they concentrate on the spectators looking at the performers or the art. In many ways Daumier epitomizes Realism, especially in this belief that looking at the world is an end in itself, and does not depend on a significant incident or an attached symbolic meaning to give it value.

Because the individual people are so memorable in both his prints and paintings, it is easy to overlook the fact that settings are important in Daumier's works. The Realist belief that people are inseparable from their environment is discussed in more than one place in this book, and this is true for Daumier. He very often takes a familiar location, like the street, with its repetitive façades, so that it is sufficient to suggest it and we remain aware of it while concentrating our attention on the people, whose movements and animation are the point of the picture. As a result, we do not necessarily realize that Daumier created extraordinary effects of weather in his lithographs [39 and 40], and that his slashing lines of rain, and falling snow, were adopted by the Impressionists in

39. *A Slight Squall* from the series *Les Canotiers Parisiens (Parisian Boaters)*. By H. Daumier, 1843, from *Le Charivari*.

40. *An Actor of the Funambules.*
By H. Daumier, 1842,
from *Le Charivari*.

their oil paintings. Very often, as is suggested in the quotation from
Dickens above, the clothing itself describes the situation of the person
wearing it.

Because Daumier does infuse so much life into his people, it is
tempting to write at length about his subject matter, yet his artistic
inventiveness is equally remarkable. He created composition after com-
position which, even when they are only lightly sketched in, play an
essential part in setting off the protagonists. In *The Orchestra During the
Performance of a Tragedy* [41], the barely more than hinted at, cut-off
figures on the stage imply the whole theater that continues above this
point without distracting us from the musicians. At the same time, the
fact that they are cut off shows their unimportance and tediousness to
the orchestra. The composition thus works in more than one way; it is
not surprising that both Manet [162] and Degas used this composition
several times in their paintings.

The often-quoted passage from Degas's notebooks, "Do every kind
of worn object . . . corsets which have just been taken off . . . series on
instruments and instrumentalists . . . for example, puffing out and hol-
lowing of the cheeks of bassoons, oboes," reminds us immediately of

Daumier. His corsets [42] have not been just taken off, but as the man is thinking of women wearing them, the idea is very close to that of Degas. In these notebook jottings it would not be surprising if Degas is unconsciously remembering Daumier, especially as he copied Daumier prints.

These corsets remind us that it is through the human body that

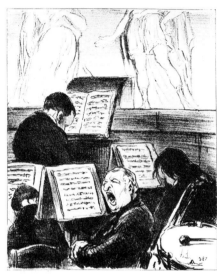

41. *The Orchestra During the Performance of a Tragedy.* By H. Daumier, 1852, from *Le Charivari.*

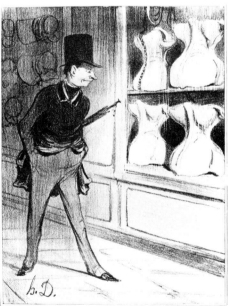

42. *The Four Corsets.* By H. Daumier, 1840, from *Le Charivari.*

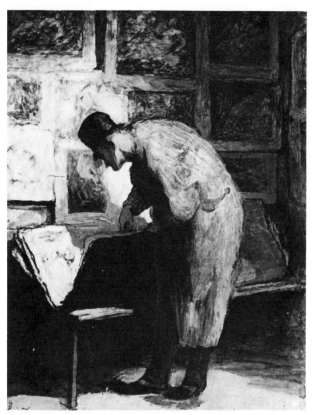

43. *The Print Collector*. By. H. Daumier, ca 1860. Philadelphia Museum of Art.

Daumier expresses the character and situation of his personages. Many of them are quite enveloped in their clothing [43], but the artist invents a contour (never the contour that was taught in the art schools) and puts in just the shading so that we feel the invisible body, the whole person seems to be involved in the action, and a static person becomes dramatically alive. This painting of a print collector gives us a man passionately concentrating on the pictures, so that every muscle from his ankle to his neck appears to contribute to the man's gaze. The contrast of the bulkiness of the figure with the slashing white plane of the portfolio can remind us of Chardin's picture of the student drawing [2]. A similar genius is working in both artists.

Typically, Daumier, like Chardin, presents a person totally absorbed in what he is doing, so that we have no feeling that he is posing for us, however striking his gestures [44]. It was also part of Daumier's enormous artistic intelligence that the same themes are treated quite differently in the lithographs and the paintings. The connoisseurs and lawyers who are ridiculed in the prints are painted as serious, intent

professionals in the oils. Daumier knew that the comic point does not work in a painting. The means would be too elaborate for the message.

The enveloped figures of the print collector and the lawyer remind us of one of Daumier's most remarkable achievements. In an age when the undressed woman provided the bread and butter for so many art-

44. *The Pleading Lawyer.*
By H. Daumier.
Armand Hammer Foundation.

ists, he rarely drew the nude. Yet we learn more about the human body, its variety of shapes, movement, and weight, from Daumier's clothed figures than we do from the hundreds of nudes who cluttered the Salon walls.

Daumier's range was so wide that he deserves a much greater number of illustrations than is possible in a general book, in order to bring out the achievements of Realism in prints and watercolor, as well as Daumier's own incomparable abilities. Furthermore, the very greatest artists always escape being confined in one particular artistic movement. Daumier's *Don Quixote* pictures summon up an existential world that seems more properly to belong to the twentieth century, and is quite unequaled by any of the other artists discussed here.

Finally, in the drawings and watercolors of street entertainers [45], Daumier created the most moving images of the bleakness and inhospitableness that the city offers to the unsuccessful, works that require no commentary.

The years when Daumier was working saw a huge number of caricatures and illustrations, and even when we have discarded all those irrelevant to the growth of Realism, we are still faced with a staggering amount of material. It is necessary to pass over a number of interesting

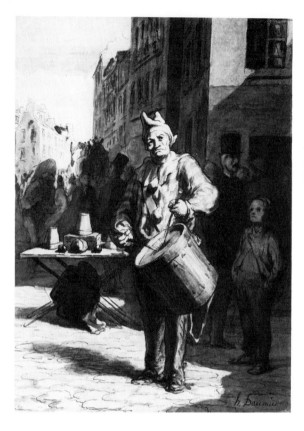

45. *A Saltimbanque Playing a Drum.* By H. Daumier, ca 1863. British Museum, London.

artists, but it is worth taking a look at Gavarni (1804–1866), one of the draftsmen who have been largely eclipsed by Daumier's brilliance. In his personal work he creates a complementary oeuvre to that of Daumier. This contrast is one of the reasons that his lithographs have not been reprinted in recent years in the way that the latter's have. While Daumier's compassionate humor makes his work irresistible, Gavarni's bitter view of the miseries of the world satisfies us in small doses.

His total output is very varied, as he received numerous commissions to illustrate books, whether the semi-sociological works like *The French Depicted by Themselves* [28] and *The Devil in Paris* or novels like Eugène Sue's *The Wandering Jew* with its fantastic episodes from history. The caricatures he did for magazines express Gavarni's own misanthropic spirit, which embodies one aspect of Realism, found also in the novels of the Goncourt brothers, who were good friends of Gavarni, and who noted down his conversation, and wrote about him. In these lithographs Gavarni deals very frequently with the relations between the sexes, husbands and wives, lovers, courtesans and their admirers,

and the whole world of prostitutes, lorettes, and grisettes. There is amazingly little eroticism in them, as he sees these relations in terms of avarice, brutality, and deception.

He also studied the very poor and the destitute, a world ignored by Daumier. Here Gavarni does show compassion, but it never softens his vision of the horrors of the world, and there is no humor or warmth. He lived in England between 1847 and 1851 and produced illustrations for French and English magazines and two series on life in London. These are scarcely known, in comparison with Doré's famous wood engravings twenty years later [234], perhaps because they focus on the people and lack Doré's fascinating evocations of the buildings and streets. The first series, *Gavarni in London,* 1849, consisted of twenty-four wood engravings after his drawings, and it was republished in France in 1862 with a very interesting text by La Bedollière, who knew London well. The second series appeared in France in 1853 as *Les Anglais chez eux (The English at Home),* twenty lithographs drawn directly on the stone by Gavarni.

Like Doré, Gavarni depicts both High Life and Low Life, but it is the latter which arrests us most. The two engravings reproduced here not only show striking glimpses of the London poor (and the omnipresence of the street in graphic art), but suggest thoughts about art. The pitiable drawing on the sidewalk [46] on one level is the incompetent scribble of the untrained beggar, but is also a reflection of the interest in crude art that we have seen drew cultured Parisian members of the art and literary worlds to the *images d'Épinal,* and led to "children's" drawings in the *Diàble à Paris.* The imperfectly understood, unarticulated dissatisfaction at this time with the skillfully executed oil painting ("everybody is painting better and better, which seems to us distressing," Baudelaire, 1845) led to a fascination with these pictures in the 1840s and to their absorption into avant-grade painting in the 1850s and 1860s. The woman with her baby [47] is reminiscent of the similar figures Courbet was to put into his *Studio* six years later, and which he said were inspired by an Irish woman and her baby he had seen on a visit to London. Courbet's memory may have been triggered by the Gavarni book, which although not published in France until later would certainly have been brought to Paris, given the brisk artistic interchange between the two countries and Gavarni's reputation on both sides of the Channel.

The lithographs of *Les Anglais chez eux* are more powerful artistically and even more moving. *Poverty and Her Children* [48] stands on the edge of Realism and allegory, and it inspired the Goncourts to write, "We could believe that we are seeing the procession of Famine. In front, a

46. *An Illustrated Sidewalk* from
Le Charivari, 1851, by Gavarni.

47. *The Baby in St. Giles* from
Les Anglais chez eux. By Gavarni, 1852,
from *L'Illustration.*

mother bent under her feebleness and her despair, a carcass of a hat on
her head, bits of flesh appearing through the holes in her rags, walks,
followed by her older daughter holding against her tubercular chest the
tatters of a dress which covers her emaciated breast. And, in the fine,
continuous rain, the eternal rain of London, lagging well behind her,
the children, fantom-like limping on the legs of a fetus.''

As in some of Daumier's works (the *Emigrants,* for example), Ga-
varni intensifies the feeling of the print by taking an extreme subject,
and by choosing an expressive composition and viewpoint, yet he
avoids the banalities of allegory by making the figures look away even
though they are walking toward us, and by his naturalistic though
evocative environment.

In one important respect Gavarni's people are the opposite of Dau-
mier's. Whereas the latter's characters burst and bulge through their
clothing in energetic movements and gestures, Gavarni's shrink into
their clothes. Very many of them are seated, lying down, slumped
down, or leaning against a wall. These are the poses of the defeated. A
whole world of exhaustion, boredom, despair pervades Gavarni's
prints. He draws very vigorously the rough garments of the two pris-
oners [49], but they slouch down, and the sense of imprisonment is
conveyed as much by their contrast with their clothing as it is by the
suggestion of the barred window.

Gavarni presented these aspects of the lower depths of society just
when Courbet and Millet launched their vision of peasant life in oil

48. *Poverty and Her Children*
from *Les Anglais chez eux.*
By Gavarni, 1852,
from *L'Illustration.*

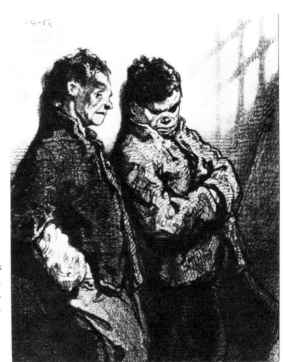

49. *The Prisoners*
from *Les Petits Mordent.*
By Gavarni, 1853,
from *L'Illustration.*

painting. These two worlds are complementary as expressions of con-
temporary life, urban and rural, at midcentury. Gavarni's harrowing
pictures could not have been produced as oil paintings in gilt frames to
hang in a drawing room. Like Daumier's comic drawings they belong
perfectly to their medium, lithography, and equally appropriately, their
popular format made them universally available. Any writing on Real-
ism that does not put together Gavarni with Courbet and Millet misses,
I believe, half of the movement.

When we look at early nineteenth-century prints and the Panorama,
which embody the desire to render perspective and detail so precisely,
we are not surprised to learn that photography was the result of a long
development, with several people working independently to achieve
the same goal. The prehistory of photography includes the camera ob-
scura and various other devices, including the camera lucida, designed
to help artists render their subjects more accurately. The camera obscura
was an old device, used by Vermeer in the seventeenth and Canaletto
in the eighteenth century, to produce perspective views of cities. The
camera lucida [50] was yet another nineteenth-century invention—a
characteristic one in that it was portable—and it was eagerly taken up
by amateur artists anxious to improve their landscape views [51]. The
artist set up the simple apparatus, and peering into the prism was able
to see the subject superimposed on the paper, so that he or she could
trace the outlines. Beaumont Newhall's *History of Photography* includes
landscapes drawn in Italy with a camera lucida by Sir John Herschel
and by Fox Talbot, who both later became important names in the
history of photography.

Daguerre, while painting his Dioramas, had worked for years to fix
pictures made by the sun. When he eventually succeeded, the French
government gave him a pension and required that the process be made
public. They recognized that this invention was so important that it
could not be retained as private property. In England, where Fox Talbot
had invented a different process, upon hearing the news about Da-
guerre he immediately demonstrated his own method in public. The
British government left Talbot to exploit his invention himself, but his
patents were ignored, and he received little support in the law courts.
Its free dissemination could not be denied.

The year 1839, when these two different methods were presented
to the public, is a memorable one. Until this date, all pictures were the
result of selection by an artist, who was working within an existing style
of representation. The Daguerreotype, or photograph, was the first ob-
jective picture, which, once the artist had pointed the camera, recorded
everything within the capacity of its lens, the prevailing light condi-
tions, and the chemical processes. The photograph made all paintings

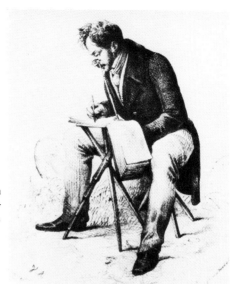

50. Using a Camera Lucida to draw a landscape. Gernsheim Collection, University of Texas.

51. *Lake Lecco, Italy.* By H. Fox Talbot, 1833, Camera Lucida drawing.

and drawings look incomplete and stylized as records of a subject. Photographic portraits [52] revealed every line, every drooping bit of skin, every blemish, and irregularity, all the things that artists had automatically eliminated. No wonder that the people who flocked to the Daguerreotype studio were often disappointed when they received

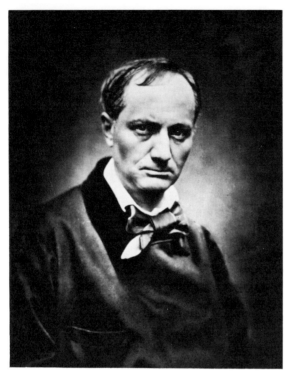

52. Photograph of Charles Baudelaire. By E. Carjat, 1860s.

53. Daguerreotype of a Paris Boulevard. By L. Daguerre, ca 1838.

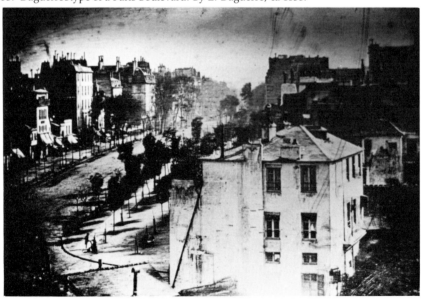

their picture. It is equally unsurprising that the phrase "The camera cannot lie" sprang up.

This assertion was quite incorrect. One of the first Daguerreotypes, a Paris boulevard [53], shows an empty street with just a bootblack and his customer. It looks as if they have been petrified by a Pompeian-like disaster from which everyone else has fled. As most people realize today, the long exposure time of early photography meant that any moving traffic or pedestrians did not register on the plate, and so only the immobile man and bootblack have been immortalized. A picture that seems to inform us that a Parisian boulevard is empty in mid-morning is clearly "lying"; nevertheless, the amount of minuscule and faithfully recorded detail (some of it so microscopic, it could be seen only with the help of a magnifying glass) constituted an overwhelming experience of reality for most people.

Photographs set a standard which intensified the pre-existing trend by artists to render detail precisely. Aaron Scharf, in his book *Art and Photography*, quotes a writer on this expectation:

> One standard . . . there does exist, and one from which there is no appeal, for it rests upon demonstration, and not upon opinion. . . . We mean the beautiful and wonderful calotype drawings—so precious in every real artist's sight, not only for their own matchless truth of Nature, but as the triumphant proof of all to be most revered as truth in art.[1]

The "realism" of the photograph is not though that of Realism in nineteenth-century art. It was the Salon-oriented artists who produced photographically detailed paintings, but even today many people confuse a photographically conceived painting with Realism. The Realist artists, whether we think of Courbet, Millet, Menzel, the Macchiaioli, or the Impressionists, all worked in a most unphotographic style. In their pursuit of truth, some of them studied the pictorial achievements of photography, like Degas making drawings after Muybridge's photographs of a cantering horse [79], but all photographic elements were transformed in the final picture. Undoubtedly one of the reasons why many Realists had difficulty in being accepted by the public was that the latter saw the photographic vision as a measure of truth, and the Realists' works seemed untrue by this standard.

Photography did reinforce the idea that the most banal scenes could be the subject of a picture. Because of the problems of photographing anything that moved, preferred subjects included buildings, street scenes, and landscape. We find many photographs of a single tree or bush, as a myriad of leaves could be captured with a completeness that

[1] A. Scharf, *Art and Photography*. Baltimore, 1974, p. 77.

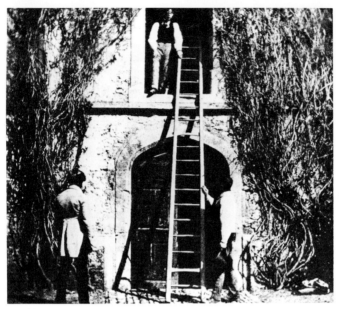

54. *The Ladder* from *The Pencil of Nature*. Photograph by H. Fox Talbot, 1843.

no artist had ever attempted [54]. The public was fascinated by every kind of photograph, even those which seem today totally uninteresting, either because of the banality of the subject or because of the visual inadequacy. There were great limitations in the early works. Daguerreotypes began as reversed images on a metal plate with excellent detail, but they were single images. Fox Talbot made negatives on paper that could be multiplied by prints, though they did not offer as good a definition as the Daguerreotypes. The inventive genius of the century was immediately unleashed on photography once the breakthrough had occurred. Lenses were improved and the chemistry refined to reduce exposure time and to permit the use of two lenses to correct the reversed image. The glass plate negative was another advance, and color photographs were produced as early as 1869 by Ducos du Hauron and by Charles Cros. Color was the ambition of many photographers, but probably to the relief of most painters, the processes were not practical.

In the 1830s and '40s when there was such a flood of outstanding prints—and this book only scratches the surface of the riches—painting throughout Europe lacked direction and was generally disappointing. The major works were those produced by the older generation of Romantic painters, Turner, Constable, Delacroix, and Caspar David Friedrich. The cliché about the individuality of the Romantic artists proved true in that none of them created a school. New subjects appeared: Italian bandits and peasants, all kinds of Oriental themes, and recrea-

tions of medieval life, but painters produced no styles appropriate to their subjects. In France, neoclassicism in principle was the dominant direction, but most people were thoroughly bored with Greek and Roman heroes striking bombastic, heroic poses, and the cult of the classical was mercilessly parodied by Daumier in his *Histoires anciennes,* 1842. Many artists applied a watered-down neoclassical style to the new subjects, to which it was quite unsuited. In the other countries of Europe, where neoclassicism never took such firm root, an eclectic mix of styles was prevalent, none of them particularly successful. It was the less pretentious paintings, the Biedermeier interiors [7] and the landscapes that avoided formulas, that are most satisfying to us today.

It was, however, in France that a specific movement appeared that led to the work of Courbet and Millet and then to Impressionism. At the Salon of 1831, after the revolution of the previous year, the most eye-catching picture was Delacroix's *Liberty Leading the People,* but it proved to be the last great allegorical painting, not a beginning but the end of an era. The future could, however, have been found in this Salon, in a group of landscapes painted by artists exhibiting for the first time.

They have come to be known as the Barbizon School, as many of the landscapes were painted near the village of Barbizon in the Forest of Fontainebleau. The term "Barbizon School" is vague, as it is also used for all the artists who came from Paris to sketch there. Located conveniently close to the city, the area offered quaint villages, farming scenes, the plain of Chailly, and the still wild Forest of Fontainebleau with its gnarled trees and great rocks. The building of the railroad in the 1830s heightened Barbizon's appeal, and canny local peasants created inns specially for the artists.

The group of painters whom we regard as the core of the Barbizon School, Théodore Rousseau, Narcisse Diaz, Jules Dupré, Charles Jacque, and Corot, who painted there frequently, are quite varied in their work, but they share certain approaches. They represent a turn away from Italy to the north, a turn to Holland and England. While the Ecole des Beaux-Arts was sending students to Italy to study landscape, and artists like Léopold Robert and the young Corot were taking themselves there, the public with its enthusiasm for the ordinary that we have been documenting increasingly appreciated not only the contemporary views of France, especially those by English artists, but also seventeenth-century Dutch landscape paintings and prints. Such interest eventually led to historical studies which further increased this appreciation: Houssaye's *History of Flemish and Dutch Painting* (1847), Charles Blanc's *The Work of Rembrandt* (1853), and the studies by Thoré and Fromentin in the sixties and seventies. This change of direction

geographically represents a profound change from an ideal to an empirical art.

The Barbizon painters studied Dutch art, and at first glance some of their pictures could be mistaken for seventeenth-century Dutch paintings, though the majority are distinctly original. An important difference comes from their admiration for Constable and the other English artists, documented above. Constable's *facture*, his use of individualized brushstrokes, the rough paint surface, which upset so many artists and critics, provided a means of bringing the smooth surface and infinite vistas with beautifully shaped clouds of the Dutch down to earth. To these sources the Barbizon painters added their own contemporary view that not only did nature offer a profound experience (as Thomson had described it), but that this was true of all nature. Categories like the Sublime and the Picturesque, in which people had superimposed their qualitative classifications onto landscape, were thrown out like the hierarchy of subject matter itself.

Two paintings by Rousseau [55] and Diaz [56] embody the new attitudes. In each picture, if we were asked to name the subject, we would have a hard job to define it. There are no particular features to identify, and if we had to choose one adjective to describe the two works, "nondescript" might be the most accurate. There are no impressive mountains, beautiful woodlands, or rivers, and no rich farmlands implying centuries of cultivation, as in Constable's pictures. The Barbizon artists painted, on the fringe of the forest, a kind of rural wasteground.

To make these paintings with no subject and no interesting composition succeed, the artists used the paint itself as the texturing, expressive element of the picture, and atmosphere and weather effects are frequently important means of giving interest to the paintings—both concepts learned from English art. Landscape artists in England at this time never made this transition. For the most part they retained the idea of subject matter in landscapes in a traditional sense. Because of the English landscape tradition of watercolor, and of painting in front of the subject, many attractive individual pictures were painted, but there was no coherent idea behind them, and no movement was founded.

The initial Barbizon pictures tended to carry on some of the sub-Romantic traditions of the dramatic storm or the flamboyant sunset, but the artists ran into difficulties as their style became more original. Rousseau, after winning a medal at the Salon of 1834, was refused by the jury for twelve years, and became known as "le grand refusé," the great rejected artist. That he could acquire this sobriquet illustrates the deep divisions in the French art world. The academicians did not necessarily

55. *The Heath.* By T. Rousseau. Glasgow Art Gallery.

56. *Landscape.* By N. Diaz, 1854. Sterling and Francine Clark Art Institute, Williamstown, Massachusetts.

reflect public taste. The artists formed a trade union, jealously excluding outsiders with new ideas. In these same years, Delacroix, who was regarded as a very great artist, was repeatedly refused for membership of the Academy, while the government representing the bourgeoisie gave him important public commissions. Critics writing about Salons, where Rousseau was not represented, discussed his work when reviewing landscapes, so that the public would be aware of his existence.

Dupré, who has been mentioned as visiting Constable in England, followed him in painting quiet, insignificant scenes [12], but more often Dupré preferred stormy skies to create dramatic emotional moods. Even

57. *Pastureland in the Limousin.* By J. Dupré, 1835. Art Gallery of Ontario, Toronto.

his *Pastureland in the Limousin,* 1835 [57], a lithograph of animals grazing, becomes almost melodramatic with its soaring trees and great expanse of sky and clouds. The animals become unimportant in the face of the great energies of nature. The similarity of feeling to Constable's print [16] is clear, and Dupré is typical of many of the Barbizon artists in producing two kinds of art: Realist pictures where the subject is allowed to speak for itself, and those like the lithograph where we feel the artist exaggerating the size of the trees and arranging the composition to create an effect. We can certainly enjoy these pictures, but the sense of manipulation by the artist damages the Realism. These inconsistencies were to be expected from artists trying to find a new approach, and to support themselves.

Prints were an important part of Barbizon art, and Dupré's are of special interest because many of his oils have been wrecked by his use of a bitumen underpainting. Rousseau's paintings too are often in bad condition today, as he worked and reworked them in his search to do justice to the magnificence he felt in nature. Even while he was painting them, his friends urged him to leave them as they were, and not spoil them. Charles Jacque's etching *The Entrance to Ganne's Inn* [58] is trebly interesting, as a print in its own right, as a picture of the inn where many of the artists stayed, and as one of the prints that inspired the next generation of artists, such as Whistler [119]. The view through a gateway to the lighter background reminds us of Dutch seventeenth-century pictures of buildings, but the loving recreation of the messy ground where the hens peck about is strictly nineteenth century. Ganne

encouraged the artists who stayed at his inn to paint on the furniture and walls in the evening; today it is a museum in the village of Barbizon.

Corot possessed the most puzzling artistic sensibility of his century. He went to Italy as a young artist, painted the most original and beautiful sketches [9], and made from them conventional paintings for the Salon [10]. He continued to paint historical landscapes with figures in histrionic poses *(Hagar and the Angel,* Salon of 1835, Metropolitan Museum of Art, New York), while at Barbizon he was painting very different pictures. Later he turned to the fuzzy, pseudo-poetic landscapes that have done so much to damage his reputation while also painting the superb pictures in a completely different style of women in interiors [59]. His variety of stylistic concepts appears in a curious mixture in his *The Artist's Studio,* 1860s. The model holding a musical instrument is a commonplace picturesque motif, as is the landscape on the easel that she is looking at. Yet Corot runs the stovepipe with its particularly jarring right-angle bend straight into her head to force a contrast with the graceful curves of the woman and her dress. The awkwardness of

58. *The Entrance to Ganne's Inn.*
By C. Jacque. Private collection.

59. *The Artist's Studio.* By C. Corot, 1860s. Widener Collection, National Gallery of Art, Washington, D.C.

the juxtaposition of pipe and head is astonishing and inexplicable in terms of conventional picture making, which Corot normally followed in his finished pictures. His *Gypsy Girl with a Mandolin*, 1874 (São Paulo Museum), for example, is a compendium of banal devices: picturesque costume, cute mandolin, and touching tilt of the head of the pretty girl. Corot multiplies the contrasts in *The Artist's Studio* with the sketches on the wall in a style different from the landscape on the easel. The girl and the picture which she gazes at seem to have been dropped into the studio from a different artistic world. Corot does nothing to try to explain this contrast—he simply asserts it in this endlessly fascinating painting.

Corot's refined color sense made his pictures different from those of the other Barbizon artists. Whereas they recreated the solidity and roughness of the forest, Corot, although painting the rocks [60], gives us a more mysterious forest with all the richness of form of the undergrowth. The remarkable composition, cut in four more or less equal parts by the trees and rocks, has no space and no top or bottom in the usual sense. The other Barbizon artists formed traditional spaces with paths entering the picture, a Dutch device, or casually placed trees and

60. *Rocks at Fontainebleau*. By C. Corot, 1830s. Chester Dale Collection, National Gallery of Art, Washington, D.C.

a pond. Corot's picture offers no entrance; it is a slice of nature thrust at us, the aim of the Realists, and totally different from his *Bridge at Narni* [10].

In the small oil sketches that Corot continued to paint of landscapes and townscapes while producing the "poetic" hazy landscapes, all his qualities are at their highest pitch. Their compositions are frequently, though certainly not always, slices of a scene, apparently composition-less, as if he thought that any bit of the view in front of him would do. The contrast with the carefully thought-out finished paintings makes us think of Delacroix, his almost exact contemporary. The latter worried again and again in his *Journal* about the fact that valuable qualities of the preliminary sketch were lost when the "finished" painting was executed. Both artists were born in the eighteenth century and both seem to have inherited and retained the traditional ideas of what constituted a picture to be presented to the public, though both artists' genius seems to most people today more fully expressed in their sketches. Corot's *Boats at a Quay, St. Malo*, 1860 [61], measuring only a few inches each way, cuts off the quay so that we cannot make out anything, while the boat is similarly concealed by the quay. The booms

61. *Boats at a Quay, St. Malo*. By C. Corot, Ny Carlsberg Glyptotek, Copenhagen.

and rigging which are visible are crudely suggested by the paintbrush on a small scale, while the far side of the river is barely visible in the gloom.

The painting offers only two colors, brown and gray, yet we immediately feel that it is a masterpiece. It evokes the dull overcast day

perfectly in a way that had not been done before. Earlier artists had used chiaroscuro in a similar scene, while Corot extends his light to the distant part of the painting, so that while everything is robbed of color, the evenness of light on a day like this is retained. Claude Monet and Pissarro both learned from Corot how to render the gray skies of Paris and northern France without painting a dull picture. Farther along the northern coast a few years later, Felicien Rops, the Belgian artist better known today for his unpleasant nudes, painted the *Breakwater at Blankenberge in the Rain* in a spirit similar to Corot's picture, and van Gogh, while in Belgium, painted *Quay at Antwerp*, 1885, also depicting rain. The diversity of Corot's work in his oil studies can be seen in this unexpected anticipation of Rops and van Gogh.

Corot is usually omitted from discussions of Realism, but many of these small sketches seem to me absolutely a part of the movement. Though the contrast in scale may make the comparison strange, the mood of this panel is not very different from that of Courbet's *A Burial at Ornans*.

Among the Barbizon painters were some who belonged to one of the major schools of the nineteenth century, which has almost disappeared today, but was extremely important. We tend to smile today at the mention of "animal painters," with memories of anthropomorphized dogs and cats of the kind that made Landseer one of the most popular artists of the century, yet all these artists are not to be despised. It must be said that there are strange and at times comic aspects. We think of horses as artists' favorite subject, beautiful, full of grace and energy, yet in the second half of the nineteenth century they were replaced by cows. We do not always realize this fact because so many of these cow pictures have stayed in private collections or been retired to museum basements. When one does research on nineteenth-century art, cows appear everywhere. There was something about the stable, unexciting, reassuring appearance of the cow that touched a deep chord in the soul of both artists and viewers. Cows did not simply appear as part of a rural scene, but artists painted what we might call cow portraits. The Realist style that developed with patches of thick pigment was well suited to rendering these animals, and we find pictures where the cow or calf fills most of the canvas. We encounter these portraits everywhere, whether done by Courbet in France, by Thomaz d'Annunciazão in Portugal, or by Horatio Walker from Canada. When Courbet asked a local peasant if he could paint his calf, the proud owner carefully washed and combed the animal, and the resulting picture was so popular that several copies were made of it.

This cow mania can be seen in its most intense form in a book published on the Barbizon School in the United States in the first decade

of this century. In his chapter on Troyon, the author compared Troyon's cows with those of Dutch seventeenth-century painters:

> People may rave as they please about Paul Potter's *Young Bull* at the Hague—to my mind a greatly over-rated picture, though deserving much praise as a careful study of a young bull—but Potter as an animal painter was never the equal of Troyon. He could paint isolated objects with harsh truth, but he never could gain the whole, the ensemble of things, as compared with Troyon. He [Potter] could paint cow hides and cow anatomy with some precision, but Troyon could and did paint cow life. Albert Cuyp could give the truth of a cow's skeleton, the rack of bones and members, with exceptional force, but Troyon in painting cow character—the clumsy, wet-nosed, heavy breathing bovine, was vastly his superior.[2]

It is difficult for us today to recapture this enthusiasm for, and close observation of, cows, but Troyon's best pictures share his colleagues' directness and tangibility [62]. Troyon, like Courbet, visited Holland, in 1847, and the experience of the pictures in the Dutch museums changed the art of both painters. Many of Troyon's works are very close to those of the Dutch, and can be too beautifully painted.

62. *The Coming Storm.* By C. Troyon, 1860. Sterling and Francine Clark Art Institute, Williamstown, Massachusetts.

Jacque was a specialist in sheep, but is represented here by his *The Percherons* [63] because it makes an interesting comparison with Géricault's pictures. It was original for the latter to paint carthorses [14 and 15], but for the Barbizon artists they were the "real" horses. Jacque

[2] A. Hoeber, *The Barbizon Painters.* New York, 1915, p. 199.

follows Géricault in his painting technique, which works so well to capture the feel of the peeling wall and the strength of the horses, but he eliminates the Romantic drama of *The Lime Kiln*. Though painting the horses from behind like Géricault in *Entrance to the Adelphi Wharf*, he replaces the mystery of the dark arch with the sunlit village street. It was the ordinary that appealed to the Barbizon artists.

Our twentieth-century scorn for the *animaliers* not only plunged Troyon and Jacque into obscurity, but also another artist who set up a studio near Barbizon, Rosa Bonheur. There was a very large number of women artists in the nineteenth century, yet few of them achieved the

63. *The Percherons*. By C. Jacque. Location unknown.

great acclaim that she did. At the Salon of 1849, where Courbet had his first great success with *After Dinner at Ornans*, Bonheur showed the very large and successful *Plowing in the Nivernais* [64], which also brought the daily life of the provinces into the Paris Salon on a heroic scale. Bonheur's picture surface is smoother than that of the other artists discussed here, and she renders detail more precisely, so the power inherent in the teams of oxen or in the great procession of the horses is reduced, and we feel that we are in the presence of a beautiful picture rather than in the middle of the coarse, sweaty work life of the peasant that we experience in the best of Millet's paintings. Nevertheless, Bon-

64. *Plowing in the Nivernais.* By R. Bonheur, Salon of 1849. Musée National du Château de Fontainebleau.

heur and Troyon, within the limitation of producing pictures that are too well painted, as Baudelaire put it, do create a breadth, a sense of actuality, by avoiding the clichés of much animal art.

Like a number of artists, Bonheur cannot be judged simply by her successes at the Salon. She painted many interesting small oil sketches, including still lifes of bunches of radishes and the like, similar in feeling to the still lifes of Ribot [116] and Millet. *The Mud Hole* [65], which

65. *The Mud Hole.* By R. Bonheur. Snite Museum of Art, University of Notre Dame, on extended loan from Mr. and Mrs. Noah L. Butkin.

measures only 11 by 17 inches, reveals again the fascination of the banal. As a sketch it possesses a rawness of paint surface that perfectly expresses the texture of the desolate ground and the mood that Bonheur also creates with the exceptionally high horizon line. This brilliantly original composition has been described as "a compelling statement of the earth's power to convey thoughts of melancholy."[3] It certainly makes us *feel* much more than the polished Salon paintings, which we can admire intellectually but which leave us less moved.

It is not possible to discuss all aspects of Barbizon art here, but Charles Daubigny's quiet scenes along the Oise River, with a few trees on the banks, and perhaps a line of ducks or geese, deserve mention [66]. Their tranquility can make them seem dull, as they lack the rough edge of the other pictures discussed here, but Daubigny's feeling for light brings out the poetry of these scenes without any sentimentaliz-

66. *The Banks of the Oise*. By C. Daubigny, 1863. Metropolitan Museum of Art, New York, Bequest of Benjamin Altman.

ing. Together with Corot's pictures they helped the young Impressionists become aware of the possibilities of subtleties of light in paintings, and Daubigny, as a member of the Salon jury, gave these artists practical help in getting their work accepted. His most useful aid came in England during the Franco-Prussian War, when he introduced Pissarro and Monet to Paul Durand-Ruel, the future Impressionist dealer.

[3] G. Weisberg, *Millet and His Barbizon Contemporaries*. Tokyo, 1985, p. 130.

Though his paintings seem so placid, Daubigny had a great sense of fun, which showed itself in the etchings he made on a trip down the Seine [67], in which he preceded Monet in painting from a studio boat.

During the second half of the century the delight of the public in the most ordinary details of life that they found in illustrations and photographs developed into an appreciation of the plainness but truth of Barbizon art. This admiration mushroomed, and at the very beginning of the twentieth century three different books were published on the school in the United States alone. Then, almost overnight, Impressionism replaced it in popularity. Barbizon paintings suddenly seemed dark, heavy, and static, while the subject matter seemed remote in comparison with the Impressionist pictures of the pleasures of Paris, or the sparkling rural canvases of Alfred Sisley and Pissarro. As noted above, the condition of many of the paintings has prevented them from regaining popularity, but as in the pictures of Courbet and Millet, who himself came to live at Barbizon in 1849, we can find something satisfyingly solid and earthy in the best works, which provide a complement

67. *The Artist's Floating Studio.* By C. Daubigny, 1861. Musée d'Orsay, Paris.

to the airiness and movement in Impressionist paintings. Barbizon prints also deserve rediscovering, as they have survived in better physical condition, and the artists felt less constrained in them.

While Scandinavian art in general saw outstanding developments only in the 1880s and 1890s, Denmark produced several painters in the 1830s who escaped the conventions of landscape art. These artists include Eckersberg, Lundbye, and the short-lived Købke, 1810–1848. His

Small Tower of Frederiksborg, ca 1835, an aerial view of a section of roof, chooses the fragmentary, and makes a picture of it through composition and through light and shadow. The ribbing on the spire consists of white highlights rather than drawn lines, and we feel the physical modeling of the architecture, even if there are remains of Romantic drama in the contrast of the high roof and the plunging vista.

While *View Through the North Gate of the Castle,* 1834 [68], is more meticulously painted, Købke disturbs the decorum of the picture with the strong red of the drawbridge in the background that disrupts the tranquil recession. The picture, though a beautiful rendering of a quiet afternoon, is thus brought to life by the vibration created between the foreground gateway and the drawbridge. Købke also anticipates another common Realist device in the figures seen from the back (like Chardin's student), who do not destroy the credibility of the scene by doing something to attract our attention or to amuse us. Whereas the spire in the previous picture is very much of a motif, the *Castle Gate*

68. *View Through the North Gate of the Castle.* By C. Købke, 1834. Ny Carlsberg Glyptotek, Copenhagen.

offers no real subject: the gate posts are not very interesting in themselves and the center of the canvas is mostly empty, while the drawbridge is cut off and its operation not clear. These two pictures, the first painterly and the second with a nondescript subject, parallel the different trends in the Barbizon School. But Købke died soon after painting them, and there was no one to develop the suggestions in these works in a bold way as in France.

The true world which science reveals to us is much superior to the fantastic world created by the imagination.

E. Renan, *The Future of Science,* 1848

The three screens. The classic screen is enlarging, the romantic is a prism. The realist screen is plain glass, very thin, very clear, which aspires to be so perfectly transparent that images may pass through it and remake themselves in all their reality.

Emile Zola

Art is nature seen through a temperament.

Emile Zola

To paint men in the sincerity of their natures and habits, in their work, in the accomplishment of their civic and domestic functions, with their present-day appearance, *above all without pose; to surprise them, so to speak.*

P.-J. Proudhon, 1865

[The non-academic artists] are moving toward the reproduction of men and of nature, as they are seen, without a preconceived ideal, without a fixed style, without tradition. It seems that these artists are taking art back to its origin, without worrying what civilized men have been able to do before them.

Théophile Thoré, review of the Salon
des Refusés, 1863

4

THE SITUATION OF ART
IN 1848

I have described in bare outline the immensely rich range of prints and photographs that flourished throughout Europe in the 1840s. Young men and women who wanted to become artists had experienced an inundation of images as they grew up, the majority of which portrayed contemporary experiences or existing landscapes, buildings, animals, and people. Most future artists had begun as children copying pictures from the magazines in their homes. When they went to art schools as teenagers, especially in France, they found themselves confronted with the art of antiquity. The Ecole des Beaux-Arts in Paris set classical subjects to be treated in the neoclassical style for the annual competition for the Prix de Rome. The pathetic results can be seen in the prizewinner for 1869 [69].

69. *The Death of Priam.*
By J. Lefebvre, 1861.

Ingres won the Rome prize in 1801, but only specialists in nineteenth-century art have ever heard of any of the winners in the following ninety-nine years of the century. To be a brilliant student at the Ecole des Beaux-Arts and to go to Rome meant disappearing off the map of art.

The huge majority of students everywhere in Europe rapidly abandoned the principles they had been taught after they left art school. Many became landscapists in various styles; many became specialists in painting animals; a surprising number actually traveled to the Middle East to paint Oriental subjects, and others painted portraits or genre scenes or peasants. A substantial number turned back to episodes from history of all epochs (an important subgenre was the specialists in battle scenes, who had to learn the disposition of troops in battle and all the details of armor and uniform), while scenes from world literature were also popular. Certain allegorical and classical themes persisted, but those which permitted the use of the female nude rather than the heroic themes the students had been taught to paint. It is a delightful inversion that the Realist artists who could never talk about art without using the word "truth" never painted *Truth*. Academic artists, who according to the Realists had no understanding of truth at all, painted her all the time. We can smile at an anonymous critic who wrote about J.-J. Lefebvre's *Truth*, "Better than anyone he caresses with a delicate and sure brush the undulent contour of the feminine form. I hasten to add that he never falls into the platitudes or grossness of realism."

The variety of subject matter at midcentury was matched by the variety of styles. David had attracted a huge number of students, and most young artists could claim to have been taught by a pupil of David's or by the pupil of a pupil, but the neoclassical style as such was more or less dead. Color, proscribed by the Davidians, was insinuating itself back into art, and not only in the work of rebels like Delacroix. The enjoyment of precise detail, which we have seen was a universal development, led to an enthusiasm for Dutch seventeenth-century art that deeply marked both avant-garde and academic paintings and prints. The whole Renaissance revival of the nineteenth century led to an appreciation not only of the Florentine Primitives but also of Venetian painting.

Italy itself had become an important source of subject matter. The artists who went there to study classical sculpture and the paintings of the High Renaissance stayed to paint Italian bandits and peasants. The latter had the advantage of being real subjects—and picturesque [10 and 11]. Artists from England, France, Germany, and the United States all complained that they would be happy to paint their contemporaries if only modern dress were not so ugly; only in Italy and the Middle East could they find clothing suitable for beautiful painting.

When painters turned to genre, their need to create an interesting subject and a "beautiful" picture led to the innumerable sentimental situations and clichéd compositions and forms. The same pyramidal groupings, outflung arms, rolled-up eyes were used again and again.

Baudelaire wrote of artists' use of the terms *poncif* and *chic* to describe these characteristics, which flourished in spite of the pejorative meanings. Greuze's *The Ungrateful Son* was still, so to speak, the model, though the neoclassic line of figures was frequently replaced by the pyramid. The admiration of Dutch art, especially for genre, meant that artists emulated the deep space of Dutch interiors and moved away from the strict foreground space of neoclassic theory.

At the Salons and annual Academy exhibitions in the different European countries it was the landscapes that provided the most authentic art. Painters went out to sketch from nature, and they were hobbled by fewer models handed down from the past. The one major tradition, Dutch landscape painting, was liberating rather than constricting, and the early nineteenth-century English landscapes that we have discussed provided in France a way of evolving from Dutch art not only for the major figures of the Barbizon School, but for many lesser painters. By midcentury historical landscape had begun to look absurd even in France.

A handful of artists persisted with religious and traditional neoclassical themes and allegory. Official commissions encouraged and tried to keep alive this kind of art, though as the artist and art historian Eugène Fromentin wrote, "Great works are asked of us, and it is time lost to undertake them: for nothing inspires them; no one believes in them, neither we nor others." Fromentin had grasped the point made at the beginning of this book that these works had become impossible within the framework of the Renaissance pictorial tradition, though he was not able fully to understand it, and the general art world certainly did not. There was simply a general dissatisfaction with the pictures produced.[1]

Sculptors found themselves in an impossible situation. Not only was their traditional subject, the allegorical monument, dead as an art form, but their standby, portraiture, also presented enormous problems. We have seen the growth of the feeling that a portrait needed the milieu of the individual to be fully satisfying. Certainly the most memorable painted portraits from midcentury on include eloquent settings: Courbet's *Proudhon* [105], Manet's *Zola* and *Mallarmé*, Renoir's *Chocquet*, and Degas's *Duranty*. The sculptor could not provide the environment,

[1] Achille Fould, the French Minister of State, awarding the medals at the Salon of 1857, declared, "The brilliance with which the French school had shone at the Universal Exposition (1855) and the time allowed the arts to prepare themselves for a new effort gave rise to the happiest expectations. If these have not been completely fulfilled, one may at least say that they have not been completely disappointed either." The admission in this last sentence on such an occasion shows that apart from the artists themselves, people were not really happy with what they saw at the Salon.

and he was even more than the painter further bedeviled by the ludicrous question of clothing. Nineteenth-century dress enveloped the body and left little scope for expressive form. The belief in accuracy of representation meant that every button, belt, and frill had to be faithfully rendered. As Kenyon, the sculptor in Hawthorne's novel *The Marble Faun,* said, all the sculptor could do was "to idealize the tailor."

The greatest sculptures in the first seventy-five years of the century were Daumier's little busts of the Parliamentaires, but his caricatural approach, which enabled him to overcome these problems, did not solve the general dilemma. Earlier, Novotny was quoted as claiming that it was the century of great landscape painting, a theme in which we can see that subject and environment are one. Sculptors could not participate in this major subject matter, though in the 1880s and 1890s Medardo Rosso tried desperately to overcome the problem of the figure in the environment and of landscape with sculptures, as in his *Impressions in an Omnibus,* 1884, and *Conversation in a Garden,* 1893.

Before we examine the historical development of the styles, subjects, and ideas of Realist art, I want to discuss briefly some of the general considerations that will help provide a perspective on the art. Courbet's assertion that artists should depict only the "visible and tangible" is a valuable, but only partial, definition of Realism. The question of style is crucial, though we tend to talk much more of the subjects and intentions of Realist artists than of their styles. Because they abandoned so much of past subject matter, it is natural to emphasize the new, yet the nature of Realism can be approached only through a study of the styles.

On examining Realism, we find a number of contradictory aspects. The admiration of the achievements of science was very great in the nineteenth century, and a number of artists and their writer friends conceived of themselves as social scientists objectively examining their subject and presenting it factually. They give a sense that their style springs naturally from the artist's surrender to the subject, on which he does not impose preconceived stylistic concepts. The word "truth" was used by every artist: although it has often been quoted, it is worth repeating the literary critic Saint-Beuve's dictum, "The beautiful, the true, the good is a fine slogan and yet it is specious. If I had a slogan it would be the true, the true alone. And let the beautiful and the good get along as well as they can."

These words could have been spoken by any of the Realist artists, and they exemplify the shift from the traditional values of art to the aims of science. Zola actively compared the novelist to a scientist in his essay *The Experimental Novel.* The consequence of this new attitude was the enormous value given to facts. Not only did the second quarter of

the century see the vast expansion of statistical surveys of society, but Thomas Carlyle, who appears as an inspiration in Ford Madox Brown's *Work* [98], said quite simply, "Facts are truth, truth is facts."

The belief in factual accuracy can be seen everywhere in mid-nineteenth century art—at the Salon in Meissonier's historical pictures, which were based on devoted research, or in the English Pre-Raphaelites' minute studies of plants and animals (C. A. Collins was praised by Ruskin: "I happen to have a special acquaintance with the water plant *Alisma Plantago*, and I never saw it so thoroughly or so well drawn"), or in Degas copying high-speed photographs of a cantering horse. These three different methods were all concerned with establishing the factual, and many critics became alarmed by what they saw as the reduction of art to the undifferentiated facts seen in a photograph. Accusations of paintings being no better than Daguerreotypes were common, and Baudelaire is famous for his attack on photography in his Salon of 1859 review, though it is not one of his most persuasive essays.

If the Realists shared this search for precision with academic artists, I believe that they very often sought a contradictory aspect, which separates them from the Salon and which often puzzles us. This characteristic might best be called "primitivism," and though it has been pointed out in the case of individual artists I do not think its general importance is fully realized.

"Primitivism" might seem a very inappropriate word to go with Realism, yet I believe that it has a relevance. Realist artists turned to crude art forms that were no more realist than academic art, but which offered models for breaking through the conventions of the latter to a more immediate experience. Throughout the century, when technically perfect prints were available to everyone, in France the crude popular prints continued to flourish. Usually known as *images d'Épinal*, after the principal source, though they were produced in several towns, their simplified outlines, awkward compositions, and flat color seem an anomaly, but they continued to appeal to both their traditional audience and to intellectuals.

Both Courbet and Manet used *images d'Épinal* as direct sources, or they adapted aspects so that their paintings were condemned (or praised) as no better than *images d'Épinal*.

Linda Nochlin begins her book on Realism with a comparison of Courbet's *The Meeting* [70] with an anonymous print of the Wandering Jew [71] being greeted by two burghers, as part of her discussion of the creation of a Realist style. This print was a source of the composition; Nochlin points out that not only did Realist artists not simply transcribe what they saw, but such a transcription is impossible. The artist must start with a priori principles of how the paint is going to be applied to

70. *The Meeting.* By G. Courbet, 1854. Musée Fabre, Montpellier.

71. Detail of a popular print of the Wandering Jew.

the canvas, of what details are to be represented and which omitted, and very importantly how the subject is to be selected and placed in the picture, and so on.

In *The Meeting*, Courbet takes the composition of the figures from a popular print (the Wandering Jew was a very popular cultural figure in the nineteenth century, and Courbet identified himself with the Jew),

but the setting may well have been inspired by a Dutch seventeenth-century painting by Van der Venne. In this painting Courbet has, in any case, concealed the crude original by the way he has painted the figures, and Nochlin does not develop the point. At other times, Courbet does present his figures stiffly or awkwardly posed so that the spectator is taken aback. Caricaturists of the time responded by drawing his paintings with the figures as dolls on a stand [72]. Delacroix admired Courbet's vigor and his painting technique, but criticized the figures. He wrote of *The Bathers*, "She makes a gesture which expresses nothing. . . . What are these two figures doing?" And of *A Burial at Ornans*, "the figures are on top of one another, the composition is not well understood."

72. Caricature of Courbet's *Young Ladies from the Village*, 1852, from *Le Journal pour rire*.

Delacroix had written in his *Journal* two days before seeing *The Bathers*, "One always has to spoil a picture a little bit, in order to finish it. The last touches, which are given to bring about harmony among the parts, take away from the freshness." Delacroix's subject is a little different, but we see the gap which has opened between an artist regarded as a radical like Delacroix and the Realists. Delacroix worries over the question of finish and harmony repeatedly in his *Journal*, but always, as here, comes down on the side of tradition. Courbet does not smooth things out—he risks disturbing us in order to achieve immediacy.

Similarly, the compositions of many of Manet's pictures have puzzled both his contemporaries and subsequent commentators. The individual figures are not fully modeled and the pictures are built up of

separate parts that do not fit together with correct scale and perspective
—exactly the characteristics of the *images d'Épinal* or the Japanese prints
with which they were compared. It must be remembered that while we
regard Japanese popular prints as high art, they were considered prim-
itive by the standards of European art. These disjunctions enabled
Manet to cut up quite a number of his paintings and exhibit the bits as
complete pictures in themselves.

While some critics have accused Manet of being unable to compose
a picture satisfactorily, his defenders have stressed that the awkward-
ness is intended to jolt us, to make us feel the work directly. In using
the loaded word "primitive," I am of course intending it in a stylistic
sense, and it has nothing to do with Gauguin's later search for cultural
primitivism. The English Pre-Raphaelites, by their choice of name, iden-
tified themselves with the Italian Primitives of the fifteenth century.
They felt that the prevailing beautifully composed pictures with figures
in graceful poses destroyed the sense of reality, and consequently the
force of the idea that the artist wanted to express.

When we look at Millais's earliest paintings like the *Cymon and
Iphigenia* of 1848, we see familiar poses and endless graceful, curving
lines typical of English painting of the time. In that same year, when he
turned nineteen and the Brotherhood was founded, his new painting
Lorenzo and Isabella is oddly composed, with an awkward superimposi-
tion of the diners at the table (though the composition is entirely differ-
ent, we could make the same criticism that Delacroix was to make of
Courbet's *A Burial)*, and Millais offers an extraordinary central motif,
the outstretched leg of Isabella's brother kicking her dog. This motif
was described at the time, quite reasonably, as "an absurd mannerism."
Yet the very absurdity grates on our sensibility and enables us to share
Isabella's feelings. Millais runs the risk, of course, of our finding it too
absurd and withdrawing from the picture. His *Disentombment of Queen
Matilda* the following year is a mass confusion of figures composed of
angles—the curves have all gone.

These Millais pictures are not Realist, but when he painted portraits
of Mr. James Wyatt and of his daughter-in-law, also in 1849, in which
the figures are firmly set in their environments, they are made quite
stiff, and the latter's daughter quite doll-like. We are reminded of Cour-
bet's figures in this respect, and the portraits must have been quite
startling in their rejection of all gracefulness when they were painted.
Mrs. James Wyatt, Junior, and Her Daughter Sarah [73] in its whole com-
position forms a striking anticipation of Whistler's *Mother* of over twenty
years later, and of his *At the Piano*, 1858–59.

I have stressed this primitivism because very often Realism is asso-
ciated chiefly with a meticulous, almost photographic representation of

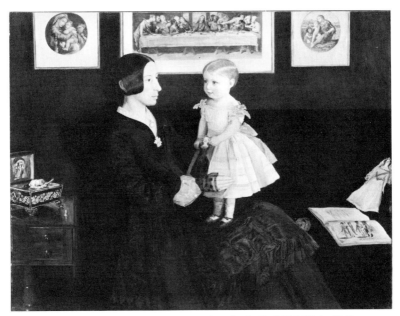

73. *Mrs. James Wyatt, Junior, and Her Daughter Sarah.* By J. E. Millais, 1849. Tate Gallery, London.

a scene. The widespread academic style that had developed by the second half of the century, which we see in the work of Gérôme and Meissonier, is thus regarded as Realist when applied to an actual scene rather than the usual invented subjects. The misconception that this type of painting is Realist has been brilliantly analyzed by Charles Rosen and Henri Zerner, who have pointed out that Realist painting emphasizes the surface of the canvas, and does not create a smooth invisible surface which is a window into the scene behind.[2]

Thus, in addition to the primitivism which destroys conventional forms to speak directly to the spectator, we must add the actual painting techniques. The latter in fact was what most often struck spectators when they first encountered Realist paintings. The artists developed their own methods of paint application. Courbet was notorious for his use of the palette knife to plaster thick gobbets of pigment onto the canvas, and the critic Castagnary devoted a long passage in his critique of the Salon of 1863 to Courbet's use of the palette knife. He explained that the artist had even designed his own version of the knife.

Millet's ponderous use of paint is one of the most evident aspects of his pictures. Théophile Gautier said of one of his pictures as early as 1847 that it was "worked over with an impasto thick as mortar, on a canvas worn bare and coarsely grained. . . ."

[2] C. Rosen and H. Zerner, *Romanticism and Realism.* New York, 1984, chapter 8.

defined realism here

~e-Raphaelites tried to keep secret the method they practiced
‿ on a wet ground in order to achieve brilliance of light and
color. The result was the astonishing effects of sunlight that were not to
be equaled until much later by the Impressionists. The Pre-Raphaelite
method also created an emphasis on the surface itself that upset critics.
It is unnecessary here to discuss Impressionist brushstroke and surface
texture, which are so well known for the dismay, even fury, that they
caused.

The importance of this manipulation of the paint lay in the fact that
with the unworkability of the old methods of conveying meaning that
we discussed above, the style became the carrier of expression in the
work of art. We can see that though the belief in fidelity to the motif
makes Realism seem remote from twentieth-century art, the destruction
of illusion and the importance of the surface pigment make Realism an
important step to modern painting.

To conclude this section, we can say that Realist paintings involved
both the abandonment of existing conventions or codes of representa-
tion and the invention of a distinct and appropriate way of applying
pigment to the canvas, and that these had to be synthesized with truth
to the motif. It is not surprising that great Realist painting was not
simple, or that many artists who thought of themselves as Realists did
not grasp all the elements involved.

Linda Nochlin has written in her book *Realism*, "Its aim was to give
a truthful, objective and impartial representation of the real world,
based on meticulous observation of contemporary life."[3] This descrip-
tion of the aim does not try to define how artists were to achieve these
goals, and we could say that this statement would include a great deal
of nineteenth-century illustration and photography that we would not
ordinarily describe as Realist. If we analyze the pictures usually re-
garded as core Realist works, we can perhaps derive principles that
separate these works from, say, photographs. From an examination of
the best pictures of the Barbizon School and of Daumier, and looking
ahead to later works, I believe the following characteristics are essential
in drawing or painting a Realist picture.

Firstly, the subject must be one that the artist has observed or ex-
perienced.

Secondly, we must be made to feel that the artist has presented the
subject just as he saw it. (The element of objectivity.)

Thirdly, the artist must create a style that produces an expressive
element in the work, the very thing that is excluded by the objectivity
of the first two principles.

[3] L. Nochlin, *Realism*. Harmondsworth, Middlesex, England, 1971, p. 13.

In the first of these principles, the word "subject" is used in the broad sense to describe everything in the picture, not just a central motif that is placed in a setting. Balzac and Duranty have been quoted to the effect that women and men cannot be meaningfully separated from their environment, yet the concept of a subject placed *against* a background, not *in* a setting, was so strongly entrenched that it persisted to the detriment of a number of works by the greatest Realist artists. Most Realist works are based on subjects the artist had seen, even if not drawn or painted on the spot, but naturally there is a fringe area which is not clear-cut. Adolph Menzel, for example, studied intensely all the artifacts of the past and fused them with his equally keen observation of the life around him. The result was historical pictures that sometimes seem more convincingly real than many other artists' pictures of their contemporary world.

The second of these principles is not discussed in books on Realism, but is extremely important. The artist must choose a moment, an angle of vision, a positioning of the figures, a relation of parts to the whole composition and to the size and edges of the picture that persuades us that this is "just how it was." This principle involves not observation so much as creative reconstruction. The key word is "persuasive." We, the spectators, must feel that the subject is not posing for us, or has been posed by the artist for the picture. When we stop to think, we realize that the artist has reconstructed his scene, but the coherence of the work must make us dismiss this knowledge.

Looking back to Chardin and Greuze, we see immediately that Greuze's figures are all posing for us, and however accurately each one is drawn as a villager of the time, the picture cannot persuade us of its reality. Chardin became a model for the nineteenth-century Realists because he makes us feel that he crept up behind the student and drew him just as he was, a kind of candid snapshot. When we examine Chardin's *Young Student Drawing* [2], we can see how he has modified the outlines and reorganized the volumes and planes to transform his initial observation of the student into a great work of art. Yet he has done this so skillfully that our first impression of its veracity is never erased.

The posed figure presented the greatest problem for the Realist artists—the conventions of landscape were less entrenched and easily dissipated by going out and drawing in front of nature. People, to be studied carefully, had to be posed (Chardin chose people absorbed in an occupation that kept them motionless, building houses of cards or reading, for example, so that they were naturally posed), and the posed or arranged figure had been the basis of art since the Renaissance. This is especially true of the single figure placed centrally on a canvas in

front of a background. In the nineteenth century, artists and critics had not articulated this problem, so that the posed figure remained a weak element in much Realist art. Both Millet and Manet provide a number of examples of this type of picture; whatever these works' other qualities, they do not ring quite true.

The posed figure is the element that vitiates so many examples of what has been called Academic Realism. The French painter Jules Bastien-Lepage provides a good example. Looking through his work as it was represented in the catalogue of the exhibition *The Realist Tradition* (1980), we find three pictures of boys, carefully observed—a London bootblack, a barge boy, and a woodworker. The themes are all Realist, but each young man looks appealingly straight at us with wide-open eyes, as if posing for a photograph, and the authenticity is destroyed. Bastien-Lepage's riverscape *Thames, London,* 1882, where nothing is straining for our attention, succeeds very well as a slice of life. The great inconsistencies within the work of one artist result especially from the lack of recognition of this aspect of Realism.

An illustration or a straightforward photograph can fulfill these first two principles; it is the last one, the creation of a style, that distinguishes the Realist picture. (The photograph, too, can have expressive style, and there is the distinction within photography between the photograph as art and as snapshot or recording.)

As expressive distortion was incompatible with Realism, it was above all the artist's way of painting, and the choice of composition (the overall approach), that gave meaning to the pictures. The enormous importance of paint application has already been discussed, and from Manet onwards, innovations in composition became equally significant. Discussions of the work of Manet and Degas have always stressed the originality of their compositions as central to their achievement, but it has been less analyzed in the case of the open-air Impressionists. Because of the overall coherence of their outdoor views, their compositional innovations have been less remarked.

One of the arguments of this book is that Realist art is not as simple as it has often been considered—the idea that the artist only has to paint what he or she sees. A consideration of the three elements defined here reveals an immediate difficulty for the artist—the conflict between the second and third. Every Realist painting involved a resolution of this conflict. If too much attention was paid to the second element, the artist concentrating on faithfully rendering as much as possible of the scene, the result was an inexpressive illustration or snapshot. Too much attention to the third meant that the Realism was destroyed.

It hardly needs pointing out that when Courbet and Millet and then the Impressionists first exhibited their work, many of the public were

so astonished by the originality of the painting style that they felt that the truth to life had been undermined by the excessive role of the patches of paint. Growing familiarity with the pictures removed this feeling, as the paint application, though expressive, was derived from the artists' visual experience.

Examples of stressing the style over recreating observation can be seen in the 1880s, when some younger artists who had begun in a Realist milieu, inspired by Impressionism and also by seventeenth-century virtuosi like Frans Hals, developed spectacular plays of brush-strokes. These artists include the American John Singer Sargent and the Italian Boldini, both of whom achieved enormous success at the time. The public, less conservative than we often think, responded to their bravura qualities. These artists' reputations have declined in the twentieth century because in abandoning Realist principles the artists did not, unlike their Post-Impressionist contemporaries, create a new pictorial system to which their flamboyant brushstrokes could relate. As a result many of their pictures look to us unmotivated, and unlike Seurat's "dots," for example, their brushstrokes have no pictorial logic.

Linda Nochlin has shown how widespread was the desire of the Realists to forget all previous art, and to paint naively what they saw (their refusal to teach, their wish to have been born blind and suddenly to have received the gift of vision, etc.). When we look back at the three points I have listed we can see why those desires were impossible to fulfill, though they were always necessary as an inspiration to the artists not to fall back into formulas. The artists' study of earlier paintings, of prints, illustrations, and caricatures, made clear the distinctions between the posed and the unposed, between a clichéd and expressive composition, and between the smooth, licked surface which tries to conceal its medium and the use of the pigment as part of the picture. The often stated belief that Realism was a straightforward kind of art is thus misguided. Whatever the painters claimed, their art is as sophisticated as any other style, and more sophisticated than that of their contemporaries who took elements from past art without any intelligent rethinking.

A theme that raised problems for the Realist artist was human sexuality and the nude. French novelists examined prostitution and sexual behavior as an essential part of their treatment of modern society, and Flaubert and the Goncourt brothers found themselves in court as a result. In England Thackeray and Henry James both complained of the limits placed on the novelist. English publishers would simply not have issued books with doubtful passages; the exception was a small independent, Ernest Vizetelly, who published the English translations of Zola's novels. He was imprisoned for his pains.

Artists found themselves in an odd position. The nude was so strongly established as a basis of art that it was acceptable and became, in fact, an outlet of sexual expression. We all know how many artists throughout Europe made their living off undressed women. It was an irony that in the academies of art, students studied the male nude extensively so that they could paint neoclassical pictures (these studies were so large a part of the instruction in France that these drawings were simply called *académies*). Once the student graduated, he largely forgot these studies and painted the female nudes that would sell. The artist was, however, expected to paint the nude in conformity with the stereotypes that had been derived from classical and Renaissance models. The result was the never-never land of repetitious Venuses, nymphs, and allegorical figures, even if artists showed, especially in Oriental themes, a considerable ingenuity in stretching the boundaries of the permissible to provoke a greater eroticism.

If the nude was a commonplace in art, there was, however, a much stricter limitation on visual than on literary sexuality, a difference which has continued up to the present. Consequently the nude was not placed in a contemporary setting, and the pictures and sculptures do not deal with human sexual relations as the French novels do. Sexual themes thus presented many problems for Realist artists. There was an enormous number of conventions to be discarded, and an almost insuperable barrier against the expression of actual sexual life. In addition, the fact that people did not see each other nude in situations where they could be painted meant that the Realist artist could not depict even a modest nude without creating an artificial pose. Renoir and Degas, whom we associate so much with the nude, painted them only rarely during the Impressionist period. It was only after the crisis in Impressionism in the early 1880s and the abandonment of strict Realist principles that they produced the series of bathers with which we are so familiar. We thus have the paradoxical situation in which sexual expression was one of the crucial elements in the French Realist novel but was almost absent from Realist art.

Courbet, with his robust appreciation of the physical pleasures of life, could not resist the nude; but with few exceptions, these are his least Realist works, and usually regarded as among his least successful. The nudes are divorced from any real context; bathers without swimsuits in unlikely postures or pastiches of Renaissance paintings, like *Nude with a Parrot*. In other words, pictures just like those of his academic enemies.

Manet started his career with two nudes, and we associate Manet so strongly with *Luncheon on the Grass* and *Olympia* that it is easy to forget they are atypical in his work and that he rarely painted the nude

again. He returned to the theme of the courtesan fourteen years after *Olympia* with *Nana*, 1877, dressed, albeit only in her underwear; but the sexual theme is quite played down, and is subordinate to the whimsical quality of the admirer sliced in half by the picture frame.

Degas also explored the world of the prostitute in his brothel scenes [74], but he never exhibited them (the prostitutes were naked rather than nude, and much too real to be shown in public), and they were found in his studio after his death. Apparently Degas went beyond the social scene of the brothel to illustrating sexual activity, as his brother destroyed many of these monotypes. In the numerous bathers from the latter part of his career Degas returned to the traditional subject but rethought it, and by his "keyhole" approach gave it verisimilitude.

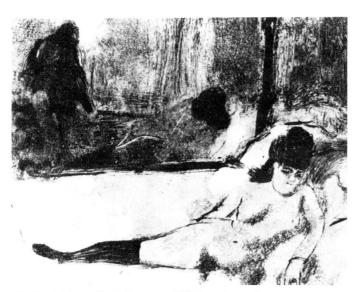

74. *Brothel Scene*. By E. Degas, ca 1879. Location unknown.

A major problem for the Realist artist was that a great amount of sexual subject matter is private and cannot be observed. Even if the artist was content to work for posterity, he would have difficulty in persuading us that he had really observed the scene. Degas, in his monotypes, did a good deal to solve this problem by the use of medium, which in its murkiness suggests the quick, furtive sketch.

Gervex's painting *Rolla*, 1878 [75], illustrates perfectly the dilemma of the sexual subject. A young artist of twenty-six, Gervex was tempted by modern subjects, but here, perhaps for safety's sake, the theme was taken from a poem by the highly regarded Alfred de Musset. The hero, at the end of his tether, gets together all the money he can so that he

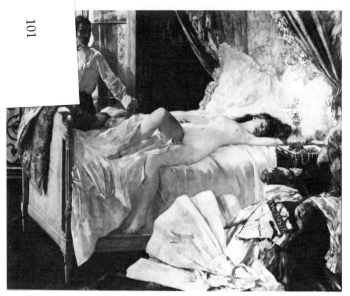

75. *Rolla*. By H. Gervex, 1878. Musée des Beaux-Arts, Bordeaux.

may spend his last night with the particularly beautiful and notorious courtesan, before shooting himself the next morning. De Musset was a member of the Romantic generation and the poem, written in 1833, is far from a Realist sexual theme, lurid though some of the novels were. Gervex thought of the naturalist effects as an important part of the work. He wrote, "It's daybreak, but on the table a lamp is still lit, and it is precisely this contrast between the artificial light of the lamp and the cold light of morning which had seduced me." Gervex also prided himself on the fact that Manet, Degas, and others who had seen the painting before the Salon, praised it. In fact, the picture had a sufficient atmosphere of the real to be soon removed from the exhibition as too immoral. It was then shown by a picture dealer, and naturally had a great success with the public, as the combination of the naturalist effects with a juicy subject could not have been better designed to appeal to popular taste by the mid-1870s. Today, the color and lighting still remain attractive, but the melodramatic pose of the man, Rolla's unbelievably perfect skin, and her sprawling pose, reminiscent of so many nymphs of the Salon and very little of actuality, fail to convince. We are back in the world of Greuze, not of Chardin, though Gervex thought of himself as a Realist.

TIME AND MOTION

It may seem irrelevant to include a section in this book on two abstractions such as time and motion, which cannot be directly represented in

art. Yet in the nineteenth century both these factors forced themselves on people as elements that constituted change, and which dominated their lives both as theoretical concepts and as lived experience. Art was affected by them in spite of itself.

The Hegelian dialectic, reinforced and made more tangible by Karl Marx, defined change as the basis of history, just as the theories of evolution and natural selection implied that the individual species, even mankind itself, was not a constant. The rapidity of the Industrial Revolution in Europe and the United States created cities almost overnight, and shattered the experience of continuity and repetition which had been a natural part of agricultural life. Even the continual introduction and refinement of tools and utensils by that favorite nineteenth-century hero, the inventor, created a sense of transience and obsolescence as well as of progress. It might be noted in passing that the inventor, by the development of the paint tube, made changes in art possible by simplifying open-air painting. We regard change as the norm today, but it was a new and both thrilling and disturbing experience in the nineteenth century, and one that thrust itself forcibly into people's consciousness. As Marx put it: "Constant revolutionizing of production, uninterrupted disturbance of all social relations, everlasting uncertainty and agitation, distinguish the bourgeois epoch from all earlier ones" (*The Communist Manifesto,* 1848).

The past, whether history or evolution, came to be seen as an inescapable influence on the present, which was continually transforming itself into an unpredictable future. The study of the past and the writing and reading of historical novels became major activities, and artists were drawn into this awareness.

The painter and sculptor with their fixed media that did not unfold in time had to struggle with these transformations. In the past, Time had been expressed allegorically through paintings and sculptures with titles like *Study Trying to Hold Back Time* or *Time Unveiling Truth.* Even the most diehard artists began to realize that this particular allegorical category was dead, though they persisted with others. While the sculptor's hands were almost completely bound, painters attempted, as we shall see, to find ways out of this dilemma and deal with the issue of Time in its larger sense, History; in its short-term cause and effect; and in its immediacy, the transformation of the present moment.

If artists could not escape this challenge of Time, both painters and sculptors could reasonably claim that motion was alien to their art. Yet ever since the Renaissance, the horse, which gave both actual and symbolic power to the aristocracy, had been a central theme in art. The inventive power of the greatest artists, Donatello, Leonardo, Titian, and Rubens among others, had been turned to recreating the dynamism of

the horseman. They succeeded because the underlying ideal nature of art permitted artists to give an emblematic representation of the horse in movement to everyone's satisfaction. In the nineteenth century, on the contrary, the need for direct representation and the growing desire for scientific accuracy meant that the traditional "flying gallop" and the rearing but static horse began to look increasingly absurd. While artists could easily avoid machinery as a subject, the horse remained a subject required of them. Both academic and avant-garde artists turned to photography for assistance, but as we shall see with mixed results.

Meanwhile the great interest in the new technology, richly illustrated in the popular magazines and exploited by novelists like Dickens and Zola, meant that while artists could ignore it, they nevertheless found themselves isolated from a vital element of their times. We shall see how one aspect of technology, and one that entered everyone's lives, the train, was tackled by the art world.

MOVEMENT

The representation of movement was the most evident problem for the nineteenth-century artist. In a world set in motion by steampower and electricity, painting and sculpture could easily seem inadequate art forms. The galloping horse set problems for the artist, who was now also confronted by the clattering factory and the steam train. The art world responded by declaring the innovations inartistic, and the role of art to be that of glorifying eternal truth and beauty. This defense persisted throughout the century, and while a thoroughly respectable one, it left many people dissatisfied with the resulting artworks. The problems were unconsciously revealed by an illustrator for the *Illustrated London News* in 1897 celebrating Queen Victoria's sixty years on the throne [76]. The contrasted pictures show the changes since her accession: the stage coach has become a steam train, the paddle steamer with sails has become a modern Atlantic liner, and gas lighting has been replaced by electricity. While the horses are very lively and the billowing sails can convey a feeling of movement, the outlines of the liner and the train are quite static. The effects of modern street lighting are represented in a schematic rather than a realistic fashion. Thus the more modern developments are the hardest for the visual artist to recreate. Throughout this book I have stressed the fact that the public eagerly responded to detailed representations of contemporary life, but they accepted the traditional assumptions as necessary for High Art. The *ILN* illustration demonstrates this attitude in an amusing way. The celebration of modern technology sets the portraits of the engineers in a border inspired by medieval manuscripts!

Eighteenth-century artists had found it much easier to represent

76. *The Progress of Technology from 1837 to 1897.* Color supplement to
Illustrated London News, 1897.

their world. From Rococo pictures of the aristocracy at play to Hogarth's
explorations of London low life, from canvases of rural laborers to
Wright of Derby's scientific experiments and the paintings of the cotton
mills and iron works, artists, even if they did not paint everything,
seem to have felt no barriers. They painted whatever their patrons
demanded or, increasingly in the latter half of the century, what struck
the artist's own fancy. The nineteenth-century artist on the contrary felt
restricted by the intractability of many new subjects, though they were
of major importance in everyday life.

The steam train and electric lighting cited above exemplify the prob-
lem. The latter innovation we take for granted, but it was a spectacular

improvement at the time that helped change people's lives. Electricity with its intangibility as well as its invisibility provided a particular challenge not only to artists but to everybody. Henry Adams's comparison "The Dynamo and the Virgin," inspired by the dynamo that provided all the power for the 1900 Paris World Fair, expresses the puzzlement felt at this new phenomenon.[4] Whereas steampower could be understood in principle and felt in practice very easily, especially standing beside a steam engine, electric power was a silent mystery. Puvis de Chavannes tried to symbolize the electric telegraph in his Boston Public Library mural, *Physics*, with black- and white-clad floating women representing bad and good news as they held on to wires, but he demonstrated both the difficulty of painting electricity and the impossibility of allegory.

As pointed out above, it was not just mechanical or electrical power that confronted the painter. The desire for fact in place of convention affected the representation of horses. The American Thomas Eakins's experiences with his painting *The Fairman Rogers Four in Hand*, 1879 [77], displayed a tragicomedy of the artist's dilemma. Eakins embodied the scientific zeal of his generation: he constructed models and prepared elaborate perspective sketches to ensure the accuracy of his pictures, and he experimented with photography of movement. When he showed this painting to friends they complained that while the horses were shown at a brisk trot, the carefully painted spokes of the wheels implied that the coach itself was at rest. When Eakins repainted the wheels as a blur (he had admired Velázquez in Spain and had seen his blurred spinning wheel), his friends now complained that while the coach seemed to be moving, the horses' legs were not similarly blurred. The animals looked like wooden horses on a carousel, legs raised but not actually in motion, and appeared to be in imminent danger of being run down by the rolling coach! Eakins, unable to resolve the problem satisfactorily, left it at that.

Muybridge's photographs of horses in motion were published in Europe from 1878 onwards, and Aaron Scharf has described very well both the pre-existing concern to establish the exact nature of a horse's gait because of the general dissatisfaction with the "flying gallop," and the excitement produced by Muybridge's work. Two such different artists as Degas and Meissonier studied and used his photographs in their paintings. A Degas drawing copying a photograph of Annie G. cantering [78 and 79] demonstrates the earnestness of the artists' search for truth and accuracy (the bond linking Degas and Meissonier), but it points up the fact that the problem was not really solved. Writers soon

[4] H. Adams, *The Education of Henry Adams*, chapter XXV, "The Dynamo and the Virgin."

77. *The Fairman Rogers Four in Hand.* By T. Eakins, 1879–80.
Philadelphia Museum of Art, Gift of William Alexander Dick.

78. *Annie G. in Canter* from *Animal Locomotion,* 1887. Photograph by E. Muybridge.

79. Drawing after Muybridge photograph by E. Degas.

pointed out that copying one of these photographs in a painting was quite unconvincing. We never see the horse's legs as in the high-speed photograph, which freezes what in fact is a continuous motion. The photographs analyze but do not represent the movement.

Scharf quotes *Le Figaro* from 1881:

> Yesterday in Meissonier's studio we witnessed a most extraordinary spectacle. M. Muybridge, an American photographer whom M. Leland Stanford former governor of California has taken under his patronage showed to an audience of painters, sculptors and men of letters, a series of projections by electric light of a novelty which was truly fantastic. It is an artistic revolution and the spectators invited by Meissonier were well entertained.[5]

These spectators saw a rapid projection of lantern slides by means of a zoopraxiscope, a development of the apparatuses discussed in Chapter 3. Though it did not offer the fluidity of the later movies, this demonstration sounded the death knell of a whole branch of art, battle painting, which had flourished in the eighteenth and nineteenth centuries but is known only to specialists today. A few years afterwards the galloping horse dominated the movie screens as the cowboy became a culture hero of the whole Western world. The painting of horses became the preserve of those conservative artists who tried to insulate themselves from the development of the modern world and of art itself, like Sir Alfred Munnings, the president of the Royal Academy, a specialist in uninspired hunting and racecourse scenes, who declared that Picasso and Matisse needed to be kicked in the pants.

Many artists, where they could represent a group of horses, followed the example of the Parthenon sculptors almost two and a half thousand years before, and overlapped the horses with the legs forming flickering diagonals in all directions. It had been a brilliant invention in ancient Greece, but the lack of blurring or of some other device to suggest actual human visual experience still left a nagging problem. Increasingly artists portrayed galloping horses from the front, so that the lack of movement was minimized. Edouard Manet tried this both in a painting and a lithograph [80]. Ingeniously he made the horse small and distant, and by scribbling over the spectators arranged in a dramatic perspective, he transferred the motion to the general composition. When we look closely at the print we see that to secure additional diagonals the horses are tilted at unlikely angles, an effect that becomes bizarre in his small painting, now in the Washington, D.C., National Gallery, where the horses are seen close up, and seem to be falling over.

[5] A. Scharf, *Art and Photography*. Baltimore, 1974, p. 215.

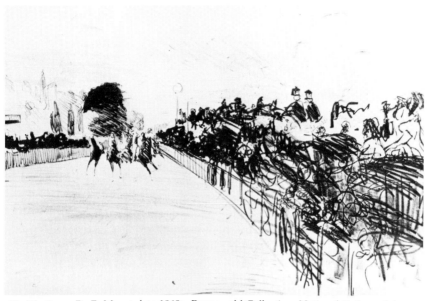

80. *The Races*. By E. Manet, late 1860s. Rosenwald Collection, National Gallery of Art, Washington, D.C.

One of the most successful of these views from the front is that of Lady Elizabeth Butler, whose *Scotland for Ever!*, 1881 [81], possesses a real excitement. Many pictures of this type suffer from heroic figures silhouetted against the sky who freeze the movement created below them (see Scharf, figs. 158 and 159), but the artist minimizes this problem. In its evocation of military glory, *Scotland for Ever!* is typical of

81. *Scotland for Ever!* By Lady Elizabeth Butler, 1881. City Art Gallery, Leeds.

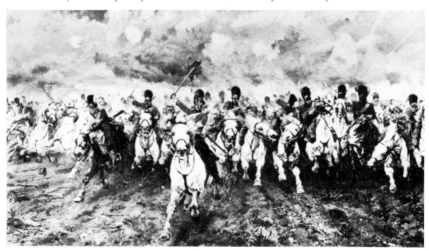

many nineteenth-century battle paintings, but it is quite uncharacteristic of the work of Lady Butler. Most of her pictures represent mournful scenes of dead and dying after a battle or columns of wounded and exhausted men in retreat. Like many painters in the 1880s whose approach was at base academic (she detested Impressionism), Lady Butler in her painting of the clouds, earth, and peripheral parts of the picture used a much more fluid brushstroke than in the carefully drawn foreground horses and their bridles. Barbizon painting and Impressionism seem to have had a subliminal influence on these artists, and by relaxing the rigidity of a tightly drawn style, give more life to their pictures than those of the middle years of the century (for example, Lady Butler's own *The Roll Call* of 1874 [collection of Her Majesty Queen Elizabeth]).

Meissonier made a very interesting attempt to suggest movement in sculpture with his *The Traveler*, 1878 [82], a sketch in red wax, with both cloth and leather used to give greater naturalism and to increase the effect of motion. The lines of the drapery blown by the gale, which is evoked by the bent heads of horse and rider, do suggest movement, while the lightness of the cloth contributes to the windblown effect. Cast in bronze, I think the sculpture would lose much of its power.

Not surprisingly, the imaginative graphic artists anticipated some of the Futurist breakdown of form and the multiplying of lines of force, but this amusing fancy did not permit a serious exploration of movement.

82. *The Traveler.* By J.-L.-E. Meissonier, 1878. Musée d'Orsay, Paris.

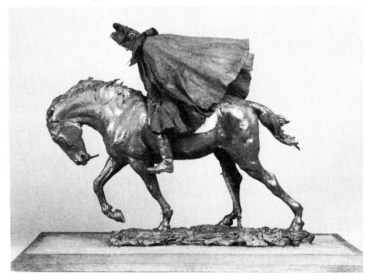

While the horse increasingly represented the past, the train became instantly the symbol of the new world that people found themselves living in whether they liked it or not. Though we tend to think of factories as the central element of industrialization, only a small percentage of the populations of Europe actually worked in a factory, and most people had no occasion to enter one. Everyone, though, traveled on trains, as governments passed laws obliging railway companies to provide trains or coaches with very cheap fares.

The illustrated magazines gave railroads an extremely prominent place because of the popular interest, and we find a wide variety of illustrations and caricatures. The latter ranged from political satires on the financial corruption involved in railroad construction to the discomforts of travel and the numerous mishaps likely to occur, not to mention the terrifying effects on farm animals along the routes. The illustrations presented the trains themselves (with varying degrees of accuracy), the stations, both as architectural engineering feats and for their human interest, the great achievements of construction involved in the tunneling and bridging, and the numerous accidents and explosions.

While the illustrators and their public reveled in all these possibilities, painters not only found the outline of a train inexpressive but, more importantly, there was no place for a train or a station in the canons of beauty. Various prominent writers denounced railroads for dehumanizing the traveler and for disfiguring the countryside. Ruskin has made himself notorious for his opposition, comparing traveling to being sent like a parcel, while he condemned the cast-iron architecture of the station sheds.

For a long time the eccentric Turner and the very original Menzel were the only major artists to include a train in a painting, and both made their trains quite a small element. The problems of representation can be seen in the fact that Turner, to catch some of the dramatic power of the train, painted the locomotive inaccurately to the point of absurdity, while Menzel's train is more accurate but not very assertive.

The way in which people did not think through the changes in art, and the consequent inconsistencies, can be seen in the attitudes to military paintings. These were expected to be accurate in detail and could include all the contemporaneity of an illustration. In 1874, just after the Franco-Prussian War, one of the French specialists in battle paintings, Alphonse de Neuville, exhibited *The Attack Across the Railroad*, which shows soldiers trying to advance across the tracks on a railroad embankment. De Neuville's works were much admired, and because railroads were more or less nonexistent at the Salon, the picture had an even greater air of authenticity. However, the striking painting

of the tracks and setting is marred to our eyes by the conventional poses: soldiers hit by bullets falling backwards with outstretched arms, and so on.

In Russia the artistic movement that became known as the Travelers encouraged its members to find new subject matter as they sought to paint Russian life in a much more penetrating way than the members of the St. Petersburg Academy. Konstantin Savitsky's *Repair Work on a Railroad* [143] was painted in 1874, the year de Neuville's picture was exhibited, and Savitsky, like the latter, avoids the problems of trains in motion, but uses the railroad tracks as a setting that asserts the contemporaneity of the scene. He also avoids the melodramatic gestures that de Neuville was obliged to introduce to suggest the drama of the military action. Savitsky's picture, which is discussed further in Chapter 6, is to my mind one of the most successful paintings of work from the middle of the century. Its sprawling composition captures the anonymity of the workers and the same effect of the messiness of construction sites as some of the magazine illustrations.

Not surprisingly, English artists with their relative freedom from academic principles, and their national pride in Britain's industrial achievements, first started including trains in their paintings, but in a rather backhanded way. W. P. Frith chose Paddington Station as a suitable setting for a painting of modern life [83], but as he wrote, "I don't think the station at Paddington can be called picturesque, nor can the clothes of the ordinary traveller be said to offer much attraction to the painter. . . ."

It was the possibility of anecdote that appealed to Frith; though he did justice to the station building, the locomotive and coaches are very much in the background, while the people form a frieze across the front of the picture. Frith epitomized the English public's attitude to art and he consequently became wildly successful (it was only a tiny avant-garde of artists who could be said to be ahead of the public; most artists lagged far behind). Frith filled his painting with anecdotal material and recognizable types of people. He claimed:

> The whole of the year 1861, with fewer interruptions than usual, was spent on "The Railway Station." My diary records incessant work, and the employment of a multitude of models. . . . Every object, living or dead, was painted from nature—often imperfectly enough, as the picture proves. The police officers, represented as arresting a criminal on the eve of escape, were painted from two detectives well known at that time.

Modern scholarship has shown in addition that the models were chosen according to prevailing theories of physiognomy—the criminal

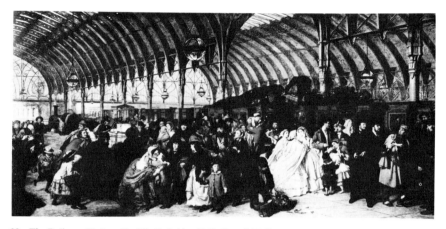

83. *The Railway Station.* By W. P. Frith, 1862. Royal Holloway College, Egham.

type and so on.[6] To an audience brought up on Dickens, the setting and the incidents, the arrest, a man arguing with a cab driver, and the touching farewells were immediately appealing. They probably appreciated just those things that Frith worried about, the faithful detail of the station roof (Frith had an architectural draftsman help him) and the truth to life of the travelers' clothing. If Frith showed a certain originality in choosing the station, his emphasis on the people and picturesque anecdote places him firmly in the tradition of Wilkie and eighteenth-century painters of contemporary life. The general idea had also appeared in the popular magazines much earlier [84].

Other English painters had already seen the possibilities of the train as a novel setting for anecdote. Abraham Solomon's *First Class Meeting . . . and at First Meeting Loved*, 1854 [85], typifies this approach with his banal idea—the young man takes advantage of the father sleeping to talk to the young woman. It is the human element that counts; the train is present only as a novelty. The style prevents any feeling of movement, and the swinging tassel is quite inadequate to overcome the static, linear conception. It also seems unlikely that the tassel would swing so violently. However, the openness of English artists to the world around them can be seen in the father's face, which has a disconcerting red glow caused by the bright sunlight coming through the red shade that he has pulled down. This mixture of stereotyped situation with fresh observation occurs in many English pictures. Several writers attacked this picture because of the reprehensible conduct of the young man; the following year Solomon exhibited an almost identical painting

[6] See Mary C. Cowling, "The Artist as Anthropologist in mid-Victorian England: Frith's *Derby Day*, the *Railway Station* and the New Science of Mankind," *Art History* (December 1983), pp. 461–477.

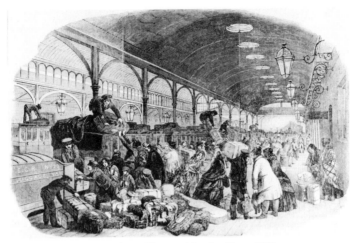

84. *The Christmas Train* from *Illustrated London News,* 1850.

except that the father was awake and the young man was talking to him and not the young woman. This time the critics were very favorable.

Solomon's painting, which may amuse us in a way not intended by the painter, and interest us with the Victorian trappings of rail travel so lovingly reproduced, hangs in the National Gallery of Canada beside Daumier's *The Third-Class Carriage* [86]. Solomon's limitations are forc-

85. *First Class Meeting . . . and at First Meeting Loved.* By A. Solomon, 1854. National Gallery of Canada, Ottawa.

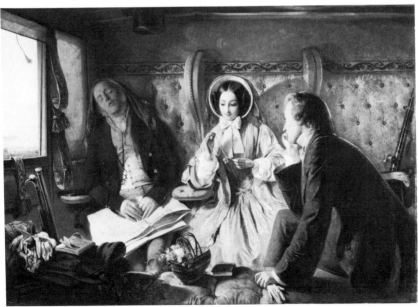

ibly revealed by the confrontation. His style freezes everything behind the picture surface like a habitat in a museum with stuffed animals amid rocks and dried shrubs. Daumier's figures, who lack this carefully painted illusionism, loom like living people. Daumier made a very large number of drawings, watercolors, and oils of train travelers in all classes, as well as of people in the station waiting rooms. The train compartment, which allows us to look at the people opposite without seeming rude, gave Daumier an opportunity to study them. With his exceptional visual memory he did not need to sketch the passengers and make them self-conscious.

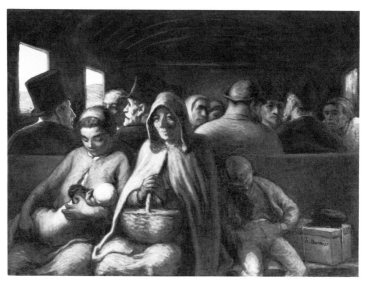

86. *The Third-Class Carriage,* detail. By H. Daumier, early 1860s. National Gallery of Canada, Ottawa.

Adolf Menzel, the German artist whose work is discussed in Chapter 6, and who was the most astonishing draftsman in the nineteenth century after Daumier, did draw on the train [87]; in fact, he never stopped drawing wherever he found himself. He was fascinated by sleeping people because he could draw them unaware; the train offered travelers dozing off, fast asleep, or waking up, and he made many drawings on all these themes.

Each of these three artists turned to the quintessentially contemporary experience of the train, but none of them, with the exception of Menzel's one canvas, painted the railroad or the trains as such. The difficulty of dealing with the physical presence of the locomotives and of representing motion itself made them focus on the human element.

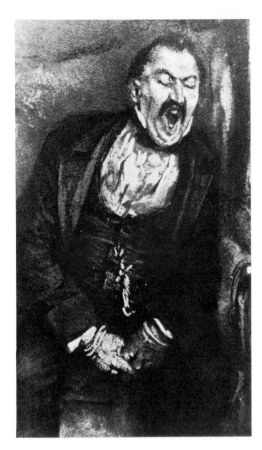

87. *Train Compartment: Man Yawning.*
By A. Menzel.
Location unknown.

It was only after the Impressionists' new style and a changed vision that it became possible to put a train on the canvas. Even then the locomotives and coaches are rarely prominent; they are distant and barely visible in the pictures by Manet and Caillebotte, while Pissarro's train in the middle of *Lordship Lane Station* [88] is a tiny part of the picture.

Only Claude Monet really tackled the subject, painting trains in motion, and his close-ups are of stationary trains. It might seem strange that Monet, no theorist about modernity and so often thought of as a painter of tranquil landscapes, repeatedly turned to this subject in his Impressionist period. In addition to the numerous pictures of the Gare St. Lazare, he painted a number of trains in the landscape that are little known, as they have remained in private collections and are rarely reproduced. He suggested movement, like many of the illustrators, by stringing the trains across the canvas with the smoke streaming along above the coaches. The imprecise outlines of the Impressionist style aided the effect but still could not fully capture the dramatic power of the subject. The train is usually set back in the landscape so that this

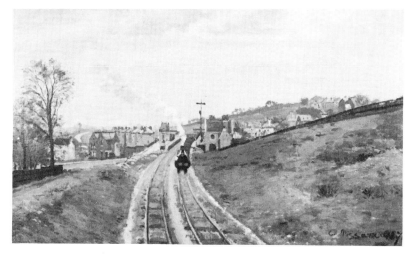

88. *Lordship Lane Station.* By C. Pissarro, 1871. Courtauld Institute Galleries, London.

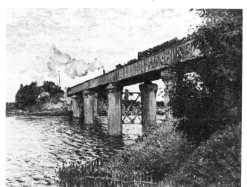

89. *The Railroad Bridge at Argenteuil.*
By C. Monet, ca 1873.
Musée d'Orsay, Paris.

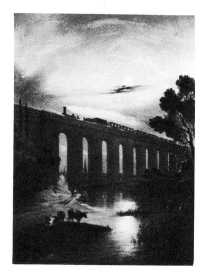

90. *The Express Galop.*
Sheet music cover, late 1840s.

aspect is not crucial, and the Impressionist style, discussed in detail in Chapter 8, creates a general sense of mobility. This movement throughout the picture is more important than the trains and locomotives that only underline the general feeling of motion.

The same approach can be seen in the paintings of the railroad bridge at Argenteuil—a modern box-girder bridge usually shown with a train crossing [89]. It cuts a sharp line across the canvas (unlike the road bridge with its partial trestle structure), giving a dynamic movement expressive of the barely visible train. The dramatic concept of the bridge reveals a parallel with earlier graphic art, the music cover inspired by the popular appeal of railroads [90]. The change in style and Monet's use of a much steeper diagonal mark the change from the illustration to the new artistic concept.

Monet took the idea of representing motion as far as it was possible within the framework of representation developed in the Renaissance. It was only with the abandonment of those principles in the early twentieth century that the Futurists could try to put a speeding train in the forefront of a canvas. Even their paintings proved not quite adequate. The desire to reproduce the movement of a train and the impact of its power on people's unconscious as well as their consciousness shows in the fact that the Lumière brothers put a train in one of their first films. Like the horses of the cowboys, trains thundered, thanks to the piano, across innumerable screens as soon as cinemas were set up.

TIME

The other basis of change, time, confronted artists even more dramatically. History became the major intellectual discipline as Hegelianism and Darwinism implied that the present could be understood only through the developments of the past. Early in the century it was announced that "History is everything," and by the end Stephen Dedalus in Joyce's *Ulysses* is proclaiming, "History is a nightmare from which I am trying to awake." Every country in the Western world produced its great historians. Men like Michelet and Macaulay were not remote academics writing for a scholarly audience, but popular heroes whose histories carried a message for the present. Similarly Ruskin in his histories of architecture and sculpture preached artistic and social reform to his contemporaries.

For many artists it seemed natural to paint historical reconstructions based more and more on archeological and documentary evidence. In keeping with the new spirit, they painted not only the great events but also the everyday life of the past. Meissonier did not even need a trivial incident, but simply painted a man smoking a pipe or reading, illustrating Carlyle's dictum that facts are truth, truth facts, though the latter,

social critic as well as historian, did not resist preaching himself. The obsession with detailed factual accuracy is illustrated by a story about the English artist Edward Poynter. He showed his latest painting, *The Israelites in Egypt,* to friends before sending it to the Royal Academy's annual exhibition, when an engineer present pointed out that there were too few figures to haul the enormous sculpture in the foreground. Poynter promptly painted in more Israelites to suffer under the overseer's lash. Many artists in a similar spirit traveled to the Holy Land, like the Englishman Holman Hunt and the Frenchman James Tissot, in order to get the settings for their biblical pictures correct. The detailed accuracy of the landscapes, however, only pointed up the implausibility of the gestures of the invented figures and the impossibility of conveying the spiritual. This discrepancy impelled Courbet and a number of the critics to reject history painting of all kinds because of the difficulty of reproducing the life of the past as opposed to the trappings.

As Castagnary put it in 1863, when discussing a Venus born from the waves by Paul Baudry, "But how much more at ease that pretty woman, with her air of a Parisian milliner, would be on a sofa! She, who lived so comfortably in her rich apartment of the Chaussée-d' Antin, must feel rather ill-at-ease on that hard rock next to those scratchy pebbles and prickly shells."

If the passionate interest in the past created difficulties for artists, the interest in the present was even more problematic. A rapidly changing world could only be understood and presented as it unfolded in time. Not surprisingly the novel became the great, universal art form of the century, as it alone could depict the origins, the progress, the context, and the consequences of events. As we have seen, everybody read novels as they were serialized in daily newspapers or weekly or monthly parts. The novel interacted with time in two ways: its subject was the unraveling of stories in time, and because of the serialization, the readers lived through time together with the characters as they waited for the next installment.

Faced with the richness of their world, novelists like Balzac and Zola wrote their multi-volume panoramas in which the same characters reappeared from novel to novel. Individual novels frequently ran to six hundred pages as authors explored the relations and conflicts within families, between brother and sister, brother and brother, children and parents, between business associates, and between the social classes. Zola, very much the child of his age, adopted a scientific attitude and even tried to demonstrate the effects of heredity from one generation to another.

In showing that events could not be adequately represented except by tracing them through many years, and through many subcurrents,

novelists presented an enormous challenge to artists. The sculpture or the painting could not show the successive aspects of a development, so that artists eager to paint their own times were faced with an almost insoluble dilemma. In recent years it seems to me that scholars anxious to discover art that deals with the major issues of the nineteenth century have completely overlooked this distinction, and examine paintings as if they were novels. T. J. Clark, for example, who has become a very admired and influential interpreter of French art, asks in his book *The Painting of Modern Life,* when discussing the representation of Paris in Impressionists' painting and its claim to modernism, "Is the truth of the new painting to be found in Renoir's *The Umbrellas* [91] or in Caillebotte's *Paris: A Rainy Day* [92]—in the sheer *appeal* of modernity, or in its unexpected desolation?"[7]

The question is, I believe, irrelevant. A painting is a tiny fragment which cannot give us the *truth* of modern life. There is no opposition, no contradiction between Renoir's appealing picture of the city street in the rain and Caillebotte's desolate one. We experience both feelings at different times. Zola wrote twenty fat volumes in his Rougon-Macquart series, many of them devoted to Parisian life, but it is doubtful if he succeeded in giving us the truth of the city, such were the richness and the changes taking place.

Clark, deeply concerned with these changes, which he believes were chiefly for the worse, and which he particularly ascribes to the physical rebuilding of Paris by Baron Haussmann, delves into the literature provoked by the demolitions and reconstructions. His book contains a long, fascinating chapter on Parisian reactions, ranging from newspaper articles to plays, showing the development of different attitudes, and he concludes that:

> Haussmann's work and its aftermath—presented painting with as many problems as opportunities. Naturally it offered occasions for a meretricious delight in the modern, or proposals in paint that the street henceforward would be a fine and dandy place. (I cannot see, for example, that Monet's two pictures of *Le Boulevard des Capucines* in 1873 [167] do more than provide that kind of touristic entertainment, fleshed out with some low-level demonstrations of painterliness.)[8]

But Clark's sociological analysis, though engrossing, is quite irrelevant to the paintings. There is no way that Monet or any other painter could have depicted the effects of Haussmannization—it required the novelist for that. Certainly neither Monet nor any other Realist painter could propose that the street could henceforward be anything. They

[7] T. J. Clark, *The Painting of Modern Life.* Princeton, N.J., 1984, p. 15.

[8] *Ibid.,* p. 70.

91. *The Umbrellas.*
By P. Renoir, early 1880s.
National Gallery, London.

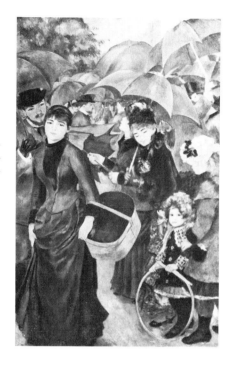

92. *Paris: A Rainy Day.* By G. Caillebotte, 1877. Art Institute of Chicago, Charles H. and Mary F. S. Worcester Fund.

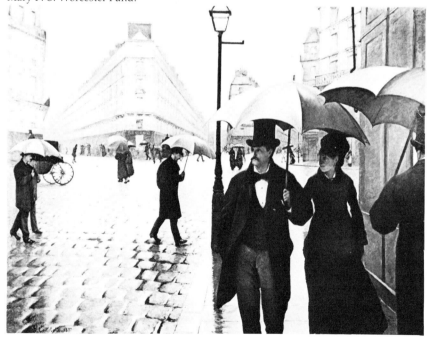

could not paint the future any more than the past. Their pictures aim at capturing an aspect of the present, and they replace the complex analysis in time that we find in the novel and in the history book with the complexity of the immediate moment. Thus Monet does something quite different from what Clark thinks, something that belongs to art, not writing, and which is as brilliant as most people have thought for the past century. I would like to add that the "objectivity" of Realist works often makes their mood difficult to determine. Clark sees Caillebotte's picture as presenting a desolate scene. It is equally possible to find it dynamic and appealing in its striking contrasts and abrupt perspectives, while the Renoir, which was painted as he moved away from Impressionism (in his *sour* period), may be seen as cold in its coloring and confused in its composition as it combines elements of both styles. To me the difference in mood between the two paintings that Clark postulates is not at all clear.

Many artists in the nineteenth century shared the public's belief that pictures were akin to literature and that they should tell stories. In order to realize this aim they adopted various means to show a development in time. A number followed Greuze in having the characters act out the scene in a melodramatic manner so that we might guess what was likely to happen. Others scattered clues around the painting to indicate how the scene illustrated came about and how it was going to end. Holman Hunt did this in *The Awakening Conscience* [96], with the readable title of sheet music, the parable told in the tapestry, the cat killing the bird, the inscription on the frame, and so on. This method created two problems: the painting seemed contrived and consequently not persuasive, and if the artist was subtle, the spectators were not sure if they were reading the clues correctly (Ruskin had to explain Hunt's painting; see p. 131). The third method to which many artists were driven was the age-old one of a series of pictures.

Greuze himself painted a sequel to *The Ungrateful Son*. The first picture, while making the predicament clear, is incomplete in that we are left tantalized by what happened afterwards. When the son returns in the second picture, *The Punished Son*, he finds it is too late; his father has just died, and his bier is surrounded by the grieving family. We are still left with questions, though: what happened to family and son while the latter was away, and whether he returned from a fit of remorse or like the Prodigal Son was rejected everywhere else.

The Englishman Augustus Egg, a friend of Dickens, went to three paintings for his *Past and Present*, 1858 [93]. The title, a later addition, expresses both the aim and the dilemma of the artist. Egg wanted to show the consequences of immoral acts in a heart-rending manner, but the pictures require explanation (Ruskin again came to the rescue), and

leave too many loose ends. The first picture sets up the drama in the same manner as Greuze, with dramatic gestures, and like Holman Hunt, a close friend, Egg adds many clues: while the wife rolls on the floor in despair, the husband holds a letter in his hand and grinds a picture of a man under his heel. She has evidently been caught in adultery; the pictures on the walls reiterate the theme of the destruction of the family, while the house of cards being built by the children is about to collapse.

The echoes and significance of Greuze and Chardin in the nineteenth century can be seen in the fact that in this Greuzian picture, Egg introduces a Chardin motif, the house of cards, but in an entirely different manner. Chardin depicted the building of a house of cards because it demanded total concentration by the protagonist, so that we feel that

93. *Past and Present* (first picture in series). By A. Egg, 1858. Tate Gallery, London.

he is unaware of being observed. The structure has no immediate symbolic value.[9] Not only does Egg give it symbolic meaning, which is incompatible with his Realist style, but with the house crumbling, a card is unnaturally suspended in mid-air.

Ruskin explained that the husband died five years later and that the other two pictures represent the same moment one evening two weeks after his death when the children are praying for their lost mother, and

[9] The careful selection and construction of the structure can be seen as analogous to the artist's task, but this is an analogy made by us, not a symbol contained in the work.

the mother herself, who had been turned out of the house, has become a vagrant with a starving bastard child seeking refuge under one of the Adelphi arches by the Thames. The clue that these two pictures do not form a time sequence is given by the appearance of the same moon and distinctive cloud in each.

The Times used the adjective "Hogarthian" to describe Egg's amassing of clues, and the eighteenth-century artist clearly provided a model. Hogarth, however, ran to six pictures for his series Marriage à la Mode and The Rake's Progress, and although they began as paintings, they were intended to be engraved and distributed as prints. His pictures were designed to be expressive in every way possible, and he sought the same dramatic presentation as Greuze. Hogarth, in fact, wrote, "My picture is my stage, and men and women my players, who by means of certain actions and gestures, are to exhibit a dumb show." Egg, working in oils, with the new nineteenth-century desire for verisimilitude, found himself confined. Many things that Hogarth would have included with his caricaturist's licence had to be omitted, and many of the important questions raised by the pictures remain unanswered.

The series is particularly tantalizing because the first picture shows a naturally dramatic situation which works very well in setting up our expectations, making us feel the emotions and thoughts of the husband and wife, while the two following pictures possess no action, and we are left wondering who is looking after the girls, and what is going through their heads. The first picture is also remarkably conceived, with the wife throwing herself on the floor in the foreground corner. She threatens to burst through the beautifully painted canvas and enter our space with the force of her despair. Not surprisingly, the pictures were not sold in Egg's lifetime. No sensitive person could live with this painting on his or her wall—it would be like experiencing a performance of Othello every day. The picture startles us all the more because Egg has completely shattered the Victorian pictorial conventions in presenting a middle-class woman with this "unrespectable" pose.

He put among his "clues" a Balzac novel, upon which the children are building their house of cards (French novels were, of course, frequently seen as responsible for leading women astray), but it would have required a novel from Egg to explore all the issues raised by the first painting. By coincidence Flaubert's Madame Bovary was published in 1857, when Past and Present was being painted. One might reverse Egg's simple-minded premise by surmising that possibly if the wife had had the opportunity to read Flaubert's immoral novel, she might have been kept on the path of virtue by Emma's horrifying fate.

If Egg's attempt is ultimately unsatisfying, it is certainly an honorable failure. Many nineteenth-century artists simply produced pairs of

cute pictures of the before and after type that were no more than cartoons, and would have worked better as such. Millais, for example, after his brilliant early paintings, produced *Her First Sermon* for the Royal Academy exhibition of 1863. It showed a young girl sitting alone in a pew listening attentively. At the exhibition the following year he showed *Her Second Sermon*—the same young girl is dozing off in the corner of the same pew. Such excruciatingly cute pictures became commonplace as artists gave up more serious but impossible challenges.

Writers on art did not recognize and discuss the problem of representing time, but the successful Realist painters instinctively avoided the snares of storytelling and anecdote by choosing to paint scenes without them. We can see here another reason why landscape was so significant; not only did it eliminate allegory and problems of motion, but it was easy to paint a landscape without introducing a story. Barbizon paintings were frequently pure landscapes, or they included one or two tiny figures, a fisherman or a peasant seated beside a pond who were just part of the scenery. These figures' chief task, as we note especially in the pictures of Constable and Corot, was to wear a red jacket in order to illuminate the complementary greens in the painting.

Even the figure paintings of Millet and Courbet are surprisingly free of anecdote. Over and over Millet depicted a young woman guarding sheep or cows, as they did all day, every day, or he painted women spinning or knitting, a repeated task. It is never the day which starts a novel when the routine is broken, when something happens. Courbet's *A Burial at Ornans* [99], a wonderful theme for a novelist, lacks all anecdote. If we think what Frith would have made of it, our respect for Courbet's self-denial increases.

The logic of Realism's fidelity to the scene depicted led inexorably to the Impressionist ideal of the moment. Some writers and other artists have described the Impressionist moment as if it were a high-speed photograph which isolated a fraction of time, but the painter in recognizing that he could not represent an event did not freeze the moment to which he was confined. The artists invented means of suggesting the passing moment, the opposite of the high-speed photograph [78], so that the picture implies a transition from past to future without attempting to describe one or the other. While solving the problem of time, they also solved the problem of movement. The painter could not convincingly represent a galloping horse or speeding train on a canvas, but the Impressionists through their brushstrokes, and contrasts of color and composition, did create a generalized movement throughout the picture that both conveys the feeling of the passing moment, and of a world in motion, the Heraclitean flux that had come to seem more the modern experience.

We come now to the last consideration; in what manner Statues are to be dressed, which are made in honour of men, either now living, or lately departed. This is a question which might employ a long discourse of itself: I shall at present only observe, that he who wishes not to obstruct the artist, and prevent him exhibiting his abilities to their greatest advantage, will certainly not desire a modern dress.

<div align="right">Sir Joshua Reynolds, 1780</div>

What person of artistic education is not of the opinion that the dress of the present day is tasteless, hideous and ape-like? In our time, therefore, art is right in seeking out those beautiful fashions of the past, about which tailors concern themselves so little. How much longer must we go about, unpicturesque beings, like ugly black bats, in swallow-tail coats and wide trousers?

<div align="right">R. Putmann, 1835</div>

I've been pegging away at my [statue of] Farragut but it is a hard "tug" with our infernal modern dress.

<div align="right">Augustus Saint-Gaudens, U.S.A., 1878</div>

However, has it not its own beauty and its particular charm, this clothing which has been so much vilified? Let not the tribe of colorists complain too much for, being more difficult, the task is only the more glorious. Great colorists know how to create color with a black coat, a white cravat, and a gray background.

<div align="right">Charles Baudelaire, 1846</div>

5

THE FIRST GENERATION
OF REALIST PAINTERS

We have examined the development of the desire for an art that combined factual description with the traditional uplifting moral purpose. This contradictory combination hindered the growth of Realism even among artists who seemed ready to abandon all the conventional formulas. The complexities facing young artists can be seen clearly in the art and ideas of the Pre-Raphaelite Brotherhood, founded in England in 1848. These very young men (Millais at the time was nineteen and Holman Hunt twenty-one) believed in "truthfulness" in art, and they went to incredible lengths to achieve it. Hunt stayed up all night outdoors, in cold weather, night after night in order to paint moonlight. Their mentor Ford Madox Brown spent days painting cabbages for *The Last of England,* and wrote in his diary for October 11, 1854, "Worked at the trees and improved them, found the turnips too difficult to do anything with of a serious kind." These painful strivings for truth to life were offset by the Pre-Raphaelites' belief in religious and allegorical subjects. The extremism of the Brotherhood, and their youthful intolerance of prevailing conventions and good taste did, however, result in a remarkable fusion. When they exhibited at the Royal Academy exhibition in 1850, reviewers exploded with rage. The *Times* critic in a notorious article denounced Millais's *Christ in the House of His Parents,* 1850, as "revolting. The attempt to associate the Holy Family with the meanest details of a carpenter's shop, with no conceivable omission of misery, dirt, of even disease, all finished with the same loathsome minuteness, is disgusting."

More surprisingly, Charles Dickens wrote in the same abusive tone, "In the foreground . . . is a hideous, wry-necked, blubbering, red-headed boy, in a bed-gown . . . a kneeling woman so hideous in her ugliness, that . . . she would stand out from the rest of the company as a Monster, in the vilest cabaret in France, or the lowest gin shop in England."

This criticism sprang partly from the anti-Catholicism that was prevalent in England at the time, and partly from the vivid contrast with the surrounding art. The Pre-Raphaelite Brotherhood termed the latter "Slosh," as it was an eclectic mix borrowing from all schools ending up with the insipid compromise that we see for example in Etty's works. The hard-edged, dazzlingly colored Brotherhood canvases not unnaturally were described as "eccentric" by more than one reviewer. However, because the works did satisfy a need, the Brotherhood found supporters as soon as the public became familiar with them. Millais especially, with his intricate painterly skills and poetic content, delighted everyone, and he not only became rich and famous but was elected an Associate of the Royal Academy only three years after this furor, at the age of twenty-four!

Millais had tried to make the historical subject persuasive and living by making the carpenter's shop as convincing as possible. He had even used an actual carpenter as a model for Saint Joseph in order to get the correct arm muscles developed—a characteristic example of what this group of artists meant by "truthfulness." Simultaneously, Millais tried to lift the scene out of the everyday by composing the figures in a frontal symmetrical composition, and by introducing details that indicated the real subject—for example, the gash in the hand of the infant Jesus which was both a likely accident in the workshop and a prefiguration of the Crucifixion.

Holman Hunt also fused or confused the real and the idea with great intensity. His *Light of the World*, 1851–56, shows Christ at night with a lantern knocking at an overgrown door that represented "the obstinately shut mind, the weeds the cumber of daily neglect, the accumulated hindrances of sloth." Hunt has described the lengths he went to in order to reproduce a moonlight effect accurately: "For my protection from the cold, as far as it could be found, I had a little sentry-box built of hurdles, and I sat with my feet in a sack of straw. A lamp, which I at first tried, proved to be too strong and blinding to allow me to distinguish the subtleties of hue of the moonlight scene, and I had to be satisfied with the illumination from a common candle."

In his *The Hireling Shepherd*, 1851 [94], Hunt created one of the most vivid suggestions of a bright sunlit afternoon ever put on canvas. We feel the heat of the scorching sunlight, and Hunt evokes the sensuality of a hot summer afternoon that is made explicit in the Shepherd's advances to the girl. Hunt wrote in a letter, "my first object as an artist was to paint not Dresden china bergers, but a real shepherd and a real shepherdess, and a landscape in full sunlight with all the color of luscious summer, without the faintest fear of the precedents of any landscape painter who had rendered nature before." It is a shock to read

94. *The Hireling Shepherd*. By W. H. Hunt, 1851. City Art Galleries, Manchester.

also Hunt's explanation that the picture was "a rebuke to the sectarian vanities and vital negligencies of the day," and that the shepherd represented "muddle-headed pastors." It is rather baffling to us that Hunt could ever have imagined this sunny picture would inspire such dark responses in the spectators, or even that it could have anything to do with English clergymen. If the picture is misconceived because the atmosphere created is at odds with the artist's moral intention, it is not a failure. Hunt has so carefully observed and executed the scene that it succeeds dazzlingly as a picture of an English summer afternoon. It was to take the Impressionists ten years of steady work before they came close to rivaling the twenty-four-year-old Hunt.

It is instructive to compare Hunt's picture with Ford Madox Brown's *An English Autumn Afternoon*, 1854 [95]. The latter is unusual as a Brotherhood picture with no intended message, and it is a picture that we

95. *An English Autumn Afternoon*. By F. M. Brown, 1854. City Art Gallery, Birmingham.

can respond to without any reservations. *The Hireling Shepherd,* for all its brilliance, is too crowded with precisely drawn detail, and the foreground figures loom up almost excessively large for the expanse of landscape—there is a hint of Gulliver in Lilliput. *An English Autumn Afternoon* fits its man and woman modestly into the scene, and although they are touching hands, because they are seen from the back we feel no obligation to try to puzzle out any significance in their presence. They are simply a couple enjoying a fine day (at three o'clock in the afternoon in late October, as the artist tells us). His attempt to render the light and weather of specific time, like Hunt's dedication in painting moonlight, shows that one important aspect of Impressionism already existed in the 1850s, and it provides a link between the two stages of Realism.

If Brown's *Afternoon* is a masterpiece of Realism, many of his pictures exemplify all the Brotherhood characteristics. He painted religious, historical, and literary subjects, and his *Coat of Many Colours,* 1864–66, is almost comic in its efforts to bring the biblical story to life with a dog sniffing at the coat.

While Millais's and Hunt's religious pictures contain these striking elements of Realism, our interest today in the Brotherhood concentrates on their treatment of contemporary subjects, in which they were also pioneers and linked with the larger Realist movement. Unlike French artists, who avoided the specifically contemporary in favor of more timeless genre scenes like the joys and sorrows of young courtship, sick children, and the like, the English painters were more ready to tackle the problems of the day.

As we have seen in Egg's pictures, the Victorians were intrigued with what they called the "problem" picture—that is, one dealing with a sexual theme (infidelity, seduction, or prostitution), though the attitude taken by the artists tended to express the most conventional retributive morality, and they were obliged to avoid any depiction of sexual passion. Hunt's most famous picture today is *The Awakening Conscience,* 1852–54 [96], which he painted as a counterpoint to *The Light of the World.* It epitomizes the difficulty of painting this kind of storytelling work, and the Brotherhood's awkward mixture of realism and symbolism. The young woman springing up from the lap of the man as they sit at the piano has been touched by the song they are singing, and remembers her childhood days of innocence before she became a kept woman. Apparently the visitors to the Royal Academy exhibition were puzzled by the scene, and John Ruskin was led to write a letter to *The Times* explaining the picture. His clarification, a brilliant example of his persuasive rhetoric, reveals perhaps as much about Ruskin's ideas as about the picture itself:

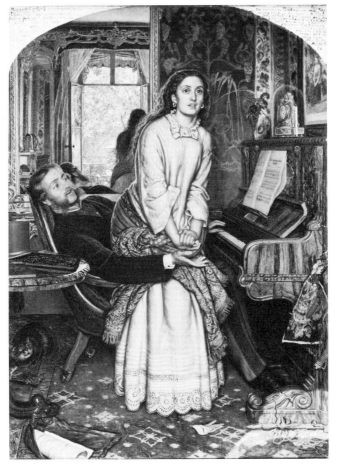

96. *The Awakening Conscience*. By W. H. Hunt, 1852–54. Tate Gallery,
London.

I suppose that no one possessing the slightest knowledge of expres-
sion could remain untouched by the countenance of the lost girl, rent
from its beauty into sudden horror; the lips half open, indistinct in their
purple quivering; the teeth set hard; the eyes filled with the fearful light
of futurity, and with tears of ancient days. . . . There is not a single
object in all that room—common, modern, vulgar, but it becomes trag-
ical if rightly read. That furniture so carefully painted, even to the last
vein of the rosewood—is there nothing to be learnt from that terrible
lustre of it, from its fatal newness; nothing there that has the old
thoughts of home upon it, or that is ever to become a part of home?[1]

[1] The purchaser of the picture found the expression in the young woman's face too
disturbing to look at every day, and he got Hunt to repaint it, so we see it differently from
Ruskin.

A visitor who did not notice the cat and bird, and did not stop to interpret the picture of the woman taken in adultery, might well have been puzzled by the contrast of the agonized woman and the delightful setting. The very pleasant-faced man and the woman making music together might well seem to represent an ideal of domestic bliss and comfort to which the spectators aspired. As in *The Hireling Shepherd* there is a discordancy between the intended message and the mood created. The objects don't speak symbolically in such a naturalistic setting, and the glove fallen on the floor, which may be intended to symbolize a future discarded mistress, remains just a glove. We might note that Max Klinger, in the late 1870s, wishing to build a series of pictures around a lost glove, started with two naturalistic scenes to lead us into the situation, but to develop his meaning he then moved off into symbolist fantasies.

97. *Retribution.* By J. E. Millais, 1854. Private collection.

Millais avoided Hunt's dilemma in his *Retribution,* 1854 [97], an outline pencil drawing with a dramatic confrontation of a married man and his wife by the former's mistress and their children. The meaning is much clearer but inevitably it is too melodramatic—the kneeling mistress, the child clutching her father's knee, and the sunken head of the latter. The very uncertainty of the Hunt makes it more convincing as a slice of life.

Dante Gabriel Rossetti (1828–1882), the mercurial Italian who was the driving force behind the Brotherhood, was in no way a Realist as a painter, but he tackled the subject of the abandoned fiancée fallen into prostitution in *Found,* an unfinished oil painting and drawing done between 1853 and 1855. Rossetti worked laboriously with Brown, learning to paint from life a sheep that symbolized the plight of the young

woman. Given Rossetti's temperament, it is not surprising the painting was not finished even though it was sold in advance, but in any case much more interesting is the poem Rossetti wrote on a prostitute, "Jenny." The poem is a silent musing to Jenny as she sits on the floor beside the speaker:

> Lazy laughing languid Jenny,
> Fond of a kiss and fond of a guinea,
> Whose head upon my knee tonight
> Rests for a while, as if grown light
> With all our dances and the sound
> To which the wild tune spun you round:
> If of myself you think at all,
> What is the thought?—conjectural
> On sorry matters best unsolved?—
> Or only is each grace revolved
> To fit me with a lure?—or (sad
> To think!) perhaps you're merely glad
> That I'm not drunk or ruffianly
> And let you rest upon my knee.

Rossetti's use of Browning's monologue form that implicates poet and reader in the situation is enormously refreshing and far more convincing that Hunt's and Millais's detached superiority to their subjects. Their pictures seem platitudinous in comparison with Rossetti's poem, even though he too takes some conventional positions. In its range of emotions and thoughts "Jenny" reminds us of the subtlety of attitude that could not be expressed in a picture. The changing feelings of the narrator from moment to moment are an essential part of presenting this kind of morally complex theme, and are entirely outside the scope of the artist.

The contradictions within Pre-Raphaelite art and artists are further shown by the fact that apparently while first writing this poem (it was not published until much later), Rossetti was painting his two pictures of the Virgin Mary (the *Annunciation* and the *Girlhood*), which embodied a Pre-Raphaelite innocence much closer in feeling to Fra Angelico's pictures than any of Millais's or Hunt's. The writer who has spent the night with a prostitute seems a far cry from the painter. It is also startling that Millais drew *Retribution* while he was destroying the Ruskin household. Perhaps he was driven by an unconscious feeling of guilt, or perhaps he was simply exemplifying the rather priggish moralizing that we find in his and Hunt's statements about the purposes of art.

A different kind of contemporary picture was painted by Ford Madox Brown. His *The Last of England*, 1852–55, and *Work*, 1852–65 [98], avoid the clichés of the "problem" pictures. *Work*, in fact, makes an

interesting comparison with paintings by Courbet and Manet that will be discussed together later. It was for *The Last of England* that Brown sweated over turnips and cabbages for days, despairing of ever getting them right. Nothing could better typify the revolutionary Pre-Raphaelite attitude. For every other painter in England needing a couple of turnips in a picture, there would have been no problem. They would simply have got a turnip and knocked it off in a few brushstrokes without stopping to think. For Brown, getting the turnips right was a moral issue. The destruction of the hierarchy of subject matter in nineteenth-century art could not offer a better example. Ten years later Jean-François Millet asked, "Why should the activity of the potato or bean planter be less interesting or less noble than any other activity?" but it was the English artists who first and most profoundly made every object and person in a picture of equal importance.

Work seems an epitome of Realism: a cross section of society is presented with an emphasis on the hard-working laborers, all the figures were painted from life, and the whole picture is informed with a progressive spirit wholly without condescension to the poorest and the incompetent. Brown wrote eloquently about his own painting; one cannot do better than quote a few paragraphs from his lengthy explanation:

> This picture was begun in 1852 at Hampstead. The background, which represents the main street of that suburb not far from the heath, was painted on the spot.
>
> At that time extensive excavations were going on in the neighbourhood, and, seeing and studying daily as I did the British excavator, or *navvy*, as he designates himself, in the full swing of his activity (with his manly and picturesque costume, and with the rich glow of colour which exercise under a hot sun will impart), it appeared to me that he was at least as worthy of the powers of an English painter as the fisherman of the Adriatic, the peasant of the Campagna, or the Neapolitan lazzarone. Gradually this idea developed itself into that of *Work* as it now exists, with the British excavator for a central group, as the outward and visible type of *Work*. Here are presented the young navvy in the pride of manly health and beauty; the strong fully-developed navvy who does his work and loves his beer; the selfish old bachelor navvy, stout of limb, and perhaps a trifle tough in those regions where compassion is said to reside.
>
> Next in value of significance to these is the ragged wretch who has never been *taught* to *work;* with his restless, gleaming eyes he doubts and despairs of every one. But for a certain effeminate gentleness of disposition and a love of nature he might have been a burglar! He lives in Flower and Dean Street, where the policemen walk two and two, and the worst cut-throats surround him, but he is harmless; and before the dawn you may see him miles out in the country, collecting his wild

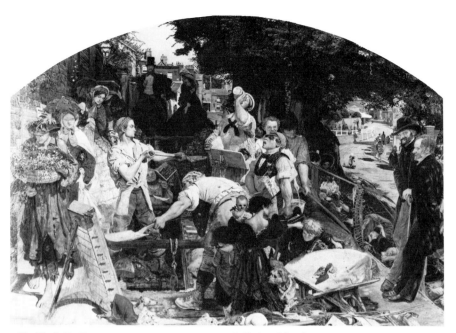

98. *Work*. By F. M. Brown, 1852–65. City Art Galleries, Manchester.

weeds and singular plants to awaken interest, and perhaps find a pur-
chaser in some sprouting botanist. When exhausted he will return to
his den, his creel of flowers then rests in an open court-yard, the thor-
oughfare for the crowded inmates of this haunt of vice, and played in
by mischievous boys, yet the basket rarely gets interfered with, unless
through the unconscious lurch of some drunkard. The bread-winning
implements are sacred with the very poor. In the very opposite scale
from the man who can't work, at the further corner of the picture, are
two men who appear as having nothing to do. These are the brain-
workers, who, seeming to be idle, work, and are the cause of well-
ordained work and happiness in others—sages, such as in ancient
Greece published their opinions in the market square.

Past the pastrycook's tray come two married ladies. The elder and
more serious of the two devotes her energies to tract distributing, and
has just flung one entitled, "The Hodman's Haven; or, Drink for Thirsty
Souls," to the somewhat uncompromising specimen of navvy humanity
descending the ladder; he scorns it, but with good-nature. This well-
intentioned lady has, perhaps, never reflected that excavators may have
notions to the effect that ladies might be benefited by receiving tracts
containing navvies' ideas! nor yet that excavators are skilled workmen,
shrewd thinkers chiefly, and, in general, men of great experience in
life, as life presents itself to them.

The episode of the policeman who has caught an orange-girl in the
heinous offence of resting her basket on a post, and who himself ad-
ministers justice in the shape of a push that sends her fruit all over the

road, is one of common occurrence, or used to be—perhaps the police now "never do such things."

I am sorry to say that most of my friends, on examining this part of my picture, have laughed over it as a good joke. Only two men saw the circumstance in a different light; one of them was the young Irishman who feeds his infant with pap. Pointing to it with his thumb, his mouth quivering at the reminiscence, he said, "That, Sir, I know to be true." The other was a clergyman; his testimony would perhaps have more weight. I dedicate this portion of the work to the Commissioners of Police.

Brown continues for pages with this lively, at times moving, often humorous exposition. We feel that we are about to enter into one of Dickens's novels. In fact, the description is more enthralling than the painting because it tells us stories that we could not even guess at from the picture. This attempt to analyze society demands that we know the past of the characters, their environment, and their future.

I have quoted Brown at length, even though omitting most of his account, because his description and his painting epitomize the dilemma of the artist wishing to convey a message in the nineteenth century. There is no way to convey this information in a picture. A further problem of trying to create a cross section of society, as opposed to a slice of life like Courbet's two stonebreakers, meant that it involved bringing people together artificially. Brown's picture not only seems crowded in an unnatural way, but it is obviously composed. The participants form a semicircle echoing the upper edge of the frame, none of them is cut off, and almost all show us their faces. In his desire to emphasize the points that cannot really be made, Brown even repeats the class divisions and antagonisms in the dogs in the foreground. If the picture ultimately fails, it still fascinates us. Brown's intense dedication to each of his subjects makes each one vital, and none is a stock type. Any one of his workers would blow half a dozen peasants by Bouguereau or his associates straight off the canvas.

The complicated knot tied together by the Pre-Raphaelites of intense fidelity to nature, of rejection of convention but love of the past, a powerful religious impulse, a love of literature and stories pregnant with meaning, and an ideal vision of art was slashed through in France in 1850 by the dramatic appearance of Gustave Courbet's Salon entries. The size of Courbet's vast canvases suggested great biblical or historical scenes, but offered only an anonymous, undistinguished funeral, and a group of uninteresting peasants returning from a fair. Most of what fascinated the Pre-Raphaelites was rejected out of hand by Courbet, who shared only their respect for the concrete actuality of the objects they painted from nature.

Courbet did not like to theorize in print, though he loved to air his views on art at the Brassérie Andler, the beer cellar in Paris where he held court. When he was forced to issue a statement, he expressed (probably with the help of one of his literary friends) some pithy dogmas that clarified the situation in art by dismissing many of the prevailing ideals and goals of artists. We find in his Realist manifesto of 1855 and his later statement on teaching the following assertions:

> I cannot teach my art, nor the art of any school whatever, since I deny that art can be taught, or, in other words, I maintain that art is completely individual, and is for each artist nothing but the talent issuing from his own inspiration and his own studies of tradition.
>
> Above all, the art of painting can only consist of the representation of objects which are visible and tangible for the artist.
>
> An epoch can only be reproduced by its own artists . . . I hold the artists of one century basically incapable of reproducing the aspects of a past or future century.
>
> I have studied, outside of any system and without prejudice, the art of the ancients and the moderns. . . . I simply wanted to draw forth from a complete acquaintance with tradition the reasoned and independent consciousness of my own individuality
>
> To know in order to be able to create, that was my idea. To be in a position to translate the customs, the ideas, the appearance of my epoch.

Courbet said a great deal in his manifestos, but still left much unsaid about his specific intentions, and debate on the meanings of his work continues. Since 1850, the exaggerated horror which greeted his apparent subversion of all the great principles of art with misguided aims and an incompetent technique has been replaced for many people by an equally exaggerated vision of Courbet as a socialist artist whose paintings contain overt messages of social protest and attacks on the bourgeoisie.

When we look at Courbet's 20-foot-wide canvas of the *A Burial at Ornans* [99] in Paris, and it is far too big to reproduce adequately in a book, we see a vast gloomy canvas with its frieze of life-size people, dressed mostly in black for the funeral. The paint is broadly applied with no fine details or beautiful color. We see no expressive gestures, except perhaps for one woman burying her face in a handkerchief (thus avoiding expression). We do not see the corpse, and there is no indication of whose funeral it is. The picture offers us very few of the elements that we expect in a representation of a funeral. What we do feel is the enormous tangibility of the people and the setting, and the size is crucial here. If the painting were small, we would not feel the same identification with the participants. We note the line of set-faced, grieving

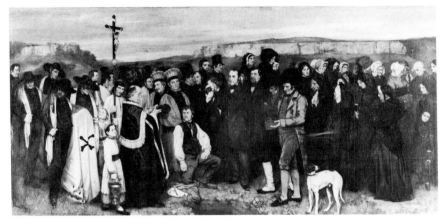

99. *A Burial at Ornans*. By C. Courbet, Salon of 1850–51. Musée d'Orsay, Paris.

mourners, the choirboy looking up inquiringly or anxiously (we can't be sure which), and the red-faced beadles looking bored—perhaps too many funerals this month. None of the people are acting out the appropriate emotions for us, there are no incidents to distract us, and there is nothing to suggest any special significance in this funeral. Yet, because the people are all individualized, we feel that it is an actual scene and one that is typical of many country funerals in the mix of people and the different degrees of involvement in the event. If we stop to think what Greuze would have made of such a scene, we can see that Courbet belongs to the camp of Chardin.

Given the lack of specific messages in the painting, why did so many people respond so negatively to it at the Paris Salon? T. J. Clark, in an interesting and immensely detailed study of the reception of the picture, points out that when it was shown in the provinces before coming to Paris, it was not rejected, and that when we read the numerous hostile reviews in the Parisian newspapers and magazines, there is no agreement on the defects of the painting.[2] Some writers liked neither the style nor subject, others thought the subject acceptable but the style atrocious, while others admired Courbet's way of painting but thought it wasted on such a trivial subject. When we criticize something new for very varied reasons, it usually means that we have been unable to put our finger on what disturbs us, and so we don't succeed in articulating our real objections. Clark suggests that many of the kind of people who wrote reviews had fairly recently arrived in Paris from the provinces, as part of the great nineteenth-century influx into the city. They wanted to establish themselves as sophisticated Parisians (writing on art, for example). Courbet's picture of rural life, which led Champfleury to write, "Is it the fault of the painter if the material interests, if the small

[2] T. J. Clark, *Image of the People*. London, 1973.

town life, if sordid egotisms, if provincial pettiness leave their claw-marks on the countenance, extinguish the eyes, furrow the brow, stupefy the mouth? The bourgeoisie are like that" upset these specta-tors, as they had just left this life to which they still had many family bonds, and the *Burial* undermined the much rosier vision they had built up of their own backgrounds.

Champfleury obviously took a delight in exaggerating the ordinari-ness of the people for comic/satirical effect, and we do not feel, used to Courbet's style as we are, that the peasants of Ornans look very differ-ent from the rest of us. That indeed is what impresses us, as they are so different from Robert's [11] or Bouguereau's peasants [148], who do not seem to belong to the real world.

Clark's interpretation of the response seems very plausible, as spec-tators in Paris were used to pictures of the Robert type, but when people had the chance to become more familiar with Courbet's pictures of peasant life and with his landscapes around Ornans, this initial rejec-tion evaporated. The physical reality of his pictures made them con-vincing, and Courbet's later controversial paintings were not of peasant life. It seems extremely unlikely that the artist intended to satirize all the people at the funeral as country bumpkins. Not only would it have been an absurd undertaking in a picture of this scale, but Courbet had become a local hero after winning his medal at the previous Salon, and he asked his family and friends to pose for the *Burial.* He was not anxious to shake the dust of Ornans off his shoes, and he returned there regularly.

Courbet described himself as "a socialist, a democrat and a Repub-lican, and above all, a Realist, that is to say a sincere lover of genuine truth," and his friend the socialist thinker Proudhon described Cour-bet's work as socialist painting. Subsequently one vein of criticism has been to see Courbet's pictures as expressing an impassioned socialist championing of the underdog, with a revolutionary content attacking the bourgeoisie. I believe that if one does not start with this *parti pris,* it is difficult to find these qualities. Courbet himself came from a wealthy peasant family, and it is members of this rural bourgeoisie who figure prominently in the paintings. The family in *A Burial* belongs to this class, and it is a substantial, respectable funeral, with nothing to indi-cate a dissatisfaction with their way of life.

In the next Salon, 1852, Courbet showed another very large canvas, *Young Ladies from the Village* [100], in which three elegantly dressed young women, one with a parasol, out for a stroll, stop to offer a piece of cake to a girl guarding cows. This picture shows very well that there is no such thing as "the peasant." There were different classes of peas-ants, ranging from the better-off ones owning several pieces of land,

like Courbet's own family, to the family owning a small plot and one cow, who scraped a bare subsistence with endless toil, like the peasants in many of Millet's paintings, to the landless laborers, not really peasants at all in the French sense, whose lives were horrendous in the days before social security of any kind, and whom we see in Courbet's *The Stonebreakers*, 1849 [101].

It is the young ladies who take center place in the picture, and seem to show by their charity that all goes well in the world, and that the poor are looked after by the more fortunate. The unsubversive nature of this picture can be seen in the fact that it was bought by the duc de Morny, who had just engineered the coup d'état which overthrew the Second Republic, and made his half brother, Louis-Napoléon, emperor of France.

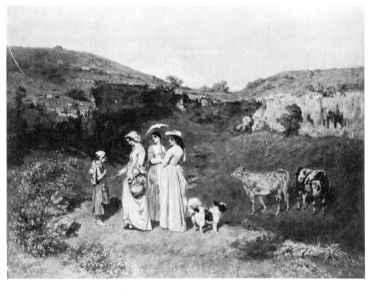

100. *Young Ladies from the Village*. By G. Courbet, Salon of 1852. Metropolitan Museum of Art, New York. Gift of Harry Payne Bingham.

There is just one painting by Courbet that offers any sense of a radical meaning, and that is *The Stonebreakers*, which was destroyed during World War II. Courbet described the origin of the painting in a chance encounter along the roadside with stone breakers who moved him as complete embodiments of hard toil and poverty. The picture has been much discussed, but Proudhon's comments are still to the point. He stressed the contrast between the old age of the man with the hammer and the youth of the boy staggering with the heavy stone, and the

sense of hopelessness in their lives. Also Proudhon praised Courbet for avoiding banality in his concept:

> What would this canvas need to enable it to receive all the votes? Precisely, to be less perfect in its type. . . . Nothing would have been easier for him than to create a contrast in his painting: he would have placed the stone breakers beside the iron gate of a castle; behind this gate, in perspective, a vast and splendid garden. . . . That would have produced its effect. Courbet preferred the open road, completely bare, with its emptiness and monotony; in this I am completely of his opinion. The solitary road has a completely different kind of poetry than that of the affected contrast between opulence and poverty. It is there that dwell work without distraction, poverty without holiday, and dreary sadness.

Proudhon, not normally thought of as a perceptive critic of art, nevertheless grasped several important principles in the art of his day, as here, where he sees the falseness of a more theatrical presentation. Courbet also avoided any possible sentimental touches by turning the boy away from us and hiding the man's face in shadow. No other artist of this time would have had the same courage in breaking with accepted ways of presenting protagonists in a painting, or, indeed, the insight to understand the reasons for doing so.

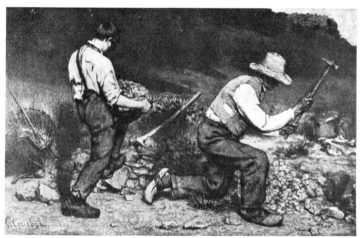

101. *The Stonebreakers.* By G. Courbet, 1849, Salon of 1850–51. Destroyed in World War II.

Yet even given the power of this painting as a moving representation of the lower depths of society, we can still feel that people have read into it what they wanted to read. There is no hint in the picture of an ameliorating political program. If we see it in the context of Courbet's

other paintings, it certainly expresses compassion, but we look in vain for the ideas that Courbet may have held personally. The feeling in the work is not very different from that of several conservative writers and artists who were horrified by the poverty they encountered. An obvious comparison is with Charles Dickens, who was extraordinarily sensitive to all kinds of suffering, but who offered no progressive solutions to the problems he so vividly recreated in his novels.[3]

When Courbet painted his *Studio* a few years later, 1854–55, he described his own place with the bourgeoisie on the right-hand side of the painting, not with the Irish beggar woman on the left. As Linda Nochlin, sympathetic to a left-wing interpretation, very judiciously writes:

> when we turn to Realist works themselves the connection between art and specific social attitudes becomes more amorphous. The precise degree to which Courbet's major paintings of the 1850s actually reflect his left wing political convictions is debatable. . . . Certainly, works like Jeanron's *Scenes of Paris*, with its starving workman pleading for bread for his family, Antigna's numerous canvases devoted to disasters in the lower strata of society . . . or Tassaert's melancholy representations of undernourished children and freezing orphans . . . spoke out against the social injustices of the period, far more explicitly than did Courbet's stonebreakers or bathers.[4]

What Nochlin senses in the pictures themselves we can see is inherent in the development of the arts in the nineteenth century. Our earlier discussion of the nature of the novel brings out the fact that painting was not a medium where the artist could speak out explicitly on social issues. The painters Nochlin mentions as having tried to do so have taken a place only in the footnotes of the history of art.

If we look at Antigna's *The Fire*, 1850 [102], which appeared in the Salon of 1850–51 together with Courbet's *A Burial* and *The Stonebreakers*, we see the reasons. It too is a large canvas, 9 feet by 9 feet, in which Antigna tries to express a dramatic situation. We see that not only has he resorted to the traditional static pyramid to organize a desperate, panic-stricken moment, but that gestures of the family and their facial expressions take us back to Greuze. In a picture where the people strike appropriate poses, we have entered the world of melodramatic acting, not reality. It could be argued that Antigna is simply an inadequate artist, falling back on conventional ideas, and while he is not a great

[3] When Henry Wallis's *Dead Stonebreaker* was exhibited in England in 1858, the *Daily Telegraph*, a conservative newspaper, expressed exactly the same compassionate sentiments as Courbet had.

[4] L. Nochlin, *Realism*. Harmondsworth, Middlesex, England, 1971, p. 46.

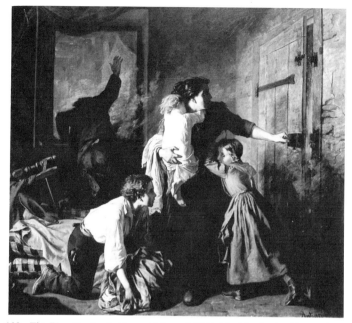

102. *The Fire.* By A. Antigna, Salon of 1850–51. Musée des Beaux-Arts, Orléans.

painter, the problem lies as much in the intention as in the artist. Antigna could have persuaded us of the reality of his scene only if he had taken Courbet's detached attitude, and abandoned his expressive aims. A comparison of the painting technique in this picture and in the *A Burial* reveals another major difference. Antigna paints the shirt sleeve of the boy in the foreground with a beautiful treatment of light and shadow. In fact, our attention is distracted by our admiration of the beauty of the shirt, and our feeling of horror at the scene is undermined. In the Courbet, the shirt sleeve of the man kneeling in the foreground is painted simply and solidly. It offers no special beauty, and though its whiteness contrasts with the generally dark colors, it does not distract us from the mood of the painting.

When we ask what we do find in Courbet's pictures, rather than what we hope to find there, the answer is not easy to give. With the disappearance of all historical and allegorical content, we are left mostly with the visual elements, which are much harder to put into words. Courbet's subject matter in the way in which he presented it is certainly important. The democratic ideas which had been gathering force in Europe, and which led to the various revolutions of 1848, had played their part in changing people's attitudes to the content of art, destroying the belief in the hierarchy of subjects and styles. In France, 1848 seems to have acted as a crystallizing force. The brief-lived euphoria of the radical members of the Revolution persuaded them that a new art was

not only possible but necessary. This belief in a new art was not unalloyed. Many people saw it as a matter of putting new wine in old bottles, and in March 1848 a contest was announced for an allegorical painting, sculpture, and medallion to be used as symbols of the new Republic.

The competing artists were unsure of what was expected of them, and at least one asked guidance from the government. He was told:

> Your composition should unite in a single person Liberty, Equality, Fraternity. This trinity is the principal theme of the subject. It is therefore necessary that the emblems of the three powers appear in your work.
>
> Your Republic should be seated to implant the idea of stability in the mind of the spectator.
>
> If you are a painter I would advise you not to dress your figure in the tricolor if it does not suit your style; however the national colors should predominate in the picture as a whole.

When the resulting works were exhibited as a group, both critics and public found them ludicrous. After some shilly-shallying by the government, a first prize was never awarded. The entry by Armand Cambon is often illustrated as a particularly inept concept, with its odd assortment of a beehive, a lion, and a cube with a hand emerging from it. Daumier produced a striking painting of a majestic woman with a child at each breast, and another reading a book at her feet. As a painting it was better than most, but it does little to evoke French national life at midcentury and the hopes aroused by the Republic, which, as we have seen, was an impossible task in any case.

In the context Courbet's art stands out for its originality and his grasp of what was significant in art. For him, Equality was not an abstraction or a symbol, but a living reality in which ordinary people were equal to kings and generals. His first great picture, *After Dinner at Ornans*, 1848–49, over 6 feet high and 8 feet wide, contains three life-size seated figures while one of the diners stands to play his violin. Courbet took a genre theme and blew it up to heroic proportions. Though this presumption was criticized, there was still enough of the democratic Republican spirit alive after the tragedies of the June days to gain Courbet a medal for the painting at the Salon of 1849.

This success encouraged Courbet's paintings of "the people," and he envisaged producing a great series of pictures of rural life, a project he never completed. In 1850, when he was working on *A Burial*, and *The Return of the Peasants from the Fair*, he wrote, "It is necessary for me to lead the life of a savage . . . my sympathies are with the people, I must speak to them directly, take my science from them, and they must provide me with a living."

Apart from a few groups inspired by popular prints like the figures in *The Meeting* [70], Courbet's aim remained in the realm of rhetoric. Large-scale oil paintings to be exhibited at the Salon did not constitute an appropriate vehicle for a people's art. He made very few prints, though we might have expected these to have been important given his ideas. Though an excellent draftsman, Courbet's whole spirit was that of a painter. We feel in his work an immensely robust, physical artist who enjoyed thick paint, large canvases, and solid objects. Over and over again he painted rugged cliff faces, whether in the Franche-Comté or on the Normandy coast, trees with massive trunks, and women with broad shoulders and powerful bodies.

These qualities prevented Courbet from creating the art of which he wrote and spoke, but led to paintings whose tangibility is unsurpassed. He became a popular painter of landscapes and hunting scenes, because the physical reality of his art corresponded with nineteenth-century taste for the actual. These themes being at the bottom of the hierarchy of subject matter, there were fewer preconceptions to prevent people responding to them. Courbet's figure paintings were another matter. People had far more fixed expectations: standards of beauty or of the appropriate way to represent people and situations, and Courbet's figures astonished them. Where they expected beauty and grace, they found ugliness and awkwardness. Champfleury has already been quoted on the participants in *A Burial. Young Women on the Banks of the Seine,* 1857 [103], lacked both seductive curves and pretty faces, even though the subject is one where we would expect them. The girl sifting corn [104] kneels clumsily, while her companion slumps down even more unattractively.

Courbet's nudes were equally disturbing. Looking through the Salon nudes we find the almost invariable type of slim-waisted woman, very seductively curved, the cliché that has persisted until the present day. Courbet's *Bather,* 1853, caused a furor because she was so heavily built, and his Muse, or model, in the *Studio,* thickset, double-chinned, scarcely represents the ideal. Nevertheless, as pointed out above, the nude was not a Realist element in itself, and many of Courbet's fall back into banal formulas.

The large number of sleeping women that Courbet painted also discomfitted the critics. It seems that Courbet instinctively found the sleeping figure suitable for his approach. It offered an opportunity to the artist to catch someone who was not aware of being drawn, and who could not pose, either consciously or unconsciously. Courbet frequently portrayed his sisters sleeping, as only the family could provide this opportunity. When sleeping, a person's body loses its spring and becomes more lumpish, facial muscles relax, the features sag. The face

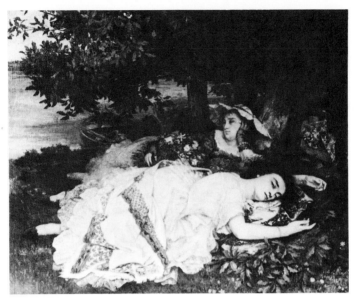

103. *Young Women on the Banks of the Seine.* By G. Courbet, Salon of 1857.
Musée du Petit Palais, Paris.

becomes lifeless and even a beautiful face can become ugly. This proved
particularly disturbing in pictures of young women, where the specta-
tors expected prettiness—for example, *The Sleeping Spinner*, *Young
Women on the Banks of the Seine*, and *The Sleepers*, where the beautiful Jo
(Whistler's companion) is hardly recognizable as the stunning woman
in Courbet's other portraits of her. It scarcely needs pointing out that
this reproduction of ugliness, which is also one of the commonest ex-
periences of life, epitomizes Realism, not just because it is an everyday
event, but also because it upsets the expectations of art.

Courbet has been criticized recently for ceasing to paint controver-
sial pictures after the mid-fifties, for ceasing to be a Revolutionary artist.
As I have tried to show, the opposition that his early pictures aroused
was due more to the newness of his art (the combination of a heroic
scale for genre subjects with a coarse, powerful application of paint),
than to any politically Revolutionary content. Antigna's large genre
canvas did not arouse the same hostility because it was "beautifully"
painted in a conventional style. As the public became more familiar
with them, Courbet's paintings became more and more popular. As
Morny bought *The Young Ladies from the Village*, so *Sifting Corn* was
bought by the town of Nantes in 1861, just seven years after it was
painted.

In denying a left-wing, political content, and an art drawn from the
people in Courbet's painting, I am not claiming that his art is ultimately
conventional. Implicit in the destruction of hierarchies of subject matter

and style is a questioning of hierarchies as such. The paintings embody a democratic spirit that is at odds with all privilege, but they do not contain a program.

Courbet possessed immense self-esteem and thickness of skin, which reduced his powers of self-criticism and led to the production of potboilers at times, especially many of his nudes. Nevertheless his arrogance and vanity had enormous practical benefits. He never faltered under the most virulent criticism, and he had the gall to mount his own one-man shows, which more than anything challenged the academic dictatorship and made the way easier for all subsequent French artists. A more modest and more sensitive artist could never have achieved this alternative to the status quo.

Though to many people he seemed to have broken all the rules of art, Courbet never denied his debt to past art ("I have studied outside of any system and without prejudice, the art of the ancients and the art of the moderns") and he claimed that while he had swum across the river of tradition, the academicians had drowned in it.

He visited Holland and Belgium in 1847, when he had not evolved his own art, and we can believe as he claimed that it was a decisive experience. Seeing such a range of seventeenth-century paintings devoted to different aspects of the artists' world inspired him to paint scenes from the life that he knew. Dutch pictures tend to be small and refined, and Courbet probably felt a sympathy for Jordaens's art. The gross fleshiness of the latter's figures reminds us of Courbet, and the Flemish artist painted very large pictures of ordinary life (the big Dutch

104. *Sifting Corn.* By G. Courbet, 1854. Musée des Beaux-Arts, Nantes.

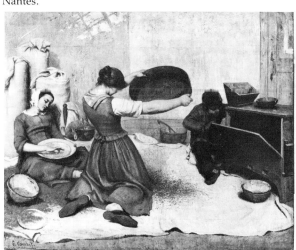

pictures are usually the more formal group portraits).

To Flemish and Dutch art, Courbet added an admiration for the brothers Le Nain, also admired later by Manet, and his first great picture, *After Dinner at Ornans*, reminds us of the solemn dignity of their paintings. Courbet's feeling for Le Nains, like his admiration for the *images d'Épinal*, provided a corrective to the refinement of Dutch art, and he also experienced another kind of artistic input. In the 1840s, while Courbet was studying in Paris, two collections of Spanish seventeenth-century art were opened to the public, that of the Orléans family, which was added to by Louis-Philippe, and that of Lord Standish.

Spanish painting, sometimes in its subject but above all in its way of painting, the harsh chiaroscuro (quite different from the gentle haze of Rembrandt), and the tangible presence of the pigment, asserted a physical reality and a simplicity that could be crude, almost primitive. This harshness cuts right through the beauty of Dutch art, the feeling so often that not only the painting itself but the subjects within the painting are under glass. Significantly, writers at mid-century frequently mentioned Ribera in connection with the Realists. His paintings epitomize these Spanish qualities and they were clearly well known, and more influential than those of Velázquez and Goya at this stage.

The absorption of these various kinds of art seems to have released in Courbet his own physical response to the world and to the physical qualities of the pigment itself. *A Burial at Ornans* does not feel derivative, it feels original; but we can sense the Spanish quality in the tangibility of the black-clad figures, which is different from the black of the Dutch burghers in the group portraits that also lie behind the composition of *A Burial*. Seventeenth-century Spanish art soon came to be regarded as one of the great Realist phases in art, and some of Courbet's Realist followers succumbed to imitating it too closely [117]. The Spanish pictures had become much blacker than when they were painted two centuries earlier.

I have noted the steadily increasing love of Dutch art, which led to many paintings closely modeled on Dutch originals. These constitute the agreeable but uninspired pictures which were such a feature of the nineteenth century. All the leading Realists admired Dutch art and learned from it, but they all felt the need for greater immediacy, and found ways of shattering the smooth surfaces.

After his *Studio* of 1855, which he described as a summing up of seven years of his life, Courbet painted far fewer peasant subjects. Although he retained his deep attachment to the countryside, he seems to have satisfied his interest in this theme, and his next Salon submission was *Young Women on the Banks of the Seine*, 1856–57 [103], two unrespectable Parisiennes out of the city for a day. Courbet's originality

can be seen in his transformation of what we would expect to be a "pretty" picture into an ambiguous one. The sleeping woman shows the lumpishness discussed above; her whole pose expresses the awkwardness of the city dweller sprawling on the ground. At the same time the density of Courbet's style creates the richness and drowsiness of the summer afternoon. We feel drawn into the scene in a way that we don't with Hunt's similar *The Hireling Shepherd* [94]. This painting has often been seen as a precursor of the Impressionist pictures of the Parisians enjoying their Sunday off at Bougival and Argenteuil. It is a magnificent painting, which must have been known to the Impressionists, as it remained in Courbet's possession until the early 1870s. Courbet did not, though, paint Parisian scenes, in spite of his long residence there. Perhaps he felt no artistic connection with the dynamism, the restlessness of the city, which was so at odds with his painting style.

While the hunting scenes and pictures of deer in the forest that provided Courbet with a good living and a steadily increasing reputation (he was the success of the Salon of 1866 with *Covert of Roe-deer*) do not appeal to modern taste as much as his peasant paintings, his other works developed in interesting ways. His portrait *Laure Borreau,* 1863 (Cleveland Museum), stands with his portrait *Proudhon and His Children,* 1865 [105], among the finest portraits of the nineteenth century. They possess a substantiality quite unparalleled by those of other artists, yet we also feel delicacy and warmth in Mme Borreau. The portrait of Proudhon, though much repainted by Courbet, is an imaginative presentation of the social thinker that not only gives us the man in his environment, but by choosing a time when he is writing out-of-doors, sitting very casually on the steps with his children playing beside him, Courbet expresses the unpretentiousness of Proudhon in the most unforced way. This painting prefigures Monet's even more informal pic-

105. *Proudhon and His Children.*
By G. Courbet, 1865.
Musée du Petit Palais, Paris.

ture of his son in the garden [189], another example of the way Courbet opened up paths for the Impressionists while pursuing an entirely different kind of art.

Realist artists regularly pushed at the boundaries of their art, sometimes overstepping them, as Courbet did in his *Studio,* or stopping just short, as he did in the intriguing series of paintings *The Source of the Loue* [106]. They become almost semi-abstract in the elimination of sky and setting, and with the thickness of the paint, which takes on a presence of its own. A powerful psychological atmosphere is created, but it is not one we can define. Some writers have seen a female sexual symbolism, which is understandable if one is familiar only with small illustrations in books; but if one has had the opportunity to experience the actual painting regularly, the large size of the picture and the paint texture of the rock face make such an interpretation both unconvincing and trite.

The most striking development in Courbet's art during the sixties exists in the seascapes he did on the Normandy coast [107]. Historians have seen these pictures, with their horizontal strips of almost empty beach, sea and sky, or wave and sky, as extremely original within French art. Whereas the British Romantic artists painted empty seascapes, the more conservative French had always introduced a motif. Boudin's pastels were only small sketches but they may have helped inspire Courbet, who had become friendly with him, to produce similar works on a larger scale in oils. The difference becomes significant, and a number of recent historians have seen them as almost abstract explorations of color in which the presence of the paint is the unifying factor. Courbet himself wrote in 1865 of painting "25 seascapes, autumn skies, each one more free and extraordinary than the last." Critics see these pictures as *modern* in the unification of the surface by the pigment, canvases that can be placed beside Manet's *Olympia* as rejecting illusionism and pointing the way to twentieth-century art. Courbet's story is therefore scarcely one of decline after the great pictures of the early fifties.

In the 1850s Courbet's name was coupled with that of Millet as the two progenitors of a new school of painting of rustic life. Subsequently Courbet's talent for self-promotion, his freedom to exhibit in the Salon, and the large size of so many of his pictures have kept him in the public eye as the central figure of Realism, and as a political revolutionary. Millet lived quietly in the village of Barbizon in the Forest of Fontainebleau and his paintings were small and at times refused by the Salon, so no one saw them. After his death he achieved a great reputation in the 1880s and 1890s, by which time people had got over their initial shock, and his work had become acceptable. His works do not have the dramatic presence of Courbet's, and his colors are drab in comparison

106. *The Source of the Loue.* By G. Courbet, 1860s. Albright-Knox Art Gallery, Buffalo.

107. *Low Tide.* By G. Courbet, 1865. Nelson-Atkins Museum of Art, Kansas City, Missouri.

with the Impressionists, so in the twentieth century he has become a very secondary figure.

An exception to this neglect has been *The Angelus,* 1855–59 [108], which has been reproduced in hundreds of forms on calendars, sheet music, postcards, and the like. I have collected a number of these and have found that Millet's man and woman have usually had their faces redrawn to make them look more handsome while the sky in the background has been rendered in prettier colors. The result of the sheer number of these reproductions has been to earn Millet a reputation as a sentimental artist among all those people who have not studied his pictures, a situation which has further diminished his standing in the art world. However, when we look at Millet's work, forgetting our preconceptions, we can discover a striking and surprising artist.

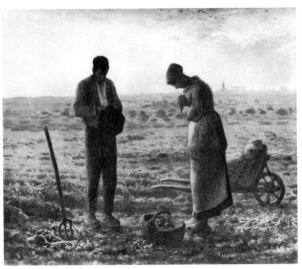

108. *The Angelus*. By J.-F. Millet, 1855–59. Musée d'Orsay, Paris.

Robert Herbert who, through his research and insights, has done so much to revive an appreciation of Millet, has stressed that Millet much more than Courbet persisted in confronting the public with disconcerting pictures. When Courbet in the later 1850s turned to less controversial subjects, Millet continued to challenge prevailing taste. A peasant by origin, he was determined to show the harshness of much rural life (and recent sociological research has shown that rural poverty was just as terrible as the more familiar urban squalor), as well as the reality of ordinary peasant life. At the Salon of 1861 the critic Olivier Merson praised Courbet's *Combat of Stags* and criticized Millet for becoming "more crude and more somber each day." When Manet and Whistler were arousing a furor at the Salon des Refusés in 1863, Millet was provoking equal indignation at the official Salon with *The Man with a Hoe*, 1861 [109].

As is the case with Courbet, Millet's work does not lend itself to a simple interpretation. Griselda Pollock has written that Millet "has been seen as a philosophical pessimist contemplating the inevitable fate of man since Adam was expelled from the garden of Eden, the voice of the oppressed peasant or the eulogist of the rural idyll."[5] Some of this variety of opinion springs from the fact that Millet painted different aspects of peasant life that he had experienced and observed. We see the grinding drudgery of bare subsistence farming as well as the hard work of more comfortably off peasants. Like Courbet, Millet came from the latter class, received a good education, and although his parents, unlike Courbet's, could not afford to send him to art school, he received

[5] G. Pollock, *Millet*. London, 1977, p.5.

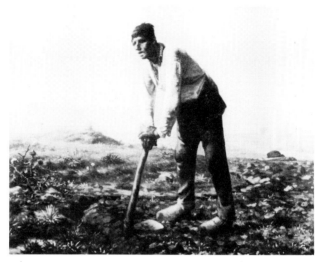

109. *The Man with a Hoe.* By J.-F. Millet, 1861. Private collection.

a municipal scholarship to study in Paris. Millet perceived, unlike many of the critics who have tried to co-opt his work as a progressive political statement, that the life of the agricultural worker is very little changed by changing the political system. Since Millet's time, mechanization has made a difference, but that has been a question of technological progress, not of politics.

Millet saw his subjects, doomed to repeat each year the same labors, in the perspective of history, and a number of his pictures are interpretations of biblical stories in contemporary terms—for example, *The Meal of the Harvesters*, 1850–51 [110], which is also the scene from the Book of Ruth in which Ruth is invited to glean by Boaz. The subject of gleaning was a much debated issue in France in the mid-nineteenth century, as a more capitalist approach to farming led to an exclusion of gleaners. If in this picture Millet may be trying to inspire spectators with the precedent of the generous landowner, he returned to the subject in a very different way in one of his most famous pictures, which concentrates on the backbreaking toil of the gleaners [111]. The artist's awareness of the past was not a falling back on reassuring traditions, as he never softened or changed the present through these allusions. For Millet, the food produced by the peasants was the staff of life without which the city and its wealth could not exist, but a staff that was too often taken for granted.

Millet's Realism lies in this unsentimental observation whatever the level of peasant he paints, and in the tactile pigment application. Théophile Gautier, who was quoted above (p. 95), wrote about *The Winnower* at the Salon of 1848, "The painting of M. Millet has everything needed to make the sleek bourgeois' flesh creep: he trowels onto a canvas more

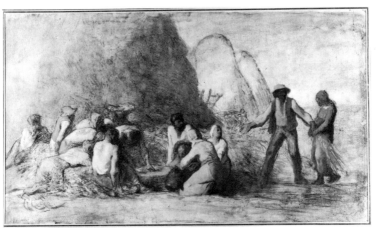

110. *The Meal of the Harvesters*. By J.-F. Millet, 1850–51. Musée d'Orsay, Paris.

suited for a dishcloth, without oil or turpentine, masonries of color that no varnish can smooth over. It is impossible to imagine something more rugged, more ferocious, more bristling, more raw." Through this technique, which overrides detail and color (sometimes too much), Millet models and makes us feel the solidity of the coarse peasant clothes, their almost equally coarse skin, and the logs they saw and the earth they hoe. He has an almost sculptural sense of molding his figures into simple, monumental shapes that are appropriate for these rough textures.

When we look back at Robert's cavorting performers [11] or Corot's sweetly picturesque country people slipped into the corner of the canvas [10], we can understand Millet's almost excessive emphasis on the *presence* of his workers. He felt strongly that a belief in the ideal, the search for the beautiful in art, robbed rural life of both its truth and its significance. He wanted to make the people in the city feel the labor which sustained their lives, its importance and its grinding toil, and he wanted "to disturb the fortunate in their rest" with *The Man with a Hoe*. He wrote in response to a hostile reviewer: "They think they can tame me, that they can impose on me the art of the Salons, well, NO! Peasant I was born and peasant I shall die."

This combative approach distinguishes Millet from Courbet, whose work as we have seen celebrates rural life on a heroic scale rather than disturbs the city dweller. In this way, as Robert Herbert has pointed out, Millet is more of a "revolutionary" artist, in spite of his fatalism, than Courbet. Yet we have to account for the fact that Millet's work, after his death, became so popular and undisturbing that it was regarded as a national calamity in France that so many of his pictures had been bought by Americans.

Some of the contemporary criticisms point out aspects of the paint-

ings that led to this change in response. Paul de Saint-Victor wrote: "His three Gleaners have gigantic pretensions, they pose as the Three Fates of Poverty. . . . These paupers do not move me, they have too much pride; they visibly betray their pretensions to descent from Michelangelo's Sibyls and their ambition to wear their rags with more pride than the harvesters of Poussin their draperies." While Saint-Victor appears in his exaggeration to be covering up his own unease with the force of the painting, Baudelaire made a similar criticism: "M. Millet particularly seeks *style*. . . . But a part of the ridiculousness which I attributed to the pupils of M. Ingres clings to him. . . . In place of simply extracting the natural poetry of his subject, M. Millet wishes at any price to add something. In their monotonous ugliness, all these little pariahs have a philosophical pretension, melancholic and Raphaelesque."

These comments pinpoint an aspect of some of Millet's pictures which does weaken them. We find a traditional element in his compositions that reminds us of paintings of saints and heroes. Especially in *The Sower, The Man with a Hoe,* and *The Angelus* we look up to figures who are silhouetted aginst the sky. In a number of works we are given a single figure, a woman spinning, a woman carding wool, a woodcutter, or a cooper. The result is that they form almost a series of icons like

111. *The Gleaners.* By J.-F. Millet, Salon of 1857. Musée d'Orsay, Paris.

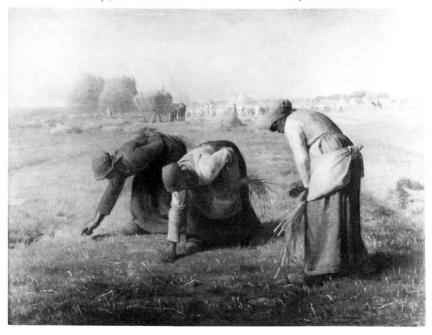

a series of the apostles. Though the women are depicted in an interior, in their environment, we don't see their family, the aging mothers, aunts, or the numerous children that formed part of their lives. Millet painted many other types of picture, but in a kind of vicious circle; the paintings that attracted most attention were exactly those that looked most traditional, most like a "picture," and these, after the initial resistance, became most easily assimilated and lost their power because they were "arty" rather than real. By the 1880s, to a public beginning to tire of the slickness of Salon art, the coarseness of Millet's style began to seem a guarantee of authenticity, while the Michelangelesque monumentality was a reassurance against the disquieting unpredictability of the city.

The question of the degrees of Realism in Millet's work is thus an important one. We have to break away from the few standard paintings that have been reproduced over and over in the histories of art. When we look at the whole range of his output, especially of the pastels and drawings, we find different qualities. Millet frequently draws people from behind so that they are not posing for us, as we can see in several of the works produced here. Also Millet almost always shows his figures working, totally absorbed in their occupation. Even when a figure is half-turned toward us, the head is bent intently and we can scarcely see the face [111]. Millet also made a number of pictures of people sleeping.

When drawing men, he most often shows them working together (in contrast to the famous pictures), so that the iconic quality only rarely appears. *The Lobster Fishermen* [112] not only epitomizes these compo-

112. *The Lobster Fishermen.* By J.-F. Millet, 1860s. Musée d'Orsay, Paris.

113. *The Shepherdess*. By J.-F. Millet, 1850–52. Museum of Fine Arts, Boston, Gift of Martin Brimmer.

sitional ideas but is a superb example of one of Millet's drawing styles. It consists mainly of horizontal lines of differing intensities of black, yet everything is powerfully realized. A more detailed, drawn style can be seen in the earlier *The Shepherdess*, 1850–52 [113]. The artist returned over and over to this theme of the young woman left by herself all day to guard sheep or the family cow. It justifies the single figure, and illustrates one of the most inescapable and monotonous of farm chores. In this wintry scene Millet uses the white paper and a nervous, splintery line to evoke the cold and the bare trees, while the woman is so muffled that we cannot see her face, an effective way of suggesting the deadening effect of these lonely vigils.

In recent years with the rediscovery of Millet, his pastels have become more and more admired, though they are frequently not exhibited in museums, so he is still not as much appreciated as he could be. He seems to have been able to handle both color and light more richly in this medium, and *The Meal of the Harvesters* [110] is more involving in its play of light and shade than the final oil painting. The freshness and green warmth of *Dandelions*, 1867–68 [114] show a surprising side of Millet, the close-up of a fragment of nature that abandons completely any kind of imposing composition. This microcosm is more reminiscent of English art, of William Henry Hunt's infinitely detailed pictures of bird's nests and flowers (W.H. Hunt is not to be confused with Holman Hunt), or of the Pre-Raphaelites; but Millet uses the softness of pastel to make his pictures of this kind more living than those of the English artists.

In the 1860s Millet turned increasingly to landscapes, and his very

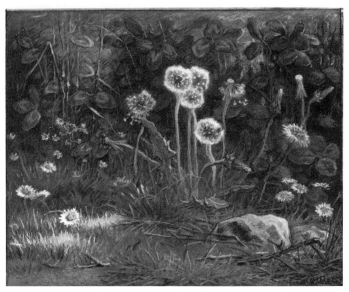

114. *Dandelions*. By J.-F. Millet, 1867–68. Museum of Fine Arts, Boston, Gift of Quincy Adams Shaw.

large *In Winter*, 1862 [115], is one of a magnificent series of pastels of the plain of Chailly. Though these pictures owe something to the spreading plains in Dutch landscapes, Millet has increased the feeling of space spreading in all directions with nothing to limit it. These pastels are the antithesis of the *Dandelions*, and almost frighten us with their emptiness and bleak mood. Everything reassuring that we expect from

115. *In Winter*. By J.-F. Millet, 1862. Calouste Gulbenkian Foundation, Lisbon.

a landscape is missing from these works. Interestingly, a version in oil is less overwhelming. The necessarily coarser handling of the paint reduces the space of the picture and stresses the farm implements more.

Millet also became more interested in dynamic compositions toward the end of his life. *Birdnesters with Torches*, 1874, has a fantastic quality, and is a memory by Millet at the very end of his life of incidents from his youth when great flights of wild pigeons would settle in the trees, and the villagers went with torches, which blinded the pigeons so that they could be killed by the hundreds, as Millet recalled. The dramatic gestures, strange lighting, and the oddness of the painting remind us of Daumier's *Don Quixote* series in their unexpectedness. We see in Millet, too, how the great Realist artists felt a need to stretch the boundaries of their styles.

Millet uses brighter color in the later oils, and in this respect his career parallels Courbet's, with the latter's remarkably lit seascapes of the later sixties. Millet also introduced movement through strong winds, especially in *The Windstorm*, 1871–73 (National Museum of Wales), which it has been suggested was inspired directly, or indirectly through his friend Théodore Rousseau, by Japanese prints. These qualities of color and movement relate to the interests of the young Impressionists. It is an impressive aspect of the two older men that late in their careers, after two decades of accomplishment in one direction, they could quite independently develop styles in tune with the new avant-garde.

To sum up, when we consider Millet's landscapes, his close-ups of flowers, his still lifes of turnips and leeks, his pictures of all kinds of rural work, and especially when we look at his pastels and drawings, we encounter a major Realist and a remarkably interesting artist.

One of the most important developments in the relation of artist and public began with Realism and specifically with Courbet—the replacement of the Salon with new channels of exhibiting works. The idea of one comprehensive exhibition every year or two, organized by the Academy of each country, developed in the seventeenth and eighteenth centuries when the art worlds were relatively small and cohesive. By the early nineteenth century the system was beginning to break down as artistic styles became diverse and even antagonistic, and practitioners of what were regarded as inferior media like watercolor were snubbed by oil painters. In the 1830s in France, artists whom many connoisseurs and fellow artists thought were exceptionally gifted, like Théodore Rousseau and the sculptor Barye, were rejected by Salon juries year after year. This led on occasion to more successful artists giving them shows in their studios and inviting the fashionable world.

In his customary fashion, Courbet entirely reversed this discreet

procedure when he opened his own pavilion at the Universal Exhibition in Paris in 1855. His move was generally regarded as an amazingly conceited and vulgar example of self-promotion more suited to a tradesman than to an artist. Consequently it seems very few people came to his exhibition, but he repeated the gesture at the World's Fair of 1867, when Manet also set up his own pavilion. We might be surprised that the sensitive Manet would take this step after the drubbing he took at the Salon of 1865, but his entries at the Salon of 1866 had been refused. He wrote in the catalogue for his 1867 show:

Reasons for Holding a Private Exhibition

When he first showed in the Salon, Monsieur Manet received good notices. But later, when he found that he was so often rejected by the jury, he realized that, if an artist's beginning is a battle, it at least should be fought on even terms. That is to say that the artist should be able to show what he has done.

The artist does not say today, "Come and see faultless work," but "Come and see sincere work."

To exhibit is for the artist the vital concern, the sine qua non; for it happens that after looking at something you become used to what was surprising, or, if you wish, shocking. Little by little you understand and accept it.

To exhibit is to find friends and allies in the struggle.

In this same year the younger artists around Claude Monet discussed a group exhibition which would have been the precursor of the Impressionist exhibitions, but they were forced to abandon it for lack of funds. Their plan was more significant for the future because it was the group exhibition of like-minded artists that became the means throughout Europe for breaking the grip of the academies.

Manet also persevered in persuading dealers to give him one-man shows, another important precedent. The exasperated frustration of original artists with the Salon system shows itself clearly in both his words and these various attempts to circumvent the jury. The harshness of the jury in 1859 led to the next Realist exhibition after that of Courbet's in 1855. François Bonvin (1817–1887) expanded the idea of an artist giving the hospitality of his studio to a refused artist. He invited a group of young men who had all been refused—Théodule Ribot, Henri Fantin-Latour, James McNeill Whistler, and Alphonse Legros. Bonvin himself had become friendly with Courbet and Champfleury, and was a habitué at the Brassérie Andler. His work and that of Ribot (1823–1891) exemplify one direction of the Realist impulse that did become acceptable at the Salon, though both had to struggle to establish their careers. Still life was a meeting place for Realism and for the public taste for ordinary subject matter that did not challenge accepted ideas too

much. Bonvin and Ribot admired Chardin and often followed him in painting genre scenes of kitchen interiors and still lifes of the humblest pots and foods. With the renewed popularity of Chardin, their work found collectors—Bonvin copied Chardins and it has even been suggested that some pictures attributed to Chardin today may be by Bonvin.

Their own works generally distinguish themselves in one important respect—the chiaroscuro, sometimes Rembrandtesque but more often Spanish. The artists eliminated much of the detail of Chardin or of the Dutch seventeenth-century works they also studied, for the sharp contrast and rawness of the Spaniards. This is particularly accentuated in Ribot's *Still Life with Eggs*, late 1860s [116], where the impenetrable gloom of most of the canvas sets off dramatically the form and texture of the jug, pan, and spoon. We feel to an incredible degree the tactility of the coarse objects, but the virtual elimination of color, atmosphere, and setting deprives the painting of complete authenticity. We often

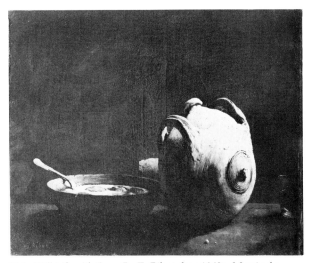

116. *Still Life with Eggs*. By T. Ribot, late 1860s. Musée du Haubergier, Senlis.

feel the same way about their figure paintings—face, hands, and a brightly colored shirt stand out from a black background. The figures are impressive in themselves but the pictures as a whole have a darkened old master quality which helped make them acceptable in the nineteenth century but detracts from their Realism today.

Bonvin's *Woman Ironing*, 1858 [117], has this black background but the woman, ironing board, and the objects on it are beautifully painted. The play of forms, the contrast between the delicate glass vase, the

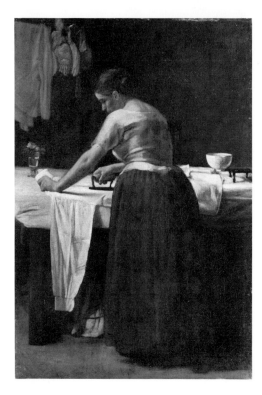

117. *Woman Ironing.*
By F. Bonvin, 1858.
Philadelphia Museum of Art,
John G. Johnson Collection.

bowl, and the solid body of the woman, and between the flattened shirt sleeve and the rounded volumes of her arms and blouse, possess something of the sober beauty of Chardin appropriate to the subject. This painting does not feel derivative, though, as Bonvin evolves his own color, lighting, and tactility of the paint surface. The subject and small size are reminiscent of the eighteenth-century master, but Bonvin achieves a greater intimacy through his means.

Ribot's *Basse Cour*, 1861 [118], succeeds because he reverses his usual lighting and creates a moving elegiac effect as the cook escapes the basement kitchen to enjoy a little fresh air and is placed against the light rather than the dark.

This reversal might seem trivial, a door or window at the back of the picture rather than the black paint of an obscured interior, but it makes a great difference. We see it not only in Ribot's works but also in those of Fantin and Whistler, who showed with him in Bonvin's studio. The dark background destroys the space and spatial relations, silhouettes the figures rather than models them, thus rendering the painting static. A light source at the back, what the French call *contre jour*, forces the artist to develop depth and to situate the figures in space. When successful, a dynamic exchange between foreground and background results, which gives the picture life even if the room is empty of people.

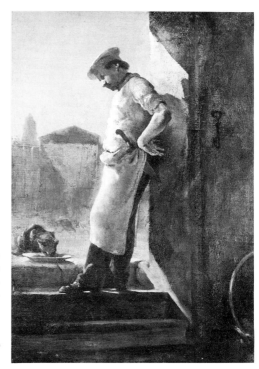

118. *Basse Cour.*
By T. Ribot, 1861.
Philadelphia Museum of Art,
John G. Johnson Collection.

Whistler's *The Kitchen* [119] exemplifies the movement possible in the absolutely static subject of the enclosed, massively walled kitchen.

It is important to distinguish between the lack of space and the silhouetted figures of Bonvin and Ribot, and the flattening of compositions later by Manet, Gauguin, and other artists. For the latter, the destruction of volume and space is part of a new idea of the total construction of a picture. For the former, it is a simplification of existing approaches where reductionism is mistakenly seen as particularly expressive of down-to-earth subjects. They did not grasp in their study of Chardin that an intense visual sophistication is necessary to achieve successfully the effect of ordinariness.

Whistler and Fantin-Latour, who also appeared in this small Realist exhibition, have always been much better known than Bonvin and Ribot, as they became part of a new generation rather than a minor continuation of the previous stage of Realism. Fantin also ensured his own immortality by painting group portraits (descended from the numerous Dutch seventeenth-century group portraits) of the greatest living artists and poets. His *Homage to Delacroix*, 1865, includes Manet, Baudelaire, Duranty, Champfleury, Whistler, and Fantin himself, stretched in a line across the canvas in front of a portrait of the recently deceased Delacroix. This assertion of the kinship of the Realists with

119. *The Kitchen.*
By J. Whistler, 1858.
Private collection.

the great colorist not only made a bold claim for the Realists' place in the tradition of French art, but signaled a change in the role of color in the younger generation. Fantin's *A Studio in the Batignolles,* 1870 [120], was even bolder, as the central figure was Manet himself, still a highly controversial artist, and the surrounding artists included Monet, Renoir, and Bazille, who had all been having their troubles with the Salon jury. But the concept of the painting was thoroughly conservative and it was accepted for the Salon that year. As Fantin omitted himself from the picture, we can see that he was probably detaching himself from his earlier Realist ideas.

Fantin had painted a still life of kitchen pots in the manner of Chardin, but he turned to the innumerable flower studies that are inescapably associated with his name today. These pictures provide the perfect example of the middle-ground artist in the second half of the century, who found himself a clientele by striking a compromise. Fantin painted light backgrounds in which his flowers can breathe, a break with the darkness of Ribot, but the flowers and fruit were sufficiently carefully drawn and modeled to satisfy collectors, so that there is none of the sparkle of Impressionist still lifes.

From the Realist point of view, Fantin's interesting pictures are those of the time of the 1859 exhibition, particularly his drawings and paintings of his sisters embroidering and reading [112]. The use of a

window rather than darkened wall as background again opens up an interesting space and play of tones, and also creates a feeling of environment rather than simply a backdrop. The absorption of the sisters embroidering eliminates any sense of their posing.

Whistler (1834–1903) developed as an artist in the late 1850s and the 1860s in the most remarkable manner, swiftly moving through two Realist stages to an early Impressionism, and on to his own prefiguration of Symbolist aesthetics. In 1858 he published a folio of etchings, the "French Set," of which *The Kitchen* [119], drawn during a walking tour in Alsace-Lorraine, is an outstanding example of the rural stage of Realism. The humble kitchen is transformed by the play of light without losing its actuality. Like Fantin, Whistler used a rear window to provide

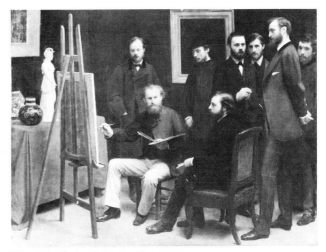

120. *A Studio in the Batignolles.* By H. Fantin-Latour, 1870. Musée d'Orsay, Paris.

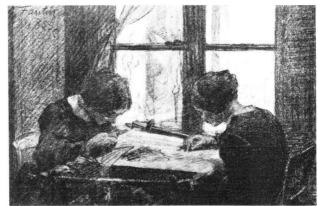

121. *The Embroiderers.* By H. Fantin-Latour, 1857. Musée d'Orsay, Paris.

depth and interesting possibilities of tone and composition. What is particularly notable is the dynamism Whistler achieves, as was pointed out above. When we look at another print in the set, like *La Vieille aux loques* (*The Ragwoman*), where the woman is set against an enclosed dark background in the manner of Bonvin or Ribot, the result is not as successful as *The Kitchen*. Though it is clear that Whistler studied Rembrandt's etchings, he used the chiaroscuro originally enough that we do not feel we are looking at a Rembrandt follower, as we do with so many printmakers of this period.

After his painting *At the Piano* was refused by the Salon in 1859 (one of the many rejections that prompted Bonvin to hold the show in his studio), Whistler moved to London. His sister was married to the English surgeon Seymour Hayden, an amateur etcher who shared Whistler's enthusiasm for Rembrandt and rural subjects, though he was not to share the later developments in Whistler's work. *At the Piano* had been begun on a stay in London in the winter of 1858, and it marks a change in Whistler's art. It is composed with a series of rectangles and simple shapes parallel to the picture plane, a very quiet picture quite unlike the vigorous hole in space of *The Kitchen.* Whistler avoided the banalities of a neoclassical composition by placing the dark in the foreground and the light areas on the background wall.

Back in London, Whistler's art was transformed with amazing rapidity. He etched the "Thames Set," which seems almost from a different hand from the "French Set." *Black Lion Wharf* and *Eagle Wharf,* 1859 [122], contain no obvious reminiscences of Rembrandt. The embracing and modeling chiaroscuro has been replaced with bands of dark and light, the latter boldly empty dividing areas of white paper. An unexpected reversal leads to barely sketching the figures in the foreground while drawing the background warehouses in fine detail. The compo-

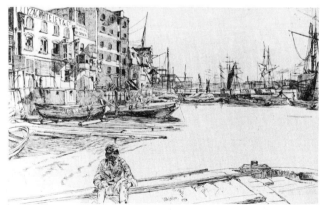

122. *Eagle Wharf.*
By J. Whistler, 1859.

sitional principle at base is the same as in *At the Piano,* but whereas the painting operates within the safe confines of a room interior, the etched view across the river takes the risk of falling apart. Our eye moves from foreground to the rear and back to the front, unable to decide where to focus. The result is to make us feel the business and complexity of the dock scene together with the spaciousness of the river.

The boldness of the compositions did not please everyone. The French critic Philippe Burty, one of the protagonists of the etching revival in France and an enthusiast for Japanese art, complained:

> Unfortunately, Mr. Whistler has evolved a "theory of foregrounds" which imposes on his designs a certain undefined photographic appearance which is greatly to be regretted. He places in these unfortunate foregrounds figures or objects which he interprets without modeling, and in a relatively exaggerated scale. . . . It is sufficient merely to glance at the admirable landscapes of Rembrandt to sense the error of the system devised by Mr. Whistler, who is remarkably gifted in all other respects.

Burty's criticism brings out the contradictory aspects of Realist art which I have seen as typical. On the one hand is a characteristic drawn from an almost scientific source, photography, and on the other, the effect in the work is seen as crude, lacking modeling and correct scale (another form of primitivism). Curiously, Burty, given his own interests, does not see the prints in terms of Japanese art.

The complex issues in Whistler's artistic thinking which led to this remarkable breakthrough (which he does not discuss in any letters of the period) are examined very well by Katherine Lochnan in her book on Whistler's etchings. She devotes space to photography, Japanese prints, and the science of optics, concluding:

> It seems likely that Whistler's "theory of foregrounds" was developed in the knowledge of contemporary photography and the new understanding of the working of the human eye which Helmholtz's research had contributed to the field of optics during the 1850s. . . . He clearly tried to compensate by selecting more than one vantage point. His interest in focus was undoubtedly prompted by a desire to carry the realist concept of "truth to nature" a step further and to place it on a scientific basis.[6]

Baudelaire did not share Burty's reservations, and was fascinated by these views of London when he saw them exhibited in Paris in 1862, calling them "the profound and complicated poetry of a great city."

The poet had written his essay "The Painter of Modern Life," hanging it on Constantin Guys, whose favorite subjects, courtesans, military

[6] K. Lochnan, *The Etchings of James McNeill Whistler.* New Haven, Conn., 1984, p. 100.

parades, and fashionable people parading in carriages, seem very tra-
ditional compared with Whistler's commercial districts. In addition,
Guys slims and elongates his people and horses in the manner of fash-
ion illustrations, a conventional but hardly persuasive elegance.

Whistler found the dock area an excellent source of subjects for
Realist art. The sleazy atmosphere and the fascinating visual richness
and variety of warehouses, pubs, cranes, and boats and ships of all
kinds provided not only subjects but an antithesis to the principles
professed at the Salon and the Royal Academy. Thirteen years later
Doré made some of his most memorable sketches down in the docks
[235]. Dickens begins one of his greatest novels, *Our Mutual Friend*, with
a search for a drowned corpse by Gaffer Hexam, an inhabitant of Roth-
erhithe. Dickens juxtaposes this ghoulish trade and the environment
with the middle-class dinner party at the Veneerings, where the aca-
demic arts are, incidentally, wittily satirized. Two of the guests are
summoned to identify the body found by Hexam, and are transported
from the luxurious dinner to the docks:

> The wheels rolled on, and rolled down by the Monument, and by
> the Tower, and by the Docks; down by Ratcliffe, and by Rotherhithe;
> down by where the accumulated scum of humanity seemed to be
> washed from higher grounds, like so much moral sewage, and to be
> pausing until its own weight forced it over the bank and sunk it in the
> river.

Dickens's abstractions ("scum of humanity" and "moral sewage")
for the place where Whistler chose to work were given much more
concrete form by a Frenchman not writing for Dickens's family audi-
ence:

> Wapping, which stretches from London docks to the tunnel, is a
> seething mass of misery. One catches glimpses of courtyards full of
> filth, littered like pig-sties and just as nauseous. Whole families vegetate
> there—mere skeletons, covered with rags of such incredible dirt that it
> makes one retch to approach them. Unless you have seen rags in Lon-
> don you can have no conception of the meaning of the word. A man
> pushes his head through a patchwork of tatters, his arms and legs stick
> out through the largest holes, and he is clothed. The skin of these
> wretched creatures is so tanned, so thickened by exposure, so en-
> crusted with grime that it is unrecognizable at first glance. But the most
> incredible thing is that these scarcely human, half-naked creatures at-
> tach the greatest importance to the wearing of a hat, or some portion of
> one, if only a brim. The women also, however scanty their clothing,
> always wear some battered, bedraggled, shapeless headdress. If some
> kind soul gives them a few coppers they rush to the nearest public
> house and spend it on gin, while their wretched children, naked and

crawling over refuse heaps, are reduced to nibbling the parings of veg-
etable and other offal fit only for swine. This appalling state of things
being out of sight in unfrequented districts does not offend the English
sense of delicacy. . . .[7]

This description by Francis Wey (Courbet's friend) recalls Gavarni's
print [48], even down to the mother's hat, and gives a vivid idea of the
young Whistler's truculent attitude in choosing this location. Neverthe-
less, Whistler did not follow in Gavarni's footsteps, for the London poor
had also been documented with great individuality and moving detail
by Henry Mayhew in his volumes *London Labour and the London Poor*,
1851. In turning to the city after the rural subjects of the "French Set,"
Whistler examined it as an engrossing visual experience—one in which
the docks offered the complexity that Baudelaire admired, as well as an
ordinariness that Whistler, like his French artistic friends, saw as nec-
essary to achieve truth. Furthermore, his use of both fine detail in the
buildings and the open spaces of white paper and the changes of focus
embody the ambivalence of the city experience, and contribute also
perhaps to Baudelaire's "poetry."

Whistler achieved equal originality in his paintings done in London.
Wapping on Thames, 1861–64 [123], is the first great Realist painting
devoted to a city subject, but one insufficiently appreciated because it
has remained in a private collection. Whistler created a masterpiece of
complexity rendered coherent. Baudelaire in praising the "complicated
poetry" of the prints described the "marvelous tangles of rigging, yar-
darms and ropes; a chaos of fogs, furnaces and corkscrewing smoke."
The prints do not quite contain the elaboration that Baudelaire suggests,
but as in the case of the drawings by Constantin Guys, the poet had the
ability to see what he was looking for in the work of an artist who had
some promise of these qualities. This quotation does, however, apply
very well to *Wapping*, which gives us a sense of the almost overwhelm-
ing richness of the scene along the river. Graphic artists reveled in the
overlapping cobwebs of rigging, which lent themselves well to a black
and white linear style, but which confronted painters with problems.
Whistler refined the broad brushstrokes and thick application of pig-
ment that he had learned in France from Courbet, Bonvin, and Ribot
without abandoning this painterly approach. He thus managed to do
justice to the intricacy of the scene and did not create a static detailed
drawing in paint. The rowing boats in the center middle distance, for
example, are composed of a few rough curving strokes.

Whistler used a very high horizon line in order to engulf the spec-

[7] Quoted in J. B. Priestley, *Victorian Heyday*. Harmondsworth, Middlesex, England,
1974, p. 203.

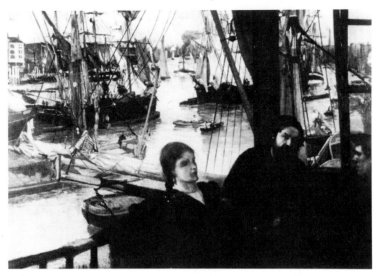

123. *Wapping on Thames*. By J. Whistler, 1861–64. National Gallery, Washington, D.C., John Hay Whitney Collection.

tator in the masts and sails and rigging.[8] He also put the dark areas in the foreground, and made the background both lighter and more color- ful so that we are inescapably drawn through the whole painting to the red funnel of the tugboat in the distance. This funnel is the brightest patch of color in the entire canvas. Whistler succeeds in striking the difficult balance between doing justice to all the detail and rendering the overall atmosphere. He avoids making the smoke-begrimed build- ings a dark blur in order to achieve space and light through the picture. Probably the buildings were much darker than Whistler painted them, but an essential part of Realism was not the exact reproduction of what the artist saw, but a reinvention of the impact of the subject. We could compare this background with Claude Monet's *Train in the Snow*, 1875 (Musée Marmottan, Paris), where the locomotive and train are painted a dark blue color. Anyone who has seen a steam locomotive against snow knows that nothing appears more solidly jet black, but Monet transformed the train to create the atmosphere that he felt. The widely held belief that the Impressionists simply painted what they saw is wildly inaccurate.

Whistler had also grasped in France the importance of not trying to

[8] *Wapping* can usefully be compared with the Dane Carl Frederick Sorensen's *The Thames and London Bridge*, 1862, private collection (illustrated in M. Warner, *Images of London, Views by Travelers and Emigrés, 1550–1920*, London, 1987, p. 165). This painting has a conventional composition with a low horizon line, a long recession in the river, and an extensive empty sky. The spectator is separated from the scene, which feels bereft of activity, more like a seaport painted by Claude Lorraine than the incredibly busy docks described by so many visitors to London, and so well evoked by Whistler.

124. *Harmony in Green and Rose: The Music Room.* By J. Whistler, 1860. Freer Gallery of Art, Washington, D.C.

tell stories. He was initially tempted in painting *Wapping* to have the young woman talking to the sailor, suggesting a theme of prostitution entirely appropriate to the locale, and one that would appeal to the English taste for "problem" pictures. But he abandoned it, and we now see the neutral scene on the pub balcony, which does not distract from the picture of the scene along the river.

Whistler's turn to painting the heart of London is especially significant because he also transformed the chiaroscuro effects of his French friends into light and color. Important roots of Impressionism can be found in his use of the city as a subject and in the new approach to color. Another of Whistler's London pictures, *Harmony in Green and Rose: The Music Room,* 1860 [124], a domestic interior, with its sparkling light and angled vision, prefigures later Impressionist works. The angles and the black silhouette of the woman in a black riding habit dramatize the scene as effectively as a moral dilemma or domestic crisis. Claude Monet's later *The Luncheon,* 1868 (Frankfurt, Städelsches Kunstinstitut), bears a striking resemblance in its composition to *The Music Room,* but it seems unlikely that Monet could ever have seen Whistler's picture. The similarity probably springs from parallel interests, and it illustrates Whistler's originality at this early period, an originality which soon led him in a new direction—to the evocative mood paintings for which his musical titles seem particularly appropriate.

The Hague School

Outlines are no longer thought about; lines are regarded as horrible and the aversion to the costumes of civilized society is so great that no virtue is seen anymore in anything but evil-smelling interiors, people with grimy hands and scenes that begin to suffer from a miserable triviality.

De Amsterdammer, 1884

Russia

Now that I have my meals in the students' dining room, I see with pleasure that these are not the fashionable students with excellent manners, speaking loudly in complex phrases, but these are the gray-footed, dirty muzhik children who cannot put together a few words, but are people with a deep soul, people who treat life seriously and who develop by themselves. This whole crowd drags home for holidays and feels happy with a third class railway ticket. They go to their dirty huts where they commune with their relatives and friends who will understand and believe them, and in case of trouble they will find support. That is why the artist must not cling to St. Petersburg.

Ilya Repin, 1872

The Hague School

Yet another characteristic peculiarity of the movement strikes one immediately. The artists try, by preference, to render *mood;* and they give precedence to *tone* above *color.* Hence their almost exclusive rights over the depiction of what is known as "dirty weather." They have revealed the poetry of *gray* in a hitherto unprecedented manner. In that gray atmosphere they find the ideal gradations of tone that they are looking for and we must recognize with admiration that they succeed in rendering what people had no idea of before with a fine sensitivity. Mauve, Sadée, Israëls, Artz . . . all of them patrons of gray painting!

Jan van Santen Kolff, 1875

The Macchiaioli

What is the *macchia* in the final analysis? A harmony of tone, i.e., of shadow and light, aimed at capturing a specific feeling in the mind of the painter. . . . This is the salient and characteristic element of the work, which derives from the play of light and shadow and which is produced by a particular arrangement of people and things in various colors.

How many times have we seen the preparatory drawings for a painting are, artistically speaking, far superior to the finished work itself? . . . its imperfections actually add a degree of efficacy to the first manifestation of a powerful impression.

Vittorio Imbriani, 1869

6

REALISM THROUGHOUT EUROPE

When we think about the primacy of French art in the nineteenth century and look at the French art world, one thing stands out: the polarization between the academy and the avant-garde. The liveliness of French art did not spring from a generally forward-looking art community. French combativeness, and the impulse to push an idea to its logical, sometimes absurd, conclusion, meant that the two groups drove each other apart—the academy became more rigid, the avant-garde more outrageous. It is hard to imagine another country where the farce of the selection of a Prix de Rome winner, with the valuable scholarship going to such absurd confections, would have been continued so long. As pointed out earlier, almost every winner chosen by this system was destined to mediocrity and obscurity. At the other pole, the Realists meeting in the Brasserie Andler, or the Impressionists at the Café Guerbois, inspired each other to the brilliant explorations that eventually won over the rest of Europe.

If the other countries only slowly absorbed these ideas, it was in part because their academies did not exclude the Young Turks and steadily assimilated them, as happened to the Pre-Raphaelite Brotherhood in England. The artists were not driven to analyze and sharpen the concepts which launched them. The overwhelming literary imagination of England was part of the artists' own outlook, and only the American Whistler freed himself from storytelling inclinations. In Italy the Macchiaioli did not push their daring sketches into major paintings. Nevertheless the prevailing belief in a Realism of one kind or another, and the consequent urge to paint the actual, led artists throughout Europe to go out and paint landscapes of all kinds, including the most unpromising, like Maris's *Allotments Near the Hague* [125]. Landscapes did not have to fulfill the same expectations as pictures showing people; the former persisted as a vital subject as artists, tempted by social themes, the natural consequence of all the novels with reforming

125. *Allotments Near the Hague.* By J. Maris. Haags
Gemeentemuseum, The Hague.

themes, found themselves frustrated by the problems discussed in
Chapter 4.

Landscape art appealed widely to the public, and it provided a
theme to which writers could not do justice. In Maris's picture, the
rendering of all the textures and tones of the mud, the nuances of the
gray clouds, and the feeling of all-pervasive wetness belong only to
the painter's world. The novelist was obliged to deal with people, while
the landscapist presented the natural world with its "intimations of
Immortality." A surprising number of nineteenth-century landscape
paintings lack people; as Runge had predicted at the beginning of the
century, landscape painting became the closest thing to religious art.
Realist landscape was only indirectly religious, but the connection be-
came evident in the 1890s when the Symbolist movement gave land-
scape a transcendental role in many of its best pictures.

While these landscapes, often with animals, became the most pop-
ular subject by far in the second half of the century, and many of them
are excellent pictures, the most interesting artists dealt very frequently
with people in landscapes or with urban life, themes that offered a
special challenge. The following section looks at a few selected artists in

a number of countries, and concludes with an analysis of the work of three of the most successful academic artists in France, who equally asserted their belief in painting the truth. This analysis aims to show that Academic Realism is not Realism, and that though some of these artists painted exceptional works, as Courbet painted some academic pictures, the bulk of their work fails because it is based on premises that no longer functioned. It becomes clear that Realism was not one possible movement at midcentury but the only valid one until the Post-Impressionists introduced new fundamental pictorial concepts.

GERMANY

In Germany, where the idealist impulse ran so deep, painting became split between the ideal (Feuerbach and von Marées almost achieved the impossible task of creating a mid-nineteenth-century ideal art) and anecdotal art of the kind we associate with Spitzweg. There was, though, one notable exception.

Today, the least appreciated great artist of the nineteenth century is Adolf Menzel (1815–1905), very little of whose work has left Germany, where his genius is recognized. He was a very great artist indeed, but my copy of a widely distributed reference work, the Penguin *Dictionary of Art and Artists,* which gives a long paragraph under the letter M to Georges Michel, a minor French landscapist, does not even list Menzel. He achieved enormous success in his lifetime because he combined a passion for factual detail with a subject matter that appealed to the public. It is perhaps these aspects that have made enthusiasts for modern art underestimate his work, and place him among the academic artists who shared those traits. Menzel, however, was one of the most brilliant draftsmen of the century, who can be set beside Daumier and Degas. Here our twentieth-century preference for color over black and white has worked against Menzel. He did produce exceptional works in color, both pastels and oils, but most of these pictures are unfamiliar, as the same few works are reproduced over and over again, when they are illustrated.

Menzel was a tiny man, less than five feet tall, whose long coat was covered with pockets, each stuffed with drawing pads and pencils. He drew incessantly, and it is tempting to compare him with Toulouse-Lautrec, both misshapen figures who sat on the edge of society observing it all the more keenly. Yet a more revealing comparison can be made with Meissonier, by chance born in the same year, and the other most highly decorated artist in Europe. They both painted pictures of their country's past that were distinguished by their fanatical research to achieve historical accuracy. Both artists avoided sentimental or easy

effects, and both shunned the nude. Yet the differences are the revealing factor. Meissonier almost never painted the present, while Menzel painted contemporary scenes more often than the past, and he drew the life around him with insatiable curiosity and without preconceptions. Meissonier followed prevailing conventions about expressive poses and gestures, so that too many of his figures look like marionettes. In his prints and paintings of the life of Frederick the Great, Menzel gave real gestures to the historical personages, and his pictures come alive. More than any other artist he made historical reconstruction seem a valid art form.

Menzel began his artistic career as a struggling lithographer, but he was invited to illustrate Franz Kugler's *History of Frederick the Great* (1840–42). The success of the book made Menzel's reputation. He taught himself to paint and went on to a distinguished career as a painter both of the Frederick scenes and of contemporary royal events in Germany, for which he was ennobled by Kaiser Wilhelm I. Remarkably, these "official" works are as interesting as the more personal of his pictures. For his illustrations of Frederick's life, Menzel made innumerable drawings of the buildings that Frederick had lived in, of the uniforms, cavalry equipment, weapons, and carriages that were preserved in barracks and arsenals. He studied all the available portraits of Frederick and his associates. Yet what distinguished his illustrations was the originality of the compositions. Menzel's research was a necessary means but not an end in itself, as he subordinated it to a rethinking of the presentation. He drew, for example, scenes in which Frederick was a tiny figure in the distance [126], giving a verisimilitude to the illustrations as a whole. Menzel seems to have understood the significance of environment as opposed to background in the new goals of nineteenth-century art.

126. *Frederick the Great Consulting with Engineers on Water Control.* By A. Menzel, illustration from F. Kugler, *The History of Frederick the Great,* 1840.

127. *The Flute Concert*, detail. By A. Menzel, 1850–52. Nationalgalerie, Berlin.

Especially when he was teaching himself to paint, he made many small, astonishing oils that he never exhibited in his lifetime. Menzel was fascinated by light, especially artificial light and fire. These light sources are the basis of art but almost impossible to represent satisfactorily, yet he achieved a remarkable level of success. The twentieth-century fascination with the sketches should not prevent us from appreciating the transference of Menzel's successful experiments to his public paintings. His famous picture *The Flute Concert*, 1850–52, [127], with Frederick the Great playing the flute and J. C. Bach at the keyboard, is much more than a historical reconstruction in its rendering of the burning candles. Much later Menzel wrote to a friend that "I only painted it because of the chandelier. . . . " This assertion is probably not quite true, but it does reveal something of Menzel's passion for painting the effects of light. Another often reproduced painting, *Théâtre du Gymnase*, 1856, with its exploration of artificial lighting, inspired Degas to paint a copy of it when it was exhibited in Paris. These pictures separate Menzel in some degree from his near contemporaries like Courbet, and open the door for Impressionist ideas, though he never adopted the new Impressionist concept of composition.

Isolated in Berlin, not pushed by the polarization of ideas that took place in Paris, Menzel painted every kind of picture from historical

reconstructions to slices of contemporary life. Menzel astonishes us because he brought the same remorseless observation to every subject. Several of the German nobles whom he painted in *The Coronation of Wilhelm I*, which involved detailed studies of 132 participants, complained that he made them too ugly. He drew and redrew the snout of a boar, a dead soldier on the battlefield, a girl drinking through a straw, an exhausted worker in the rolling mill, the emperor, a saddle, or a landscape, all with the same intense desire to get it right. No artist tackled a greater range of subjects than Menzel, and no artist left more drawings that stay in the mind.

His intensity shows itself in the rapid but masterly drawings, superimposed one on top of another, as he sought the most incisive rendering [128]. Such drawings underline how little Realism has to do with photographic accuracy, and how much with style. The overlapping drawings, by emphasizing how the artist works, destroy any illusionism, but the frankness of showing the method, the possible versions or even the unsatisfactory versions, convince us of the artist's authenticity.[1]

With this determination to draw things "as they are," Menzel made more and more sketches of people from behind, so that he could draw them unobserved, as we see in the young girl drinking through a straw [129]. The number of these pictures from behind or in *profil perdu* strikes us as astonishing when we go through a book of his drawings. Like Chardin he wanted to eliminate any self-conscious posing by the subject, and also to record the actual gestures of life [130]. This latter desire marks a difference from Chardin, who painted people most frequently in a static position, gesture suspended so that the stillness of the oil painting appeared quite natural. Menzel, a man of the nineteenth century, felt the need to study action. He was the same age as Millet and older than Courbet but he seems to belong to a more modern era because of this concern.

Menzel lived a large part of his life with his sister and her husband, and like Courbet he took advantage of family intimacy to draw and paint a number of pictures of his sister sleeping [131]. It hardly needs pointing out that Menzel's passion for fidelity to life did not involve a passive recording. He possessed an overriding vision of space and volume. The latter is clear in the sketches both of his sister and of his fur

[1] We see the difference between Menzel's and traditional sketches like Raphael's where the latter covers a sheet of paper with drawings of a mother and child in different positions in order to find the most beautiful and expressive one for the ideal pose of the Madonna and Christ child. Menzel saw a man or woman at a café or concert and struggled to render the figure's profile, shape, weight, and action as he saw them, never satisfied that he had done justice to the commonplace, ever needing to improve it.

128. *Studies of a Head.* By A. Menzel, 1858.
 Edinburgh National Gallery.

129. *Girl Drinking Through a Straw.* By A. Menzel,
 1884. Private collection, Hamburg.

130. *Man Washing,* study for *The Iron Rolling Mill,*
 1872. By A. Menzel. Staatliche Museen, Berlin.

coat [132], where the play of forms is fascinating in its own right. He chose surprising angles of vision for his interiors and landscapes so that the space becomes expressive without distorting the subject.

It would be easy to imagine Menzel as two artists: the inspired draftsman and watercolorist of intimate scenes, and the traditional

131. *The Artist's Sister Sleeping*. By A. Menzel, ca 1848. Kunsthalle, Hamburg.

132. *The Artist's Fur Coat*. By A. Menzel, 1840s. Neue Pinakothek, Munich.

133. *The Ball Supper*, pencil study. By A. Menzel.

painter of the pompous official occasions. When we examine the latter we find, though, that he does not abandon his everyday insights. One of these paintings, *The Ball Supper*, 1878 [134], is a dazzling study of light effects that defies reproduction rather than a record of the assembled bigwigs; right in the front Menzel placed a splendidly uniformed general, a plate in his left hand, fork in his right, and his imposing hat held awkwardly between his knees [133]. Menzel encapsulates the difficulties of a buffet supper, the observation from life, and the human ordinariness beneath impressive costumes. This undercutting presentation continues in the women beyond the general so that what at first glance seems a glittering celebration of a glamorous event, soon shows itself to the spectator as another slice of life, full of imperfect humanity. Not surprisingly, Degas copied this scene too.

134. *The Ball Supper*, detail. By A. Menzel, 1878. Nationalgalerie, Berlin.

ENGLAND

The Pre-Raphaelite combination of an idealist, moralizing strain with their potential Realism was not the only reason for the disappointing path of their art. There was no rigid Academy excluding them, and, as we have seen, they were rapidly accepted after their initial rejection. In contrast to the French polarization, the English love of compromise and distrust of theory meant that the Royal Academicians in their own work pursued no extremes, while the young artists with little to rebel against did not further develop their own principles.

The English natural feeling for literature, and the passion for Dickens and other novelists of contemporary life, meant that exhibitors at the Royal Academy easily turned to themes from contemporary life and literature. In London we find a whole series of paintings whose subjects anticipate those of the Impressionists, city streets and parks, the racecourse, the railway station, and holiday makers on the seaside beach.

The delight of the public in such pictures, what Frith called "modern-life subjects," can be gauged from the fact that the astute dealer Flatow paid Frith £4,500 for his painting *The Railway Station* [83], the sketch, and the copyright. The latter was of great importance, as artists at times made more money from the engravings than from the sale of the picture itself. These engravings were executed with dazzling technical skill and often took a year to complete. They were consequently expensive, but they found a wide distribution in middle-class homes. In the days before magazines, books with color plates, and our numerous traveling exhibitions, most people knew contemporary paintings through these prints. Though the public flocked in great number to the Salons in Paris, London, and elsewhere, many still did not get there. Furthermore those who went were faced with thousands of works jammed up against each other, and in the crush of people it was difficult to absorb much even from the most striking. The large engraving hung in a drawing room was a much better place to get to know a work, and though the engravers could reproduce chiaroscuro, the loss of color meant that paintings with a great deal of linear detail came through best. The works of an artist like Frith with their mass of well-delineated characters lent themselves particularly well to engraving.

Many books on nineteenth-century art not only ignore the impact of these reproductive engravings on artists and the public but also omit to point out their significance for the Impressionists. Their painting style did not lend itself to engraving, and as few people went to their exhibitions, their work was more or less unknown. Most people knew of Impressionism only through the hostile newspapers' reviews, so that

a great deal of commentary on the blindness of the public to the movement is irrelevant. The public never saw the paintings in any form.

Flatow, incidentally, paid Frith another £750 not to exhibit *The Railway Station* at the Royal Academy's annual exhibition. The dealer dared to pay these astronomical sums because Frith's *Derby Day* [19] had been such a draw at the 1858 exhibition that a rail had to be erected in front of it. Flatow then exhibited the new painting at his gallery, charging admission, and not only recouped the £750 but provided himself with a captive audience to whom he could sell the engravings. Frith recorded in his memoirs that "twenty one thousand one hundred and fifty people paid for admission in seven weeks, and the subscription of the engraving was equally surprising and satisfactory. Flatow was triumphant; coaxing, wheedling, and almost bullying his unhappy visitors. Many of them, I verily believe, subscribed for the engraving to get rid of his importunity." Durand-Ruel could not promote the Impressionists in this way.

The pictures of modern life tend to be filled with anecdote, which occurred throughout Europe, but was perhaps particularly the case in England given the literary inspiration of many of these paintings. Few people could appreciate a picture without a story in England, unless it was a landscape, and even these were often provided with a subject. Paintings of animals that were enormously popular did not escape this tendency. Edwin Landseer became the most loved painter in England with his anthropomorphic creatures. *The Shepherd's Chief Mourner*, showing a collie dog gazing sadly at his master's coffin, was one of the most popular pictures of the century.

In this atmosphere of enthusiasm for storytelling, landscape painting, sustained by the achievements of the early nineteenth century, alone at times succeeded in escaping from anecdotalism. Certain artists turned to unpretentious subjects, continuing the English interest in atmosphere and light. This change can be seen in a charming picture by C. R. Leslie, Constable's biographer. In *A Garden Scene*, 1840 [135], Leslie retains Constable's observation of all the different greens and the dappling of light, with patches of red to set off the greens. He gives up Constable's crisscrossing diagonals, which introduce a baroque grandeur of space into the most ordinary scenes and his tumultuous skies. His garden is bounded by a high wall and trees, and the blue sky is barely visible through the branches. Leslie also abandons Constable's brushwork for the more precisely drawn detail that had begun to prevail. The result is a picture similar to German Biedermeier celebrations of domestic life, but with exceptional freshness due to the Constable coloring. Leslie also introduced one remarkable feature, the sheets hanging on the laundry line, which are bold, large patches of bright

135. *A Garden Scene.* By C. R. Leslie, 1840. Victoria and Albert Museum, London.

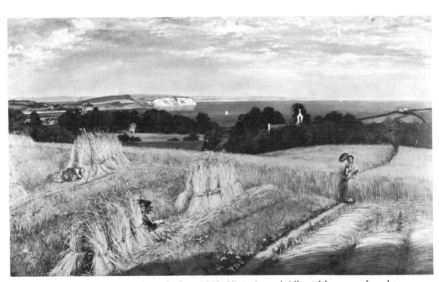

136. *Isle of Wight.* By R. Burchett, before 1863. Victoria and Albert Museum, London.

white that contribute to the luminosity as well as to the naturalness of the subject. As the artist did not remove the laundry, we have the sense of a slice of life. The picture reminds us of Claude Monet's painting thirty years later of his small son with a hobby horse in the garden, though Monet's broader brushstrokes give a movement lacking in the Leslie.

Another anticipation of Impressionism in light, color, and subject,

though not in brushstroke, can also be found in the Victoria and Albert Museum, Richard Burchett's *Isle of Wight* [136], acquired in 1863.

One wonders whether Claude Monet and Pissarro saw these or similar paintings when they went to England during the Franco-Prussian War. We have already noted the admiration of English art in France, and Pissarro was eager to know if his son Lucien had visited the National Gallery when he went to Britain. The Barbizon artists and the Impressionists saw the possibilities in English art for new developments to which the native artists were blind.[2] The English art world, with very few exceptions, was unable to accept Impressionism until it was already *vieux jeu*, a sad decline from the originality of English art at the beginning of the nineteenth century.

ITALY

We are all aware that no country suffered more from the greatness of its artistic past then Italy. The religious and allegorical decorations of the Renaissance and the Baroque imposed themselves as the forms to which artists should aspire. A tour of the Vatican reveals the impossibility of the task. The visitor passes from Michelangelo's and Raphael's vital frescoes to vast areas of wall painted with innumerable figures, almost all depressingly lifeless, the product of the academic formulas of the nineteenth century. Not surprisingly the most interesting paintings in Italy at this time were tiny pictures of nothing at all like Giovanni Fattori's blank wall [137] or Abbati's blocks of marble lying in the cloister of Santa Croce in Florence, an oil painting not quite 10 inches wide. A similar picture, executed at the same time in the early 1860s, Sernesi's *Roofs in the Sunlight* [138], possesses the same determination to make a picture out of a simple visual experience. The artist avoids not only anecdote or historical reference but also any associational interest. *Roofs* measures 7 by 7½ inches, and lacks even the fine detail that Meissonier put into his small pictures.

These painters possessed the Realist belief that there was no privileged subject matter in art, that walls or rooftops, like Rosa Bonheur's *The Mud Hole* [65], provided a sufficient basis for a picture if only it was well enough painted and avoided the clichés that surrounded the art-

[2] Thoré's review of the London International Exhibition of 1862 points this up: "One cannot help remarking that in praising Constable, the English always slip in some proviso: 'he paints with the palette knife; he is too crude; his skies are overdone, etc.'; there is always some criticism. He is, however, a great painter, Constable! and one whom the French do not hesitate to place, without any reservations, in the first rank of modern landscapists, with that other brilliant artist, Bonington, who when he began, also found more understanding in France than in the country where he was born.

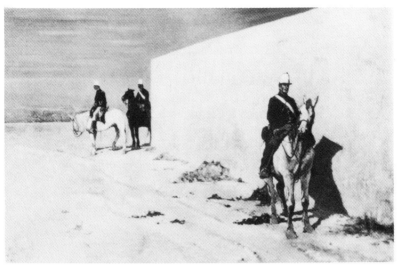

137. *The White Wall (The Look Out).* By G. Fattori, ca 1872. Private collection, Rome.

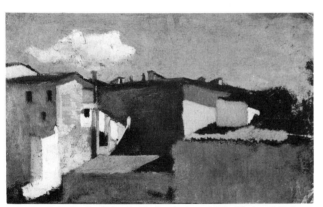

138. *Roofs in the Sunlight.* By R. Sernesi, ca 1861. National Gallery of Modern Art, Rome.

ists. They used the *macchia,* or patch, as the building block, and one of the artists wrote, "The real appears on the canvas as the result of using *macchie* of color and chiaroscuro, each of which can be measured by means of relation. In every *macchia* this relation has a double value as both chiaroscuro and color." The artists' concern with these visual relations, which Adriano Cecioni, typical of the age, described in scientific terms, might suggest an Art for Art's Sake movement, but the Macchiaioli were driven by a rich mixture of ideas and beliefs. The word *macchia* itself contains multiple meanings,[3] including a stain or patch,

[3] Scholars disagree on all the implications of the word for the artists. See the essays in the catalogue *The Macchiaioli.* Los Angeles, 1986.

and in artists' jargon, a preliminary sketch. It also means a thickly wooded area where malefactors can hide out, and *macchiujolo* was used pejoratively by a critic to imply that the painters were artistic criminals. As with the term "Impressionist," the artists themselves proudly adopted it.

As was the case with the *Peredvizhniki,* or Travelers, a decade later in Russia, the artistic originality of the Italians sprang partly from political/social beliefs. They formed a vital part of the Risorgimento, as they wished to sweep away the immediate past and rejuvenate Italy together with its art. The force of their commitment shows in the fact that Abbati and Sernesi fought with Garibaldi, the former losing an eye and Sernesi dying of wounds. This dedication to Italian independence led artists to paint scenes from the struggle. Though Fattori painted battles, with their attendant pictorial problems, other members of the group chose subjects more easily handled on canvas, like Borrani's *The Seamstresses of the Red Shirts,* 1863 [139]. At first glance this picture looks like a gentle, domestic Biedermeier interior, until we realize that the women are sewing shirts for the Garibaldini. In such a quiet occupation the drama is necessarily implicit rather than explicit, but most people today find Borrani's painting as gripping as Fattori's scenes of the battles themselves. The former expresses the drama not through facial expression or gesture, but through the startling reds which flow through the picture in the shirts being sewn, in the women's shawl and ribbons, and in the sofa. The *Streamstresses* combines carefully drawn detail, typical of the period, with great delicacy in the handling of the light penetrating the curtained windows, which prevents it from becoming lifeless.

One of the seamstresses sits parallel to the picture plane and another directly faces us, which seems natural in the group, but in other Macchiaioli paintings all the figures are arranged in this geometrical fashion, and often separated from each other. A number of young Italian artists (like the Pre-Raphaelites in England) admired Fra Angelico for his refreshing simplicity in comparison with the elaborate effects of much contemporary art. While the Brotherhood admired Angelico more in theory than in practice, the Macchiaioli often imitated his compositions, which makes their everyday scenes look artificial. We find this approach in a number of works by Silvestro Lega, but in *The Trellis,* 1868, where several women are sitting in an arbor having coffee after lunch, he conceals the underlying geometry with the irregularities of the leaves and lighting. This particularly beautiful work has often been reproduced in color, as it is one of the finest Macchiaioli pictures, where the play of light and shadow through the leaves reminds us, like the subject, of Impressionist painting. Indeed, a number of their pictures

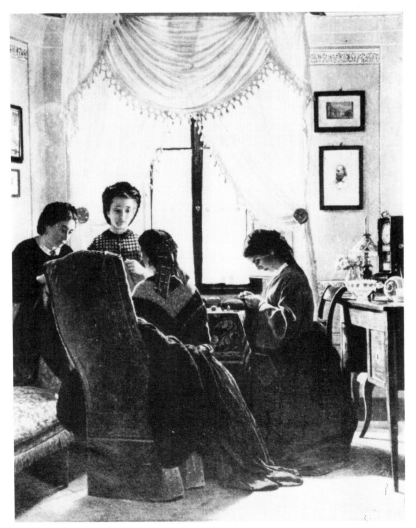

139. *The Seamstresses of the Red Shirts.* By O. Borrani, 1863. Private collection, Montecatini, Italy.

have the same subjects as the Impressionists—for example, Signorini's views down streets, and they have been called the Italian Impressionists. While they share in part the Impressionist approach, there is a significant difference. Whereas the Frenchmen used their individualized brushstrokes to create movement throughout their canvases, however static the scene they were painting, the Macchiaioli, especially in their larger works, froze their pictures with distinct outlines and broad areas of color. As a consequence, they never developed a major modern movement from the early brilliant paintings, though among the later works, Signorini's views of streets from the 1880s are outstanding.

RUSSIA

Artists in Russia, caught between the Byzantine tradition and the forced Westernization of Peter the Great, did not produce outstanding modern art until the later nineteenth century. Though competent genre painting existed, the Academy encouraged the Grand Style, and the most famous Russian painting of the first half of the century was Briullov's *Last Days of Pompeii*, 1830–33. This huge painting, the epitome of the contrived, melodramatic historical reconstruction, had a great success when shown in Western European cities too, but it did not represent a vital trend. A few painters following in the footsteps of writers like Gogol attempted themes of social criticism, such as Perov in the 1850s, but with one exception—the tragic life of Taras Shevchenko—it was not until the 1870s that a vigorous movement, that of the Travelers, asserted itself.

The remarkable career of Shevchenko (1814–1861) illustrates the situation which inspired artists to attack injustices. A serf born in Ukraine, he drew as a child and learned to read and write. In spite of beatings he continued to draw, and eventually when his owner moved to St. Petersburg, Shevchenko was apprenticed to a painter. His talent and character built up a circle of friends who included established writers and artists, one of whom, the famous Briullov, painted and sold a picture to obtain the money to buy his freedom in 1838.

The young artist read voraciously in world literature, and he began writing poetry both on social themes and Ukrainian history in the Ukrainian language. He felt deeply the destruction of Ukrainian culture and independence, and this became a major theme of his writings. A collection of his poems was published by a merchant patron in 1840, and though attacked by Russian critics, Shevchenko achieved immediate fame in his native land. He returned there for several visits while studying at the Academy of Art to which he had been admitted, and made sketches of historic places, planning a series of pictures of Ukrainian history which would be issued as prints. He intended to use the proceeds to buy his family's emancipation from serfdom, but partly as a result of his involvement in literature, the project never materialized.

In 1846, Shevchenko settled in Kiev and became associated with a circle of intellectuals who developed ideas of a Pan-Slavic federation where each national group would be allowed to develop in its own way. Shevchenko continued to write poetry. He not only attacked the czarist regime and the Russian domination of Ukraine but also, in poems circulated in manuscript, the czar and czarina personally (even though it was the latter who had bought the painting that gave him his freedom).

The following year the group was denounced by an informer and the members arrested. Shevchenko was condemned to indefinite hard military service in the East, and the czar forbade him to write or paint. This sentence ended his hopes of an artistic career. Though he wrote surreptitiously, it was another matter to obtain painting supplies. Shevchenko has come down in history as a great poet and national hero, and his vocation as an artist has been largely ignored. The hardships of his life can be imagined, but his sufferings were alleviated at times by sympathetic officers and their wives who responded to his plight. One example was his appointment as military artist to an expedition exploring and charting the Sea of Aral as part of the Russian push toward Afghanistan. Far from St. Petersburg it was possible, when no other artist was available, to ignore the prohibition. Thus Shevchenko was given a free hand to draw landscapes, though the physical conditions of the expedition, which lasted eighteen months, proved appalling.

There was not proper food and water for crossing the Karakum Desert and the inhospitable areas beyond, and Shevchenko suffered severe health problems. When eventually seven years later, after further tribulations, he was allowed to return to St. Petersburg in 1857, he was a broken man. He died in 1861 just forty-seven years old, a week before serfdom was abolished.

I have outlined Shevchenko's life because it reveals such a difference from the sufferings of Western European artists (poverty, lack of recognition, etc.). When it came to the desire to portray the sufferings of oppressed people, Shevchenko had the great advantage (or disadvantage on the personal level) of experiencing them at first hand. Just before his release he made a series of drawings for prints to illustrate the horrors he had felt and witnessed. A devout if unorthodox Christian, Shevchenko planned a series of prints inspired by the parable of the Prodigal Son and set in the present. Several drawings showed the savage punishments meted out to the soldiers, an example of Shevchenko's courage in continuing to attack the authorities.

Running the Gauntlet, 1856 [140], shows a punishment that was particularly horrible. The prisoner, stripped to the waist, was led slowly by guards between two immensely long lines of soldiers armed with wet birches who rained blows on him. Apparently a coffin was often brought along, as the victim frequently did not survive the ordeal. Shevchenko instinctively avoided the melodramatic. He chose the moment when the man is stripped and the corporal or sergeant who has knocked off the shackles announces to the presiding officer that everything is ready. A feeling of bleakness is created by the economy of the setting, while the contrast of the modeled foreground figures with the silhou-

140. *Running the Gauntlet.* By T. Shevchenko, 1856. Shevchenko Museum, Kiev.

etted soldiers suggests something threatening in the latter, and the line seems infinitely long. Shevchenko also creates a disturbing mood with the main figures, as the sergeant is awkwardly obscured by the prisoner, and their heads face in opposite directions. The use of the back view works well to separate us from the event, and to carry the movement into the background.

We think of Goya when looking at this drawing, not only because of the theme and the compositional concept, but the wash drawing would naturally translate into aquatint, though Shevchenko does not quite achieve the gritty, bleak reality of the Spaniard. Shevchenko received his artistic training in the 1830s and early 1840s, and he retained some of the neoclassical ideal of form taught at the Academy. We see this in the beautifully smooth skin of the prisoner and his powerful stance.

While Shevchenko's drawing cannot be called Realist, I have included it as a remarkable achievement by a man whose artistic training

had given him a very limited knowledge of European nineteenth-century art, and who had been cut off from art for nine years. He took a subject which was the kind of issue dealt with by Realist writers but which is rarely found in art. As I pointed out earlier, the Realist artists were a good deal more conservative than we often like to think, and even their controversial subjects were safely controversial. Courbet's stonebreakers and Millet's brutalized peasants might be attacked as unfit themes for art, but there was no danger of the artists being imprisoned. Shevchenko opposed the oppression of czarist Russia, suffered for it, but continued to risk appalling consequences. He seems less a contemporary of the French artists than a predecessor of many of the "unofficial" artists in the Soviet Union.

The largest and the most successful attempt by artists to free themselves from the oppressive grip of an Academy and to set up an exhibition system of their own took place in Russia. Given our interest in the artistic struggles of the nineteenth century, it is surprising that the history of the *Peredvizhniki*, or Travelers, is not better known. The political goals of the Travelers have also been surprisingly neglected by writers interested in art with a social purpose, as the Russians offer far more cogent material than Courbet. Historians of nineteenth-century Russian culture always stress the strength of the belief in the necessity of art to act as a reforming force in society. The writings of Chernyshevsky and Tolstoy were not so much an influence as a powerful expression of a common belief. Perhaps, as is the case of the Scandinavian art discussed in Chapter 9, the fact that most of the paintings have remained in the region where they were produced has reduced our interest in them even in an age of international art books.

The Academy in St. Petersburg, which dominated Russian art, was artistically a dismally conservative institution, while politically it expressed the will of the czar. Not surprisingly the dissatisfaction of the intelligentsia spread to young artists. In 1863, by chance coinciding with the Salon des Refusés in Paris, a group of students walked out of the Academy School in protest against the imposed subject for the gold medal competition. They set up an artists' co-operative, which while it did not produce remarkable art, paved the way for a bolder group of artists, who in 1870 founded the Association of Traveling Art Exhibits. The annual exhibitions that they organized traveled from St. Petersburg and Moscow to the provincial cities of the Russian Empire like Kiev, Odessa, and Vilnius, where they created enormous interest, and gave the artists the opportunity to find new patrons.

These artists shared in part the beliefs of the Populists that a regeneration of Russia could not simply be the work of the intelligentsia, but must spring also from the Russian people. Consequently, not only did

the exhibitions travel, but the artists abandoning classical and mythological themes went out themselves to paint the Russian peasants, landscape, and the life of the small towns, often satirizing the provincial bureaucrats, the local gentry, and the priests. Subject matter was crucial and the pictures were enthusiastically received by all the different groups of people unhappy with the czarist regime. The pure landscapists were even criticized for not including people in order to point a moral or convey a message. The artists were also often caught between the pressure for a progressive content and the tastes of their patrons, the merchant class, who, while chafing under the aristocratic despotism, were naturally conservative in a number of respects. However, the belief in the innate goodness of the Russian people easily led the *Peredvizhniki* to the Pan-Slavism of the later nineteenth century and to the corresponding belief in the degeneracy of Western European institutions and influences. In the 1880s and 1890s these attitudes led to a patriotism that allied the artists with the government and permitted a rapprochement with the Academy, ending the Travelers as a vital force.

The rejection of the West meant that the aesthetic discussions that raged in France were ignored, especially questions of style. The Russian concern for a moving subject matter relegated style to a minor place, and there was no Art for Art's Sake movement until the very end of the century. The artists were, of course, cut off from the French art world by the geographic factor, but when they did travel or see pictures, not surprisingly they admired painters like Meissonier and Gérôme whose photographic style, and in the case of the former genre subjects, seemed very modern to the Russian artists. The Russians chose types of subject equally undogmatically, moving freely from contemporary scenes that they had observed to invented ones to historical reconstructions.

If the Travelers did not produce as many powerfully conceived works as they might have done with a more rigorous aesthetic, their intense desire to capture what they saw as quintessentially Russian led to many interesting pictures and to a remarkable exhibiting system. Year after year their latest pictures toured the provinces and sparked an enthusiasm among the middle classes and the intelligentsia who flocked to see them. In France, Courbet's *Burial at Ornans* was very well received when he showed it at Dijon before sending it to the Paris Salon, and both Boudin and Claude Monet won medals at provincial exhibitions, but the French artists were so indoctrinated by the primacy of Paris that they never sought to organize shows outside the capital or build up an audience in the provinces. The museum in Bordeaux had bought works by members of the Barbizon School as early as the 1850s, an indication that provincial taste cannot simply be dismissed as an out-of-date reflection of that in Paris.

Ilya Repin (1844–1930), though not a serf, like Shevchenko came from a very poor family in Ukraine. His, however, was a success story, and he has become by far the best known internationally of all the nineteenth-century artists from the Russian Empire. After an apprenticeship to an icon painter, he showed sufficient talent to receive commissions, and he saved some money and went to study in St. Petersburg in 1863. Though he had to live from hand to mouth he too found patrons, and his abilities soon got him accepted by the Academy School, and into advanced classes. In spite of his hard work and intelligence, Repin was slow to establish himself. He worked his way through the many grades of the Academy, which encapsulated the many hierarchies built into czarist society, winning the small gold medal in 1869, and the large gold medal in 1871 with *The Resurrection of Jairus's Daughter*. Though he belonged to the intellectual circle of students who had left the Academy in 1863 protesting against prescribed subjects, Repin's poverty obliged him to follow the official road to success. It was not until 1877, at the age of thirty-three, when the six-year scholarship that went with the large gold medal expired, that he felt able to cut his ties with the Academy and join the Travelers.

While painting *Jairus's Daughter*, Repin had been working on a subject of his own choice taken from life, *Burlaki*, also known as *The Bargemen* or *The Volga Boatmen* [141]. When he exhibited the painting in 1873 just before leaving for Paris on his scholarship, it eclipsed all the previous works of the Travelers. Vladimir Stasov, the critic who regarded himself as the mentor of Russian artists and by force of his intellect and his self-confidence imposed himself on the public, praised it unreservedly:

> One look at Repin's *Burlaki* and one is at once compelled to admit that no one before has dared to undertake such a theme. Such a deeply moving picture of Russian folk life has never previously been seen, despite the fact that this task has been before us and our artists for a long time. Is it not the quality of a great artist to observe and incorporate in his creation that which is truthful and obvious, and yet which is passed unnoticed by hundreds of thousands of people. . . .

Repin had made a boating trip down the Volga in the summer of 1870 when he decided on the subject; he persuaded the bargemen to pose for him and made friends with them. For the artist, his subject exemplified both the back-breaking labor of the poor people and their individual humanity. The painting is different from Courbet's *The Stonebreakers* [101], where the workers are turned away from us, anonymous examples of what Courbet himself described compassionately but detachedly as "the most complete expression of poverty." The *Bargemen*

has been criticized for the conventionally arranged composition of the figures and their presentation as "characters." These characteristics do not surprise us, given Repin's artistic background and his interest in the men themselves. Nevertheless the latter are powerfully created, and we feel Repin's desire to create real people, not stock types. Not surprisingly he was an excellent portraitist and left memorable portraits of Mussorgsky, Tolstoy, Stasov, and the collector Tretyakov among others. These portraits vary in format, some with the traditional blank background, but in others Repin's originality asserts itself—especially in his pictures of Tolstoy, who is shown sprawling on the grass reading or guiding a plow. We feel the relation of the writer and his environment so successfully that Tolstoy's wife tried to suppress the publication of a print of the latter.

141. *The Bargemen.* By I. Repin, 1873. Russian Museum, Leningrad.

In Paris, Repin looked at the Impressionists but found their style incompatible with his own desire to explore the problems of Russian life. He did see possibilities of color, brushstroke, and composition in their work, and where the subject was appropriate, he experimented with these new ideas, as in his portrait of his daughter entitled *À la Manet,* or in a painting, *The Garden Bench,* 1876, of his family sitting in the garden reading and sewing. Not only is the unpretentious treatment without anecdote typical of the Impressionists, but so is the color and lightness of touch.

Back in Russia Repin painted a variety of pictures, typical of his colleagues' range, including reconstructions of both Ukrainian and Russian history. Several of the Russians felt a deep need, partly because of censorship, to comment on the present through famous incidents of the

past. Free from the Western European artists' self-consciousness about history painting, they were still able to put life into this genre, and Surikov's pictures *Boyarynia Morozova* and *Morning of the Execution of the Streltsy* stamp themselves on our mind. Repin's paintings vary from bizarrely gripping psychological studies like that of Ivan the Terrible with the son he has just killed in his arms, to the overdone caricatures of the *Zaporozhie Cossacks Writing a Reply to the Turkish Sultan* (as in the case of the *Bargemen*, Repin's preliminary portrait studies possess more authenticity).

From the Realist point of view, Repin's pictures inspired by the political situation of his day interest us more. They also illustrate the difficulty of portraying events and experiences the artist has not observed or participated in (Shevchenko's case is exemplary—the artist undergoing the experience could not paint it). At the same time Repin's genius led him in the 1880s to find one outstanding solution and to paint two other very interesting pictures. All the themes were bold, and Repin wrote: "I am a man of the sixties. I try to embody my ideas truthfully; life around me stirs me deeply, gives me no rest, cries for the brush; reality is too full of injustice for one to be able to trace pretty sketches with an easy conscience."

Refusal of Confession Before Execution and *Arrest of a Propagandist* necessarily involved imagining a dramatic moment. The revolutionary in his prison cell rejecting the priest is enveloped in a Rembrandtesque chiaroscuro that destroys the environment in the conventional way that we find in Jozef Israëls's interior [144], and that is common in the paintings of the Travelers with titles like *The Sick Woman, The Sick Husband,* and so on. The *Arrest* shows police officials going through the papers of a young man, looking for subversive pamphlets, in the peasant house where he is staying. He is obviously a Populist trying to arouse the peasants to revolt: commentators have pointed out that the peasants in the background pay no attention to the arrest, apparently indifferent to his mission. Again we find the problem of interpretation of Realist works where the artist does not superimpose an established code of gestures. It is equally plausible to think that in self-protection the peasants are withdrawing from the event.

Repin's style varies considerably, a product of his lively, inquiring mind. As opposed to the Rembrandtesque chiaroscuro of the *Refusal,* Repin in the *Arrest* defines the space, introduces far more detail, and gives us the sense of an actual place. The painting is still rather dark, but there is a richness of color that probably owes something to his admiration for Rubens (yet another example of the importance of seventeenth-century art for the Realists). As opposed to the impassive

peasants, the arresting officers gesticulate a little too enthusiastically, and most writers have picked out *They Did Not Expect Him*, 1884, re-worked until 1888 [142], as the masterpiece of this series.

When this painting, which shows an exile returning unannounced to his family house, toured with a Peredvizhniki exhibition in 1884, it was praised or attacked in the newspapers according to their political orientation, and drew enormous crowds. There are no Baroque echoes in the style, the emotional moment is not overdone, and the picture possesses the ring of contemporaneity. In fact, Repin brilliantly handles the responses of the family. The man's aged mother in the foreground has her back to us, his wife is half concealed by the mother, the son's joyful face is pushed to the side of the canvas, while the daughter who is more conspicuous is not old enough to recognize her father and looks

142. *They Did Not Expect Him.* By I. Repin, 1873. Tretyakov Gallery, Moscow.

slightly fearful at this apparition. Repin used his own family as models, and he succeeded in creating individuals, not types. The surprise of the family is expressed through the composition, the abrupt angles of the armchair, and the contrasted directions of the mother, wife, and sheet music, and the dark/light contrasts of clothes, hands, and faces.

Repin divided the canvas in a masterly way, with the exile placed in a separate vertical pocket of space formed by the door and the steep perspective of the floorboards. This division suggests the separation that has taken place and the psychological drama of the return, but there is nothing artificial in it. The placing of the cook and the maid behind the exile link him to the group as a whole, and the picture strikes us as quite authentic. George Heard Hamilton sees this composition as the result of Repin absorbing ideas from Degas's canvases that he had seen in his Paris stay,[4] and we can also be reminded of Caillebotte's pictures of the 1870s.

Repin continually repainted his pictures; there exist a number of accounts, not always consistent, of the changes he made in the exile's face. Not only did he change the expression from a confident one to one that showed the intense sufferings the man had undergone, but he repainted it also at the request of Tretyakov, who had bought the painting. Critics have read a whole commentary on the changing Russian political situation in these successive expressions, but their interpretations seem to owe more to their own preconceptions than to any convincing evidence. Repin was an excellent painter of faces and in the final version we have a complexity of expression that to me evokes the diversity of the man's experiences from the ordeals of exile to his liberation. It is difficult to extract a very specific message from it. The picture as a whole, including the face, makes us feel the pervasiveness of the totalitarian feudal system where a comfortably off middle-class family is just as riven by anguish as a peasant or serf family like Shevchenko's.

Savitsky's *Repair Work on a Railroad*, 1874 [143], referred to in Chapter 4, may have been partly inspired by Repin's *Bargemen* exhibited the year before, but it overcomes in a very original way the compositional weakness of that picture. Almost all the paintings that we have looked at by Courbet, Millet, Brown, and so on were based on the traditional concept of the protagonist or hero (which may be a small group) who occupies the center of the picture. As we have seen, this contrived composition was one of the stumbling blocks to creating Realist art. Savitsky, by putting in over thirty workers and by leaving the immediate foreground empty, eliminates the "heroic worker" with his air of pictorial cliché rather than messy reality.

[4] G. H. Hamilton, *The Art and Architecture of Russia.* Harmondsworth, Middlesex, England, 1975, p. 268.

The proliferation of diagonals of the planks laid as footpaths through the mud, of the wheelbarrow sides, the arms and bent backs of the workers, of the railroad tracks and the slope of the cutting, effectively convey the chaotic nature of large-scale construction projects. Even the dipping of the horizon line at the center of the picture disperses the action to the sides. We feel that Savitsky draws as much on the world of the magazine illustrator as on the painterly tradition, and that he has very successfully synthesized the two.

143. *Repair Work on a Railroad.* By K. Savitsky, 1874.

THE HAGUE SCHOOL

At the end of the nineteenth century, the Dutch Hague School achieved international popularity with the same broad public who admired the Barbizon School. We can see many similarities between the two schools in both the ordinary subject matter and the desire not to romanticize it. The Dutchmen painted many dismal landscapes with the color drained out in the constant drizzle blowing in from the North Sea. Yet though they produced good pictures, in general they are disappointing. The artists were timorous, caught between their admiration for the seventeenth-century masters and the Barbizon School. The painting does not assert itself, and the artists seemed content to look back.

Israëls's *Grandmother's Treasure*, [144], typifies not only one aspect of the Hague School but a large number of paintings produced throughout Europe in the nineteenth century by artists who regarded themselves as Realists of one kind or another. These painters wished to

depict everyday life with seriousness and dignity, but they employed an overwhelming chiaroscuro that picked out the figures in the foreground unnaturally brightly while burying the background people and setting in a thick gloom. They probably thought that with the heavy beams and small windows this lighting was accurate, yet it came from

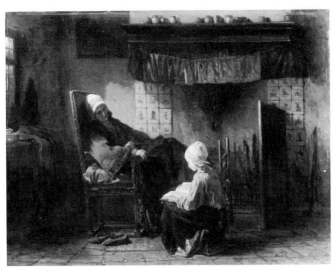

144. *Grandmother's Treasure.* By J. Israëls. Metropolitan Museum of Art, New York, Mr. and Mrs. Isaac D. Fletcher Collection, Bequest of Isaac D. Fletcher.

convention. At first the pictures seem to resemble Daumier's oils with the dark brown palette, but scrutiny reveals a crucial difference. Daumier uses his chiaroscuro to bring out the solidity of the bodies beneath the clothing and the force of the objects with which the people interact [43]. Israëls cooks up a brown soup where we identify the clothing but cannot feel the bodies beneath, and where the furniture melts into the clothing and there are no hard edges or sharp planes. The work lacks the slabs of assertive paint that pick out the shapes in the French Realist pictures.

Too great an admiration for Rembrandt prevented an artist like Israëls from seeing what was necessary in his own work. Dutch seventeenth-century art, which inspired so many of the Hague School, was not reworked with Spanish art as it was in Paris, so that the Hague pictures often seem to emerge from a time warp as if they were a development of the art of a century and a half earlier.

While the interiors fade into a brown fog, the landscapes take on a grayness which was criticized by writers at the time. The three pictures by leading members of the school, J. Maris [125], A. Mauve [145], and

P. Gabriel [141], are all wonderful evocations of rainy days, but their compositions with profound recessions into space set them comfortably into the traditions of Dutch painting. If we compare them with the abrupt perspectives of the contemporary Impressionist paintings or the slashing lines of rain in Degas, which vibrate with nervous energy, we sense the two worlds of tradition and modernity. It takes an effort of will to remember that these three canvases were all painted after Claude Monet's sparkling views of Holland painted at the beginning of the 1870s.

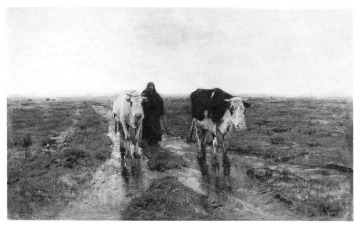

145. *Changing Pastures.* By A. Mauve. Metropolitan Museum of Art, New York, Bequest of Benjamin Altman.

146. *Train in a Landscape.* By P. Gabriel, 1887. Rijksmuseum Kröller-Müller, Otterlo.

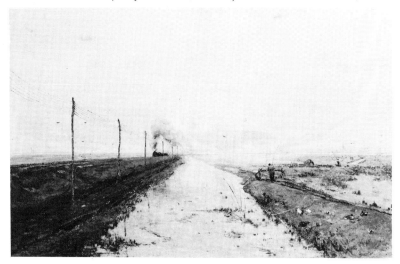

Vincent van Gogh, briefly a pupil of Mauve, painted pictures like these when he began his artistic career, but he transformed his art when he went to Paris in 1886 and saw the Impressionists' and Post-Impressionists' canvases. The outlook of the painters who remained in Holland can be seen in the art collection of Mesdag, who had the luck to be an independently wealthy artist and collected French pictures in addition to those of his colleagues. We find the Barbizon artists Rousseau, Diaz, Daubigny, Corot, Millet, and Courbet, but no Impressionist paintings.

THE SALON

A number of scholars today are working to revise our conceptions of the dramatic opposition between *"pompiers"* and the avant-garde in France. Many books on nineteenth-century art have presented a clear-cut division between the bad and the good—the mediocre painters of the Salon using every means to crush new ideas and really talented young artists. The revisionists are attempting to show that the leading artists of the Salon were much better than we have thought, and the art of the avant-garde was not so different from theirs after all. Certainly a comparison between the work of the academicians and of the Realists can clarify both, as both groups claimed that they were seeking "truthfulness" in their paintings.

I have chosen three of the most popular French painters of the nineteenth century, who each thought of himself as devoted to "truth" and each rejected the Impressionists very forcibly.

Bouguereau, Gérôme, and Meissonier have kept their names in the histories of art, if only as villains, when many of their once famous colleagues have been largely forgotten.

The term *pompier* fits Bouguereau (1825–1905) particularly well. Its original meaning of firefighter is supposed to suggest the uniforms of the latter and of academicians, and to suggest pompousness too. He could cheerfully paint voluptuous nudes and the Virgin at the same time, but never anything that he saw around him, while maintaining his devotion to the pursuit of truth. Everything vital in the art of his lifetime passed him by. Bouguereau achieved his popularity, and many decorations, through the smooth surfaces of his canvases which express in places his talent as a colorist, the irresistible sentimentality of his dressed young women pretending to be peasant girls (usually in Italy though painted in Paris), and the equally irresistible sexiness of his undressed young women. Sprinkled through all the paintings, but es-

pecially his religious ones, are naked babies and young children whose pearly skins, large eyes, and adorable expressions have a universal appeal.

In the twentieth century these characteristics made Bouguereau's name synonymous with the worst aspects of Salon art, but recently there has been a major effort to present him as a significant and misunderstood artist. Scholars and museum curators from three countries organized a major retrospective exhibition in 1984, and they produced a substantial catalogue. It is claimed there that Impressionist painting is very pleasant but offers nothing to the mind, while the art of Bouguereau and his colleagues gives importance to thought. There is the artistic thought that goes into the works, and reflections on culture and history.

When we study Bouguereau's art we may doubt these claims. The concepts of most of his works and the poses are drawn from earlier pictures and sculptures, and it is difficult to see how he has rethought them. The concepts, as suggested above, are commonplace. The upturned eyes of his *Virgin of Consolation* (the whites prominent) and the clenched hands of the angels in the *Pietà* add nothing to previous models, and the religious genre remains dead. Bouguereau's compositions are particularly lacking in artistic thought and seem mechanical in their frontality and centrality. In pictures with one or two figures, they are placed in the center of the canvas looking at the viewer as though posing for a photograph. He has a curious habit of squashing the figures together into a lump as if he could not organize them in space. There is very little interaction with the surrounding space in consequence, and the works look doubly photographic as the backgrounds in contrast to the modeling of the people are flat and smudgy like a photographer's studio's painted backdrops.

Orestes Pursued by the Furies, 1862 [147], offers conventional figure types, whose originals the experienced gallery goer will recognize. Even though the subject is dramatic, the gestures still seem melodramatic in the tradition of Greuze. Orestes is solidly modeled like most of Bouguereau's figures, and stands firmly on the ground, but the draperies float according to no earthly logic and seem to have come from another pictorial order. The catalogue lists some of Bouguereau's borrowings but makes no attempt to explain where there is thought or meaning in the picture. It does point out that this kind of picture became increasingly difficult to sell, again without comment. If the art public was not attracted by this grotesque grouping of Orestes' mother, a dagger in chest also included, it is not surprising. The subject required the real rethinking of a Freud to give meaning to the psychological possibilities

of Greek myth in expressing the love-hate relation between children and parents.

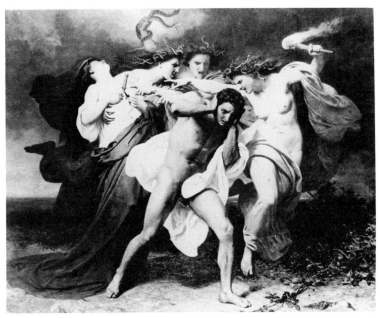

147. *Orestes Pursued by the Furies.* By W. Bouguereau, 1862. Chrysler Museum, Norfolk, Virginia, Gift of Walter P. Chrysler, Jr.

This picture was painted in the same year as Manet's *Concert in the Tuileries* [155], another crowd of people. The Manet may seem a trivial subject, but it had more meaning than the irrelevant *Orestes*. If the public was not ready for Manet, it felt the obsolescence of the Bouguereau. And if Manet had his artistic sources too, he rethought them thoroughly so that his painting has the freshness of a new vision. *Orestes* is awkwardly crowded, while Manet creates a new beauty out of the crowd.

Bouguereau's peasant girls [148] are also posed; the feeling of a photographer's studio and rented costumes is particularly strong here, but there are no forced expressions and the clothing hangs naturally and is beautifully painted. Bouguereau's greatest talent lay in recreating the nuances of color and shade in clothing, especially in the white blouses and shirts he so often gave his figures. He possessed a wonderful feeling for the different whites, creams, and light grays created by the folds and wrinkles in sleeves. Each of the shirt sleeves would make a beautiful painting in itself. The dark clothing which he has to intro-

duce, which does not permit these nuances, is much less interesting than the light-colored garments.

If Bouguereau had confined himself to painting sleeves and similar details, he would have been a fascinating painter. But he could not resist sentimental or erotic touches, and these two peasant girls look like models hired for the occasion. We are reminded of Millet, who said, on seeing a picture like this, "Girls as pretty as that wouldn't have stayed in the village long."

Bouguereau never seems to have painted what he saw about him, except for the details of costume, or even to have wanted to recreate actual events from history. All his pictures seem to float in a never-never land, which may account for the success of his nudes, and the fact that he was not accused of indecency. One of the features of Bouguereau's pictures has always been the sheer sexiness of his women,

148. *The Crown of Flowers.*
By W. Bouguereau, 1884.
Montreal Museum of Fine Arts,
Gift of R. B. Angus.

whose pose is often extremely provocative. The architect Charles Garnier wrote of *Nymphs and Satyr*, 1873 [149], "He had depicted a rather risqué subject with charm and delicacy; he has represented nudity with modesty and voluptuousness without lewdness." There have been people who have found these nudes enjoyably lewd, like Théophile Gautier, who in his Salon reviews wrote in a similar vein to Garnier, but who in private wrote indecent poems inspired by these same paintings.

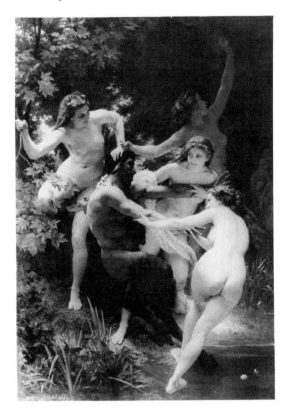

149. *Nymphs and Satyr.*
By W. Bouguereau, 1873.
Sterling and Francine Clark
Art Institute, Williamstown,
Massachusetts.

Hypocrisy was understandably an endemic vice in writing about nudes in the nineteenth century.

Nymphs and Satyr is exceptionally well composed for a Bouguereau painting, and was a huge success when hung in the bar of the Hoffmann House Hotel in New York at the end of the nineteenth century. His painting of skin matched the beauty and subtlety of his white and creamy draperies. It would be a very puritanical person who did not find Bouguereau's nudes appealing, but I cannot find the qualities of thought and High Art in his work that his present-day enthusiasts emphasize.

We think of Gérôme (1824–1904), like Bouguereau, as primarily a painter of bosoms and bottoms, although he painted other subjects. However, Gérôme had such a talent for finding undressed women in almost any situation that it is hard to remember the other pictures. Socrates, who inspired most artists with ideas of philosophic nobility, or stoic courage at his death, was presented by Gérôme beset by nude seductresses. Few of us think of a cockfight as an event that spectators attend unclothed, or that women play bowls in the buff, but Gérôme did. On the other hand he had a much wider range of interests than Bouguereau, and a genuine curiosity about the appearance of an exotic world. He traveled to Egypt and the Middle East several times to draw and to sketch in oils. He was very much part of his time in feeling the need to transform Oriental pictures from fantasies to accurate representations of the people, architecture, and landscapes through direct personal observation. In addition to these sketches, he had photographs taken, and the dazzlingly rich reproduction of Arab calligraphy in some of his mosque scenes must depend on these photographs.

Nevertheless, Gérôme found it hard to resist the appeal of the nude, and fantasy reappeared in his pictures as he enjoyed the juxtaposition of black- and white-skinned women, or the unpleasant sado-masochistic sexual theme of a young white woman in a slave market being poked by lustful Arab buyers. When Gérôme stuck to straightforward observation, he could be much more interesting. It is a fashion today to dismiss almost all of nineteenth-century pictures of the world outside Europe and North America as imperialist and racist. Any examination of the works themselves and of the writings of the men and women who traveled in Africa reveals a whole range of attitudes, including very importantly a genuine curiosity about all aspects of the little-known, mysteriously appealing "dark continent." Many of these explorers and travelers were not condescending in the least, and were anxious to bring back accurate reports in the best tradition of nineteenth-century science. Gérôme seems to have combined the extremes of the different approaches, flitting from one to another. When he was fascinated by an actual subject—a rug merchant, the interior of a mosque with worshippers, or the desert landscape—he documented it conscientiously, and we see the truthfulness that he and his colleagues called for allowed for once to prevail.

A painting like *Interior of a Mosque,* 1870s [150], persuades us of its actuality. We feel no sense of posed costume drama as in his *Napoleon in Egypt,* 1863 (Art Museum, Princeton University), or of marionettes frozen in mid-gesture, as in *Dance of the Almah,* 1863 (Dayton Art Institute). Rosen and Zerner have suggested that the "licked" surface is incompatible with Realism, as it tries to create an illusion of a real scene,

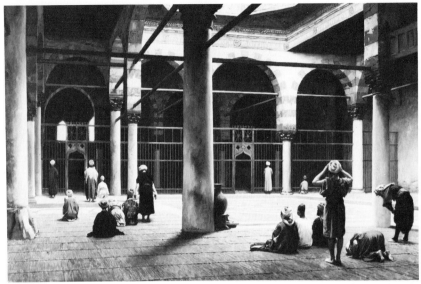

150. *Interior of a Mosque*. By J.-L. Gérôme, 1870s. Memorial Art Gallery of the University of Rochester, Gift of Mr. and Mrs. F. Harper Sibley.

and consequently Academic Realism is an impossibility.[5] Their principle is correct, but I believe that certain pictures succeed in transcending the contradiction. The *Interior of a Mosque* possesses two elements that enable it to escape theatricality. The absolute stillness would be broken by visible brushstrokes, patches of light or bright color. The deep and expansive space articulated by the architecture plays an essential role in creating the contemplative mood of the painting, so that the smooth surface and depth construction work as expressive elements rather than illusionistic scaffolding. Gérôme, perhaps unconsciously, has adopted the Realist backview of the worshippers, which not only contributes to the quiet effect but eliminates any temptation to make their faces "interesting." Surprisingly, the floor seems to curve downwards at the front of the painting. This oddity of perspective may stem from the use of photographs with their foreshortening, but it is a device used by Degas to bring the spectator into the picture and give it immediacy instead of the detachment that results from a correct perspective.

It seems that the success of works like *Interior of a Mosque* results not so much from conscious decisions as from the artist's unimaginative treatment once he has selected the theme. I write this not derisively but sadly. Gérôme himself said of one of his imaginary constructions, *The Apotheosis of Augustus*, "it lacks invention and originality." The willingness to try to paint such an uninspiring subject says much about the

[5] C. Rosen and H. Zerner, *Romanticism and Realism*. New York, 1984, ch. VIII.

mindlessness of the academic artist. Gérôme, like his colleagues, provides a good example of Coleridge's distinction between the "fancy" and the "imagination." The fancy is the mere juxtaposing of unlikely elements while the imagination is the creative synthesis of a new vision. Gérôme's lack of an artistic imagination can be seen in his choice of *Truth Emerging from a Well* as a subject. The canvas must be one of the most hilarious of the nineteenth century. We are confronted with a perfectly ordinary well in the corner of a courtyard out of which climbs, with an astonished expression on her face, a nude woman. Not only were all of the Realist artists intelligent enough to understand that this kind of allegory was no longer possible, but they also realized that the desire for truth common to them and the academic painters meant that the sight of a Parisian model climbing out of a well was ludicrous. The picture would have been even funnier if Gérôme had executed one of his preliminary drawings in which two men haul a bucket up out of a well with the naked lady standing in it, her balance looking very precarious in the small bucket.

Meissonier (1815–1891) was potentially the most interesting of the three artists, and as we have seen his career has a number of parallels with that of Menzel, who was born in the same year. Both started as book illustrators with a fanatical desire for historical accuracy which led them to conduct arduous research in order to get costumes, utensils, and settings correct. As painters they continued this approach, and they became the two most admired and honored artists in Europe. Meissonier not only received the highest prices of any artist for his pictures, but he was promoted in 1889 to the highest grade of the Legion of Honor, the first artist to be so dignified. His work is perhaps the best example of Academic Realism, if we accept the term. He ransacked the flea markets of Paris for clothes and accessories, and spent hours in libraries studying historical sources in order to achieve a minute and perfectly detailed representation of all the trappings in his pictures. At the same time he had a horror of painting anything that he had seen himself, and his enormous reputation was gained by the recreation of genre scenes from the times of Louis XIII and Louis XV.

Initially Meissonier's keen interest in the past pointed him to history painting, but he was dissuaded by his friend the painter Chenavard, who recognized where his talents lay, and who urged him to paint genre scenes. These latter, men reading, smoking, playing chess, looking at artists at work, horsemen stopping at an inn for a drink, fascinated the public and other artists throughout Europe. Meissonier was seen as working in the tradition of the Dutch seventeenth-century painters, and Théophile Gautier claimed that his pictures rivaled when they did not surpass those of the Dutch. Exaggerated claims of this kind

sprang from the fact that Meissonier avoided any of the vulgarity of the lively brothel scenes of Jan Steen or Terborch's searchers for fleas. Meissonier was described as "a Dutchman with style"—a judgment strange to us, but Vermeer was only being discovered at that time.

The pseudo-science of gesture and expression discussed earlier contributed to Meissonier's reputation, as his gesticulating figures were seen as exemplary, though today they appear as animated puppets exaggerating every expression. A musketeer twirls his mustache like a villainous squire in a Victorian melodrama, and even in a quiet scene, a poet at his table bites the end of his quill pen as he searches for a line. Meissonier painted many of the same scenes as Daumier, but his figures strike a pose while Daumier's are intent on what they are doing.

Surprisingly for an artist who painted Rococo interiors, Meissonier rarely painted women and avoided the nude, something that must have been inexplicable to Bouguereau and Gérôme. This further parallel with Menzel involves us with the interesting side of his art. Meissonier was driven by his need for historical accuracy, tormented by the difficulty of finding sufficient sources or the correct accessories. He rejected entirely the meretricious appeal of shapely young women in imaginary situations, in favor of the everyday which we could see had we but a time machine. I believe that his exceptional success with the public lay in this fact. He satisfied people's intense curiosity about the past without making them feel unconsciously that they were being manipulated, as probably happened when they were admiring Bouguereau or Gérôme.

In 1848, at the age of thirty-three, Meissonier made a venture into the present. As a captain in the National Guard he took part in putting down the popular June revolt. His company stormed one of the last barricades of the poorly armed people, and Meissonier, for reasons that are not at all clear, painted the aftermath of the slaughter. *The Barricade,* 1849 [23], exhibited at the Salon of 1850–51 with Courbet's *The Burial* and his *Stonebreakers,* measures only 11½ by 8¾ inches but is equally as arresting as the giant paintings. The dusty, shuttered street, the pile of cobblestones, the grimy shirts and trousers of the slain, form an urban counterpart to one of Millet's drab, small paintings, as well as being a reminder of Daumier. The banality of Death that Nochlin wrote about finds early expression here, and the picture seems light-years away from Delacroix's mythologically heroic *Barricade* of only eighteen years before.

We know Meissonier today as a painter of Napoleonic pictures because of the popularity of *1814,* or *The French Campaign,* as it is sometimes called [151], but these constituted only a tiny part of his work. He had thought of Napoléon as a subject, but to an artist with Meissonier's devotion to accuracy, a battle picture presented enormous difficulties.

He generally included no more than four figures in a painting and they were seated or standing still. However, in 1859 Napoléon III took Meissonier on his campaign in Italy and commissioned a painting of the Battle of Solferino. The artist met this challenge, though the painting was promised for the Salons of 1861 and 1863 but appeared only in 1864.

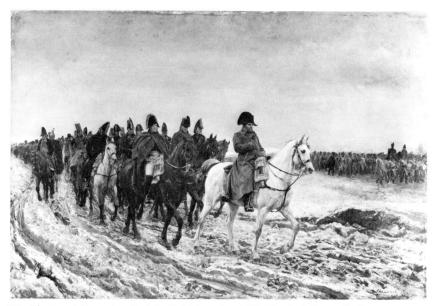

151. *The French Campaign.* By J.-L.-E. Meissonier, 1864. Musée d'Orsay, Paris.

After this baptism he began his Napoleonic cycle, which remained unfinished, but offers an interesting perspective on nineteenth-century art. He worked on *1807* (Metropolitan Museum, New York), inspired by the Battle of Friedland, with its cavalry charge through a field of wheat, for twelve years. His preparations included buying a field of wheat and having horses gallop through it to trample the wheat in the correct way—a story which reminds us of Claude Monet buying the poplar trees he painted in the late 1880s so they would not be chopped down before his series was finished. In spite of this verisimilitude, admirers even at the time felt that the overall compositions of the various groups were not persuasive, and we encounter the problem of the galloping horses frozen in mid-stride—the insoluble difficulty of the academic meticulously detailed style. Meissonier had gone to the trouble to have a trolley on rails built so that he traveled beside a galloping horse to observe it closely.

The French Campaign, with its slow movement of the French army

making its painful way back from Russia, works much better. The representation of the dirty trampled snow is a tour de force of painting, much more convincing than his human subjects. Meissonier waited until he had a day with snow on the ground and "a sad, black sky filled with opaque thick clouds." When he did observe the world around him, as here, his pictures come to life. The *Barricade* is an unforgettable painting, and some oil sketches of horsemen on the beach at Antibes show a freshness and feeling for light lacking in the reconstructions.

Looking at these three artists—Bouguereau, Gérôme, Meissonier—all believers in "truth," and convinced of the necessity of carefully rendering textures and reproducing detail with photographic accuracy and with the illusionistic effect of invisible brushstroke, we can see that Realism, or successful painting in the mid-nineteenth century, had nothing to do with this kind of academic accuracy.

Bouguereau, though he showed a feeling for color in sections of his pictures, lacked all idea of composition, and more importantly, of what was appropriate to a serious painting. His pseudo-Virgins, pseudo-goddesses, and pseudo-peasant girls are frankly absurd, and those people today trying to advance him as a significant painter seem, to put it gently, misguided. Gérôme produced so many meretricious, bizarre, and to our contemporary view, distasteful paintings that it is hard to put them out of our mind and to see that in a handful of pictures, where an Eastern subject seemed interesting enough in itself and needed no spicing up, Gérôme could paint an actual scene in a solid way. Meissonier could have been a remarkable artist if he had given the same passionate research to the present that he gave to the past (Menzel's art discussed above throws a revealing light on Meissonier's). As it was, rarely observing actual human gestures and poses, he lifted all his figures from other art. But hampered by nineteenth-century "taste," he was, as Baudelaire put it, "a Fleming without the fantasy, the charm, the color and the naïeveté—and the pipe!"

The gulf between the successful art at the Salon and Realist art can be seen in three peasant paintings, Bouguereau's *The Crown of Flowers* [148], Jules Breton's *The Potato Harvest* [152], and Millet's *The Potato Harvesters* [153]. Breton has been put forward as a Realist in recent years because he returned to his native region to make careful studies for his paintings, but only too often, as here, he chooses reasonably attractive young women and places them in a nobly silhouetted pose. The comparison of Bouguereau's and Breton's traditional compositions with Millet's figures, turned away from us and bent over, express more eloquently than words the necessity of the unposed, slice-of-life viewpoint for Realist painting, and indeed for successful painting at that time.

152. *The Potato Harvest*. By J. Breton, 1868. Pennsylvania Academy of the Fine Arts, Philadelphia, Bequest of Henry C. Gibson.

153. *The Potato Harvesters*. By J.-F. Millet, 1854–57. Walters Art Gallery, Baltimore.

Modern times find themselves with an immense system of institutions, established facts, accredited dogmas, customs, rules, which have come down to them from times not modern. In this system their life has to be carried forward; yet they have a sense that this system is not of their own creation, that it by no means corresponds exactly with the wants of their actual life, that, for them, it is customary, not rational. The awakening of this sense is the awakening of the modern spirit.

<div align="right">Matthew Arnold, 1863</div>

What is the object of painting?

"To express the *Ideal*, depict the Beautiful," cries a chorus of enthusiasts.

Hollow words! . . . Beauty is not a reality existing outside man. . . . Let us come down to earth where truth lies . . . painting should accompany society step by step and mark its incessant transformations.

<div align="right">Jules Castagnary, 1863</div>

The Bourgeoisie has subjected the country to the rule of the towns. It has created enormous cities, has greatly increased the urban population as compared with the rural, and has thus rescued a considerable part of the population from the idiocy of rural life.

<div align="right">Karl Marx, 1848</div>

The naturalist school re-established the broken connection between man and nature. In a double effort—on country life which it already interprets with such rustic power, and on city life, which [the naturalist school] still holds in reserve its greatest triumphs—it strives to encompass all the forms of the visible world.

<div align="right">Jules Castagnary, 1863</div>

7

CHANGING IDEAS AND
THE EARLY WORK OF MANET

RUSKIN AND BAUDELAIRE

The complexity of the desire for visual accuracy, truth to life, and the contemporary can be seen in the contrast between the two most remarkable writers on art in the mid-nineteenth century, John Ruskin, 1819–1900, and Charles Baudelaire, 1821–1867 [52]. Neither was a propagandist for Realism like Champfleury, who defended Courbet vigorously and edited the magazine *Le Réalisme,* but both advocated either an intense study of nature or a spirit of contemporaneity that furthered Realism.

The two men could hardly have been more different, in their ideas or their careers. Ruskin's numerous books on art became best sellers, and he preached a moral purpose in art with messianic assurance. His desire to reform the world led him to write more and more on social and economic matters, which made him an inspiration for reformers at the end of the century. Baudelaire wrote chiefly brief pamphlets or for small magazines. In his lifetime his reputation was confined to a small circle in Paris, and his ideas were spread as much by his conversations as by his writings, though after his premature death in 1867, admiration for his work increased steadily. Baudelaire did not stress any moral or social ideal for art, and he became associated with the school of Art for Art's Sake in the public mind.

The one thing the two writers did share was the possession of an exceptional number of contradictions. Ruskin as a young man of twenty-four published in 1843 the first volume of *Modern Painters.* He wrote it as a defense of Turner because Ruskin had been exasperated beyond measure by the attacks on Turner's later pictures. An immediate contradiction emerges, since Ruskin shared his generation's belief in factual accuracy of a most specific kind. He not only praised the young

Pre-Raphaelite C. A. Collins for his precision in painting a waterlily, but gently chided him for making a tadpole a little too large. Yet Ruskin remained devoted to Turner, who painted nothing precisely at this stage of his career, and Ruskin condemned Constable:

> I have never seen any work of his in which there were any signs of his being able to draw, and hence even the most necessary details are painted by him inefficiently. His works are also eminently wanting both in rest and refinement; and Fuseli's jesting compliment is too true; for the showery weather, in which the artist delights, misses alike the majesty of storm and the loveliness of calm weather; it is greatcoat weather, and nothing more. There is strange want of depth in the mind which has no pleasure in sunbeams but when piercing painfully through clouds, nor in foliage but when shaken by the wind, nor in light itself but when flickering, glistening, restless and feeble.

Nevertheless Ruskin's belief in fidelity to facts ("no great school ever yet existed which had not for primal aim the representation of some natural fact as truly as possible") led him to write endless chapters on rock and cloud formations in succeeding volumes of *Modern Painters* that make the book hard to read today. He came to the defense of the young Pre-Raphaelites because of their painstaking fidelity to the facts, but also because of their moral purpose. The passage from Ruskin's letter to *The Times* quoted on page 131, explaining Holman Hunt's *The Awakening Conscience* [96], embodies Ruskin's own powers of observation and the ease with which he extrapolated ideas from a picture. He also believed that the greatest pictures contained the greatest number of ideas. Ruskin thus shared the contemporary taste for factual detail and the belief in a didactic purpose for art, and he intensified and spread this through the mesmeric effect of his prose style. He increased the British interest in art and helped the public to appreciate the Pre-Raphaelites and the paintings of contemporary scenes [85 and 94], but he hindered an understanding of the important developments of the 1860s and 1870s with his rejection of Impressionism and his contempt for Whistler, who was praised by Baudelaire.

Reading Ruskin today gives us an insight into an important strain of nineteenth-century thinking and feeling about art, as well as providing pleasure for its own sake. If *Modern Painters* cannot be read as a whole, innumerable passages in his extensive books are thought-provoking and striking in style. For fifty years after his death in 1900 Ruskin's reputation declined steadily, but there has been a great revival of admiration for him because of his attempt to see life as a whole, to connect work, art, and economics in a humanly satisfying way. Part of his richness can be seen in the fact that his thinking played a major role inspiring the ideals of the British socialists who first managed to get

elected to Parliament and also those of Mahatma Gandhi, while his prose style helped form that of Marcel Proust, who translated Ruskin's *Bible of Amiens* into French!

The following passage encapsulates Ruskin's extraordinary powers of observation, the respect for visual facts, his desire to incorporate them into a larger vision, his magnificent style, and his excessiveness combined with an uncritical self-confidence:

> We know that house, certainly; we never passed it without stopping our gondolier, for its arabesques were as rich as a bank of flowers in spring, and as beautiful as a dream. What has Canaletti given us for them? Five black dots. Well; take the next house. We remember that too; it was mouldering inch by inch into the canal, and the bricks had fallen away from its shattered marble shafts, and left them white and skeleton-like; yet, with their fretwork of cold flowers wreathed about them still, untouched by time and through the rents of the wall behind them there used to come long sunbeams, greened by the weeds through which they pierced, which flitted and fell, one by one, round those grey and quiet shafts, catching here a leaf and there a leaf and gliding over the illumined edges and delicate fissures, until they sank into the deep dark hollow between the marble blocks of the sunk foundation, lighting every other moment one isolated emerald lamp on the crest of the intermittent waves, when the wild seaweeds and crimson lichens drifted and crawled with their thousand colours and fine branches over its decay, and the black, clogging, accumulated limpets hung in ropy clusters from the dripping and tinkling stone. What has Canaletti given us for this? One square red mass, composed of—let me count—five-and-fifty, no; six-and-fifty, no; I was right at first—five-and-fifty bricks, of precisely the same size, shape, and colour, one great black line for the shadow of the roof at the top, and six similar ripples in a row at the bottom! And this is what people call "painting nature"!

Whereas Ruskin wrote a poetic prose, Baudelaire separated the two, and achieved notoriety in his lifetime as a poet, though subsequently his prose, the more incisive because he did not try to be especially poetic, has rivaled his poetry in interest. In fact, so penetrating were some of Baudelaire's insights that he has tended to be admired uncritically.

As a young man of twenty-four, fascinated by pictures, he wrote a review of the Salon of 1845 and another in 1846. In these reviews we see him trying to understand his responses to contemporary art. He had developed a passion for Delacroix's paintings, and most other pictures seemed flat in comparison. In the *Salon of 1845* he discussed history paintings first and landscapes last, following the traditional hierarchy of values, though he mentions a large number of landscapists, an indication of the popularity of the genre. This section begins, "At

the head of the modern school of landscape stands M. Corot.—If M. Rousseau wished to exhibit, this supremacy would be in doubt. . . ." Baudelaire not only took the opportunity to slip in praise for Rousseau, but wrote about Corot at length to praise the qualities of naivete and of paintings that are not carefully finished. His review ends with the famous paragraph deploring the dullness of the Salon, and complaining that the heroism of *modern life* is ignored, while predicting that the true painter will be he "who will know how to tear the epic side out of contemporary life and make us see and understand, in color or in drawings, how great and poetic we are in our cravats and our patent leather boots."

By the following year these ideas had clarified and developed, and his *Salon of 1846* was not a review but a series of statements by Baudelaire of his ideas on different aspects of art, illustrated by reference to works in the Salon. His task was extremely difficult because there was no vital painting or sculpture by which to orient his thoughts. Delacroix by this time represented the past rather than the future, and the Barbizon School was almost lost among the numerous landscapes plastering the Salon walls. Baudelaire's genius enabled him to pinpoint the failings of the art of his time, and it is valuable to read this *Salon* if only to avoid our contemporary tendency to try to find merit again in the mediocre works. Baudelaire had to invent the art that he wanted to see; in what had become a whole section headed *The Heroism of Modern Life* he tackled the excuses of artists that modern life was too decadent and that modern dress was too ugly to paint successfully. Baudelaire's reference to *Heroism* and some of his examples show him still thinking partly in traditional terms (he seems torn between using the word seriously and ironically), but his conclusion with its praise of Parisian life as a subject, his search for modern beauty, and his praise of Balzac's characters set the critic firmly in the actuality of the contemporary world, which was that of Balzac's novels.

Though he was friendly with Courbet for a few years, Baudelaire could not wholeheartedly admire the Realists of the 1850s. He wrote little on Courbet, and criticized Millet. His interest in the city as the center of modern life cut him off from appreciating rural painting, and his developing ideas made him unsympathetic to their style. Furthermore Baudelaire's deep need to transcend his daily life led him to make a cult of the imagination and of his passion for Delacroix, and it prevented him from accepting the basic principles of Realism. This need led him to express ideas that not only became an inspiration for the Symbolists of the 1880s, who decisively rejected Realism, but provided a contradictory element in Baudelaire's own attitudes. He desired both an art that expressed modern life and one that went beyond it. His

poetry could contain both these impulses in different works, but he could not reconcile them into a coherent theory on art.

Dissatisfied with current painting, he wrote extensively on graphic art and caricature, where he found both artists who depicted the contemporary city and people wearing cravats and patent leather boots, and an art whose fantasy fired his imagination. He praised Meryon's etchings of Paris: "We have rarely seen represented with more poetry, the natural solemnity of a great capital. . . . None of the complex elements of which is composed the sad and glorious decor of civilization, are forgotten." Whistler's views of the London docks contain "the profound and complicated poetry of a great city." The repetition of "poetry" reveals Baudelaire's need for more than factual description, and accounts for his unreasonable attack on photography in his *Salon of 1859*, and also his difficulty in formulating a really satisfying program in his major essay, *The Painter of Modern Life*.

This essay, written in 1859–60 and published in 1863 in *Le Figaro*, thus gaining a wider audience than many of the poet's writings, is both extremely stimulating and in places infuriating. Baudelaire in presenting his ideas on modern art hangs them on the art of Constantin Guys, the illustrator whose drawings vary between the lively [154] and a hackneyed elegance. Baudelaire did not quite succeed in the dual task of doing justice to Guys and to his own ideas, and we cannot be sure whether some of the strange inclusions and omissions result from the limitations inspired by Guys's art or from deficiencies in Baudelaire's own thinking. He oscillates between defining the painting of modern life and discussing Guys's work, but inserted in various places like the

154. *The Tavern: Prostitutes and Sailors.* By C. Guys. Musée Marmottan, Paris. This drawing belonged to Claude Monet.

proverbial raisins in a pudding are the famous insights which have subsequently been quoted so many times.

Baudelaire begins by claiming that he wants to discuss art of the second rank, *la peinture de moeurs,* the painting of manners, but then goes on to establish his theory of beauty, which clearly has a larger significance, even if he slips into it through the discussion of fashion. He neatly calls into question the received ideas of his time by insisting on the dual nature of beauty, combining eternal beauty and the specific style of each age.

In turning to Guys himself, Baudelaire cites the work of Daumier and Gavarni as being often praised as the pictorial equivalent of Balzac's *Comédie humaine.* We thus find ourselves in the street with these artists, far from the Salon, and Baudelaire leads us further into the life of the street. He presents Guys as the detached but fascinated observer:

> The crowd is his domain. . . . His passion and his profession, is to marry with the crowd. For the perfect *flâneur,* for the passionate observer, it is an immense pleasure to choose to be at home in the mass of people, in the undulent, in the movement, in the fugitive and the infinite. . . . Thus the lover of universal life enters into the crowd as into an immense reservoir of electricity. We can also compare him to a mirror as immense as this crowd; to a kaleidoscope gifted with consciousness, which, in each of its movements, represents the multiplicity of life and the mobile grace of all the elements of life.

Baudelaire describes Guys as spending his day always observing, seeking: "And what does he seek? . . . He seeks what we choose to call *modernity.* . . . Modernity is the transitory, the fugitive, the contingent."

After this gripping start, Baudelaire goes on in a series of short chapters to praise Guys's handling of his themes, military subjects, state occasions, soldiers, women, and he ends with the carriages of the aristocracy. This anticlimax is prefigured in a passage that comes shortly after the quotation above:

> [Guys] regards the landscapes of the great city, stone landscapes caressed by the fogs or struck by the blows of the sun. He rejoices in the fine turnouts, the proud horses, the dazzling grooms, the dexterity of the drivers, the graceful gait of the women, the handsome children happy to be alive and well dressed; in a word, universal life.

What an extraordinarily limited conception of life and modernity after the introduction, and especially after the references to Gavarni, Daumier, and Balzac! Baudelaire's equally limited conception of women has also been criticized. Yet his initial vision overturned all the prevailing ideas of great art as being static, monumental, and aimed at a time-

less ideal. He perceived that the center of modernism is the city, and that the street forms a particularly potent image (one that played such a large role in the illustrations and such a negligible one in the Salon). In his choice of adjectives—"transient," "fugitive"—he expressed the same sensibility that we find in the other early diagnoses of the modern spirit, though they do not bring it into the visual arts. Baudelaire's thought also parallels Karl Marx's vision fifteen years earlier, transposing it into personal experience, though Baudelaire totally ignores the industrial and social developments that inspired Marx, and which have much more to do with modernity than the carriages in the Bois de Boulogne or the courtesans seated in the cafés. Guys and Baudelaire ignore the great mass of "ordinary" people who in fact compose the crowd.

The incisive parts of Baudelaire's essay form a complement to the passage by Matthew Arnold quoted at the beginning of this chapter. Arnold writes of the awakening of the modern spirit being the awareness that the "immense system of institutions, dogmas, customs" does not correspond with the needs of modern life (the change that led to the end of allegory as a meaningful form). Whereas Arnold might be seen as desiring a new set of dogmas, Baudelaire understands that change has become the norm, that it is the end of ideology. The different possibilities open to literature and art respectively can be seen in the contrast between Baudelaire's exhilarating picture of the art of transience, and Arnold's unforgettable lines of poetry on its anguish:

> And we are here as on a darkling plain
> Swept with confused alarms of struggle and flight
> Where ignorant armies clash by night.
>
> ("Dover Beach")

Art had to break from Realist principles at the end of the century to express existential dread, as we see in the pictures of Munch, Hodler, and Toorop.

In places in Ruskin's writings we find the possibility of insights similar to those of Baudelaire, but they are quickly submerged under the flood of his hypnotic prose, which seeks an absolute, which is inevitably static, and could offer no constructive thoughts to artists. He identified those qualities in Constable's paintings that made him so exciting to French artists when he complained that Constable could find pleasure only in foliage shaken by the wind and in light when "flickering, glistening, restless"—adjectives that might have been written by Baudelaire. The latter had, in a curiously awkward way, unlike Ruskin, challenged the painters of the sixties to move on from the eternal verities of rural life to look at the modern world around them, and not to

leave that world only to the artists of the illustrated magazines.

In France, by the early 1860s, Realism had established itself. The Academy might denounce it, but the Barbizon landscapists were now recognized as significant artists; Bonheur and Troyon had made straightforward painting of animals a popular art form, and Courbet had become what we might call the Official Villain, attacked but accepted. Several critics contrasted him favorably with Millet, and a growing number of collectors bought his pictures. The works of all these artists were distinguished by their tangibility and their rural themes. People, trees, rocks, interiors, all became equally solid, immovable objects. Admirers responded to these qualities and found the surrounding art artificial and bloodless.

Yet a few people found something lacking in this Realism even while praising it. The young critic Jules Castagnary wrote in his Salon review of 1867, "Hurry, don't wait an hour: forms and appearances will have changed tomorrow. To paint what exists, at the moment you see it. . . ." In the epigraph for this chapter, Castagnary, in 1863, commended the rural Realists but pointed out what still needed to be done.

Like Baudelaire eighteen years earlier, Castagnary felt the need for a painting of modern life, springing from the experience of the city. Perhaps inspired by Baudelaire's later ideas he also urged artists to "render palpable the most fleeting sensations." In appealing for "a French painting that may be made in its own image, and no longer in that of long dead peoples," he asked for "the imprint of its own luminous grace." The qualities that Castagnary sought were to be created by the Impressionists a few years later.

Intelligent critics usually grasp the importance of what has been created by innovative artists and try to explain it to the rest of us, who are confused or alienated by the new work. Around 1860 we have the unusual situation of critics putting forward the new ideas first. The reason for this reversal seems to be the sheer difficulty of envisaging what the new painting would be like. The very achievements of the Barbizon artists and of Courbet and Millet led in a different direction. Not only were modern clothing and the modern city ugly, but, as we saw earlier, the fact that art does not unfold in time and space made the static monument appear to be the natural goal of painting and sculpture.

In the 1860s it had become a commonplace that the world was being transformed into someting not only different, but new in kind. And this is the case whether we read Karl Marx or a more conservative thinker like Matthew Arnold. The novels of Dickens and Zola documented these changes, and Alice shrinking to a few inches in height or growing

up level with the treetops is a metaphor for such dizzying transformations. We can understand that artists hesitated to bridge these two worlds of past and unstable present, and that Edouard Manet, who tried, encountered enormous difficulties. He simultaneously tried different methods, achieved no consistency in his development, and puzzled both his contemporaries and posterity. Robert Rosenblum has written very pithily:

> Manet's art . . . poses problems of interpretation that have intrigued one generation after another, with results that offer a welter of contradictions. For some, Manet was the purest painter who ever lived, totally uninterested in his subjects except as neutral excuses for a light-dark contrast or a patch of lilac or lemon yellow. For others, Manet constructed symbolic cryptograms, in which everything, from an orchid or a crane to a captive balloon, could be deciphered in a private but intelligible way. For some, Manet was the first genuinely modern painter, who liberated art from its mimetic chores and asserted the primacy of flattened pattern and color. For others, Manet was essentially the last great old master, rooted in a multitude of art historical references. For some, Manet was a technically defective painter, incapable of compositional and spatial coherence. For others, it was exactly these "defects" that made up his intentional contribution to drastic redirections of pictorial structure. As is often the case with a genius of Manet's stature, almost all these contradictory points can be plausibly argued, the only certainty being that future generations will put forward quite different opinions.[1]

Indeed, since Rosenblum wrote this, it has already been wittily pointed out that Manet's fondness for quotations from other artists could make him the father not of modern but rather of post-modern art.[2]

After his success at the 1861 Salon when he was awarded a second-class medal for his *Spanish Singer*, 1860 (Metropolitan Museum, New York), Manet worked extremely hard producing a great number of paintings and prints before the next Salon, which was held in 1863. The variety in style and type of subject is still startling. It included the *Concert in the Tuileries* [155], a sparkling slice of contemporary city life, *The Old Musician* [156], an artificial arrangement of figures taken from other works of art of the past and from contemporary art, completely the opposite of the *Concert*, and *Luncheon on the Grass*, apparently a picture of contemporary life, but as static and posed as *The Old Musician*,

[1] R. Rosenblum and H. W. Janson, *19th-Century Art.* New York, 1984, p. 278.

[2] D. Carrier, "Manet and His Interpreters," *Art History,* vol. 8, no. 3 (Sept. 1985): 320-35.

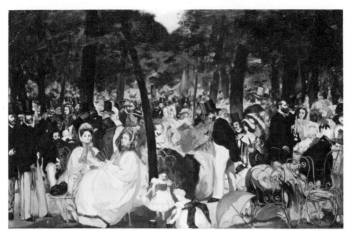

155. *Concert in the Tuileries.* By E. Manet, 1862. National Gallery, London.

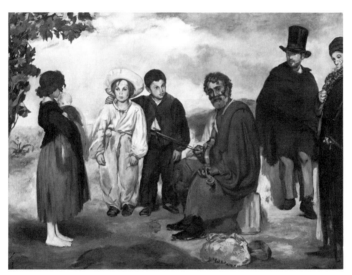

156. *The Old Musician.* By E. Manet, 1862. National Gallery of Art, Washington, D.C., Chester Dale Collection.

and containing the unlikely nude woman. Manet also painted two large canvases of single figures that are different again, *The Street Singer* (Museum of Fine Arts, Boston) and *Mlle Victorine in the Costume of an Espada* (Metropolitan Museum, New York). The former is a slice of life, but one that is carefully arranged to locate the singer in the center of the canvas looking straight at us, while *Mlle Victorine* is a fantasy of the woman in a bullring whose perspective is completely distorted. What are we to make of this mish-mash? As Rosenblum points out it is endlessly dis-

cussable, and we might add that the more convinced Manet interpreters are of their own thesis, the less persuasive they usually are to others.

From the viewpoint of Manet's relation to Realism, we might see him responding to a number of concerns. He takes themes that are familiar to him as a Parisian, and that meet the critics' demands for a painting of contemporary city life, but he explores them in different ways. He follows Courbet's use of traditional compositional ideas and modeling, but he also questions the static, monumental aspects of his work in two ways. The *Concert* comes to life with a flickering patchwork of light and dark colors that create movement at the expense of legibility. *Mlle Victorine*, by tilting up the floor of the bullring and playing with the size of the background figures, upsets our reading of depth and we respond immediately to the different elements, near and far, in the picture.

Manet was always fascinated by costumes, dressing up, incongruities, and the grotesque. These characteristics, which might seem to have little to do with the serious business of the founding of modern art, play, I believe, an important part in Manet's diversity, his experimentation, and in both successes and failures. His idea of redoing Giorgione's *Fête champêtre* in modern life, using contemporary clothing for the men like the Italian artist, creates a comic incongruity that raises the whole question of the propriety and purpose of the nude in the art of the time. The *Luncheon* is not a Realist painting, even if there was a rich sexual underworld in the nineteenth century. As we have already seen, this was an almost impossible subject for the Realist painter, and Manet's composition of the figure group, taken from Raphael in another amusing gesture, is quite unconvincing as a slice of life. Ann Coffin Hanson has shown that this theme of the figures with a boat existed in more than one of the illustrated books of the 1850s. This contemporary touch from what we may call Low Art places the borrowings from Giorgione and Raphael in a more playful light than even the modern clothing.

Examples of the comically absurd run through Manet's painting: the top-hatted man cut in half in *Nana*, the legs in the upper left corner of *The Bar at the Folies Bergère*, or Berthe Morisot's strange face when seen through a veil. This spirit meant that he was prepared to use the flat, naive prints from Épinal far more directly than Courbet, who reworked them with a Baroque three-dimensionality. Manet's appreciation of the grotesque and the humorous also enabled him to absorb elements of Japanese prints where they are so important. These primitivisms that were discussed earlier were a means for Manet to break through the conventions not only of academic art, but also of the earlier Realist art.

In stressing these aspects of his art, I do not wish to imply that they fully characterize it. They were complemented by Manet's feeling for Realist art and what it stood for. He admired the French Realist tradition, and his friend Antonin Proust reported him as saying, "We have in France a core of honesty which brings us back always to the truth, in spite of the feats of the acrobats. Look at the Le Nains, Watteau, Chardin, David himself. What a feeling for truth." Proust, writing many years after the event, also recalled an anecdote from their student days that has a poetic truth, even if it is not strictly accurate. Manet, irritated by the artificial pose of the model who was proud of his ability to hold the difficult positions necessary for neoclassic subjects, asked if that was the way he bought radishes. We feel in looking through Manet's drawings and his small paintings that he admired the vignettes of contemporary life in the magazines [30 and 40], and the way these artists tried to reproduce the gestures of contemporary life.

At the same time, Manet the *boulevardier*, a man about town, had a keen eye for style and for beautiful women and their fashions. No artist painted feminine accoutrements, fans, gloves, parasols, and hats with such elegance. Nana's powder puff is as memorable as its owner. We are reminded of Baudelaire's *The Painter of Modern Life* where he writes about women and specifically about the effect of their clothing: "Is there a man who, in the street, at the theater, in the park, has not enjoyed in the most disinterested way, a skillfully composed *toilette,* and has not carried away an image of that toilette inseparable from its bearer, thus making of the two, the woman and the dress, an indivisible totality?" With this conception, the nude becomes unnecessary in creating feminine beauty.

His double interest in elegance and truth led Manet to Spanish art, not to Ribera or Zurbarán, admired by the first generation of Realists, but to Velázquez, who combined both those qualities. By a quirk of chance, one picture in the Louvre which fascinated Manet at the beginning of his career has subsequently been taken away from Velázquez, but it proved a fruitful error for Manet. It was one of the inspirations for the *Concert in the Tuileries* [155], which all recent books on Manet and Impressionism have seen as a seminal painting. In this picture, Manet solves the problem of making something beautiful out of ugly modern clothing (justifying Baudelaire's assertion sixteen years before), gives us a slice of life with no feeling of the people posing for us, and with the patchwork of brushstrokes he carries our eye continually around the picture. Again, Baudelaire's perception that movement and the fugitive are inseparable from modernity is exemplified in this picture. He had written also of the prints of Debucourt, and one print, the *Public Promenade*, 1792, with its mass of people under the trees and the chairs in

the foreground, does seem to have given Manet the basic idea for his composition. The so-called Velázquez, *The Little Cavaliers*, with its painterly treatment of the black costumes, showed a way of transforming print into painting. But if Manet followed the other Realists in using several previous works of art to approach a slice of life, it is his own contribution, the patches of bright color everywhere among the black, that makes it quite different from any earlier picture. Manet gives an unprecedented sparkle, and an animation, to this block of people. The lack of detail and the reduction in modeling, which was absolutely necessary to keep the eye moving, apparently infuriated some of the first viewers. One of the children in the foreground looks like a cut-out, a figure from an *image d'Épinal,* and we can understand how people might be disconcerted by her appearance in an oil painting. I suspect that she is an example of Manet's sense of humor, as she is different from the surrounding figures, and the parasol next to her is drawn quite three-dimensionally.

Without the signature and the written evidence, we would not attribute *The Old Musician* [156] to the same painter as the *Concert,* especially if we knew that they were painted in the same year. In the latter picture Manet chose to paint a contemporary subject in a new way that paralleled some of the very original and dynamic ideas of his close friend Baudelaire. In *The Old Musician* he gives us a group of firmly modeled people taken from other works of art, arranged in a static, inexplicable way, based on seventeenth-century compositions. Although very large, the picture is so puzzling that it had rarely been discussed until it was recently very brilliantly explicated by George Mauner.[3] He analyzes it as a contemporary theme, that of the outcasts of society, the wandering musician, the ragpicker, the gypsy girl, and the archetypal characters of Pierrot and the Wandering Jew. Their presentation through other artworks (the gypsy girl came from a recent Salon painting, the young Pierrot is Watteau's Gilles, the black-clad boy comes from Spanish art, the musician from a copy of a Greek statue from the third century B.C., the ragpicker from Manet's own *Absinthe Drinker)* gives them allegorical meaning.

Pierrot and the Wandering Jew were already allegorical figures, and extremely popular in the mid-nineteenth century. Champfleury, Courbet's defender, who had transferred his friendship to Manet, wrote plays for the Funambules Theater and its famous mime Debureau, who played Pierrot. Théophile Gautier, who together with Champfleury (and Baudelaire) appears in the *Concert in the Tuileries* had written of the Funambules: "The crowd has lost the meaning of these high symbols,

[3] G. Mauner, *Manet, Peintre-Philosophe.* University Park, Pennsylvania, 1975, ch. 2, upon which the following interpretation is based.

of these profound mysteries that make the poet and the philosopher dreamers. . . . Pantomime is the true comedy: and although it does not use two thousand characters like that of M. Balzac, it is not less complete. It does everything with four or five types. . . . All humanity lives and feels in half a dozen names."

Pictures by the Le Nain brothers provide the composition of *The Old Musician* with its separate figures who do not communicate with each other, though there is a hint of Velázquez's *Drinkers* in the general arrangement. Champfleury had also been a pioneer in the nineteenth century in writing about the Le Nains: "I even admit my weakness for their awkwardnesses. . . . Their way of composing is anti-academic; it escapes from even the simplest laws. . . . They went even so far in seeking reality as to place isolated figures in the middle of the canvas; in this way they are the fathers of contemporary experiments, and their reputation can only grow."

Champfleury's admiration for their awkwardness, and Manet's belief in their truthfulness, brings together these two elements of Realism in the work of the brothers Le Nain (and we see again the importance of untutored primitivism as a guarantee of authenticity). However, whereas Courbet linked the isolated peasants of Le Nains into a natural grouping in his *After Dinner at Ornans,* Manet has arranged his figures quite arbitrarily. The lack of meaning in the composition, and the quotations from other pictures, makes Manet's private symbolism inaccessible. Mauner's interpretation is convincing as a theoretical statement, but it is not something we grasp from looking at the work. The picture is not a failure, as the spectator does gain a certain feeling from the pictorial conception of the picture. It is a precursor of the Symbolist paintings of the 1880s and 1890s, where the figures stand facing the spectator in a formal arrangement that deliberately avoids the groupings of everyday life. It has been suggested that *The Old Musician,* exhibited in the Manet retrospective of 1905, inspired the young Picasso's *Family of Saltimbanques,* one of Picasso's last Symbolist works before he began the explorations that led to Cubism. Certainly *The Old Musician* was not a Realist work, nor was it a model for Manet's subsequent work. In fact it makes us look back to Courbet's *Studio,* another personal allegory grouped around an artist in an inexplicable way; but *The Old Musician* does reveal the complicated mind behind Manet's debonair exterior.

The mingling of the allegorical with the contemporary also appealed to Manet, and we find it in several of the early works. The *Luncheon on the Grass* includes a bird in the top of the painting and a toad in the lower left, both invisible in most reproductions. These have been interpreted as traditional symbols of spirituality and sensuality respectively,

although the bird has also been seen as representing sensuality too. Which interpretation is correct hardly matters, as both creatures are presented too naturalistically to carry allegorical meaning, which, as we have seen, does not function in nineteenth-century pictures in any case.

Another aspect of this allegorical impulse can be seen executed in purely naturalistic terms in yet another picture of 1862, the lithograph of a balloon ascent [157]. Manet has placed a crippled beggar in the miscellaneous crowd that has gathered for the occasion. He belongs in this setting, but as he is separated out from the crowd and placed directly beneath the balloon, we are forced to compare the earthbound cripple with the soaring balloon. Theodore Reff has seen in this contrast a critical comment on the differences between the aspirations and the reality of Louis-Napoléon's regime.[4] We do feel the human contrast, but a political meaning is not something made evident in the print.

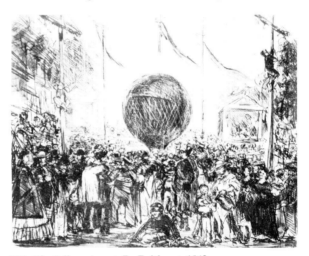

157. *The Balloon Ascent.* By E. Manet, 1862.

As this was Manet's first lithograph, the originality of his "furious scribbling," as it has been called, strikes us as an attempt to carry the ideas of the *Concert* even further, and something at the opposite pole in terms of movement from *The Old Musician.* The crowd stands there, but the linear movement of the crayon suggests the energy and the density of the throng. For the lithograph Manet has turned to contemporary popular prints for his composition and style. The style of drawing is similar to that we see in Gavarni's *Vireloque* [168], while the subject of balloon ascents occurs very frequently in magazine illustrations [158]. The example reproduced here is from England, though it shows an

[4] T. Reff, *Manet and Modern Paris.* Washington, D.C., 1982, p. 260.

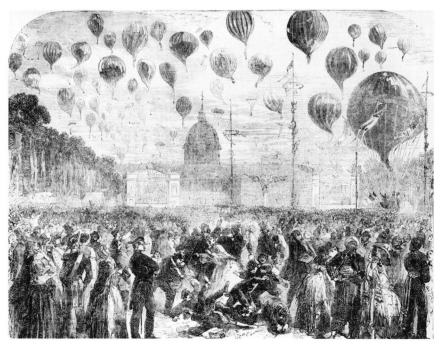

158. *Release of 300 Balloons from the Esplanade des Invalides* from *Illustrated London News,* 1856.

ascent in Paris. It is typical of the genre, and we can see that Manet has followed the general composition. In the *ILN* print, the sky filled with balloons has a remarkable visual effect, and we can see that an entirely different theme, with a striking composition by Degas [174], has affinities in the filling of the upper part of the picture. Degas has not copied a print, but his pictorial sensibility, like Manet's, developed through his acquaintance with the prints and their sometimes remarkable visual effects.

Manet's work in the 1860s is so varied in concept—scenes in Paris, imaginary bullfights, important contemporary events that he had not witnessed, like the *Battle of the Kearsarge and the Alabama* and the *Execution of Maximilian,* religious paintings, portraits, contrived subjects like the *Woman with a Parrot*—that it defies classification. If *Concert in the Tuileries* was painted as a response to Baudelaire's ideas (and the poet appears in the painting), then Manet made no systematic attempt to develop a style from this initial picture.

Olympia [159] epitomizes the problems Manet's inventive spirit provides. He painted it in 1863 just after the *Déjeuner,* and as that picture's subject was derived from Giorgione's *Fête champêtre,* so *Olympia* was taken from another Venetian painting of the nude, but an interior scene this time, Titian's *Venus of Urbino,* which Manet had copied as a student.

Olympia was submitted to and accepted by the jury for the 1865 Salon (we do not know why they accepted it). The sensation that it created unleashed a flood of writing that has continued to the present. *Olympia* has been described as a revelation of the significance of prostitution in Paris, and as the first modern painting, important rather for its style, the flattening of the composition, and above all for the structuring of the picture in terms of the patterning of shapes rather than by the construction of objects in space. In the 1880s and 1890s the latter aspects inspired Post-Impressionists like Gauguin, who painted a copy of it.

Many features of *Olympia* are quite un-Realist: the artificial pose of Olympia herself, and the relation, or lack of it, to the servant, the Renaissance drapery in the upper left, and the comical cat on the right. At the same time Olympia has a riveting sense of presence, an actuality

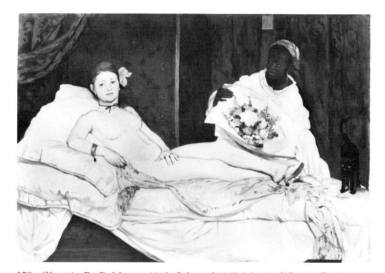

159. *Olympia*. By E. Manet, 1863, Salon of 1865. Musée d'Orsay, Paris.

for the spectators. This combination of contradictory qualities, and it runs in many ways through the painting, which is so typical of Manet, is one of the disorienting factors that helped make the painting's initial reception so vituperative.

In addition to the shallowness of the space and the thrusting forward of Olympia onto the surface of the canvas, the dominant angularity plays an important part in making her so assertive. The angle formed by her body and legs is divided into two more angles by the vertical straight line, and the triangle of the servant, and the triangle of the piece of bed visible, all suggest the awkwardness of an *image d'Épinal*. This primitive quality discussed earlier, though not illusionistic, does,

when treated in painterly terms, paradoxically give greater immediacy, and thus a greater actuality to the figures.

Equally important I believe is the treatment of Olympia's body, which reverses all expectations of the nude. When we look at Titian's Venus, we see a figure entirely composed of graceful curves. An examination of Olympia shows that she does not possess a single graceful curve! As we have seen, her body and legs form an angle, and her head is set at right angles to her shoulders. Where Titian hides the further shoulder with Venus' hair, Manet exposes the bony angle, and where Titian buries the pointed elbow in the soft pillow, Manet does not. Venus' legs are turned to create a continuous flowing line, but Olympia's left leg is seen as an inelegant profile complete with a knobbly knee; and, finally, where Titian gracefully curved Venus' hand as a *cache sexe*, Olympia's hand is splayed out like a giant spider. Olympia's breast, the only curving part of her as painted by Manet, is silhouetted against her arm of the same color so that its form is lost.

These details need emphasizing because the elegant approach that we have noted in the Titian is true of all the other nudes in the Salon. One reason Olympia disturbed the spectators lies in this total reversal of expected qualities, and is an important factor in the almost incoherent rage which greeted her. The fact that this systematic "ugliness" of Olympia was not really recognized by the reviewers meant that it was a more or less unconscious element complicating their responses.

Olympia is so unprecedented in painting that we have to ask if Manet invented her entirely from scratch, or if there is another source for this conception. In the following paragraphs I want to argue that there was such a source, and that it was one that underlined the reality of *Olympia*.

"A woman more or less naked and leering at the spectator with a conscious impudence . . . brutal vulgarity and coarseness . . . as surprising as it is disgusting. . . ." This reads like one of the hostile comments made when *Olympia* was first exhibited at the Salon, and which have been so often reprinted. In fact the quotation has nothing to do with *Olympia*, but is from the English *Saturday Review* of 1858 describing contemporary nude photographs. The *Review* complained that "there is hardly a street in London which does not contain shops in which pornographic photographs and especially 'stereoscopic' photographs, are exposed for sale."

I would like to suggest that an important source for *Olympia* was the contemporary pornographic, stereoscopic photographs. The derivations of *Olympia* in the fine arts tradition are well known. However, one of the most important aspects of *Olympia* was her modernity—the introduction of a conception quite different from that of the Titian. The

contemporary critics did not mention Manet's debt to the sixteenth century in their comments; it was either the ugliness or the immediacy, the contemporaneity of *Olympia* that overwhelmed them. As Theodore Reff has pointed out: "For Titian's ideal of a natural sensuality, conscious of its charm yet somewhat chastened, Manet substitutes a contemporary ideal of artificiality perversely attractive in its very lack of warmth."[5] It is this transformation that makes Manet interesting, and separates him from the many dull painters who borrowed from Titian. We find, investigating this change, that important features of *Olympia* are identical with those of the pornographic photographs that were so widely distributed in the major cities of Europe. The *Saturday Review* writer quoted above speaks of nearly every street in London possessing stores that sold the pictures—undoubtedly an exaggeration, but indicative of an immense production. This needs to be emphasized, as very few of the photographs are known today—for obvious reasons.

The mixture in *Olympia* of an exotic odalisque setting with the very real, unexotic woman is typical of the photographs [160], which often sought a veneer of respectability by borrowing trappings from the paintings of nudes that proliferated in the Salon. This combination can be seen in a photograph by Durieu of the 1850s, with its pictorial drapes and very unpicturesque nude [161]. The *Saturday Review* writer's violent reaction to photographs of nude women, when the nude played such a large part in painting, springs from the particular response to the photograph. All nudes up to 1839 had been drawn and painted by artists following idealizing principles. Even when the artist worked from the model, she was remodeled according to these principles. Contemporary accounts make it clear that when men saw photographs of nudes for the first time, there was a particular erotic charge, as the viewer was aware that he was looking at a real woman (most of the numerous more or less nude women in the magazines were clearly drawn from prototypes in the artists' minds and not even from the model). So "real" seemed the photograph that it was not regarded as respectable for artists' models to pose for photographs, and apparently most of the models for quite a period were drawn from the lower ranks of prostitution. This helps account for the almost grotesque contrast between the model and the setting in many of the photographs.

In addition to this similarity of content between the Manet nude and the photographs, there is a remarkable visual resemblance to the stereoscopic pictures. Unfortunately this cannot be illustrated except by looking into a stereoscopic viewer. No nineteenth-century home of any

[5] T. Reff, "The Meaning of Manet's *Olympia*," *Gazette des Beaux-Arts*, LXIII, no. 1141 (Feb. 1964): 112.

160. Photograph of a nude. Anonymous, 1850s.

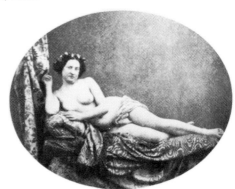

161. Photograph of a nude. By E. Durieu, 1850s.

pretensions was complete without a viewer and a collection of photographs. The stereopticon was one of the major optical devices of the century, of the kind discussed earlier in this work. The characteristic of the stereoscopic photographs is to create an illusion of actual depth, but each object in the picture if there is a contrast of dark and light appears flat—a cardboard cutout. The flattening in *Olympia*, which is such a revolutionary stylistic element (the "playing card," as Courbet called it), is thus extremely close to the effect of the main figure in many of the stereoscopic shots.

Manet's acceptance of such a composition undoubtedly owes something to Japanese prints. Photography and Japanese art often contained very similar effects that inspired a number of innovations adopted by

the Impressionists in the 1860s and 1870s. It is perhaps because these ideas came from more than one source that they were so rapidly and wholeheartedly taken up by the avant-garde artists. The characteristics of Japanese prints ceased to be curiosities when they were backed up by the evidence of the "truth" of photography. It was their compositions that provided the composition for *Olympia* and enabled Manet to tie the different parts of the picture together in such a forceful surface pattern—the photographs having no overall composition but simply the figure set in the middle of a space.

One of the most significant comments on the influence of photography on figure painting is Delacroix's *Journal* entry of May 21, 1853, when he complains of the unbearable anatomical inaccuracy of some of Raimondi's prints that he had looked at immediately after examining Durieu's photographic figure studies. This diary entry reveals that Delacroix, who had used the nude model all his life, could see the human figure accurately only when he had studied photographs of it. His previous perceptual *Gestalt* was formed by the Renaissance/Baroque tradition. It required the photograph to create a new visual conception of the human body. Delacroix himself could not break from the tradition he had grown up in; his own paintings from photographs are prettied up—the angles rounded off, the awkward proportions modified.

What Delacroix perceived is exemplified in a very elaborate photograph taken in a mirror with objects on a dresser top, drawn from the same painterly tradition as *Olympia,* but adding by the use of the reflection a suggestion of the camera lens as peephole [160]. The attempted arrangement of the flowing curves in the odalisque manner is contradicted by the angularity of the arms and the sharp face. It was this reality that Manet absorbed from the photographs and that he incorporated into *Olympia*. He realized that by emphasizing the angularity of the human body, he could give *Olympia* that immediacy and reality that so startled the people who saw it.

If we accept that Manet was influenced by these types of photographs in the creation of the painting, then the furor that greeted *Olympia* is even more understandable. Not only did she upset the spectators by her shameless suggestiveness, but she was also directly reminiscent of the pornographic photographs that the male audience at least would have gloated over.

In this connection, further evidence of the widespread distribution of these photographs in Paris comes from Manet's friend Baudelaire. In the section on photography in his *Salon of 1859,* he wrote:

> A little later a thousand hungry eyes were peering through the eyepieces of the stereoscope as if they were the portholes of the infinite. The love of pornography, which is as alive in the natural heart of man

as the love of himself, was not to let escape such a fine opportunity for self-satisfaction. And do not think that it was only children coming back from school who took pleasure in these follies, everyone was infatuated with them.

There is thus clear evidence that Manet would have been very familiar with the type of nudes I have illustrated.

The destruction of the ideal concept of the nude by its relation to indecent photography was reinforced by the harsh dark and light contrasts that reminded most reviewers of Spanish painting, which was associated with raw realism. As one wrote:

> Separate mention must be made of the black painting of the *Saint Sebastian* by Ribot who, finding his inspiration in the crude manner of Ribera, wantonly cultivates ugliness but displays energetically pictorial qualities. A much more pronounced ugliness is apparent in Manet's paintings *Olympia* and *Christ Scourged*, whose pictorial value we confess we do not appreciate.

Many reviewers spoke of the ugliness of the color ("a yellow stomach," "the color of the flesh is dirty"), which clearly signals their discomfort with the picture, because I think it true to say that it is a masterpiece of beautiful color. Manet has created a tour de force in the related tones, the whites and creams of the sheets, shawl, skin, and paper. The subtlety of these juxtapositions must be seen as the opposite of crudeness and ugliness (and it largely disappears in all reproductions), and it is a quality that we can especially appreciate now that *Olympia* was cleaned for the Manet centenary exhibition in 1983.

I do not believe that we can give a final interpretation of *Olympia*. The confrontation of opposed characteristics: the artificiality of the pose, but the reality of Olympia herself; the trappings suggesting a successful courtesan, and the feeling that she is nevertheless a low-class prostitute; the overt reference to Titian's Venus but the reversal of Titian's approach; the appeal to tradition and the extreme modernity; the sense of the actuality of prostitution, but the "playing card" that pointed to a new basis of painting—all these opposites can be assessed and a different weighting given by each of us. We will continue to see what we want to see in *Olympia*.

This multiplicity of contradictions suggests that the picture's initial impact resembled that of Courbet's *A Burial*. The spectators were so nonplussed that their responses were irrational and a great deal of what they had to say was irrelevant to the actual image. We therefore need to be careful in reading too much into those outpourings. Once this first shock was over, and people had the chance to see *Olympia* when she entered the Luxembourg Museum in 1890, she was rapidly acclaimed a

masterpiece, in spite of her being a reminder of the different levels of prostitution that pervaded French society.

This change took place because Manet had forged a visually coherent picture out of his diverse sources, but one so remarkable, poised on the turning point where Realism moved into a quite different art, that he did not follow it up. Manet's pictures of the year after he painted *Olympia* include beautiful still lifes in the seventeenth-century Dutch tradition where space and volume are emphasized, and the *Battle of the Kearsarge and the Alabama,* which though still startling by Salon standards, modified the boldness of *Olympia.*

Most books and articles written on Manet have concentrated on the first decade of his career, as the puzzling pictures come from this period. After the Franco-Prussian War, Manet came increasingly under the influence of the younger Impressionists, whom he had inspired earlier. They had developed the ideas that they found in a picture like *Concert in the Tuileries,* and Manet turned to the possibilities that they had revealed. His color became fresher as he painted out of doors, and he took up their subjects in his canvases of Paris streets, cafés, theaters, people playing croquet or skating, or enjoying boating at Argenteuil. These pictures present few problems, but they deserve examining because they add another dimension to Impressionism and to Manet's own art.

Looking back from the twentieth century with our knowledge of subsequent developments in art, we tend to pick out those nineteenth-century works which are closest in form to twentieth-century art as the significant ones, and implicitly the best. This assumption is questionable, and in Manet's case it has distorted our response to his art. The belief that "flatness" in a picture is the crucial element of modern art, and that it characterizes Manet's paintings, can be seen as inadequate. The number of "flat" pictures by Manet is very small. We find reference over and over again to *Olympia* and *The Fifer,* 1866, for although other pictures have a shallow space, they are not flat. Typically a standing male from about the same time as *The Fifer,* the *Matador Saluting* (Metropolitan Museum, New York) is fully modeled. In Manet's work after *The Fifer* we see, rather than a flattening of the figures, an emphasis on the three-dimensionality of the forms. In *The Luncheon,* 1868, he uses Baroque devices to dramatize this aspect of the people and objects. A spherical medieval helmet and a curving scabbard are placed in the left forefront of the painting, the boy in the middle is placed on our side of the table, and a knife handle and lemon project toward us as they overhang the table edge in best seventeenth-century Dutch style.

This delight in the volume of forms becomes the principle of a new pictorial concept for Manet. The immediacy which he achieved in the

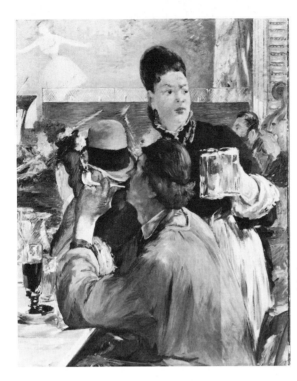

162. *The Waitress.*
By E. Manet, 1879.
National Gallery, London.

Concert in the Tuileries by the contrast of patches of color, he now creates by forms which thrust out into our space. In *The Waitress*, 1879 [162], the picture is based on a witty play of rounded volumes jammed against each other in an energetic diamond configuration. We see at the top and bottom two large, blunt, football-like shapes of the waitress's and the customer's heads, one seen from the front and the other from the back to give a light/dark contrast, and cylindrical shapes contrasted at the sides, the two golden tankards of beer and the gray hat. The latter is domed so that it is not a simple cylinder, again avoiding direct repetition. These shapes are placed in the foreground of the picture, exactly at our eye level, and their closeness to us is increased by the shoulder of the blue-smocked man which thrusts out of the canvas.

At this time Monet and Renoir had evolved the small, independent brushstroke that emphasizes the surface of the painting and destroys solid form. Manet does not follow them, but uses longer, broader strokes that model the forms. He painted the background of the café thinly, and the figure on the stage is small and scarcely modeled, so that they seem to belong to peripheral vision and we are not attracted to look at them. Consequently the people in the foreground, instead of receding into the canvas, seem to loom out into our space. A comparison with Jean Béraud's *The Pastry Shop "Gloppe,"* 1889 [163], reveals the particular qualities of Manet's style.

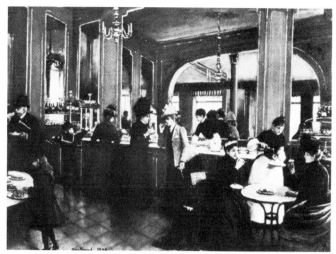

163. *The Pastry Shop "Gloppe."* By J. Béraud, 1889. Musée Carnavalet, Paris.

Béraud was one of a number of artists who became popular in the 1880s by taking Impressionist subjects of Parisian life and something of the latters' lightness of color and atmosphere, but adapting them to the conventional ideas of picture construction and paint application. He did not use Impressionist brushstroke, but gives us a smooth surface behind which opens up the café. It is an extremely pleasant picture with its cream and gold decoration, but everything is frozen behind the surface. We feel that we are looking into a fish tank in which the fish are plaster models. We cannot enter into this world, whereas in the Manet we feel we are part of the café as it opens out to us.

If Manet looks to Baroque painting for his modeling of people, hats, and so on, his destruction of the Baroque space that would flow back into the picture is extremely important. He has eliminated the element of time, of movement through the painting. We are hit by all the objects at once, the Impressionist moment that will be discussed in the next chapter. Equally, though the major forms in *The Waitress* are static ones —hats, tankards, heads—their abrupt juxtapositions, the turning of the people in different directions, the swirls and directions of the brush-strokes, create a feeling of the passing moment as the waitress is about to sweep on her way.

In these pictures of the 1870s, Manet chooses subjects around him; there are no quotations from other pictures to distract us or symbolic elements to be interpreted. We can simply enjoy the sparkling colors, the witty compositional ideas, the animation of the pictures with their evocation of the pleasures of Paris. There still remain questions of re-sponse, as we will see in discussions of the interpretations of Impres-sionist painting.

The painters who love their own time from the bottom of their artistic heart, understand reality differently. They try above all to penetrate the exact sense of things; they are not content with a ridiculous trompe-l'oeil, they interpret their epoch as men who feel it living in them, who are possessed by it and are happy to be possessed.

Among these painters I would place Claude Monet in the first rank. He was suckled on the milk of our age, he has grown up adopting what surrounds him. He loves the horizons of our cities, the grey and white spots which our buildings make against a clear sky; he loves, in the streets, the bustling people in their overcoats; he loves race courses; he loves our women, their parasols, their gloves, their ribbons, even their hairpieces and make-up, every-thing which makes them daughters of our civilization.

Out in nature, Claude Monet prefers an English park to a cor-ner of forest. He likes to find everywhere the signs of people, he wants always to live in the midst of us. Like a true Parisian, he brings Paris to the country; he cannot paint a landscape without putting in it well-turned-out men and women. Nature seems to lose its interest for him if it does not bear the imprint of our time.

He is an excellent painter of seascapes. But he understands the genre in his own way, and there again I find his deep love for contemporary realities. One always notices in his seascapes the end of a jetty, a section of a quay, something which indicates a date and a place. He seems especially to like steamships.

<div style="text-align: right">Emile Zola, 1868</div>

Constant revolutionizing of production, uninterrupted disturbance of all social conditions, everlasting uncertainty and agitation, distin-guish the bourgeois epoch from all earlier times. All fixed, fast-frozen relations, with their train of ancient and venerable ideas and opinions, are swept away, all new-formed ones become obsolete before they can ossify. All that is solid melts into air.

<div style="text-align: right">Karl Marx, 1848</div>

8

IMPRESSIONISM

I have stressed the inconsistencies of the Realist painters: Courbet's academic nudes, Millet's presentation of peasants as Christian saints, Corot's ambivalence, and Manet's uncertainties. The work of these men shows how difficult it was for artists to free themselves from accepted ideas, and recreate what they saw without resorting to established formulas. What strikes us about the next generation of the avant-garde, following in their footsteps, is their consistency. Once the Impressionists had developed their styles, we find diversity but not regression. The ground had been broken for them, and working as a group they propelled each other forward. It was clear to them that the new art was the only kind, and the determined young Claude Monet was unsparing in his criticisms of what he considered the backslidings of Courbet and Manet, who were among the chief inspirations for his painting in the 1860s. The Impressionists not only launched modern art through the impact of their canvases, but by the example of their exhibitions and their artistic integrity, they killed the official Salon as a place where serious artists could exhibit.

Yet if consistency is an important aspect of Impressionism, we can also be surprised by the very divergent attitudes toward it in the twentieth century. For the general public with an even marginal interest in art it has become the most popular of all movements, but professionals in the art world have admitted its fundamental importance while at the same time condemning it as mindless copying of what the artists saw in front of them. Numerous books have quoted the saying sometimes attributed to Cézanne and sometimes to Degas, that "Claude Monet was only an eye." In the 1930s and 1940s Cézanne with his concern for form and structure was seen as the important artist of the Impressionist generation. While the triumph of Abstract Expressionism in the fifties and sixties forced a reevaluation of Impressionism, it has come under

new attacks recently because of its inadequate portrayal of the social realities of its time.

I wish to show by a careful study of the works that not only did the Impressionists create great paintings, and the general public is not naive or sentimental in admiring them, but that many of the criticisms are irrelevant or inaccurate. In order to do this, it is necessary to define Impressionism, a concept that has become enlarged to include a great number of late nineteenth-century artists, who are quite out of place. In order to understand Impressionism we have to narrow it down to the artists who are at the heart of the movement, and to limit it in time. Like most modern art movements it was short-lived, even though several of the artists continued to paint for thirty or fifty years after its demise as a movement.

These later works are a considerable modification or even a rejection of Impressionist principles. The core consisted of about ten men and women, Monet, Renoir, Sisley, Pissarro, Berthe Morisot, Boudin, Manet in his later work, Degas, Mary Cassatt, and Caillebotte. The latter two artists are rather peripheral, and some of their most important works represent a new direction that signals the end of Realist ideals. Degas, who was stylistically and temperamentally distant from the other painters, shared much with them in the 1870s. Although Cézanne was an almost exact contemporary of Monet, Renoir, Morisot, and Sisley, and was also like them an open-air painter, he does not fit our definition, drawn from the work of the other artists. Impressionism was for Cézanne a catalyst that enabled him to relinquish his early, emotionally based paintings for works derived from close observation of nature but quite different from those of the Impressionists, Bazille, who died at the age of twenty-nine in the Franco-Prussian War, can also be included, though his contribution was necessarily very small. Impressionism crystallized in the later 1860s, reached its height in the 1870s when the first exhibitions were held, and disintegrated in the early 1880s, when the artists found themselves seriously questioning their work. The last exhibition was held in 1886, but few of the original artists participated, and it was dominated by artists who were to become leading figures of Post-Impressionism and Symbolism like Seurat, Signac, Gauguin, and Redon.

Monet, Renoir, Sisley, Morisot, Bazille were born within two years, 1839–41, and their formative years as artists were the late fifties and early sixties, when Courbet was at the height of his notoriety and Manet first exhibited his pictures. Pissarro, who was older, came to Paris from the West Indies in 1855, and he shared these experiences. As young artists they admired the older generation of Realists—Courbet, Millet, Corot, Daubigny, and Daumier. They also grew up with the illustrated

magazines and the photograph, and were consequently aware of a whole mass of pictures of contemporary life that had not yet penetrated into painting. Monet had even copied the caricatures in the illustrated magazines, and made money from them as a schoolboy. They shared Courbet's belief that they should depict what they saw about them, and they mainly painted landscapes and still lifes. Quite a few of the landscapes were painted at Barbizon; and Monet painted a still life in 1862 of a raw lamb chop, a kidney, and a couple of eggs, following Ribot and Bonvin. By the mid-sixties, though, while still painting from nature, their goals had changed and they were launched on an investigation that looks very simple, but is rich and complex.

The misconceptions about Impressionism are numerous. It needs looking at carefully, but we find it easier to approach even visual art with intellectual conceptions (or preconceptions). For many years one of the textbooks on the history of art maintained that Impressionists did not use green paint but applied strokes of blue and yellow that the spectator's eye mixes to create green. Even though a cursory glance at a painting shows that the artists applied green pigment, this error is still widely believed.

Another common but mistaken belief is that the Impressionists used color straight from the tube and did not mix it on the palette. Again, looking at the numerous different greens, or creams, for example, should quickly dispel this idea, but it does not seem to have done. In their search to reproduce all the nuances of color that they observed, the artists mixed colors frequently. Some of these myths seem to have sprung from the division of color that they did practice, but this meant using the constituent elements of a color for shading and highlights— for example, instead of brown and white with grass they used blue for the shadows and yellow for the highlights.

Many writers have insisted that there was no specific Impressionist subject matter, that the artists would paint any subject, and that it was only the technique that counted. This particular mistake has begun to disappear, with good reason, as I will show later. Even as distinguished a scholar as Fritz Novotny claims that Claude Monet by 1874 was already a pure landscape painter, an oversimplification typical of the writings on Impressionism.

The sources of Impressionism reveal a good deal about the extent and nature of the change from their initial direction. Whereas the first generation of Realists had learned so much from seventeenth-century art, the Dutch, the Spanish, and the brothers Le Nain in France, the Impressionists turned away from the seventeenth century, admired Rococo art, and were fascinated by Delacroix as a colorist. Japanese art played a crucial role in catalyzing the new style, while Monet and Pis-

sarro's stay in London during the Franco-Prussian War enabled them to see Turner, Constable, and other English artists, who also played a part in their development.[1] Their sources are thus quite different from those of the earlier Realists, and reveal a search for a dynamic, not a static, vision of the world.

If we follow Claude Monet's career in the mid-sixties, we can understand the developments that led to *plein air* Impressionism, as Monet became a leader both through his strength of character and his artistic innovation. As we have seen, he began with an admiration for the Barbizon landscapists and for Millet and Courbet. He used thick paint and a dark palette, and took over their belief that the most ordinary subject is fully worthy of being painted. The year 1864 marks a change in his work. He painted a large still life of flowers and recommended this theme to Bazille, his close friend, who had remained in Paris when Monet went to Honfleur on the Normandy coast to paint with his old friend Boudin and the Dutchman Jongkind. Monet also wrote of painting a study entirely in front of nature, and of a relation to Corot's work in one of his pictures. These statements indicate a new interest in color and atmosphere and a move away from his earlier subject matter.

Monet wrote too of the benefit of being in the company of the other artists. Boudin with his pastels of the sea and sky, had already aroused the admiration of Baudelaire, who was not particularly responsive to landscape: "These studies so rapidly and so faithfully sketched after what is the most inconstant and the most ungraspable in its form and color, after the waves and the clouds, bear always, written in the margin, the date, the time and the wind." In the summer of 1864 Boudin began producing his small pictures of holidaymakers on the beach at Trouville [164]. These became the forerunners of so many canvases by the other Impressionists of people enjoying themselves by the water. Monet, though a close friend of Boudin, did not paint similar themes until three years later. He was fiercely independent and probably deliberately avoided seeming to imitate Boudin. Nevertheless, the large painting Monet conceived over the following winter did involve middle-class leisure. Jongkind, a Dutchman working frequently in France, and something of an alcoholic, has become a minor figure in the history of

[1] The question has been raised whether the Impressionists were able to see Turner's remarkable watercolors, but Thoré's comments in his review of the 1862 International Exhibition in London show that not only were the watercolors on exhibit but that they were regarded as important by the forward-looking members of the French art world: "And Turner! what a great artist! Happily his work is not rare in London. The National Gallery in Trafalgar Square has consecrated a whole room to him: more than a hundred paintings; and add the paintings and watercolors in the Kensington Museum. At the International Exhibition there are around ten canvases and more than fifty watercolors."

art, though he was an excellent painter. Monet credited him rather than Boudin with the "final education of my eye." Jongkind employed modified Baroque compositions to open up vistas of beach, sea, and sky [165], which made Boudin's views seem as timid as he described them. Monet, a couple of years later, was to further modify Jongkind's ideas to create a characteristic Impressionist composition of the river or road that thrusts straight into the picture.

As a result of these experiences, and a sense of having arrived at a certain artistic maturity, Monet in early 1865 embarked on one of the most ambitious, even foolhardy, projects of Impressionism. At the age of twenty-four he set out to challenge and replace Courbet and Manet, the two leading figures of the avant-garde. His picture, 15 feet high and 20 feet wide, was the same vast size as Courbet's famous canvases, and

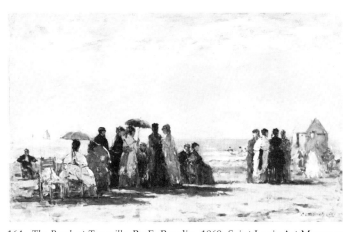

164. *The Beach at Trouville.* By E. Boudin, 1869. Saint Louis Art Museum.

165. *The Beach at Sainte-Adresse.* By J. B. Jongkind, 1863. Musée d'Orsay, Paris.

its subject, a *Luncheon on the Grass*, was the same as Manet's picture exhibited two years earlier at the Salon des Refusés. Monet intended to eclipse Courbet by turning from rural to city life, and by introducing far more light and color than we find in the dark, gloomy pictures like the *Burial* and the *Combat of Stags*, the gigantic canvas by Courbet that had been very successful at the Salon four years earlier. Monet must have found Manet's picture deficient in two respects: the introduction of the nude women into the company of the dressed men was not Realist, and smacked of the indecency of academic painters like Gérôme, while the atmosphere was more that of a studio landscape. Monet's figures were all dressed, it was a real picnic, and he made all the sketches out of doors so that he could reproduce the feeling of actual sunlight filtering through the trees.

The *Luncheon* was to be the culminating masterpiece of Realism and open up a new stage of modern painting. In the event, Monet had undertaken too much. The learner of the previous summer was not artistically ready to succeed on this scale with a kind of subject he had not painted even on a small scale before. His finished sketch, a large painting in its own right, 6 feet wide almost, now in the Soviet Union, is an outstanding painting, but the enlargement created difficulties. The upper half of the sketch is almost solid foliage, and blown up, it became oppressive. The brushstrokes that created the play of light on the leaves in the sketch could not simply be enlarged, so Monet boldly repainted the dress of the woman on the far left with bands of bright red to brighten the painting. Monet never quite finished the picture, was obliged to abandon it, and when he finally recovered it in a damaged condition, he cut it up, so that today there remain large fragments.

The most important of these, the central part of the picture with the figures around the picnic cloth, has until recently remained in a private collection and has been very little known [166]. This is unfortunate as it is a magnificent picture in itself, and a pivotal work in the development of Impressionism. If hung beside Manet's *Déjeuner*, it would reveal that Monet had eclipsed the former in creating a work that is more interesting artistically and one that showed the way to the future.[2] Though not exhibited, it was known to all the future Impressionists and can be compared to another unfinished, exhibited work, by a twenty-five-year-old that provoked a sensation among his friends, Picasso's *Desmoiselles d'Avignon*.

Monet did not attempt such a huge canvas again until the twentieth

[2] This claim may sound excessive, but Manet's *Luncheon on the Grass* has become celebrated because of its startling and puzzling character, not because it presents a persuasive new vision. *Olympia* was a far more stylistically coherent and influential painting.

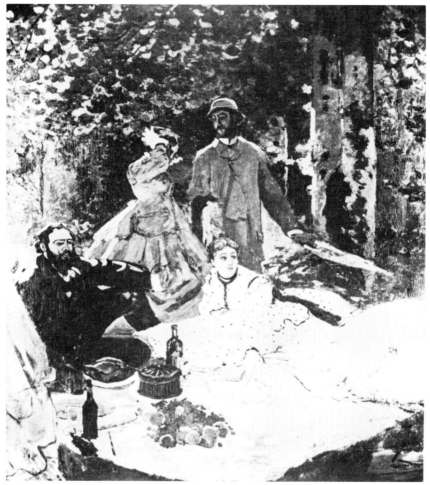

166. *Luncheon on the Grass*, detail. By C. Monet, 1865. Musée d'Orsay, Paris.

century with his *Waterlilies*. His ambitions, however, were not discouraged and he went on to paint large pictures, but ones that could be painted mainly on the spot, not back in the studio from sketches. He and his friends now embarked on the gradual evolution of Impressionism. They retained the Realists' belief in an ordinary subject painted from life as truthfully as possible, but they abandoned the solidity of Realism for the insubstantial experiences that paralleled Baudelaire's idea that the modern world was one in motion.

If we look at Impressionism in the wider sense of its content, the synthesis of subject matter and style, we can see it as a painting of everyday life (without patronizing or comic aspects) that celebrates its possibilities of happiness and freedom from the more oppressive as-

pects of nineteenth-century social attitudes. It depicts the world of the modern town dweller, specifically that of Paris, with its joys and personal satisfaction, the life of the café and the boulevards, the dance halls and theaters, and of the excursion resorts outside the city. What we think of as Impressionist landscapes are in fact the scenes painted at Argenteuil, Bougival, and Chatou, and the other river resorts on the edge of Paris to which Parisians flocked. The figures that animate the canvases are not peasants, but holidaymakers in their top hats or best dresses. When Monet and Renoir paint the sloping fields away from the river, subjects in which we might expect rural life, the people depicted are again not peasants but promenaders in their Sunday best (for example, in Monet's much reproduced *Field of Poppies,* 1873). In spite of his strong left-wing views, even Pissarro, when he puts peasants into his paintings, usually shows them resting, or if they are working they are tiny figures who complete the pastoral scene. They do not give any feeling of toil as Millet's peasants did, but are simply part of a delightful scene.

The development of the Impressionist style created this mood; the individualized brushstrokes and the new compositions meant that everything is seen in motion with lightness and airiness. There is no dwelling on anecdotes or suggestions of stories, which were left to writer friends like Zola and Guy de Maupassant. Each canvas captures with unprecedented intensity the experience of the moment in its transformation, solving the problems of representing both time and motion discussed in Chapter 4.

A discussion of Impressionist subjects and style will bring out the particular character of Impressionism. We must make the proviso that the paintings are total works that do not have subjects in the normal sense, as will appear in the following analyses.

PARIS—ITS STREETS AND PARKS

A characteristic subject is the life of the city itself in its most lively and delightful aspects. Monet, Renoir, and Manet recreated the animation of the boulevards and parks, themes also painted by Pissarro when he returned to Impressionist ideas near the end of his life. We might find it surprising to realize that Claude Monet, so often thought of as a landscapist (exclusively a pure landscape painter, as Novotny described his work of the 1870s), painted Paris frequently. In the 1870s he painted his two famous views of the Boulevard des Capucines, the Pont Neuf, several views of the Parc Monceau, the Gare St. Lazare series, and views of the streets decorated with flags to celebrate National Day, June

30, 1878. This was not a case of painting what was at hand, because at this time Monet was living at Argenteuil, and deliberately chose to come into the city to paint these themes.

Monet's *Boulevard des Capucines*, 1873 [167], exhibited at the First Impressionist Exhibition the following year, typifies these works. The plunging view down into the street gives us a feeling of the busyness of the boulevard, the flow of people, but it is a generalized impression of movement, and of the vivacity of the city street. We cannot distinguish individuals; there are no little scenes played out to concentrate our attention, which moves through the pictures following the line of trees and cabs. We are attracted by the spots of pink and red, and respond to the different directions and weight of the brushstrokes.

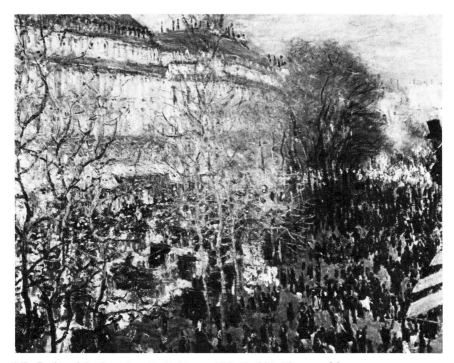

167. *Boulevard des Capucines.* By C. Monet, 1873. Pushkin Museum, Moscow.

We realize that it is not a picture *of* the boulevard—we cannot see the architecture properly, the angled view prevents us from seeing the boulevard as a whole, and we have no idea of what stores or cafés are located on it. Nothing could be further than a novelist's description of a boulevard. Though setting up his easel on a balcony and very conscientiously rendering the specific place, Monet has created a general pic-

ture of the feeling of the city street. A reviewer of the Impressionist Exhibition said about this canvas:

> Never has the prodigious animation of the public street, the swarming of the crowd on the asphalt and of the coaches on the roadway, the agitation of the trees on the boulevard in the dust and the light; never has the unseizable, the fugitive, the instantaneity of the movement been grasped and fixed in its prodigious fluidity, as it has been in this extraordinary, in this marvellous sketch that M. Manet [sic] has catalogued under the title of *Boulevard des Capucines.*

Chesneau's vocabulary recalls Baudelaire's use of "fugitive" and "fluidity," while his "fourmillement de la foule" recalls "Fourmillant cité" in Baudelaire's *Tableaux Parisiens.* Chesneau recognized that Monet had gone further than Manet in his *Concert in the Tuileries* in capturing the feelings embodied in all those nouns. We realize that the actual movement of the city, pedestrians and horse-drawn traffic, was not much greater than it had been in the swarming city one hundred years before; the change lies in the psychological response to the city, which sees in it an expression of the feeling of contemporary life.

This painting shows the compositional conceptions of Impressionism very well. By taking a plunging balcony view Monet makes everything equidistant from the viewer, so that we do not feel that some things should be more detailed or more solid than others. The tipping up of the perspective as we look down also brings everything onto one vertical plane so that we are aware of the whole picture at once—the impression. Monet, with the benefit of experience, has been able to avoid the discordances of scale that Manet did not altogether escape in some of his bold pictures of the early sixties. Monet's picture certainly owes something to the many views of Paris streets in the illustrated books [168], but by taking the angled view he has also avoided Gavarni's discrepancy between the modeling of Vireloque and the surrounding people.

Renoir, Pissarro, Morisot [169], and Caillebotte also used the view from the balcony to give distance and to avoid close-ups, though in one picture, *Place Clichy,* ca 1880 [170], Renoir faced the challenge of the anecdotal street view. The foreground head and shoulders of the young woman, cut off by the frame, works well, as a momentary glimpse of someone crossing the street (the profile view, the upper part of the face including the eyes hidden by the shadow of the hat) prevents the woman from catching our eye and "speaking" to us. We can contrast it to Baudelaire's poem "To a Passer-by," in which the poet passes a woman on the street whom he instantaneously feels could have been the woman of his life, and in the last line he sees her as having recog-

168. *Thomas Vireloque and People Entering the Opera Ball* from *Tableau de Paris*, 1852, by E. Texier. Illustration by Gavarni.

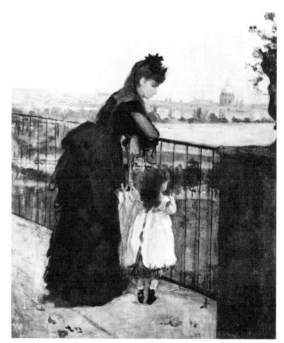

169. *On the Balcony.*
By B. Morisot, 1872.

nized this, before they are separated by the crowd. Renoir's concept eliminates the anecdotal, expressing only the charm of the woman's appearance, which is created not by her face but by her hat and ribbons, thus also avoiding the cliché of the pretty woman.

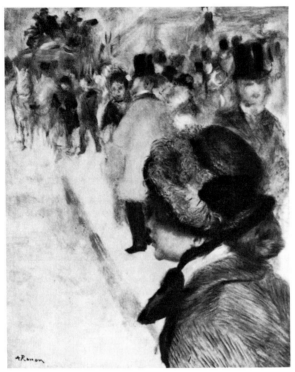

170. *Place Clichy*. By P. Renoir, ca 1880. Private collection.

The change in the content of the city view appears in a trio of pictures, Corot's *Rome: The Castle of Sant' Angelo with St. Peter's*, 1826–27, Monet's *The Garden of the Princess*, 1867 [171], and the *Boulevard des Capucines*. Corot renders each facet of the architecture as a patch of color with incredible sensitivity to each nuance of tone, carefully composing the canvas and almost eliminating people so that he expresses the static quality of the buildings. The painting is an extraordinary harmony of mud-colored tones. Monet had learned to appreciate this subtlety in Corot, and he had also developed the range of brushstrokes he had inherited from Courbet and the Barbizon painters. For each element in *The Garden of the Princess*, the grass, the people, the foliage of the trees, the background buildings, and the clouds, Monet uses a different type of brushstroke, which replaces drawing as a way of distinguishing

171. *Garden of the Princess.* By C. Monet, 1867. Allen Art Museum, Oberlin College, R. T. Miller, Jr., Fund.

them. He seeks variety whereas Corot unifies his picture, and relieves the typically gray Parisian day with a contrast of different lights and darks throughout the painting. Monet follows Corot and Constable in introducing a patch of red against the green, here the flag, to enliven the foliage with a complementary clash.

The numerous people, each composed of three or four brush-strokes, flicker through the middle band of the picture, the first step toward the fluidity of the figures in the *Boulevard des Capucines*. Monet constructs his composition with the sides of the garden converging toward the center church dome. The transition from the traditional well-composed picture can be seen, though, in the fact that Monet has se-lected a vertical rather than a horizontal format, losing the stability of the latter, so that he gives us a slice of city rather than a vista in spite of his elevated viewpoint. The concealing of most of the architecture by trees also creates irregularity rather than regularity.

PARIS—CAFÉS, THEATERS, AND STORES

Some of the most celebrated Impressionist paintings are those which extend the theme of the Paris streets into the cafés, especially the café concert, the theaters, and the milliners' shops. The same spirit of Paris as dynamic and exhilarating animates them. Though we see close-ups frequently, the artists do not involve us in the lives of the people they paint. Renoir's *The Moulin de la Galette*, 1876 [172], with its dance hall and the table of young people in the foreground, provided a perfect

172. *The Moulin de la Galette*. By P. Renoir, 1876. Musée d'Orsay, Paris.

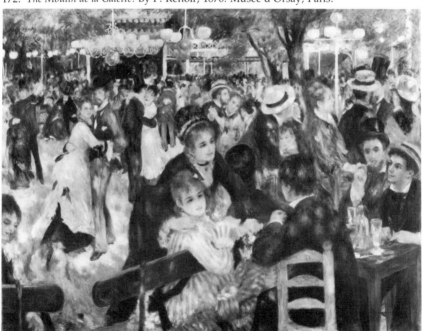

setting for the kind of anecdotes that Frith, for example, delighted in. Yet Renoir avoids any suggestion of stories, of love affairs springing to life or ending, or of jealousy. We have only to think of the Rococo pictures which inspired Renoir to see what he has done. In the picnics and concerts of Watteau, Lancret, Pater we see a couple sitting happily together but a third person in the group looks across at them enviously, or a man pays court to a young woman who steals a glance at another man totally involved in his companion. The human predicament is most exquisitely expressed by Watteau in the *Embarkation for Cythera,* so much admired by Monet. The three couples in the foreground tell a story. The right-hand couple are seated together, the happy lovers; in the next couple the man is pulling the woman to her feet; while as the third couple walk away, the woman turns to look back wistfully toward the happy couple. Never has the transience of human happiness and human love been more exquisitely represented. Monet's scenes with people in a landscape omit any suggestion of this elegiac mood.

Renoir learned from the Rococo artists the importance of the brush-stroke, how it can be a fluid element that creates movement throughout the painting even when the people are all seated, the touches of color and light evoking beauty without making the people ideally beautiful; and especially from Watteau he could learn to observe the gestures of everyday life and how to reproduce them faithfully, and still make a graceful painting. Finally, from the Realists Renoir learned the impor-tance of the fleeting moment of ordinary life, not as symbolizing a particular human experience, but for its own sake.

He expresses human interaction by the standing woman leaning with a hand on the shoulder of the seated girl—she has stopped in passing to exchange a word, insignificant or important we shall never know. The scene is a dance hall, and Renoir creates movement and mood not through the gestures of the dancers, but by the patches of light that filter through the trees, the lively spots of the lamps, hats, and faces. Our eye is never still as it tries to absorb and follow this confetti of light, which makes all the elements listed equal. Renoir had reached back to the seventeenth century for the opposed diagonals that organize the complicated composition, but he has overlaid it with the surface pattern of light and color that gives such immediacy to the whole painting.

In their scenes of the theater and the café concert, the Impression-ists' approach means that usually our attention is not concentrated on the performers; they share the stage, so to speak, with the audience, the musicians, and the setting. It was the general spectacle of the the-ater which attracted the painters, and in its liveliness it was a kind of continuation of the street scenes. Degas's *Aux Ambassadeurs,* 1876–77

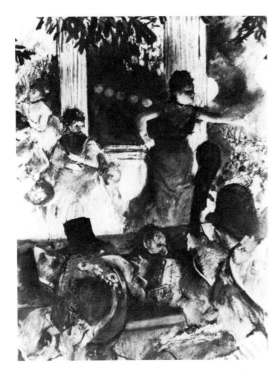

173. *Aux Ambassadeurs.*
By E. Degas, 1876–77.
Musée des Beaux-Arts, Lyon.

[173], for example, includes all these elements in a balance where we cannot say that one is more important than the others. By looking over the shoulders of the audience Degas can delight in the shapes and colors of the hats and the musical instruments, and like Renoir in his *Place Clichy* avoid distracting us with the faces of the spectators. The performers in the background become part of the play of light and color, and the light background against the dark foreground balances the two parts in interest, forming a picture in which we feel everything on one plane.

As a friend of the Impressionists, Georges Rivière, wrote in 1877 when works like this were exhibited by Degas: "His prodigious skill bursts out everywhere; his ingeniousness, so appealing and distinctive, places the people in the most unexpected and amusing way, at the same time that it is always true and always normal. . . . He is an observer: he never seeks exaggeration; the effect is always obtained through nature herself. . . ." Degas's amusing observations can be seen in his use of the hats and the unnatural pallor of the singer's face caused by the artificial lighting. We have already seen Manet's similar witty play with the rounded shapes of the heads, hats, and beer tankards in his *The Waitress* [162]. This visual wit, which makes use of all different kinds of objects in the scene, replaces the subject in its accepted sense by giving point to the slice of life.

Both of these pictures by Degas and Manet were inspired in part by Daumier's prints [41], which contained similar compositions of both theaters and café concerts. The cut-off figures in the background of the *Waitress* can be found in Daumier, though it is the type of compositional device that has often been attributed to Manet's and Degas's encounter with Japanese prints. These later artists thus found both composition and subject in Daumier, not to mention some of the visual wit that has been discussed.

We have seen the importance of hats as visual devices for several of the painters so it is not surprising that milliners' shops were also painted by Renoir, Degas, and Manet. Degas's *At the Milliner's*, ca 1883 [174], offers almost a bird's-eye view inside the shop, so that the hats fill every part of the picture; there is no foreground and background, but rather a staccato punctuation of hats and wall, with the hats at the top of the picture making us feel that we are leaning over the table and are right among them.

174. *At the Milliner's.*
By E. Degas, ca 1883.
Private collection.

If Degas owed an important part of *Aux Ambassadeurs* and similar pictures to Daumier, *Women on the Terrace of a Café*, 1877 [175], with its columns slicing through the figures, comes from the Japanese. Degas's treatment of the cut-off chairs and women again pulls us right into the pastel, and we can make the same comparison that we made between Manet's *The Waitress* and Béraud's *Pastry Shop "Gloppe"* [163]. In this pastel, Degas obviously represents prostitutes, one of the few Impressionist pictures which does represent low life, and a reminder that the world of prostitution fascinated Degas, although he usually confined it

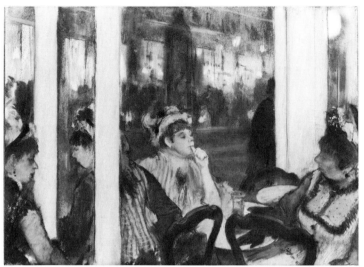

175. *Women on the Terrace of a Café.* By E. Degas, 1877. Musée d'Orsay, Paris.

to his extremely personal monotypes. Even here Degas puts so much emphasis on the play of forms—the straight verticals on the left and the disjointed curving space on the right—that the women are not protagonists but players in the game. Degas, as we have seen, ransacked French and Japanese graphic art for ideas, but when we study the three entirely different compositions in the three pictures examined in this section, his own genius in composition is evident.

RECREATION AND SPORT

The second half of the nineteenth century saw an enormous flourishing of sport and recreation of all kinds. In 1965 and 1966 the centenaries were celebrated in England of the founding of the Football Association and the Wimbledon tennis tournament, the world's leading professional team sport and the leading amateur game. Though these two sports do not appear in Impressionist painting, we do find many pictures that include horse racing, riding, sailing, rowing, swimming, skating, and croquet, and even pictures of cricket matches [178] painted by Pissarro, who developed an enthusiasm for the game on his visits to England (not surprisingly, museum curators have not always recognized what is happening in these paintings when writing the labels).

The pictures of recreation continue the mood of the café and theater scenes in which the artists interest themselves more in the overall feeling than in the event itself. The difficulty of representing horses galloping has already been discussed; most of Degas's racing pictures show horses before the start or focus even more on the spectators. The jockeys' colorful silks play a prominent part both pictorially and in suggest-

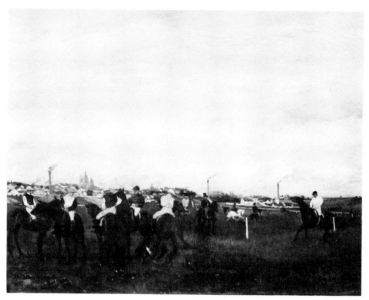

176. *The Races*. By E. Degas, ca 1873. Widener Collection, National Gallery of Art, Washington, D.C.

ing the cheery spirit of the races. As in *The Races*, ca 1873 [176], Degas usually paints amateur races rather than professional meetings, where the betting was more important than the races. This painting, like many Impressionist pictures, includes factory chimneys in the background. Degas could have omitted them very easily, but he chose deliberately to put them in. The races took place on the outskirts of Paris, where the new factories were built. Obviously Degas felt that they were part of the world he lived in, and that they gave a feel of contemporaneity to his work. They were just the thing a conventional artist would have omitted and would have appealed to Degas's combative spirit on just that ground.

Degas produced so many horse-racing pictures that it is easy to forget they were also done by Manet and Boudin, and there was apparently at least one among the many lost works of Claude Monet from the mid-sixties. Once more, the English artist Frith pioneered with this subject as a slice of modern life, rather than the sporting print with the group of horses in the inevitable flying gallop. His *Derby Day*, 1858 [19], shows the crowd with the mixture of social classes, the itinerant entertainers and the criminal elements, that characterizes a great racing occasion like the Derby. The careful selection of as many different types as possible and the profusion of anecdotes and freshness of its theme made the *Derby Day* a huge success at the time. It is still a vastly entertaining picture today, though as an eventful illustration rather than a gripping work of art.

177. *Hide and Seek*. By B. Morisot, 1873. Private collection.

Renoir's skating in the *Bois de Boulogne*, 1868, stands out as a work that develops Monet's composition in the *Garden of the Princess* and Manet's in his *View of the Paris World's Fair*, and points the way to the *Boulevard des Capucines*. Renoir took a raised viewpoint on a hill and scattered his figures through the picture to create different kinds of movement, linear in the patterning of the people, more abrupt in the contrast of dark and light. We feel a natural disorder in the scattering of the skaters that makes both the Monet and the Manet paintings feel very deliberately constructed. In spite of the artistic success of the work,

178. *Hampton Court: Cricket Match*. By C. Pissarro, 1890.
Location unknown.

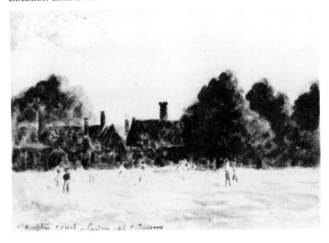

Renoir, who felt the cold very keenly, resolved not to
snow scenes.

No sport was too humble for the Impressionists; i'
a snob appeal, with its associations with the Jockey ˰
willing also to paint butterfly hunting and hide and seek [1//].
of these pictures, as in Pissarro's *Hampton Court* with its cricket matu.
[178], the balance of trees, houses, sky, and people evokes an afternoon
rather than describes an event.

RAILWAY STATIONS AND TRAINS

The problem of bringing the railroad into art was discussed earlier, and
we saw that if the Impressionists are celebrated for introducing the
painting of stations and trains into French art, they could not success-
fully tackle the train in motion. At this point, when we have analyzed
some of the Impressionist approaches to subject matter, we can see that
this conquest of the locomotive was not necessarily one of their goals.
Train stations and the tracks usually take up only a small part of the
canvases in which they appear, like the Gare St. Lazare almost hidden
down below in Manet's *Gare St. Lazare* and Caillebotte's *Pont de l'Europe*,
1876 [179]. Pissarro and Sisley in their much more rural paintings occa-
sionally introduce railroad crossings and embankments with the smoke
of a train cutting across the country scenes.

As was the case with the factory chimneys at the back of Degas's

179. *Pont de l'Europe.* By G. Caillebotte, 1876. Musée du Petit Palais, Geneva.

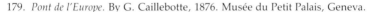

acecourse pictures, the railroad gives a sense of contemporaneity to a canvas, but is not an end in itself. The Impressionists wanted to find beauty in modern life while including the chimneys and trains. Baudelaire had written in his first Salon review in 1845, "He will be the *painter*, the true painter, who knows how to tear the epic side out of contemporary life." It was this tearing, this struggle to find a way of *expressing* contemporary life, not merely a change of subjects, that mattered.

Caillebotte's *Pont de l'Europe* demonstrates this struggle as he set himself the task of making an engrossing picture out of an ugly modern girder bridge. In his oil sketches he began looking straight at the bridge, an idea probably taken from Japanese prints, where timber-trussed bridges of similar forms are given very prominent roles. He then changed from this rather static concept to the very dynamic roadway plunging straight into the canvas, the composition developed by his close friend Monet, who was painting the tracks down below the bridge at the same time. In this new arrangement the diagonal beams of the bridge also take on a much more vigorous role.

THE RESORTS AROUND PARIS

The railroads needless to say took Parisians on a Sunday to Argenteuil, Bougival, and Chatou, where the Impressionists painted them sailing, rowing, swimming, or simply enjoying strolling on the riverbanks and eating at the outdoor restaurants. Claude Monet moved to Argenteuil after his return to France at the end of the Franco-Prussian War, and his friends visited him there, which accounts for the large number of paintings of Argenteuil.

So numerous are these paintings by Renoir, Monet, Manet, Sisley, and Caillebotte that they have come to epitomize Impressionism. They began in 1869 when Renoir and Monet painted together La Grenouillère (the Froggery) at Bougival. This collaboration has often been seen as the beginning of Impressionism, and for a decade the image created at Bougival of the pleasures of summertime, boating and walking along the river, when the sun is always shining and there is always enough breeze to fill the sails, inspired canvas after canvas.

The Impressionist style reached its climax in these pictures: Renoir and Monet's *Sailboats at Argenteuil*, 1874, painted side by side; Manet's *Claude Monet in His Floating Studio*, 1874 [182], and his *Argenteuil*, 1874; Sisley's *The Seine at Argenteuil*, 1872 [181]; Monet's *Roadstead at Argenteuil*, 1875 [180], and *Woman Reading in the Grass*, 1876 [204]; and the spectacular *Luncheon of the Boating Party*, 1881 [183], by Renoir, the culminating masterpiece that marks the end of Impressionism as a coherent movement.

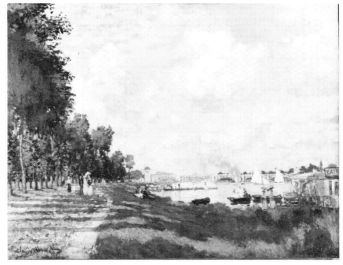

180. *Roadstead at Argenteuil.* By C. Monet, 1875. Musée d'Orsay. Paris.

Monet's *Roadstead* [180] reveals the richness of Impressionist vision. In one sense it is very empty, an exhilarating open space with the trees pushed off to the side and the boats and bridge distant and very small. It is static, nothing is happening, yet continual movement is created by the perspective of the towpath and riverbank, which pull us into the painting and right to the back where the line of the treetops and the

181. *The Seine at Argenteuil.* By A. Sisley, 1872. Private collection.

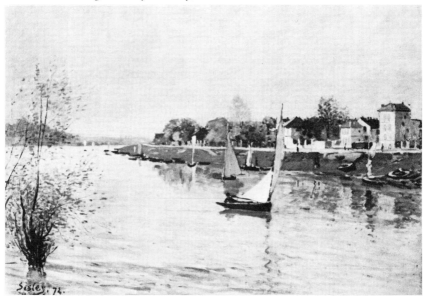

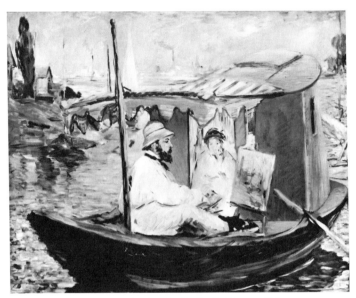

182. *Claude Monet in His Floating Studio.* By E. Manet, 1874.
Neue Pinakothek, Munich.

bridge sweeps across the picture and we are brought back to the foreground by the boats and clouds. There are pulls in various directions, the horizontals of the tree shadows and the bridge, the vertical of the trees themselves, and the movement inward of the path. The variety of forms, the linear aspects, the irregular brushstrokes of the clouds, the

183. *Luncheon of the Boating Party.* By P. Renoir, 1881. Phillips Collection, Washington, D.C.

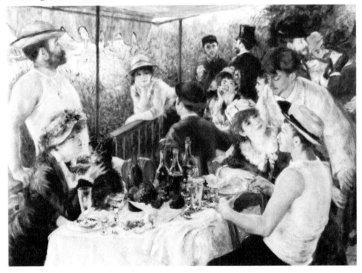

contrasts of dark and light throughout, result in a picture of a still scene that is full of movement—the quintessential Impressionist painting.

The painting of the clouds, which is a particular strength of Monet's, reminds us of Sisley's words: "What is more splendid, more thrilling, than the sky that recurs so frequently in summertime, a blue sky with fine, white, scudding clouds? What a movement, what a sight! The effect is like that of waves on the high sea, it exalts and carries you away."

In spite of these words, Sisley's own art was not as robust as Monet's, but in the early 1870s his recreation of the finest nuances of color and light makes his pictures among the most subtly beautiful of the Impressionists. *The Seine at Argenteuil* [181] has affinities with Corot. The sails, the buildings, and the river itself are all variants of a cream color created by the unifying effect of an overcast day, but each element is a different tone depending on its material or position. The difference from Corot's architectural paintings is that the sweep of the river and the contrast of forms create a gently flowing movement back along the river and through the sky. Sisley's picture avoids every kind of pictorial rhetoric—almost the entire painting consists of similarly colored water and sky, uninflected by waves or clouds, and the buildings and boats are few and distant. Sisley's achievement, like that in the pictures by Rousseau and Diaz discussed earlier, lies in his ability to make an engrossing painting out of nothing, out of an almost nonexistent subject. Yet these artists would regard this as a wrong formulation. They were painting the ordinary, the most universal subject of all. For the Barbizon artists, the solidity of the rocks, trees, and earth constituted reality. Sisley paints the presence of man in nature, the embankment along the river's edge, the houses, the boats, a more changing world than the forest of Barbizon. This general truth in the Sisley has become specific, as a century later we can see the Forest of Fontainebleau still looking exactly as Corot saw it, while Argenteuil has become a shack-covered urban slum.

After the breadth of Monet and the nuances of Sisley, Manet's *Claude Monet in His Floating Studio* assaults us with contrasts: the black band of the boat against Monet's white shirt, and complementary blue and orange throughout the picture. The boat itself bursts out of the picture at us like the cylinders in *The Waitress,* an emphatic three-dimensional curving form, reinforced by the complicated perspective of the roof of the cabin. No motif could better express the spirit of all the Argenteuil paintings than Monet at work in his floating studio. In the Impressionist world nothing is firmly anchored, everything is in transition, finding its counterpart in sky, light, breeze, water, and in the unstable reflections of everything that might seem solid.

As in the Degas racecourse pictures, Manet includes factory chimneys in the background. The industrial age could even be incorporated as one of the main themes in a canvas. Monet several times painted the iron railway bridge at Argenteuil, as well as *The Train in the Snow*, 1875, in Argenteuil station. It strikes us again that however many pictorial sources the Impressionists used, there is an originality of concept. The idyllic world of Argenteuil is created out of urban sprawl. All the hierarchies of subject matter, all assumptions of what was fit to mix and what was not fit to mix in a painting have disappeared. Just as Courbet seemed to have broken through all the traditional ways of dignifying and idealizing death, to give us a real funeral, so in Impressionist paintings, we feel the artists had found a beauty in contemporary life that convinces us because it is unlike the beauty in previous art.

This painting of the Parisians' Sunday afternoons on the Seine reached its most brilliant expression and its finale in the *Luncheon of the Boating Party* at Chatou, 1881, one of the greatest paintings of the nineteenth century. Renoir composed it of a myriad of touches of intermingled colors applied with an astonishing variety of brushstrokes, to create a work which is very complex, yet absolutely coherent. The technical expertise vanishes under the persuasive effect of the whole. Renoir very much admired Veronese's *Marriage at Cana* in the Louvre and took the foreground motif of the people gathered to eat and drink around a diagonally placed table from Veronese's splendid wedding feast. Yet Renoir outdoes this Venetian splendor with a typical group of Parisians having lunch at a simple outdoor café.

The painting exemplifies Renoir's "rainbow" palette at its best. He uses the three primaries and their three complementaries throughout the picture, with a little black and a lot of white. The vivacity created by the complementary clash is built up in innumerable ways: the very bright red of the flowers in the girl's hat in the foreground abuts on the green bush behind, the yellow of the hat itself is played off against the violet band around the hat, the blue of her dress is pressed against the orange light of the man's hand and the chairback. In front of her the different kinds of fruit, the wine bottles, and the glasses multiply these contrasts and repetitions. The large wineglass in the front is a painting in itself—the different kinds of brushstrokes defy description. They are the culmination of fifteen years of experiment in a new way of representing the world.

What the Impressionists capture in these pictures done along the riverbank is something that could be expressed only in a painting. These are the impressions and feelings that we have all experienced walking beside a river on a day when the sun shines; there is enough breeze to make the air alive, the water ripple and sparkle, and the leaves

scatter the sunlight. We use the expression of "feeling at one with the world," and we feel happy not because something good has happened to us, but because we are alive to so many sensations. None of the writers who went to Bougival or Argenteuil could capture this mood, as it would take seven or eight pages to describe all the effects of the light, of the breeze, the water, the boats, the clouds, the women's dresses, and so on. Not only would these descriptions not do justice to the scene, but we would have forgotten the beginning before we reached the end, so that we would not feel the richness and the exhilaration that we get from looking at the canvases. Instead, the writers described love affairs and the flirting that went on, fascinating stories in their own way, but entirely different in content from the painting. The exhilaration that I have described is only momentary, because a friend calls to us, or our companions shriek with laughter, and the spell is broken. The canvas can give us this moment, which is none the less real for being transient. The Impressionist brushstroke and color re-create both the moment and its passing quality through their evocation of the flickering light and atmosphere.

THE SEASIDE RESORTS

The railroads also made possible the vast expansion of holidays at the seaside, and for the Impressionists provided an extension of the resorts around Paris. The change in Monet's pictures shows how important the type of subject was to the Impressionists. He had grown up on the Normandy coast at Le Havre, and among his earliest paintings were views of the beach at nearby Honfleur with boatyards, and the fishing boats, the world of the working residents, pictures derived from the Realists whom he admired, such as Millet. In 1867 he painted a regatta with excursionists watching from the beach, and in 1870 at Trouville he painted several pictures of the promenade and of his family with parasols on the beach. Though Monet, with his love of river and sea, never ceased to interest himself in docks and commercial shipping, the direction of his subject matter changed in the later 1860s. Manet, Berthe Morisot, and even Degas worked at the seaside, though, surprisingly, not Renoir until the 1880s.

The pioneer of this subject was Boudin, whose watercolors [164] of holidaymakers on the beach are particularly radiant. He began these pictures and the accompanying oils in the early 1860s, following up the pastels of the sea and sky that had delighted Baudelaire. Boudin clearly felt that he was daring in what might seem a trivial subject. He wrote to a friend in 1868:

September 3, 1868

Your letter arrived just at the moment when I was showing Ribot, Bureau, and another person my little studies of fashionable beach resorts. These gentlemen congratulated me precisely for having dared to put into paint the things and people of our time, and for having found a way of getting the gentleman in an overcoat and his lady in a raincoat accepted—thanks to the sauce and the seasoning.

This attempt is not new, however, since the Italians and Flemish simply painted the people of their own period, either in interiors or in vast architectural ensembles; it is now making its way, and a number of young painters, chief among whom I would put Monet, find that it is a subject that until now has been too much neglected. The peasants have their painters of predilection: Millet, Jacque, Breton, and this is good; these men carry on sincere and serious work, they partake of the work of the Creator and help Him to make Himself manifest in a manner fruitful for man. This is good; but between ourselves these middle-class men and women, walking on the pier toward the setting sun, have they no right to be fixed on canvas, to be brought to light? Between ourselves, these people coming from their businesses and their offices are often resting after hard work. If there are some parasites among them, aren't there also those who fulfill their tasks? This is a serious, irrefutable argument.

I should not like, under whatever pretext, to condemn myself to paint clothes, but isn't it pitiful to see serious men like Isabey, Meissonier, and so many others, collecting carnival costumes and, under pretext of picturesqueness, dressing up models who most of the time don't know what to do under all their borrowed finery?

Although his pictures are tiny, Boudin played an important role in launching Impressionism because his contemporary people were painted in a convincing, light-filled atmosphere. It is one of the saddest events in nineteenth-century art that Boudin, who accused himself of timidity in his art, became more conservative in the late sixties, just as Monet and Renoir were developing the possibilities he had demonstrated. He introduced browns, blacks, and dark grays into his canvases, losing all the luminosity he had discovered, and his later work is a disappointment.

Berthe Morisot's *The Harbor at Lorient*, 1869 [184], though less dynamic than the canvases Renoir and Monet painted that same summer at Bougival, possesses the light-filled radiance of a Corot harbor scene. The static quality is appropriate for this Sunday afternoon with the ships all idle, and Morisot prevents any possible dullness by the insertion of the woman, in white with a parasol, at the right. She is large enough to be a visually dramatic element without destroying the mood.

The Impressionists naturally did not confine themselves exclusively

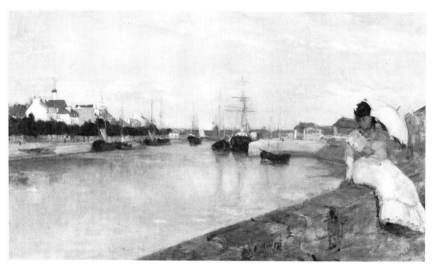

184. *The Harbor at Lorient.* By B. Morisot, 1869. National Gallery of Art, Washington, D.C., Ailsa Mellon Bruce Collection.

to depicting holidaymakers. Monet in London during the Franco-Prussian War painted the docks, and Pissarro, when he returned to Impressionist ideas at the end of his life, painted the quay at Rouen, 1896 [185]. Neither artist chose close-ups of the cranes and ships in order to illustrate them, but they preferred to capture the animation of the commercial subject.

185. *The Boiledieu Bridge at Rouen on a Rainy Day.* By C. Pissarro, 1896. Art Gallery of Ontario, Toronto.

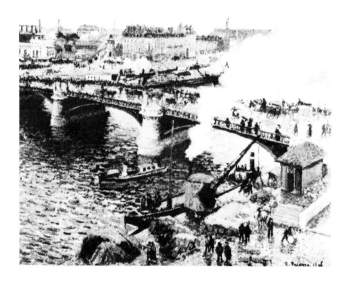

DOMESTIC LIFE AND INTERIORS

Scenes of domestic life were popular with almost all the Impressionists. They depicted a comfortable, but not luxurious, middle-class life in its daily and most commonplace pleasures. We see people chatting, eating, reading, sewing, and children playing. We do not encounter the formal occasions that play such a large part in French family life: dinners, receptions, weddings, or funerals. The artists avoid everything that might suggest a story. We have only to think of the increasing number of paintings in the Salons of Europe as the century progressed that used domestic scenes to suggest banal situations of flirtation or unhappy love. These tended to have titles like *Six Months After the Marriage* or *Two Beaux to Her String,* and they turn out to be as cutesy as their titles suggest.

Pissarro painted a number of pictures of his large family. *Louve-*

186. *Louveciennes: The Road to Versailles.* By C. Pissarro, 1870. Emil G. Buhrle Foundation, Zurich.

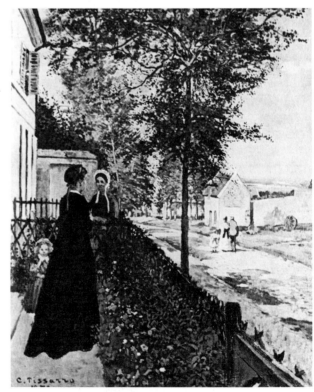

ciennes: The Road to Versailles, 1870 [186], shows again that Impressionist paintings do not really have subjects but rather themes. The road is not the subject, nor are the artist's wife and child talking over the fence with a neighbor. Though Mme Pissarro stands conspicuously in the foreground in her black dress, because she is seen from behind our attention is swept past by the perspective of the fence and road. There is no hint of the subject of the conversation, nor of a story, nor of any significance in the setting or the moment, of the kind that we find later in a picture by a Symbolist artist like Munch or Khnopff.

In discussing this picture, John Rewald quotes the critic Théodore Duret writing in this same year of 1870, that for Pissarro, "a landscape must be the exact reproduction of a natural scene and the portrait of a really existing spot of the universe. We cannot refrain from observing that by following too strictly this theory, he frequently selects insignificant sites where nature itself does not present a composition, so that he produces a landscape without painting a picture." For the inheritor of the Realist tradition, there could be no higher praise than to be told that one had not painted a picture, that one had succeeded in escaping the conventions and had presented the portrait of a really existing spot. We can see what Duret means in connection with this painting, where there is no center, no building up of a composition. The fence starts off on a strong diagonal but stops just in the middle, the entirely undistinguished road turns a corner and disappears. The major tree to the right of center is very unimpressive, spindly and shapeless. The lack of subject and the lack of "composition" mesh with, and form, each other.

We understand why Duret and so many other people were puzzled by Impressionist pictures, which did not fulfill any of their expectations. Pissarro has selected a composition, as Rewald points out, a diagonal division with a darker foreground against a distant light sky. It also has a theme, "the mood of a quiet day in the provinces," as Rewald puts it.[3] The intangible nature of a mood, like the intangible composition, took a while to insinuate itself into people's understanding, but Duret himself went on to publish a sympathetic study of the Impressionists as early as 1878. Rewald's sentence continues, "without any suggestions of movement or animation." Though the painting is as quiet as he describes it, and lacking in movement, it is fair to say, as always about Impressionist pictures, that there is internal animation: the spots of the red flowers against the green vegetation, the flickering of the innumerable leaves' silhouette against the sky, and the fluidity of the brushstrokes of the shadows on the road. Without this inner movement, Pissarro's picture would be as uninteresting as Duret suggests.

[3] J. Rewald, *Pissarro.* New York, 1963, p. 74.

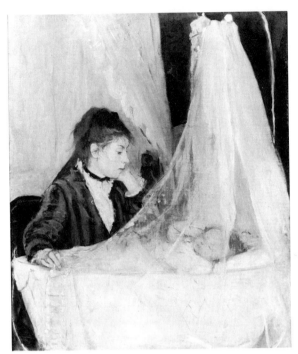

187. *The Cradle.*
By B. Morisot, 1873.
Musée d'Orsay, Paris.

188. *The Artist's Mother
Reading "Le Figaro."*
By M. Cassatt, 1883.
Private collection.

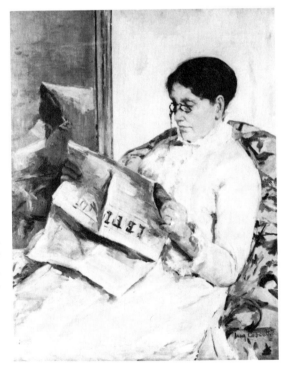

Mother and child, as in this painting, appear again and again in Impressionist canvases, but all the banal emotions and situations that made this a favorite Salon subject are eliminated. Berthe Morisot painted her sister with her baby in *The Cradle*, 1873 [187], concealing the infant behind the muslin hanging, conveying tenderness but not sentimentality. Mary Cassatt's mother engrossed in reading *Le Figaro* [188] typifies many of the canvases by Cassatt, Morisot, and Renoir. The solidity of the subject is dissolved by the light tones, beautifully nuanced, and by the fluid brushstroke. Sisley forms a more staccato rhythm of spots of color for his children absorbed in the *Lesson*, a rhythm which perhaps expresses the difference between the young children and the elderly lady.

Claude Monet's domestic scenes are particularly attractive. Less gregarious than his friends, he seems to have taken a greater pleasure in family life. The often unpleasant aspect that Monet's character presents in his hectoring, begging letters is mitigated by the numerous scenes of his wife Camille and their son Jean. Typical is the *Luncheon in the Garden*, ca 1873 [189], with Jean barely noticeable at first seated in the shadow in the left corner with his constructor set, and the two

189. *Luncheon in the Garden.* By C. Monet, ca 1873. Musée d'Orsay, Paris.

women half-hidden by the tree at the rear. The Impressionists usually painted small pictures that could be largely completed in front of the motif, but from time to time they synthesized their accumulated mastery in a large canvas, and this *Luncheon* (5 feet 6 inches by 6 feet 10 inches) displays Monet's skills at their height. The complex composition, the richness of color, the play of light and shadow make it an anticipation of, and possible inspiration for, Renoir's spectacular *Moulin de la Galette*.

Characteristic of most of the domestic scenes is the absorption of the sitters in what they are doing, whence the popularity of sewing or reading as motifs, to avoid the feeling of a posed portrait. For example, Degas, hardly a family man, depicted his father listening to the guitarist Pagans, lost in contemplation. The result of this approach is that we often find it difficult to decide whether an Impressionist picture is a domestic scene or a portrait, which is not a question with most of their contemporaries' works.

PORTRAITS

Examples of this difficulty can be seen in the portraits of Duranty and Cassatt by Degas, and Bazille's *The Studio*, 1870 [190]. If we compare the latter with Fantin-Latour's *A Studio in the Batignolles* [120], painted in the same year, and with Bazille's own *Family on a Terrace Near Montpellier*, 1867–69, we see the changes that have taken place within Impression-

190. *The Studio*. By F. Bazille, 1870. Musée d'Orsay, Paris.

ism. Bazille's *Family* consists of a group of portraits. The people are turned toward the artist as if posing for a photographer, and it can be seen in the light and shade of some of the faces that they were in fact copied from photographs. In the *Studio* it is the room which has become the subject, and the artists, most of whom also appeared in Fantin's painting, are a part of it, as are the paintings on the wall. None of these elements can be singled out. The lightness of this room and its emptiness, with the artists pushed to the back and the sides, remind us of Pissarro's non-composition discussed above. Like the latter, it forms a manifesto of the new art as well as marking a change from Bazille's earlier rather hard-edged style (his death later in the year in the Franco-Prussian War leaves us tantalized about his possible future development). Artists' studios in the nineteenth century tended to be filled with all kinds of decorative bric-à-brac that was regarded as picturesque: pieces of armor, swords, casts, wall hangings from the Near or Far East, potted palms, and so on. The airiness of Bazille's studio suggests not only the Impressionists' feeling for light, but also for unimpeded movement.

Fantin's retreat to "safe" painting can be seen in the dark colors and the closing off of the back of the picture with a wall, but also in the massing of the figures into an immobile lump. They meld together quite differently from the black-clad figures in Courbet's *Burial*, where the texture of the paint gives body to each individual. I have no explanation of Fantin's curious psychology, nor why as a friend of Manet and the Impressionists, he chose to commemorate them in a style that rejected everything for which they stood. In spite of their difficulties, they were advancing their styles at this time, not retreating.

While the Impressionists received few portrait commissions, they delighted in picturing each other and their writer friends. Sometimes, as in Renoir's portrait in the Musée d'Orsay of Monet standing at the easel, they approach a conventional portrait; but more often they resemble another of his portraits of Monet, where the latter stands at his easel in his garden, 1873, a relatively small figure, as we have already seen him in Manet's picture *Claude Monet in His Floating Studio* [182]. All these portraits are marked by their unpretentiousness, whether the subject is seen at a distance or in close-up. In one of the latter, Manet's picture of the poet Mallarmé [191], where we might expect a certain formal quality, the poet is slumped down exactly as he might be in a casual moment. The squiggle of paint that depicts the cigar smoke not only reminds us of Mallarmé's famous poem on smoke rings, but expresses the intangibility of the moment. Not surprisingly, Mallarmé was an enthusiastic admirer of Manet and of Claude Monet, especially the latter's works of the eighties when he developed his series. Though Mal-

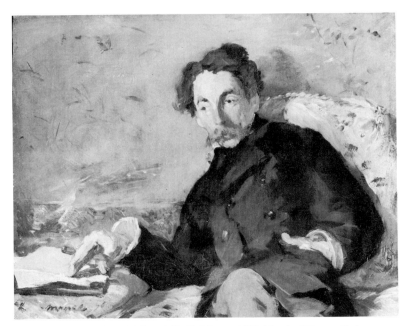

191. *Portrait of Stéphane Mallarmé.* By E. Manet, 1876. Musée d'Orsay, Paris.

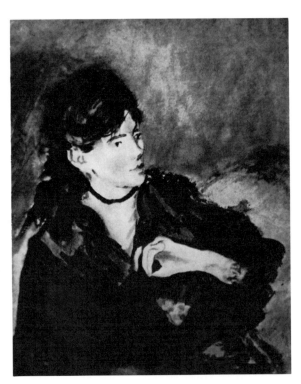

192. *Portrait of Berthe Morisot.* By E. Manet, 1874. Art Institute of Chicago, Joseph and Helen Regenstein Foundation.

larmé's Symbolist ideal lay at the opposite pole from the Realism of the first generation, the nuances of sensibility of the Impressionists corresponded with the writer's search for refined suggestion rather than simple description. In this portrait Manet uses fluid brushstrokes that give internal movement and life to the poet without destroying his relaxed pose.

Just as Manet painted Mallarmé not as the inspired poet but as the reclining smoker with a hand in his pocket, so he painted Berthe Morisot not at her easel but fan in hand [192], though unlike Mallarmé she is alert and gesturing. Where the open-air Impressionists used the independent brushstroke, which develops in oil paint and does not lend itself so well to watercolor, Manet's longer, fluid strokes were suitable, and he used this medium frequently.

Degas did paint the writer at his desk in his *Portrait of Edmond Duranty*, 1879 [193], in a fascinating composition. Duranty, lost in thought, his finger pushed inelegantly against his eye, is separated

193. *Portrait of Edmond Duranty.* By E. Degas, 1879. Glasgow Museum of Art.

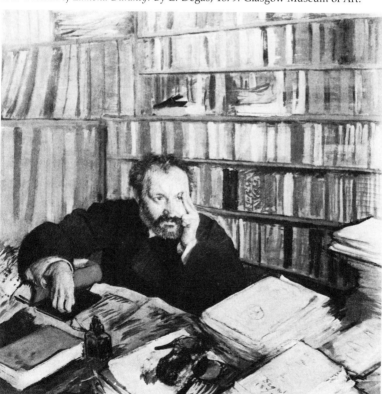

from us by the barrier of his desk and side table, but Degas slopes the desk top downward at the front edge of the picture, so that we feel we are leaning over it and very close to the writer. Duranty occupies only a small part of the canvas, which is overflowing with books and papers, yet he dominates it through Degas's modeling of his shoulder and sleeve. There is a strong reminiscence of Ingres's *M. Bertin*, 1832, the finest and most famous of his male portraits. Degas admired Ingres, but we feel the difference he created by replacing the blank background of the Bertin portrait with Duranty's environment. Part of the power of the picture comes from the contrast between the author's solid gray form and the movement in the multicolored book spines, which keep our eyes flickering back and forth picking up the repeated colors. The fact that most of the color appears in the background brings it forward

194. *Edouard Manet at His Easel*. By F. Bazille, ca 1870. Metropolitan Museum of Art, New York, Robert Lehman Collection.

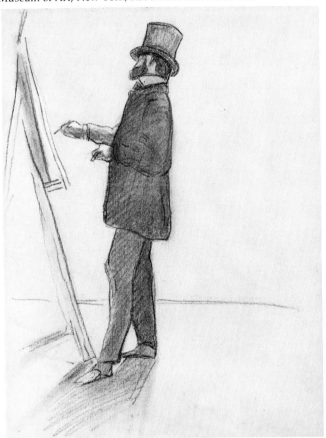

and amplifies the immediacy above. A final brilliant touch is the very small but three-dimensional, vertical inkwell, which reestablishes a sense of the plane of the desk top. Without it the papers would threaten to spill on the floor and destroy our concentration. Degas may have painted equally good pictures, but he probably never painted a better one than this.

The contrast between his *Zola* and his *Mallarmé* illustrates the change in Manet's art between the sixties and the seventies. The almost monumental figure of Zola and his study, held between the rectangles of screen and pictures, against a dark background, forms a static concept, even if enlivened by the color of the still life of books. In the later portraits, the fluid elegance achieves both a less hierarchical, more democratic vision of the artist and also greater beauty, the paradox that enriches Impressionism. Bazille captures this sense of style in the mundane in his drawing of Manet working at his easel [194], wearing not a smock but his coat and top hat. Manet may seem to be playing the role of the dandy, but his art—the portraits, the beer drinkers in the cafés, the single stalk of asparagus or the single lemon—is entirely unsnobbish.

STILL LIFES

When the weather did not permit painting out of doors the Impressionists turned to still lifes, which the earlier Realists had established as an almost symbolic expression of their approach. The young Claude Monet followed in their footsteps with pictures of pieces of raw meat, kidneys, garlic cloves, and earthenware mugs. When he painted flowers in 1864, and recommended this subject to Bazille, it signaled as we have noted the change that was rapidly taking place in his art. After this he painted pheasants, fruit, and bouquets of flowers, with the dark Realist background replaced by white cloths and light walls. The climax of this development can be seen in the *Sunflowers,* 1880 [195], which helped inspire van Gogh's *Sunflowers* a few years later. Both fruit and flowers, which were painted by all the Impressionists, encouraged the sparkling dabs of color that contradict the term "still life" in English and in French. These are not "still" lifes, as they shimmer and vibrate, and neither are they *natures mortes,* dead nature.

Renoir produced probably the most spectacular example in *Bouquet in Front of a Mirror,* 1876 (private collection), which is quite unreproducible with its dazzling reflection that multiplies the brilliant array of flowers. He also painted a *Still Life with Bouquet,* 1871 [196], which unusually carries an implicit statement. In the upper left we see a copy

by Manet of a painting in the Louvre attributed to Velázquez, a refer-
ence to the Spanish seventeenth-century influence on Realism and on
Manet's early work. This dark coloring is repeated in the lower right by
the leather-bound books, but the Japanese fan with its bright color
obscures the right-hand side of the print. Japan has replaced Spain, and
the bouquet of roses in the lower left reinforces the message.

Manet produced a wealth of still lifes, many of them extremely
unpretentious, like the *Stalk of Asparagus*, 1880 [197]. This painting owes
its existence to a typically delightful Manet touch. A friend had bought
a still life of a bunch of asparagus from Manet and had rounded out the
price. Manet then painted this work and sent it with a note saying that
one of the stalks had fallen out of the bunch. The painting is more than
a witty trifle, as Manet found a surprising number of colors in the stalk,
and the creamy painting of the marble-topped table with the diagonal

195. *Sunflowers*. By C. Monet, 1880. Metropolitan Museum of Art,
New York.

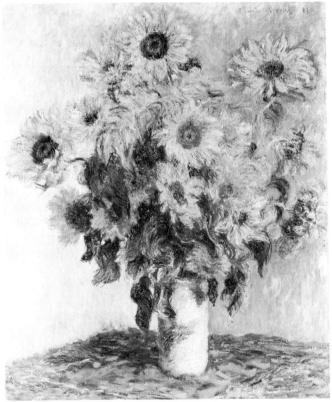

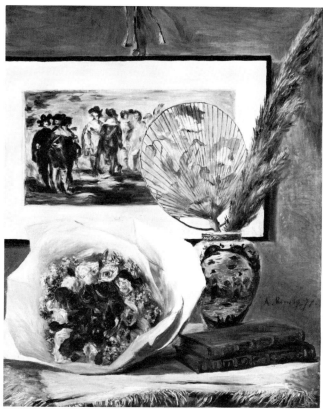

196. *Still Life with Bouquet*. By P. Renoir, 1871. Museum of Fine Arts, Houston, Robert Lee Blaffer Memorial Collection, Gift of Sarah Campbell Blaffer.

197. *Stalk of Asparagus.* By E. Manet, 1880. Musée d'Orsay, Paris.

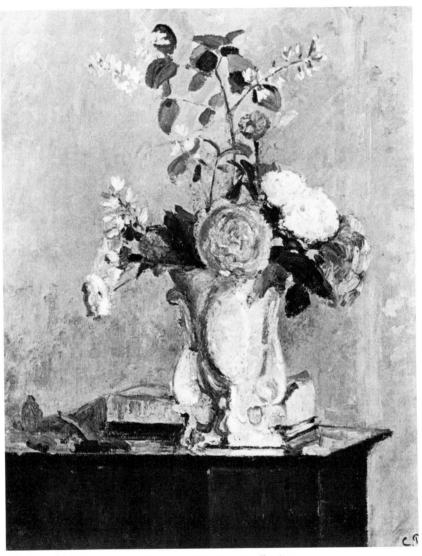

198. *Bouquet of Flowers*. By C. Pissarro, 1873. Private collection.

veins like wavelets gives a motion to the tiny canvas (just over 6 inches by 8¼ inches) that makes it a microcosm, and immensely satisfying.

While the specific subjects had changed from the turnips, garlic, and pots of Millet, Ribot, Bonheur, and their generation, and the color had become infinitely richer, the Impressionists' underlying belief in the ordinary had not changed. We see Pissarro's *Bouquet of Flowers*, 1873 [198], as a beautiful still life, and it appears a return to the tradition of flower paintings; but inspection shows that it is made up of the inconsequential. The lumpy, undistinguished vase sits on a crude piece of

furniture which it shares with fallen leaves and petals. The bouquet itself is not a very rich one, yet Pissarro transforms everything with his choice of tones for the light blue wall, and the possibilities of harmony between pinks and grays in the flowers and vase.

The false idea that the Impressionists simply painted what they saw is nowhere more clearly disproved than in these still lifes. Unlike the problems of painting the moving river, the changing light of an afternoon, or the eddying crowds on the boulevard, the still life sat quietly in front of the artist; but Monet's flaming sunflowers, Manet's dynamic asparagus stalk, and these flowers transcend the objects the artist saw, giving us what they saw in them.

RURAL SCENES

Unlike the other artists discussed here, who lived in Paris and its environs, Pissarro and Sisley lived outside the city. They painted rural scenes, only occasionally Paris and Argenteuil, though when they traveled to England they painted the Londoners' resorts like Hampton Court and Kew Gardens. However, their pictures of Pontoise and Louveciennes do not differ as much as we might expect in underlying approach from those of the city painters. Unlike Courbet and Millet they do not paint as country dwellers, but instead give us the view of the outsider. Pissarro's *The Haystack,* 1873 [199], can be contrasted with Millet's *The Gleaners* [111], where the haystacks are the background for powerfully evoked work. Pissarro's peasants are tiny figures resting,

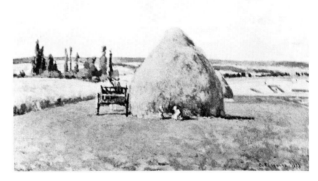

199. *The Haystack.*
By C. Pissarro, 1873.
Private collection.

part of a rural staffage, as if seen by a passing excursionist. In Sisley's *The Meadow*, 1875 [200], as in Monet's much reproduced *Poppies*, we seem to be offered the real countryside, though on close examination the figures turn out to be not peasants but Parisians in their Sunday best. Similarly in Sisley's *The Sèvres Road*, 1873 [201], we are presented with the houses either side of the road, but at such an acute angle that we can make out very little of them. Sisley may have known these houses and their inhabitants well, but he chose to focus on the road itself, which stretches across the whole width of the canvas. We are swept along by the powerful perspective like an impatient traveler hurrying to the town in the distance.

The change from the earlier French paintings does not need emphasizing. Pissarro and Sisley vividly recreate the beauty of the countryside, but it is one in which we find the rural factory and the railroad crossing, and they leave the peasants (who still constituted the majority of French people) to Millet and Courbet. We recognize the new sensibility that enabled Pissarro to return to the Impressionist themes of the Parisian boulevards and the Rouen docks later in life without any sense of strain. It is not as if Pissarro despised the peasants, and relegated them to staffage. He was a socialist and in the late seventies he did a

200. *The Meadow.* By A. Sisley, 1875. National Gallery of Art, Washington, D.C., Ailsa Mellon Bruce Collection.

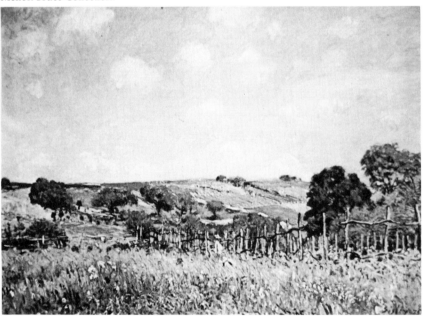

201. *The Sèvres Road.* By A. Sisley, 1873. Musée d'Orsay, Paris.

series of close-ups of peasant women and of the markets at Pontoise and Osny, but he never attempted to redo Millet, which would not have worked in the Impressionist style, and was unnecessary.

I have analyzed the themes of Impressionism at length because they are distinctive, quite different from those of the painting of the Salon artists. Only the categories of portraiture and still life overlap, so that far more is involved than simply the introduction of a new style. Landscape was an important category at the Salon but it consisted of pure landscapes, of peasants and animals in the landscape. Yet as I have tried to show, naming the ostensible subjects does not really describe the content of Impressionism. The paintings evoke a mood created by the subject, and one which cannot be put into words very well. The painters recreate the pleasures of the most ordinary experiences, strolling along a village street, enjoying the bustle and atmosphere of a railroad station, or looking at a bouquet of flowers. The mood has as much to do with color, light, and weather as the "subject," because inseparable from the artists' approach is the recreation of a world in movement.

The Marxist historian of art Arnold Hauser analyzed this underlying principle of Impressionism in his *Social History of Art* (1951) and better than almost all the commentators up to that point, he understood its character: "Impressionism is an urban art . . . because it describes the changeability, and nervous rhythm, the sudden, sharp but always ephemeral impressions of city life. . . . The whole method of impres-

ism, with all its expedients and tricks, is bent, above all, on stressing that reality is not a being but a becoming, not a condition but a process."[4] Interestingly, in line with the Marxist praise of Courbet, Hauser, who has understood Impressionism so well (at least in part), does not admire it for the expression of the dialectical nature of reality, but concludes: "Impressionism is the climax of self-centered aesthetic culture and signifies the ultimate consequence of the romantic renunciation of practical, active life." He goes on to write that Impressionism is "a departure from reality," a "series of reductions, a system of restrictions and simplifications."[5] One might have expected, given Marx's own vision, quoted from the *Communist Manifesto* at the head of this chapter, of modern reality as in constant flux, that Hauser would have praised the Impressionists.

Hauser's lengthy denunciation contains its own inner contradiction because it is hard to see how a movement so full of reductionism could succeed in being such an effective urban art. He himself praises Impressionism's "enormous expansion of sensual perception" and writes of its recognition of "the dynamic and organic elements of experience." If, unlike Hauser, we accept the latter as valid experiences, then we can admire him for bringing out so vividly the essential nature of the movement. Nevertheless his attitude reminds us of how deeply ingrained are the concepts that art should be monumental and that it should express a "message" about life.

When we look at the range of content in Impressionist pictures, the limitations of Baudelaire's modernity make themselves felt. We have seen his enormous sensitivity in grasping a concept of modernity and understanding the significance of the city, in presenting the street as one of the central elements available to artists, and his definition of the qualities of the transitory and the fugitive. In addition to his ignoring of the role of technology, especially in the way it interacts with daily life, he said nothing about what we might call the modernism of domestic life. This latter is not surprising as it was perhaps something only practicing artists could discover in the act of painting. Monet's *Sunflowers*, Renoir's roses, and Pissarro's straggly bouquet express a new sensibility, as full of movement and life as their views of the boulevards. Nobody could have imagined Monet's sunflowers until he had painted them. If we look at Fantin-Latour's bouquets we see exactly what an intelligent observer might have expected from an advance in flower painting, but Fantin's pictures belong to another world from those of the Impressionists. I have chosen this traditional motif because it does

[4] A. Hauser, *The Social History of Art*, vol. 4. New York, n.d., pp. 168, 169. The following quotation comes from p. 170.

[5] Ibid., p. 172.

appear the most unlikely thing to bring up as an example of modernity, but if a bunch of flowers can contain the same qualities as a view of a busy street, then our vision of what modernity means in painting must be much broader than that of modern "subjects."

If we think of modernity having this domestic aspect (and can it be a real modernity if it does not?), then we can see a dimension of Impressionism that has been very neglected. Renoir, Monet, and Pissarro painted numerous pictures of people seated reading, sewing, and crocheting, of mothers and fathers with their babies and children, which we touched on earlier. These are historically "women's" subjects that perhaps we associate more with Berthe Morisot and Mary Cassatt, but they were just as popular with these male artists, and Morisot and Cassatt, in spite of their close friendships with Manet and Degas, respectively, belong more with the open-air Impressionists in their art. Many of these domestic paintings were garden scenes that flow naturally into the picture of games and sports in the fields, and to the beaches of the resorts, the latter a subject that we associate with Morisot just as much as the other artists.

We have noted the lack of formal occasions in these scenes, and we feel a vision of life quite different from that which appears in the other painters of the time. It is one that values not only the informal but also the pleasure of the moment. In his famous article fifty years ago, Meyer Schapiro emphasized the aspect of recreation in Impressionism, and its "urban idylls," trying to correct the popular idea of Impressionism as simply landscape painting; but he presented the movement as "closely related to the consumer of luxury goods," and he sympathized with the lot of the "imaginative members of the middle class who accepted the norms of freedom, but lacked the economic means to attain them."[6] Yet when we examine the numerous paintings that I have been describing, we see them celebrating simple, inexpensive pleasures of reading, playing with children, and the like. Even the seaside was not necessarily a luxury if we remember the excursion trains laid on for the working classes. At that time Schapiro's Marxist orientation obliged him to impose a negative interpretation which not only seems unjustified to me, but which he dropped in his later lectures on Impressionism.

IMPRESSIONIST COMPOSITIONS

Equally as important as the development of the more commented on Impressionist brushstroke was the evolution of new compositions. The fact that the open-air artists show us what we regard as normal views

[6] M. Schapiro, "Nature of Abstract Art" (1937), reprinted in *Modern Art, 19th and 20th Centuries*. New York, 1978, pp. 191-93.

along the river or across the fields, in contrast to Degas's abruptly sloping floors and cut-off figures, conceals the originality of their compositions.

In this respect, Claude Monet was the most inventive of this group and his compositions were adopted by the other artists. The majority fall into three basic types: the road or river that runs straight into the canvas, the use of horizontal bands of land, water, and sky across the painting, and the diagonal division of the picture by a view from above or below. The aim of each is to give us a swift view of the whole picture, rather than letting our eye explore it at leisure or stop to dwell on interesting details. Consequently we immediately gain the impression of the entire scene, and the artist's desire to recreate the moment for us is achieved.

In the first of these compositions, an exaggerated perspectival effect is created. The very symmetrical quality of this composition meant that it had been used only sparingly before. The Barbizon artists had used it, in particular Corot, but Monet's use is significantly different. In a painting like Rousseau's *Village of Becquigny* (Frick Collection, New York) the road is a relatively narrow strip down the center of the picture, thus creating great depth which is defined by the houses and trees beside it. It takes time to travel back through the painting, and we are tempted to stop and examine the different objects. In Monet's painting [202], the road occupies the whole width of the bottom of the canvas and then comes to an apex near the center so that it forms a triangle rather than a depth-defining device. Our eye is caught up and funneled directly to the apex by the abruptness of the narrowing. We are not able to stop and look at things at the side of the road, and when we reach the center there is no motif placed there, so our eye travels off over the rest of the painting, and we have quickly gained the impression of the scene. The sense of this spaciousness of the landscape has been achieved (in this way it is "true to life"), but we have become more aware of the scene as a whole than of the distances involved.

The enormous popularity of this type of composition among the Impressionists sprang from this very satisfying solution to the problem of reconciling the actual depth of the landscape with their desire for immediacy in the picture. Though Monet perfected this composition, it was initially developed by the Dutchman Jongkind [165], with whom Monet had painted at Honfleur. When Monet visited Pissarro at Louveciennes in 1870, the latter painted an identical view of a road as Monet, and the same thing happened after the Franco-Prussian War when Sisley visited Monet at Argenteuil in 1872.[7] Sisley's *The Sèvres*

[7] These identical views are illustrated in J. Rewald, *The History of Impressionism,* fourth rev. ed. New York, 1973, pp. 212, 213, 288.

Road [201], discussed in the section on paths and roads, provides the perfect contrast with Rousseau's painting and reveals clearly the Impressionist viewpoint.

In 1867, when Monet painted the snow scene, he also later in the year painted the *Terrace at Sainte-Adresse* [204], which established the

202. *Road Near Honfleur in the Snow.* By C. Monet, 1867. Private collection.

203. *Terrace at Sainte-Adresse.* By C. Monet, 1867. Metropolitan Museum of Art, New York.

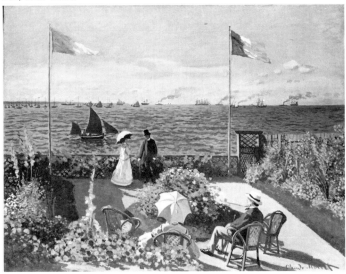

second type of composition, with horizontal bands. Although many of the individual parts are three-dimensional, Monet arranges major elements so that they form a two-dimensional pattern. The painting is divided into three horizontal strips, land, sea, and sky, with nothing in the sea or sky to indicate recession. Consequently we see them all at once, and they all lie on the surface. The flagpoles cross all three areas and repeat the bright yellow, reds, and blues of the flowers of the lower part, in the sky, bringing it forward. The verticality of the poles combines with the horizontals to form a grid superimposed on the surface. Monet further connects the different planes by having objects in different zones touch each other, like the bowsprit of the boat which touches the lady's parasol. It takes a while to realize that the horizontal fence at the right is in fact running out from the observer toward the sea. All these manipulations of an actual scene show how sophisticated Impressionism really was. As was the case with the previous type of composition, we are aware of the recession to the distant horizon of the actual seascape, but we feel it simultaneously.

This frontal composition was used very frequently for the views across the river of the 1870s, where the artists simply painted the riverbanks, the water, the line of trees, and the sky as bands across the canvas. It hardly needs pointing out how important these pictures were for the following generation of Post-Impressionists in suggesting an entirely flattened composition to artists like Emile Bernard and Gauguin. By the 1870s the artists did not need to construct these pictures as Monet had done in the *Terrace*, but had learned how to discover them readymade in nature.

This composition had numerous variants; sometimes a sailboat is placed right in the foreground, an immediate motif, or the horizontals are overlaid with a vertical grid of trees. It even appears in Manet's interior scene, *The Masked Ball at the Opera*, 1873.

For pictures of man-made structures, the Impressionists favored the plunging diagonal across the whole painting so that top and bottom are given equal weight, and the sky does not create a recession in the upper part. Characteristic examples are the plunging views from balconies [167] and the views from below the railway bridge at Argenteuil [89]. The latter is what we might call a worm's-eye view as opposed to the bird's-eye view from the balconies.

We find variants and combinations of these compositions as well as the generalized composition in which foreground elements are distributed equally throughout the canvas, giving every part equal weight.

The aim of all these approaches is twofold: to secure the immediacy which gives us an instantaneous impression, and also the immediacy which breaks down the feeling that we are looking at a "picture." The

Impressionist brushstroke naturally constitutes the complement to these compositions by giving a physical reality to the surface of the canvas, thus reinforcing the overall qualities of the compositions, and by the richness of the strokes replacing the detail that had been lost in the simplifying of the forms. We see an important development in the 1870s. In the sixties, the artists had evolved different types of brushstrokes to depict and differentiate between different textures (see p. 252), but in the seventies the brushstrokes became smaller and more uniform—the "independent" Impressionist brushstroke, or the "comma," as it was nicknamed. The comma was varied, but it no longer represented a definite form or texture. We see these touches at their height in Monet's *Woman Reading in the Grass,* 1876 [204].

This emphasis on the surface, and on the uniform touch, not only led to the Post-Impressionist Pointillism, but eventually was one of the factors leading to the crisis in Impressionism in the early eighties, when the artists found themselves carried by their own evolution away from the Realist principles with which they had started and sustained their art, a crisis that will be discussed in the last chapter.

Linda Nochlin was quoted earlier as pointing out that in spite of the Realists' claiming that they wanted to transcribe nature without any

204. *Woman Reading in the Grass.* By C. Monet, 1876. Private collection.

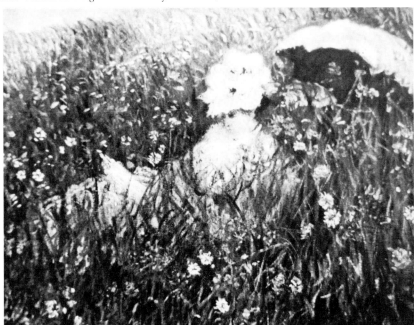

preconceptions, their art is dependent on preceding examples. Not only did the Impressionists impose a vision, as we have seen in the discussion of compositional types, but an examination of their sources shows a surprising richness. They learned from the first Realist generation the importance of painting only what they could see, and that anything was worthy of being painted. In the work of the graphic artists of the magazines they discovered a range of subjects that was more contemporary than those of the Realist painters, as well as at times compositional ideas. Many of the caricaturists presented their subjects in a dynamic manner that also gave them a modernity lacking in the Realist paintings. Daumier drew a very large number of lithographs of rain, snow, and wind that are not often commented on today, but which must have impressed the open-air painters.

This said, the difference between a comic black and white Daumier print and an Impressionist painting is very great, and the artists were also very responsive to earlier painting. As we saw earlier in this chapter, Rococo painting very often offered pictures of contemporary people enjoying themselves in the outdoors, with a lightness of touch, a freshness, and a sense of movement. It gives us an insight into the changes in Realism after midcentury that the Goncourt brothers, the authors of sordid Realist novels, were also admirers of the Rococo and wrote about the artists. The strength of Impressionist color comes though not from the delicacy of the eighteenth century but from the example that Delacroix had provided of the possibilities of color without drawing as a fully expressive means. Manet and Renoir both copied Delacroix paintings, while Monet's favorite reading matter was Delacroix's *Journal* when it was published. Monet's sudden prosperity in his fifties also enabled him to buy Delacroix watercolors, and Degas too owned works by him. Pissarro, whose color was never as intense as Renoir's or Monet's, was briefly a pupil of Corot, and he remained indebted to Corot's color sense.

These diverse elements—Courbet and Millet, Rococo painting, popular illustrations, Delacroix and Corot—were catalyzed by the discovery and study of Japanese prints, which by an extraordinary coincidence arrived in Paris at the same time as the young artists. The impact of Japanese prints was so great but often so well absorbed that even now, over a century later, its significance is frequently not fully understood.

The impact of Japanese prints on Manet and Degas has always been recognized, yet their influence on the open-air Impressionists has been seen as minor. The stylized forms and arbitrary compositions of Japanese art seemed to have no relation to the Impressionists' faithful views of a scene, while nothing could be more different from the Impressionists' desire to render every possible nuance of tone in a motif than the

printmakers' use of one green for all vegetation, one undifferentiated blue for the water.

Nevertheless, in spite of these fundamental differences (and the Japanese artists were also very happy to portray the famous beauty spots of Japan that they had never visited), the Japanese prints played a very important part in the development of Impressionism as a whole. Claude Monet, for example, has always been regarded as the purest Impressionist, but he was a leader in absorbing lessons from Japan. This has not been widely recognized in his work in the 1860s and 1870s because this truth to the motif has been seen as incompatible with the "flat, decorative" qualities of Japanese art, as they have so often been defined. This cliché about the flatness of Japanese prints has been so ubiquitous in fact that it has prevented us from seeing how varied were the qualities of Japanese art.

The Japanese artists who particularly interested Monet and his friends were the landscapists whose prints were not "flat." The great artists of the late eighteenth and early nineteenth centuries—Kiyonaga, Hokusai, and Hiroshige—were part of a new Realism in the arts in Japan. These print artists partially rejected the Japanese pictorial tradition and eagerly studied the Western landscape prints (chiefly Dutch) that trickled into Japan through Nagasaki. Not only were European perspective concepts adopted but Hokusai even signed some of his landscapes in horizontal Western fashion to indicate his sources.

Japanese artists began to copy European perspective in the middle of the eighteenth century. At first these pictures, known as *uki-e* (not to be confused with *ukiyo-e*), were curiosities or were used for architectural scenes where the lines of the buildings provided a natural linear perspective scheme. An emphatic, exaggerated one-point perspective was used in these latter works, presumably because it could be more easily constructed and because the dramatic result suited Japanese tastes.

This type of perspective, as mastered by Hiroshige, proved to be a decisive influence in Monet's development during 1866–67 (the crucial takeoff period for Impressionism), and through him it affected all the other Impressionists. Monet's *Road Near Honfleur in the Snow*, 1867 [202], can be compared with Hiroshige's *Asakusa Kinryuzan Temple*, 1856 [205]. The reason Monet borrowed a perspective scheme from Japan that had come from Europe in the first place is that the Japanese exaggeration of the foreshortening contributed to the kind of painting that the Impressionists were trying to evolve. As we have seen, they wanted to paint a scene that seized us with its immmediacy, but they wanted to be true to the light and atmosphere. The traditional Japanese picture precluded these latter elements, while the one-point perspective style in Western landscapes created a steady recession with a time element that elimi-

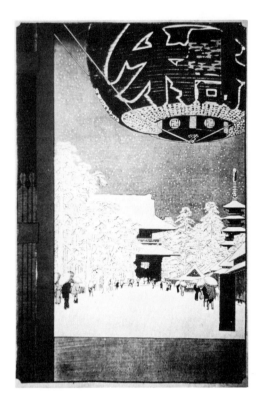

205. *Asakusa Kinryuzan Temple.*
By A. Hiroshige, 1856.
Philadelphia Museum of Art,
Gift of Mr. and Mrs. Lessing
J. Rosenwald.

nated immediacy. Monet found in Japanese prints the rapid funneling
of the spectator's eye into the distance and its return to the foreground
and the upper part of the picture, so that front and back, bottom and
top are received almost as a simultaneous experience. We can see how
Hiroshige used the lantern and Monet the cut-off trees to bring the top
of the painting to the foreground plane and not leave it as empty reced-
ing sky. I have discussed the spread of this composition among the
other Impressionists, and the composition in horizontal strips and the
steep diagonal also occur in Japanese prints.

The most widespread influence of the Japanese on the Impression-
ists was the freshness and brightness of their color. So different was the
Japanese use of color from that of the open-air painters that it might
seem an unlikely source of influence. Yet the earliest writers on Impres-
sionism and the Japanese—Armand Silvestre and Théodore Duret—
both singled out Japanese color as a major influence on these painters,
who were well known to them as friends. Though the Impressionist
brushstroke and optical realism created an effect very different from the
arbitrary Japanese color, the connection was clearly expressed by Duret:
"Well, it may seem strange to say it, but it is nonetheless true, that
before the arrival among us of the Japanese picture books, there was no

one in France who dared to seat himself on the banks of a river and to put side by side on his canvas, a roof frankly red, a whitewashed wall, a green poplar, a yellow road, and blue water."

The freshness of Japanese color thus inspired French painters to seek color boldly in their observation of the motif. This is particularly true of Monet, most of whose works in the sixties were not particularly bright, since he was seeking a harmony of light. In 1871 he bought a number of Japanese prints in Holland (earlier he was too poor to acquire them), and his color immediately became brighter. *Blue House at Zaandam*, 1871–72 (private collection), is an obvious example. The Renoir painting *Still Life with Bouquet*, 1871 [196], shows how the color of a Japanese fan can set the tone for a whole painting. It also illustrated the importance of fans and prints in studios and homes of French artists, for Monet was not the only painter to come under this influence. In 1873 Silvestre wrote in the preface to the volume of etchings of paintings belonging to the Durand-Ruel Gallery: "What seems to have hastened the success of these newcomers, Monet, Pissarro and Sisley, is that their pictures are painted in the singularly joyful range of color. A blond light inundates them and everything in them is gaiety, sparkle, springtime fete, evenings of gold or apple trees in flower—again an inspiration from Japan."

Silvestre's comment suggests another aspect of the Impressionist-Japanese relationship: subject matter. Just as the Impressionists painted scenes of recreation in Paris and the surrounding resorts (the cafés, dance halls, race courses, theaters, boulevards, and bridges, and the promenading and boating at Argenteuil, Bougival, Chatou, or at the seashore), so the *ukiyo-e* prints depicted the pleasures of Edo (the theaters, street scenes, and wrestlers, the café life of the brothels, and the many excursionist scenes of surrounding beauty spots). This correlation must have encouraged the assimilation of Japanese qualities and shows why the Impressionists were much less influenced by Japanese paintings and screens.

Pissarro, the most rural of the Impressionists in this period, reveals still another aspect of the influence of Japanese prints in the weather effects of mists, fog, and snow that occur in his canvases. Eventually he was to write his son Lucien after seeing a show of Japanese prints at the Durand-Ruel Gallery: "Damn it all, if this show doesn't justify us! There are gray sunsets that are the most striking instances of impressionism. . . . Hiroshige is a marvelous impressionist. Monet, Rodin, and I are enthusiastic about the show."

I have given so much space to the relationship with Japanese art because it reveals a fundamental element of Impressionism and of Realism as a whole. To Europeans in the 1860s and 1870s Japanese art

came as a delightful, exotic, and quaint discovery. Japanese prints were seen as appealingly primitive: the artists could not get the perspective right and they could not model human bodies at all, or get the proportions correct. The color was crude as in *images d'Épinal* and there was no ability to render textures. Yet this "inept" art was recognized by the Impressionists as great art. It not only contributed the numerous elements listed above, but gave a decisive concept, that of the composition as a surface pattern that pulls together all the diverse parts of the picture. The Impressionists in turning to this imported art showed that the European tradition no longer sufficed, and that the creation of an illusion was not only unnecessary, but was dead as an art form. All the conventional ideas of Realism were out of date, and meaningful art had to create new directions. The Impressionism of the seventies thus made inevitable the developments of the 1880s, when painters like Gauguin and Van Gogh, both deeply involved also with Japanese prints, abandoned the Renaissance principle of reproducing the view through the window.

Impressionism was consequently the first modern movement in the sense that it was necessarily short-lived like all subsequent movements in Western art. The pursuit of a pictorial idea rooted in the concept of change meant not only that the artists embraced an alien art tradition, but that there was no fixed new style to arrive at. Each achievement, however brilliant, demanded further refinement or rethinking. We encounter for the first time the tragic situation familiar to us in the twentieth century, in which artists produce great works, but having exhausted this initial development cannot find a way to continue, and find themselves at the age of thirty-five or forty finished. We think of so many artists like Denis, Derain, Severini, Kirchner, Delaunay, de Chirico doomed to paint lesser pictures for another thirty years after an astonishingly brilliant youthful period. The greatest artists are those who have managed to develop new ideas, though they too have frequently gone through barren periods.

The Impressionists in the early 1880s experienced what has been called the crisis in Impressionism, when several of the artists found themselves unable to go on repeating their existing methods. Degas wrote that he had kept all his plans locked up in a cupboard and that he had lost the key, and was now rolling down a hill wrapped in bad pastels. Pissarro wrote that he hesitated to turn around his recent pictures propped against the studio wall because he feared that he would find them horrible. Claude Monet complained of his continual frustrations, that his pictures would not go right, while Renoir immediately after the spectacular achievement of the *Luncheon of the Boating Party* felt a need to entirely rethink his style. The result of these feelings was that

Pissarro at the age of fifty-five became a follower of Seurat, who was only twenty-five. Renoir went through a complicated development in the 1880s before settling down to his later style, while Degas and Monet evolved into new phases that were more part of Post-Impressionism, though the fact that in their case there was no abrupt change obscures its extent. It is important to understand that this crisis did not come about because the artists found themselves mechanically repeating their ideas or painting much poorer pictures. It was at the height of their style that the crisis occurred, when Renoir was painting the *Luncheon*, Degas an exceptional work like the portrait of Duranty, Pissarro his figures like *Woman and Child at a Well*, 1882 (Art Institute of Chicago), and Monet his *Sunflowers*.

The artists realized that unlike the past, when a painter who had developed a new style could then go on to exploit it, now the development had to continue because each success was a precarious balance. Sisley and Berthe Morisot seem not to have felt the need for such a rethinking and their work in the eighties onward becomes increasingly disappointing. Sisley could not handle the accentuated brushstroke satisfactorily in canvases whose subject demanded smooth areas—for example, blue skies—and Morisot adopted long, flowing brushstrokes which gave neither specific experiences of color nor modeled form, so that her paintings became slack and dull. Both artists still painted occasional outstanding pictures, but their work as a whole from this later period bears no comparison with that of Monet and Pissarro, who underwent painful rethinking but did find new directions as a result.

This crisis in Impressionism has often been seen as a minor event, the dissatisfaction of the Impressionists with the lack of form and structure in their works, and frequently historians have implied that the artists deserved the crisis, as they had ignored these important elements. On the contrary, I believe that it was a major event, that it was, as suggested above, the crisis of the whole Renaissance tradition. It is worth noting that Degas, who is so frequently praised in contrast with his colleagues for his mastery of form, felt the crisis equally profoundly.

Looking back, we can see that Realism coincided with the narrowing down and exhaustion of the Renaissance tradition. Courbet found that a large number of established themes—allegory, history, religion, and literature—could no longer be used successfully. The Impressionists felt a stylistic problem; the solid, static painting that had flourished since the Renaissance, and had been continued by Courbet and Millet, had become an artificial arrest of a world in movement. Thus, when the Impressionists had exhausted the possibilities of the fleeting moment, the next generation of sensitive artists found that they had to modify Renaissance principles. Nothing worthwhile could be done by return-

ing to a pre-Impressionist style. Consequently Gauguin flattened objects and space in an arbitrary way, Cézanne destroyed the coherence of objects and perspective, while van Gogh's extraordinary brushstrokes redefined picture making, and his desire to "express the terrible passions of humanity" by the complementary clash of reds and greens opened a way to abstraction. The following generation built on these breakthroughs and the Cubists, Futurists, and abstractionists like Kandinsky and Mondrian created new bases for art that ignored Renaissance principles completely.

The dilemma of sculpture too at this time was demonstrated by Degas with the *Young Dancer* [206] that he showed at the 1882 Impressionist exhibition. We have seen that most traditional sculptural subjects were not viable in the nineteenth century, and even those sculptors who wanted to emulate the Realist painters could not present

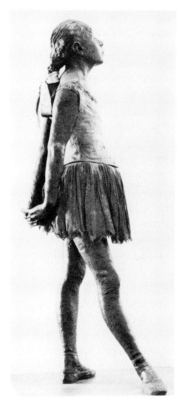

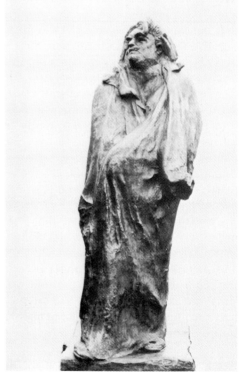

206. *Young Dancer*. By E. Degas, 1880–81. Metropolitan Museum of Art, New York.

207. *Honoré de Balzac*. By A. Rodin, 1898. Museum of Modern Art, New York.

the environment. The problem of clothing too was greater for the sculptor, overwhelming his sitter with all the intricacies of the contemporary costume rendered in bronze or marble. Degas, wittily and imaginatively, confronted the problems by using a piece of wood to represent the dance floor as a base, and giving the wax dancer a real ribbon in her hair and a gauze tutu. These hints of environment and of the ligther texture of clothing (Meissonier had already worked along the same lines [82]) carried their own inner logic of development, which led inexorably to duplicating a favorite Victorian entertainment, the wax works show (the sculptural equivalent of the Panorama).

Degas's attempt was as far as a sculptor could go without making a wax work figure and falling into the trap of illusionism. He went on to model his small clay sketches of women and horses but he did not make any more "finished" sculptures. It required Rodin's enormous genius to create in *The Burghers of Calais* and in his *Balzac* [207] a means of rendering clothing abstract and expressive rather than naturalistic, and to bring sculpture to life again. Rodin, an exact contemporary of Claude Monet, began his Balzac statue with a typical Realist zeal for accuracy. He studied every available photograph and picture of the novelist, went to Tours to study the physiognomies of Balzac's fellow countrymen, and even obtained the measurements of Balzac's clothes from his tailor and had a suit of clothes made. This programme proved a useful base, but Rodin found himself obliged to transcend it in order to create an expressive and moving sculpture. Even then the difficulties were excessive; although the end of the century produced so many outstanding painters, sculptors were on thin ground until twentieth-century art opened up entirely new possibilities for sculpture.

The end of Impressionism in the 1880s marked the end of the movement that had begun in the 1830s and 1840s, though as we shall see in the last chapter, some of the artists in provincial centers produced a last phase of Realism in the 1880s, but a short-lived one, and some of the major Post-Impressionists went through a Realist period as young artists while finding their own directions. The Impressionists themselves continued many of the methods that they had developed, yet the aim of truth to appearances was very much modified. Monet in his series such as the *Haystacks* spent a long time in the studio finishing these pictures so that they harmonized with one another, rather than concentrating on their fidelity to the motif. We see in Degas's late dancers and bathers that they are no longer placed in an actual environment but in abstracted settings that, as in Monet's paintings, form a poetic harmony.

Living in the nineteenth century, in a time of universal suffrage, democracy, liberalism, we asked ourselves whether what are called "the lower classes" do not have a right to the novel. . . . We asked ourselves whether in this age of equality there should still exist classes too unworthy, miseries too base, dramas too squalid, catastrophes too ignoble to record. . . . Today when the novel has assumed the methods and duties of science, it is entitled to claim the liberties and frankness of science.

<div align="right">E. and J. Goncourt, 1864</div>

We are tired of the everyday, and the compulsorily contemporaneous: we wish to be able to place the development of the symbol in any period whatever, and even in outright dreams (the dream being indistinguishable from life).

<div align="right">Gustave Kahn, 1886</div>

The Impressionists heed only the eye and neglect the mysterious centers of thought.

<div align="right">Paul Gauguin</div>

I am always hoping to make a discovery in the study of color, to express the love of two lovers by a wedding of complementary colors, their mingling and their opposition, the mysterious vibration of kindred tones.

<div align="right">Vincent van Gogh, 1888</div>

There is a way of drawing which the imagination has freed from the encumbrances of naturalistic particularities, so that it can apply itself freely to the representation of imagined things.

<div align="right">Odilon Redon</div>

But the artist is born to pick, and choose, and group with science, these elements, that the result may be beautiful—as the musician gathers his notes, and forms his chords, until he brings forth from chaos glorious harmony. To say to the painter that Nature is to be taken as she is, is to say to the player, that he may sit on the piano.

<div align="right">James McNeill Whistler, 1885</div>

9

THE END OF REALISM

By the 1880s Realism had become a broad movement in Europe, above all in rural painting. The Barbizon artists had now acquired international fame and admiration, the Hague School was firmly entrenched, and throughout the Western world painters went out to document the landscape, the inhabitants, and the animals that they encountered in the fields and farmyards. Naturally, quite a number of artists came armed with preconceptions, and often a desire to find the "beautiful," but many shared the beliefs that drove the Barbizon artists. Their work was not especially original, and we do not find it exciting today, but it is solid and satisfying, and we can come across some excellent pictures by relatively unknown names. They have been thrown into obscurity by the dramatic appearance in Paris and elsewhere in Europe at this time of the Post-Impressionists and Symbolists. The quotations from the mid-1880s on the previous page indicate the sharpness of this break and the forcefulness of the rejection of the Realist attitudes. The most gifted artists joined the new tendencies, and Realism in its various forms came to an end as a dynamic movement.

SCANDINAVIA

In Scandinavia, however, the 1880s saw a belated but a very vigorous Realist movement created by a large group of talented artists, most of whom went to Paris and responded to the Realist and Impressionist pictures that they saw there. This movement is not well known for two reasons: almost all of the paintings have stayed in Scandinavia, so we do not see them in North American museums or in the major museums of Western Europe. Secondly, the movement was very short-lived. The artists went to Paris in the 1880s just as Impressionism was being ousted by the Post-Impressionists, and most of the northern artists, after ini-

tially responding to Realism in one form or another, quickly developed into Symbolists. This transformation has been well analyzed by Kirk Varnedoe, and Roald Nasgaard, in his catalogue *The Mystic North*, has provided a thorough documentation of the Symbolist impulse. These scholars' recent work has done a great deal to make people aware of this flowering of Scandinavian art, which comprised artists from all the countries, including Iceland.

The brilliance of this Symbolist painting has obscured the brief Realist phase, which is nevertheless too rich to do real justice to here, but a look at a few artists will show something of its scope and the extended life of Realism in what we might call the artistically provincial countries. One beginning can be seen in the 1870s when artists came to the remote fishing village of Skagen, on the northernmost tip of Denmark. Though very far from Copenhagen, it was relatively close to Norway and Sweden across the Skagerack and the Kattegat. Like Pont-Aven in Brittany, Skagen had the appeal of the unspoiled, primitive fishing town with its fisherfolk and the seascape itself. It attracted artists from the neighboring countries, who formed a summer colony around Michael Ancher (1849–1927) and his wife Anna (1859–1935). She was the daughter of the hotel keeper in Skagen, and a painter herself. Another prominent figure who drew other artists was Peter Krøyer (1852–1908), also a Dane. The leading visitor was the Norwegian Christian Krohg (1852–1925), who came to Skagen in 1879 after studying in Berlin, where he was a friend of the young Max Klinger.

In 1882 Krohg went to Paris and his career embodied the change in Scandinavian art. Traditionally the artists had gone to Germany, but now they flocked to France to study, a fortunate choice in the second half of the nineteenth century. Even though they frequently studied in a conservative milieu, they soon encountered all the new developments in Paris. These two poles of Skagen and Paris embody the duality that played an important part in the eighties art in France: Gauguin in Paris and Pont-Aven, Cézanne in Aix and Paris, and Vincent in Paris and Arles. Monet, who had spent the seventies in and around Paris, now traveled to the islands of the Brittany coast, to the Mediterranean, and settled away from Paris at Giverny.

For the Scandinavians, Skagen offered spiritual resources and Paris artistic inspiration. Edvard Munch, the artist we are most familiar with, came to study in Paris, and as is well known it was an important experience for him, but by the eighties it was no longer a pioneering venture. He found a well-established Scandinavian artistic community, whose closeness and conviviality are celebrated in a large picture by the Swede Hugo Birger, *Scandinavian Artists' Luncheon at Café Ledoyen on Varnishing Day, 1886* [208]. The styles of these artists varied, but like many foreign

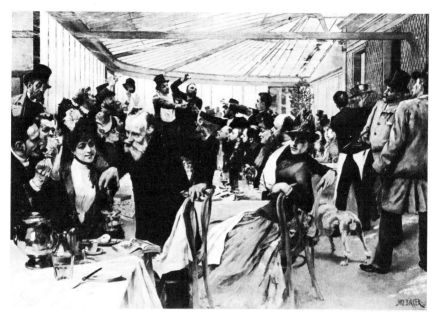

208. *Scandinavian Artists' Luncheon at the Café Ledoyen on Varnishing Day, 1886.* By H. Birger, 1886. Konstmuseum, Gothenburg.

painters in Paris, they found both the more rigid academic approach and its attitude to subject matter unappealing. They turned to the younger artists who were seen as Realists at the time because of their contemporary subject matter, especially Jules Breton and Bastien-Lepage. Birger's picture, with its wealth of detail and careful portrayal of the artists present, belongs to this trend. He observes very persuasively the gestures and poses of the participants, and captures the disorder of the crowded, rather unruly scene in an apparently uncomposed arrangement. But as in the work of the artists who inspired him, the contrast of animated gesture and photographic treatment makes the people seem rather unnaturally frozen in mid-movement. Birger's canvas is in some ways a redoing of Renoir's *Luncheon of the Boating Party* in this alternative style, and we can see in the comparison the Impressionists' skill in avoiding the abruptly arrested quality.

Birger's resembles a great many of the eighties pictures with a contemporary subject where the artist has tried to reconstruct an actual scene, forgetting conventions of pose and composition, and rendering everything with great detail. The aim is that of photographic truth; reproduced in black and white, the painting does have a look of a photograph, particularly as the woman in the middle turns to look out at us, exactly as if the photographer had just called out, "Look this way, Mrs. Birger." This description is not meant to be taken negatively, be-

cause if the painting does not have the overwhelming life of the Renoir, its ingenious composition does seem to capture a slice of life at the same time that it presents a remarkable number of portraits.

Another artists' reunion, Krøyer's *Hip, Hip, Hoorray! An Artists' Party at Skagen,* 1888 [209], comes stylistically between the Birger and the Renoir. The outdoor scene, with the people and the tablecloth dappled by the light and the freer brushstroke, all contribute a vitality appropriate to the occasion. Krøyer has skillfully chosen his moment, that of the toast when everyone is momentarily stopped as they hold up their glasses, and when they are striking self-conscious poses. The result is quite convincing: although the scene is a more static one than in the Birger, we actually feel more movement because of the light and the brushstrokes.

The Scandinavians liked to paint these scenes with a meal table that brings people together, and there are numerous examples at all social levels, but they also typified their epoch in painting scenes of work. Just as the German painter Max Liebermann started his career with pictures like *Women Plucking Geese,* 1872 [220], and *Women Preserving*

209. *Hip, Hip Hooray! An Artists' Party at Skagen.* By P. Krøyer, 1888. Konstmuseum, Gothenburg.

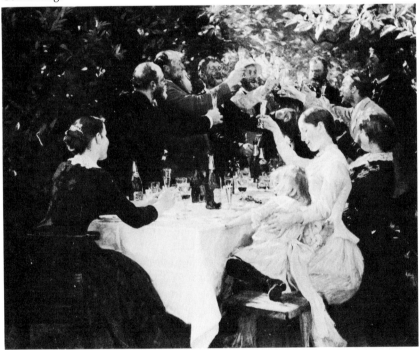

Vegetables, 1873, Krøyer painted women working in a sardine cannery at Concarneau in Brittany in 1879. Krøyer like Krohg had gone to Germany before going to Paris, where he began studies with Léon Bonnat in 1877. Bonnat had grown up with an enthusiasm for Spanish painting, and as a young artist was regarded as something of a Realist with affinities to Ribot. His later career was disappointing, as he unaccountably became a very successful portraitist, setting woodenly painted figures against impenetrable black backgrounds. However, he sent Krøyer to Spain, and the latter wrote about his enthusiasm for Ribera and Velázquez in a letter describing the cannery picture, which is enveloped in shadow (also like Liebermann's early works, which Krøyer would have known). Both artists worked away from this Spanish chiaroscuro toward Impressionist lightness, but the Spanish phase was probably valuable, as it had been for French artists like Courbet, in providing an alternative to the contemporary well-painted picture.

The Norwegian Christian Skredsvig (1854–1924) chose the unusual subject of *Snow Dumping in the Seine* for a very large picture of 1880 [210]. The gray light, the simple, massive forms of horses, and carts

210. *Snow Dumping in the Seine.* By C. Skredsvig, 1880. Private collection.

arranged off center, result in a highly effective bleak wintry work scene in which the physical size of the painting (4 feet 8 inches by 8 feet 4 inches) helps overwhelm us with its atmosphere. Skredsvig, too, does not escape entirely the discrepancy of considerable detail in the horses and less detail in the broadly brushed snow, the latter especially well painted. Even Jens Willumsen, best known as a follower of Gauguin at

Pont-Aven, and the creator of extraordinary and at times bizarre Symbolist pictures, produced a Realist *In a French Laundry*, 1889.

The Scandinavians, although we think very often of their evocative landscape pictures, painted a large number of interiors, perhaps because of the long winters with so few hours of daylight. In looking at these works, an artistic question that becomes evident is of angle of vision. The standard procedure of placing the rear wall more or less parallel to the picture plane was frequently abandoned, presumably because it does not give an expressive enough composition. Instead, we often find a perspective plunging straight back which gives a dramatic effect even in calm scenes of people sitting at a table [211]. These interiors are a development of the earlier Realist pictures with a window at the rear that were discussed in Chapter 3, and their dynamism helps overcome the static quality of the figures. A few of the Scandinavian works seem to show a knowledge of Degas's pictures. The Finn Eero Jarnefelt (1863–1937) uses a spiral staircase in *Le Franc, Wine Merchant, Boulevard de Clichy, Paris*, 1888 [211], to give movement and to dislocate the space in a manner similar to Degas's use of the same motif in several of his dance rehearsal pictures. Jarnefelt reproduces the background light on the counter and bench in a fascinating way, and even if the foreground detail is a little too careful, the resulting picture possesses more life than Béraud's *The Pastry Shop "Gloppe"* [163], to which it has affinities.

Krøyer's *In the Store During a Pause in Fishing*, 1882, painted at Skagen, was one of the earliest of these pictures, and while it lacks Jarnefelt's complex play of light and space, it creates a mood very effectively. The composition is the same as his picture of the women working in the cannery painted three years earlier when Krøyer was under the direct sway of Bonnat and the Spaniards. That picture is so bathed in black that it is not worth reproducing in black and white, but in the interim he had grasped the importance of light, not as something passive that falls on the scene but as an active element that models. This subject of the fisherman in the store is typical of Skagen pictures. Because the one industry was fishing, there are very few pictures of work compared to those painted in France, but very many of fishermen resting, quietly mending nets, or gazing out to sea.

Michael Ancher, who settled in Skagen after his marriage, specialized in large pictures of groups of fishermen, usually seen from the front, each weatherbeaten face carefully rendered [212]. Choosing a moment when the men are motionless, lost in thought as they look out to sea or along the beach, Ancher makes the posed quality look natural, and his paintings are very impressive. Anna Ancher was discouraged in her lifetime by critics, even being advised to give up painting when

211. *Le Franc, Wine Merchant, Boulevard de Clichy, Paris.* By E. Jarnefelt, 1888. Konstmuseet i Ateneum, Helsinki.

212. *Fishermen on the Beach at Skagen.* By M. Ancher. Private collection.

she married; a century later only one of her pictures was included in a big exhibition of Scandinavian art of the 1880s, in comparison with five by her husband, an undeserved slight.

Her early *Lars Gaihede Whittling a Piece of Wood*, 1880 [213], with its dark tonality and the man totally absorbed in his task, exemplifies the

tradition of Millet. She strikes a very successful balance between the detail of the face and the powerful modeling of the clothing with much broader brushstrokes. Ancher's colors brightened considerably as she

213. *Lars Gaihede Whittling a Piece of Wood.* By A. Ancher, 1880. Museum, Skagen.

came into contact with a wider range of contemporary art; in contrast to her husband's frontal views, she painted many pictures of people from behind as they worked in front of a window. These are typical later Realist works, with the flood of light and the anonymous figure. These paintings with a single person are less ambitious than her husband's, which include up to a dozen fishermen, but they are often beautifully realized.

The pull toward Symbolism in Scandinavian Realism shows itself in Hanna Hirsch Pauli's portrait of the artist Venny Soldan-Brofeldt, 1887 [214]. The twenty-three-year-old painter was Swedish (1864–1940), the subject a Finn, and the picture was painted in Paris and exhibited at the 1887 Salon. The Scandinavians were, incidentally, extremely successful at gaining admission to the French Salon and winning medals—their work was fresh but not too radical at this moment when Seurat was at the center of attention in the Paris art world. Pauli's painting is a youthful inspiration with its almost square format, the life-size artist seated casually on a paint-bespattered canvas on the floor, the empty receding space behind her. Soldan-Brofeldt herself comes straight from a Bastien-Lepage in the photographic appearance of her head looking directly out at the viewer, but she has been transported into this strange setting of

a canvas on the floor looking like an odd carpet (doubly strange to us because it looks just like a 1950s Abstract Expressionist canvas), and the curious space.

The picture can be seen as Realist in its recreation of a slice of informal studio life, or as Symbolist in its evocation of the mystery behind the smooth, youthful face of the subject. The diagonal composition with the sloping floor is unusual in Scandinavian art—Anna Acher always uses a conventional frontal space—only occasional works like this one and Jarnefelt's show an interest in Degas. Perhaps these artists were really most moved by what is solid in the world. They never adopted the independent Impressionist brushstroke, and unlike artists from Belgium and Holland, the Scandinavians showed no interest at all in Pointillism although they must all have been very aware of it.

The most remarkable among all these painters was Christian Krohg, who for a few years successfully synthesized his desire to express social problems with a Realist style. He avoided the unpersuasive clues or the sentimental touches that usually marked these attempts. Krohg became a writer as well as an artist, and the inaccessibility of the Norwegian language and the fact that his pictures have remained in Norway have kept in obscurity a very significant Realist.

Krohg followed the pattern of studying in Germany in the 1870s,

214. *Portrait of Venny Soldan-Brofeldt.* By H. H. Pauli, 1887. Konstmuseum, Gothenburg.

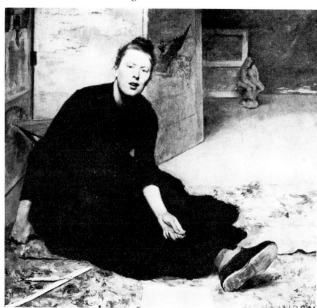

but what might have been a dead end became extremely valuable. In Berlin he met Georg Brandes, the charismatic Danish literary critic and impassioned protagonist of Realism, who converted Krohg from a conservative to a radical in social thought. In Paris he admired the work of Courbet and of Caillebotte, the least Impressionist of the group. Caillebotte painted solid forms rather than adopting the Impressionist brushstroke, so that his appeal to the Scandinavian is not surprising. Kirk Varnedoe has shown Caillebotte's importance for Munch's early development, too.[1]

Krohg successfully assimilated these experiences, and produced a remarkable series of works in the 1880s that fall into three groups: scenes of everyday life, compassionate pictures of sick children and tired mothers, and paintings with a social purpose.

Krohg seems to have instinctively understood and solved the problems of painting social issues. His writings on art threatened a clumsy propaganda when he called for "a simple art that captures, moves, angers or delights the great mass," but his pictures were sophisticated, and their meanings are implicit, not spelled out. From his earliest mature works he followed Courbet and Menzel (whose works he probably knew from his stay in Berlin), and he painted people asleep or seen from behind, an unexpected direction for an artist who believed in an art that would speak passionately to a great number of people. There is an amusing picture from Skagen of the very plump Rasmus Gaihede seen from behind as he lay on his side asleep, like a beached walrus.

Interestingly, Krohg tackled the most debased subjects in nineteenth-century art, babies and sick children, who had been the topic of so many excessively sentimental pictures. It was almost as if Krogh wanted to undermine much nineteenth-century art by showing what a real picture of those subjects was like. He painted two different, large versions of *The Bath* [215], where the women watching the baby are seen from behind at an angle, in *profil perdu,* and the baby is scarcely visible in the bath. With the close-up of the women crowding the picture surface, and the steep perspective of the bath, we are reminded of Degas's pictures like *At the Milliner's* [174]. Krohg's dramatic composition conveys something of the excitement of the real, eternal human response to the wonder of new life without any clichés, at the same time that the bending woman and the diagonal of the bath create a complex and interesting play of forms.

The sleeping mother exhausted by looking after her sick child [216] is to me the most original of Krohg's works. An earlier, smaller version shows the mother and child similarly placed, but there is no table on

[1] K. Varnedoe, "Christian Krohg and Edvard Munch," *Arts* 53 (April 1979): 88–89.

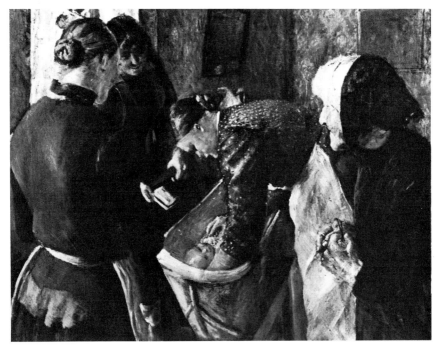

215. *The Bath.* By C. Krohg, 1889. Rasmus Meyer Collection, Bergen.

216. *The Sleeping Mother.* By C. Krohg, 1883. Rasmus Meyer Collection, Bergen.

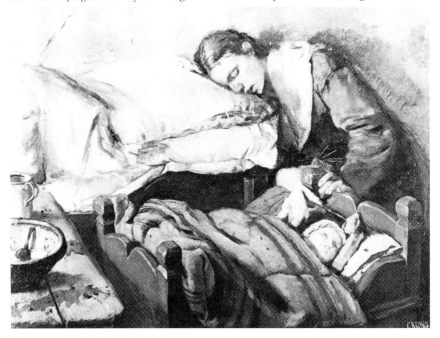

the left and there is more space above the mother, as the format is almost square. In the final version a parallelogram is formed by the beds, table, and the mother's back, which changes the picture. The lack of space at the top gives a locked-in feeling to the slow movement around this parallelogram where the mother and child are bound in a cycle of suffering. Nothing is refined, everything is plain and solid, the table, the crib, and the figures themselves. Krohg chooses exactly the right kind of brushstroke, color, and light to express the scene without falsity. There is none of the gloomy chiaroscuro that was usually applied in scenes of this kind; in fact the color is relatively bright as it reproduces the whitewashed walls of the room. The heaviness and squareness of the furniture embody the exhaustion of the mother and the mood of the painting, without any additions by the artist. On the raw wood of the table beside the bowl is a splatter of brownish-red liquid, spilled medicine or spat-up blood we are not told.

Krohg became absorbed by the theme of seamstresses doing piece-work at home on their sewing machines, forced to work long hours to make a bare subsistence. He painted several versions of a seamstress fallen asleep at her machine [217], her lamp still burning as daylight

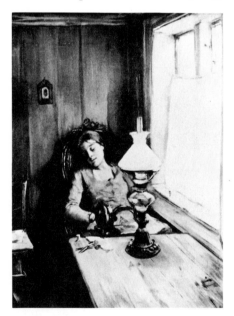

217. *The Sleeping Seamstress.*
By C. Krohg, 1885.
Nasjonalgalleriet, Oslo.

broke (the same play of light used by Gervex in *Rolla* [75], but Gervex's pretensions to be a Realist fade in the comparison). Krohg uses the diagonal of the table top to lead us to the seamstress but also to separate us from her as she is trapped in her corner.

His concern for this situation led Krohg to the theme of the seam-stress forced into prostitution by her poverty; again, with remarkable artistic instinct, he did not try to paint a picture telling a story, but wrote a novel, *Albertine*, published in 1886. The book was immediately seized by the police because of its sordid nature and its social criticism. We can see that Krohg could not have demonstrated the play of social forces, the grinding down of Albertine's virtue, or the sordid details in a picture. What Krohg did do was to paint an enormous canvas, 7 feet high by nearly 11 feet wide, of one scene from the novel [218]. Alber-tine, who has very reluctantly turned to prostitution, is brought to the police doctor's waiting room for a humiliating medical inspection. She is looked at with curiosity by the established prostitutes who are attrac-tively dressed as part of their professional appearance, while Albertine wears her working woman's very plain clothing, and a head scarf in-stead of a fashionable and impressive hat. Krohg put Albertine in the back of the painting, almost inconspicuous, her face barely visible. She is picked out only by other elements: the gaze of the women, her jux-taposition with the policeman, and the edge of the doorpost which bisects her.

Krohg does not try to explain anything. He simply presents the scene to us. The result is enormously engrossing even if we do not know the novel. The difference in clothing (which is a powerful visual contrast), Albertine's demeanor compared to the other women's, the

218. *Albertine*. By C. Krohg, 1886–87. Nasjonalgalleriet, Oslo.

whole arrangement of the figures create a tension in the canvas, a sense of drama and of pathos. Krohg had an inspiration in putting Albertine at the back and in making the two most conspicuous women at the front so involved in their own concerns that they do not look at her. As a result we do not feel that we are being manipulated, and we believe that this visually fascinating interplay of a dozen figures is a slice of life. Interestingly, Krohg later felt that the painting was too much a slice of life, too incomprehensible; he painted an oil sketch with Albertine's face slightly more visible and the women in the foreground all turned, looking at her. This picture is not an improvement.

In the original painting, we see that Krohg must have made changes in the composition after he had finished it, as there are obvious pentimenti, visible even in reproduction, like the shifting of the noticeboard to a less central position, but these pentimenti do not harm the effect of the picture. *Albertine* is far too big to send away to exhibitions so it has not received the recognition that it deserves, but I believe that in an ideal exhibition of Realism, if Courbet's *Burial* were placed at one end of the central gallery to mark the first great masterpiece with its rural scene, *Albertine* could be placed opposite at the other end to mark the end of Realism with its urban setting, and it would stand up to the comparison.

Krohg painted only a few pictures of social criticism, the seamstresses, *Albertine*, and two versions of *The Struggle for Existence*, 1888–89, which shows a group of people in a wintry Oslo street reaching for free bread at a window. The theatricality which Krohg had avoided earlier appears in this painting in the frantic gestures and the pathetic expressions. These two pictures have generally been described as less convincing. Presumably Krohg chose this theme and approach because his other paintings were not explicit enough. The seamstress asleep in her home does not make a point about the evils of the piecework system unless it is explained to us, and we have seen that Albertine's story is not evident in the painting. Perhaps surprisingly, Munch found an expressive possibility in the composition of *The Struggle for Existence*, and he adapted and exaggerated it for his *Karl Johann Gate*, the famous picture with the people on the street at night with skeletal faces.

Krohg's lack of international recognition lies in the very strength of his Realism. At the end of the 1880s, when the other Scandinavian artists turned to Symbolist concepts, Krohg could not follow them, and his work lost direction. What should have been the major part of his career became an anticlimax. Krohg did inspire the young Edvard Munch, who started painting in the late 1870s in the Realist milieu, and who gave Krogh's original compositional ideas a new lease of life. Munch painted a number of Realist pictures before finding his own path

with the *Sick Child,* 1885, a tribute to and an announcement of independence from Krohg.

Munch's *Portrait of Hans Jaeger,* 1889 [219], points to the path that Krogh could not take. From one point of view it is a Realist protrait showing Jaeger, one of the leaders of the Bohemian intelligentsia of Oslo (called Christiania at that time), who went to prison for his writings, seated in his natural environment at a café table. Munch probably took the composition from Krogh's seamstress picture, but he subtly changed it. Though set in a café, the painting is very empty, with the solitary glass on the table and no sense of the rest of the café or its clientele. Jaeger is presented as isolated, the mood enhanced by the blue tonality which modifies the actual colors. The portrait thus can also be seen as a proto-Symbolist picture.

219. *Portrait of Hans Jaeger.*
By E. Munch, 1889.
Nasjonalgalleriet, Oslo.

A tour of the Scandinavian art galleries reveals a large number of Realist pictures in the seventies and eighties, and some excellent painters for whom there is not space here like Fritz Thaulow, Harriet Backer, L. A. Ring, Nils Kreuger, Richard Bergh, the early works of Zorn and Gallen-Kallela, or the curious pictures of birds by Liljefors.

GERMANY

In Germany good painting is scarcely known. They are all after the negative qualities of art—one of the principal qualities in their eyes is the perspective. They speak of it all day long; there is also one great quality, the accuracy of the historical costumes. They are very much into anecdotal painting, and all the walls of Munich are covered with frescoes like wallpaper, with coats in red, blue, green, yellow, rose, etc., silk stockings, riding boots, lace; here there's a king preaching a sermon, there a king who is abdicating and over there is a king who is signing a treaty, etc., etc., who is getting married, who is dying, etc. (1869)

This amusing letter from Courbet during his extended trip to Germany exaggerates only a little. A love of the past and of the ideal possessed German artists in the nineteenth century. So powerful was the belief in the ideal that Anselm Feuerbach and Hans von Marées (who both naturally went to live in Italy) almost succeeded in making allegory work, though usually today we prefer their most straightforward works—Feuerbach's portraits and von Marées's murals drawn from life that decorate the Zoological Institute in Naples. Menzel's example was little followed, probably in part because his oil sketches were not exhibited while his fanatical approach to drawing was rooted in his personality and could not be copied.

After midcentury, the European-wide fascination with contemporary life in its most ordinary aspects affected German art, but most of the painters could not help modifying their pictures with ideal and traditional concepts. In the work of men like Schuch, Thoma, Trubner, Uhde, and in the oil sketches of Wilhelm Busch, like those of Blechen earlier, we find a few canvases that escape studio clichés, but none of these artists can be called Realists if we look at their work as a whole. Because of the shortage of Realists in Germany, Carl Spitzweg and Wilhelm Leibl are often given honorary memberships in the movement. However, Spitzweg's anecdotal pictures with their theatrical, quaint figures exemplify what Realism is not. Many of Leibl's paintings fall into the category of the Rembrandtesque, both in figural pose and in the omnipresent chiaroscuro. The most reproduced picture by Leibl, *Three Women in a Church*, 1878–82, looks back to the fifteenth century, and recalls the English Pre-Raphaelites, except that it lacks any note of the modernity that we find in their best work.

The long struggle by Max Liebermann (1847–1935) to free himself from a close adherence to established models shows the grip of tradition in German art. After studying in Germany, he worked in Paris from

1873 to 1878, and made frequent journeys to Holland to study Dutch art and life. An exceptional artist, Liebermann turned to painting working people (his *Women Plucking Geese* created a sensation), and produced a series of such pictures inspired by the Hague School and the Barbizon artists. Though he was living in Paris during the major Impressionist exhibitions, he retained the Rembrandtesque chiaroscuro which so deeply affected people in the nineteenth century.

The *Women Plucking Geese,* 1872 [220], typifies a large number of paintings by artists who supported Realist aims of showing the life of the poor as it was, avoiding making hard work and poverty look picturesque. Liebermann equally rejected the noble pose that Jules Breton and a number of artists employed to dignify their peasants [152], but he did not escape the chiaroscuro that created its own picturesqueness— not that of prettification, but more literally reminding us of previous pictures. Painting outdoor subjects, as so often in nineteenth-century art, helped free Liebermann from convention, and his *Potato Harvest,* 1875, inspired directly by Millet [153], though dark, does not look back to the seventeenth century.

It was only in the 1880s that Liebermann's palette really lightened and he created the distinctive series of works, many of Dutch scenes, that we immediately associate with him. Over and over he created a very deep diagonal space filled with light. Many of these pictures of orphanages and old people's homes represented a change in Liebermann's thinking. Rather than record the working lives of the poor in a dismal light, he wanted to show the enlightened Dutch treatment of the unfortunate as a model for Germany. His new, brighter style thus went

220. *Women Plucking Geese.* By M. Liebermann, 1872.

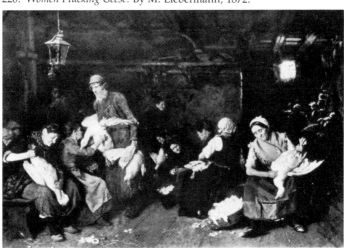

hand in hand with his new subjects. It has been suggested that in his enthusiasm Liebermann made the scenes look happier and less regimented than they were in actuality, which is quite probable, but he avoids the pitfalls of sentimentality.

The *Leisure Hour at the Amsterdam Orphanage*, 1881–82 [221], characterizes these pictures in which the rapid perspective prevents us from lingering on the individual people; though Liebermann does not create a surface composition like the Impressionists, and his brushstrokes are not as individualized as theirs, he does create a convincing atmosphere

221. *Leisure Hour at the Amsterdam Orphanage.* By M. Liebermann, 1881–82. Städelsches Kunstinstitut, Frankfurt am Main.

and internal movement. This particular picture reminds us of Herkomer's *Old Age—A Study at the Westminster Union*, 1877 [222], with its rising perspective and foreground group; as Van Gogh was inspired by this picture, it may be that Liebermann was too, especially as the theme was one that he painted several times. The differences between the Herkomer and the Liebermann show the latter's abilities. Herkomer has carefully composed his foreground group of women sewing or reading, so that they are almost thrust out of the canvas for our attention, as if playing a role for us, and they are not integrated into the perspective space.[2] Liebermann places his girls sewing farther back from the viewer; less obviously grouped, they become part of the general scene.

[2] In the painting of this scene, exhibited the following year, Herkomer added more figures in the foreground and made the picture more anecdotal. He also changed the title from *Old Age* to *Eventide*.

222. *Old Age—A Study at the Westminster Union* from *The Graphic*, 1877.
Illustration by H. von Herkomer.

Liebermann has been criticized for his pictorial timidity and for offering a diluted Impressionism that did not challenge the prevailing pictorial conventions. It is true that his work did not offer the extreme qualities of Degas's; but, like Christian Krohg, he seems to me to have created his own niche within Realism and to have produced impressive paintings that, although they did not open a path to the future, which was impossible at this late date, are extremely successful in their own right.

We have already discussed the problems set for artists by the popularity of the novel, but the impact was not always negative. By the 1870s and 1880s the universality of the Realist novel with its theme of the modern city led a number of painters outside France to feel that this was an inescapable theme of the modern world, as we have seen in Krohg's work. Their interest was quite different from that of the Impressionists, as they followed the writers into the social and sexual problems; but the best of them, like Krohg and his friend the German Max Klinger, avoided the snares of storytelling.

The significance of the novels and evidence of the artists' specific readings can be found in their pictures. Max Klinger's portrait etching of Christian Krohg in a garret includes a copy of the Goncourts' novel *Manette Salomon* (Krohg as we have seen to write his own Realist novel, *Albertine*), while Van Gogh painted several still lifes and portraits with books where we find the novels of both the Goncourts and Zola. Vincent's letters of course include references to his reading of a great range of novels in both French and English, and even Carlyle's *Sartor Resartus* appears in a painting, an interesting link with Brown's *Work*. The Goncourts are less read today but they were extremely important in the nineteenth century, perhaps especially for artists. They not only

wrote important books about art, but they were competent draftsmen and printmakers themselves. Their novel *Manette Salomon*, 1867, has an artist as a central character, and the Goncourts challenged artists in two ways: firstly, the painter Coriolis is not appreciated for "the new realism which he brought, a realism outside the stupidity of the daguerreotype, outside the charlatanry of the ugly, a realism which strove to draw contemporary style from the typical form—selected and expressive of contemporary images." If on the one hand the Goncourts emphasized style (and, published in the mid-sixties, their novel coincides with the work of Manet and the beginnings of Impressionism), the subjects of their own novels were taken from the impoverished and sordid sides of life.

The Goncourts the previous year had published *Germinie Lacerteux* with the preface quoted at the beginning of this chapter encouraging the study of "the lower classes." The artists who had read the Goncourts, like Klinger and Krohg, must have found the earlier paintings of the poor (though not the illustrations) too composed [102] and too "arty." Bouguereau had attempted an *Indigent Family* the year that *Manette Salomon* appeared, but the family was so beautifully and ideally treated that he was universally criticized. Breaking through the traditions of painting to treat depressing urban subjects was still extremely difficult, and several of the artists discussed below produced prints before painting their subjects. These artists included as well as Klinger and Krohg, Fildes and Herkomer in England.

Klinger (1857–1920), who wrote of the impact on him of reading the French Realist novelists, found himself almost inevitably thinking in terms of a series of prints telling a story, with all the problems that involves. Nevertheless, his series *A Mother*, 1883 [223 and 224], comes off well because he treated a theme that was melodramatic but real, from the point of view of social context and response rather than by dwelling on the lives of the individuals. Consequently we do not ask all the unanswerable questions that Egg's and Hunt's pictures provoke. Though there is a great deal of descriptive detail in Klinger's prints, the meaning is expressed through a completely different composition for each episode rather than by lots of clues to a story. This use of expressive space marks Klinger as one of the artists in the mid-eighties who were moving from Realism to late nineteenth-century Symbolism, in which space, color, and line carried the meaning rather than the subject matter. These artists thus overcame the death of traditional allegory and religious symbols that was discussed at the beginning of this book, though the personal content of the resulting works did not permit the resurrection of conventional religious meanings.

Klinger's medium is etching with aquatint—Goya's influence again,

223. *A Mother I.* By M. Klinger, 1883.

and one very suitable for this bleak tale of a despairing mother in the lower depths of society who tries to drown herself and her son. Like Flaubert with Mme Bovary, Klinger found his story in a newspaper, but

224. *A Mother II.* By M. Klinger, 1883.

he made no attempt to flesh out the life of his woman; in fact we have to search to find her in each scene, as the artist is less interested in story than in mood.

In the first print [223], the chaos of diagonals of the "picturesque" slum architecture forms an unstable, threatening world. A curving diagonal line spirals inwards from the stick of the man, the woman restraining him, the tail and body of the cat on the perilous edge of a scrap of roof, and the narrow top of the wall in the foreground. It is picked up by more roofs and the bundle of laundry carried by the woman in the middle of the print. There is no way out of the claustrophobic space, which creates a feeling of entrapment. Though there is considerable detail, it is subordinated to the composition, and to the gray mood of the aquatint. Klinger himself has escaped the problem of a wealth of illusionistic detail.

The second picture in the series [224], where the mother has been rescued from the water but her son has drowned, is composed of horizontals and verticals, grids of window panes, building facades, and steps that imprison both the living and the dead. The environment in each of these two prints is convincingly naturalistic, yet each is brilliantly conceived to create the appropriate mood, so that Klinger does not have to introduce theatrically gesticulating figures. For me the one weakness of this picture can be found in the background building inscribed *"Deusche Kunst."* This misspelling, which could have been caused by the difficulty of writing backwards on the etching plate, strikes a false note. A recent book on Klinger suggests that it has symbolic significance, "perhaps it implies a critique of the tradition based on official art instruction that does not concern itself with social problems of contemporary society."[3] If this is the case, and it seems that there would be a specific reason for introducing the words "German art" into the picture, it belongs to a different order of expression from the rest of the picture.

The third print, the tribunal judging the mother, is set in a claustrophobic interior that reinforces the feeling of entrapment in a new way, and the mother is a tiny figure hidden off in a corner in the gloom. Klinger is so little interested in conventional storytelling that it was only in a later edition of the series that he explained in a note that the mother was freed, something that cannot be learned from the print itself. Klinger having confronted himself with the problem of unfolding a story does it as effectively as possible; he resists the temptation to add an unconvincing device to let us know the ending in the picture itself.

The success of his series led Klinger to make more, but working at this unclear turning point between Realism and the various kinds of Post-Impressionism, and lacking the stimulus of the incisive intellectual life of Paris, he often wavered between the new Symbolism and tradi-

[3] J. Kirk Varnedoe with Elizabeth Streicher, *Graphic Works of Max Klinger*, New York, 1977, p. 83.

tional allegory. Some of his work is quite unsuccessful: the ten-print series *A Love*, 1887, frequently becomes ludicrous with the introduction of cupids and the like into contemporary scenes.

THE END OF IMPRESSIONISM

The year 1886, in which Krohg wrote *Albertine* and began one of the last great Realist pictures, saw the publication in Paris of the Symbolist manifesto and the last Impressionist exhibition, where the most important painting was Seurat's *Grande Jatte*, a Post-Impressionist work that marked the beginning of a new era. While this new avant-garde was a minority it was a large minority, and it gathered in most of the gifted young artists. Many of the latter started their artistic careers with an allegiance to Realism or Impressionism but changed direction when they encountered the new spirit, and those artists who persisted with Realist ideas were not talented enough to give them a new lease on life.

Paris especially became a crucible in which Pointillism, Synthetism, Cloisonnisme, Symbolism, and numerous other isms fought for definition and predominance. The young artists involved in these movements, such as Toulouse-Lautrec, van Gogh, Bernard, and Signac, briefly but intensely asserted their Realist apprenticeship before they found their own directions. Seurat himself, in his drawings of the early eighties [225], created some unforgettable Realist images of Paris and its

225. *Place de la Concorde, Winter.* By G. Seurat, ca 1883. Solomon R. Guggenheim Museum, New York.

suburbs, before he turned to the deliberate artificiality of *La Grande Jatte* and *Le Chahut*.

Many of the young artists, like the older Pissarro, turned at first to Pointillism because it seemed to offer a more scientific, thus more Realist style than Impressionism, and their paintings are different from Seurat's. Pissarro soon abandoned Pointillism because the scientific premises proved false. The static quality of the dot led to an unnatural frozen effect, the very antithesis of the Impressionist view of the world. Pointillism could work well for very quiet scenes like Pissarro's own hushed *Ile Lacroix, Rouen—Effect of Fog,* 1888, or for empty landscapes, but it was not flexible enough for artists driven by a Realist aesthetic. Signac also used the Pointillist technique very effectively in *Gasometers at Clichy,* 1886 (National Gallery of Victoria, Melbourne) a work typical of the young artists around Seurat. Signac was only twenty-three when he did this painting and a preliminary drawing (226), choosing as subject the edge of the city where new industry is located, and where there is a kind of wasteland that is neither town nor country, as factories are built near farm buildings and the fields are abandoned to the weeds. J-F. Raffaelli was praised in 1889 by Octave Mirbeau, the novelist, friend of Claude Monet, and journalist, for having treated "the suburbs of Paris, the bizarre intermediary world, both swarming and desolate . . . where the skies smeared with the sweat of factory chimneys, where the landscape, made up of scraggly vegetation and gray profiles, possesses such a distinctive character of suffering and revolt, such a poignant color of melancholy."

These areas replaced the boulevards and Argenteuil as subject mat-

226. *Passage du Puits Bertin, Clichy.* By P. Signac, 1886. Metropolitan Museum of Art, New York, Harris Brisbane Dick Fund.

e artists sought a new mood. The fortifications of Paris were
/veled and the city spilled out beyond them. It is an area of
d roads, railway yards and the shacks that spring up in such
plac... We see it in paintings by Angrand, *The Railroad Embankment*,
1886 (private collection), and Van Gogh, *The Outskirts of Paris*, 1886
(private collection). One aspect of the life there was caught by Maximi-
lien Luce, not in one of his Pointillist paintings but in his lithograph
from the series *Small Betting (Corners of Paris)*, 1889 [227]. A particularly
evocative work is a large lithograph by Henri Rivière for the series
Paysages Parisiens (the two antithetical terms express the new subject).
The rain, the puddles in the road, the shacks all contribute to the dismal
scene, which is perfectly realized.

This imagery of the desolate suburb has its counterpart in the in-
door café theme of what we might call the solitary glass. Whereas the
majority of Impressionist café scenes show groups of people and we are
made to feel the conviviality of cafés, the young artists preferred people
seated alone with one glass on the table, an image of isolation and
loneliness. Van Gogh not only painted *La Segatori* seated alone with a
glass at a table, but *Still Life, Absinthe*, 1887 [228], shows only the glass.
Toulouse-Lautrec painted several versions of women seated alone at a
table, including the moving *À Grenelle*, ca 1888 [229], and even his
Portrait of Van Gogh, 1887, shows Vincent alone with a glass. These
pictures immediately precede Munch's portrait of Hans Jaeger [219],
and we see how the search to express subjective mood leads away from
Realism.

227. *Small Betting (Corners of Paris)*. By M. Luce, 1890.

228. *Still Life, Absinthe.* By V. van Gogh, 1887. Rijksmuseum Vincent van Gogh, Amsterdam.

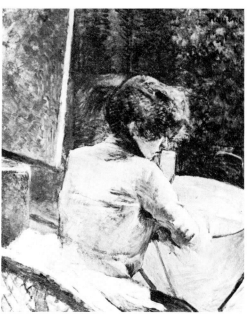

229. *À Grenelle.* By H. Toulouse-Lautrec, ca 1888. Sterling and Francine Clark Art Institute, Williamstown, Massachusetts.

This new subject matter and melancholy mood seem also to be a projection of the artists' dilemma as they worked within the Realist principles that could not satisfy their impulses. Gauguin wrote that the ceiling of the Impressionist boat was too low, while Munch said that he had had enough of pictures of people sewing and reading and wanted to paint human love and suffering. Van Gogh in his letters discussed the limitations of Realism, while at the same time he could not tear himself away from nature.

Another of these strivings to modify Realism has already appeared in the work of Gustave Caillebotte, who has always been seen as a peripheral member of the Impressionist group, part of Impressionism but looking out to something different. When in the early 1880s he tried to paint specifically Impressionist pictures of sailing boats at Argenteuil, they are quite unsuccessful—we find contradictory elements like very blue water and gray skies. Caillebotte's use of drawing and modeling rather than brushstroke to build his paintings gives them a static quality, or would do if the artist had not played with perspective and close-ups even more dramatically than Degas. He painted plunging views from balconies that are quite dizzying in comparison with those of his friend Monet, and they inspired Edvard Munch, who modified and developed them to create some of his Symbolist compostions.

The roadway and lattice of the girder bridge in the *Pont de l'Europe* [179] form a perspective more dramatic than Monet's similar views, and hint at psychological overtones that became overt in *Man at a Window*, ca 1875 [230]. The woman isolated down below in the street stands out like an exclamation point, and though the difference in size between her and the man is grotesque, we feel a relation between them because of the repetition of shape. This grotesqueness and the play of enclosing planes give a foreboding air to the picture which is quite un-Impressionist, but again reminds us of Munch.

The later eighties saw the development and spread of Art Nouveau.

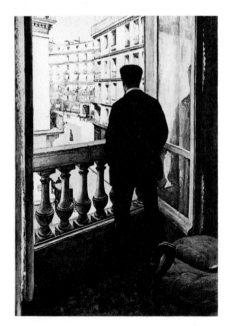

230. *Man at a Window.*
By G. Caillebotte, ca 1875.
Private collection.

The most talented graphic artists throughout Europe responded to the new movement, and drew the illustrations for magazines like *The Studio* and *Pan.* It was the competent but not the inspired artists who turned out the mass of factual book and magazine illustrations that still continued. If interesting Realist illustration had come to an end, there had been a final stage in the 1870s when in London *The Graphic* challenged the pre-eminence of the *Illustrated London News.* Unlike the more staid compositions of the *ILN*, the *Graphic* artist invented dramatic views to give a more dynamic life to the pictures. The gallery of the Victoria Theatre on a Saturday night [231] looks like an inspiration from Degas, but it appeared in 1872 before Degas had produced his steep views from theater boxes. It is not inconceivable that Degas with his interest in graphic art looked at the English press, though his ideas may have been sparked by Grandville's imaginative illustrations from the 1830s and 1840s. Certainly Lautrec's *At the Cirque Fernando: Equestrienne,* 1888 (Art Institute of Chicago), his first major breakthrough into a Post-Impres-

231. *Saturday Night at the Victoria Theatre* from *The Graphic,* 1872.

sionist style, seems to have sprung from a Grandville circus drawing. It was also Grandville who had suggested some ideas to Lewis Carroll for *Alice in Wonderland* (1865), so that the dialogue across the English Channel continued, as well as the awareness of the golden age of popular graphic art in the thirties and forties.

The remarkable *November Fog* [232], also from 1872, reminds us of the parallel efforts of the Impressionists to render weather effects more originally and persuasively than before. Artists such as Luke Fildes and Hubert von Herkomer, who achieved great fame as painters, worked for *The Graphic,* and some of their most successful paintings originally appeared as illustrations. Their pictures of the poor, the aged, and workers on strike and their families also moved from the documentation of the earlier illustrations into more self-conscious compositions. Von Herkomer, whose *Old Age* [222] was discussed in connection with Liebermann, tugged at the viewer's heart strings in a very subtle way, placing his old women conventionally in the very forefront of the picture, but the exaggerated perspective dramatically silhouetting the two figures in the background suggests that they are about to leave for a different world from the busy figures in the front. This use of perspective rather than gestures and facial expressions to create feeling leads to Symbolism, and it apparently suggested the composition for van Gogh's *Night Café at Arles,* 1888 (Yale University), as he had cut this illustration out of *The Graphic* to add to his very large collection of magazine illustrations. These English artists are frequently called Social Realists, though this is a very vague term, as it seems difficult to determine why these pictures are more social than other pictures of groups of people— for example, Menzel's *Ball Supper,* which is as *real* as Herkomer's pictures, and certainly shows a social occasion. Should we regard Daumier's *The Third-Class Carriage* as Social Realism, but not his *The First-Class Carriage?*

The urge to stretch the boundaries of Realism in order to express feelings that were impossible within the principles of the movement can also be seen in the 1870s in the graphic art of Gustave Doré, especially in the famous wood engravings of London, published in 1872. Doré was a naturally imaginative artist who achieved fame with his illustrations for Rabelais and Cervantes, which are fantastic but possess a naturalistic composition and detail that made them perfectly suited for the Victorian audience. Invited to London to make a comprehensive series of drawings of London high and low life, Doré produced from the tension between his imagination and the actual scenes he visited his most memorable works. The drawings of the London poor in particular have been reproduced over and over again to evoke the misery of the lower depths of a Victorian city.

232. *London Sketches—A November Fog* from *The Graphic*, 1872.

Doré made only rough sketches on the spot, since like Daumier he relied on his visual memory (which was not as extraordinary as Daumier's); the drawings that he did back in his room are full of inaccuracies of detail, but also more deliberate exaggerations of perspective and scale. Some engravings where the subject is striking in itself are straightforward [233], but in others, like Herkomer, Doré pushes and pulls at the forms for expressive effect. His high-life scenes are bathed

233. *Workmen's Train on the Metropolitan Railway* by G. Doré from *London: A Pilgrimage* by B. Jerrold, 1872.

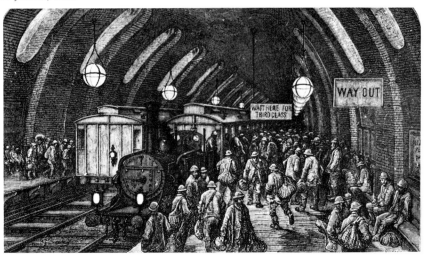

234. *Wentworth Street, Whitechapel.*
By G. Doré from *London: A*
Pilgrimage by B. Jerrold, 1872.

235. *Hayboats on the Thames*
by G. Doré from *London:*
A Pilgrimage by B. Jerrold,
1872.

in brilliant light and the low life in fog and darkness [234]. Doré, incidentally, had to use a number of engravers for the large number of drawings, but he was able to use chiefly craftsmen in whom he had faith.

The docks, by far the largest in the world, and the river drew not only English artists but many of the visitors, like Géricault, Whistler, Daubigny, and Monet. As Hippolyte Taine put it: "This, surely, is one of the mighty spectacles of our planet. A forest of masts and rigging grows out of the river: ships coming, going, waiting in groups, in long files, then in one continuous mass, at moorings, in among the chimneys of houses and the cranes of warehouses—a vast apparatus of unceasing, regular and gigantic labor."

Doré made numerous pictures of the London docks. At the beginning of this book we saw Géricault's *Adelphi Wharf* [15], and at the end of the period we are covering we can see the final examples of the Realists' fascination with street and wharf. The river itself makes a fitting end; Doré's *Hayboats* [235] can be contrasted with a picture from a comparable book on London, Smith and Thompson's *Street Life in London* (1877), which was illustrated with photographs and marked the beginning of the end for documentary graphic art [236].

236. *Workers on the "Silent Highway"* from *Street Life in London*, 1877; author A. Smith, photographer J. Thompson.

BIBLIOGRAPHY

There has been an enormous amount of writing on nineteenth-century art, and I believe that a long, undifferentiated list of titles is less useful than a brief, annotated bibliography. The recent publications described below contain excellent bibliographies which enable specific topics and artists to be investigated in detail. I have largely confined this bibliography to accessible books in English, and have included a number of magazine articles, as important work on aspects of Realism has appeared in periodicals in the past few years.

GENERAL

While there has been much writing on aspects of Realism, and it is discussed in general works on nineteenth-century art, few books have been specifically devoted to the movement. Among the former, Richard Muther's *History of Modern Painting*, written at the end of the nineteenth century and published in several English-language editions, still has great value, as Muther grew up with the art and was aware of it in a way that we have lost today. Robert Rosenblum and H. W. Janson's *19th-Century Art*, New York, 1984, is wide-ranging and richly illustrated. It is based on chronological divisions that I find quite puzzling, but Rosenblum's discussions of the individual pictures are extremely stimulating. The division of the Pelican volumes on the history of art, partly by country and partly on a European basis, leads to a fragmentation of Realism, though Fritz Novotny's *Painting and Sculpture in Europe*, 1978 edition, Harmondsworth, Middlesex, contains valuable material, and Novotny, unlike most writers on nineteenth-century art, realized the importance of graphic art. Lorenz Eitner's *An Outline of 19th Century European Painting*, New York, 1986, offers excellent accounts of the careers of a number of the painters discussed in this book, and forms a useful complement.

Linda Nochlin's *Realism*, Harmondsworth, Middlesex, 1971, consists of a series of excellent general essays, with some outstanding insights. She

does not trace the chronological evolution, and does not make the distinctions between Realism and Impressionism that are seen as important in this book, nor does she treat graphic art. See also the essay by Dario Durbé in the McGraw-Hill *Encyclopedia of World Art.* Essential complements to any book on Realism are the anthologies of nineteenth-century writings on art by Elizabeth G. Holt, *The Triumph of Art for the Public,* Washington, D.C., 1980, and *The Art of all Nations,* New York, 1981, and by Linda Nochlin, *Realism and Tradition in Art, 1848–1900,* Englewood Cliffs, N.J., 1966, and *Impressionism and Post-Impressionism,* 1966.

For French art, Gabriel Weisberg and Petra Chu, *The Realist Tradition: French Painting and Drawing, 1830–1900,* Cleveland, 1980, includes a large number of artists as Realism is understood in a very wide sense, but the catalogue is invaluable for its mass of not easily obtainable information. Graphic art is largely omitted. Charles Rosen and Henri Zerner, *Romanticism and Realism,* New York, 1984, consists of book reviews turned into articles, so it treats only certain aspects of Realism, but it does so very cogently, and is essential reading.

CHAPTER 2

W. H. Pyne's *Microcosm* is available in reprint, New York, 1971, with a helpful introduction by A. E. Santaniello. For information on the Diorama and the development of the Daguerreotype, see H. and A. Gersheim, *L. J. M. Daguerre,* New York, 1968. There is no substantial work in English on the Panorama, but Stephan Oettermann, *Das Panorama,* Frankfurt am Main, 1980, not only contains numerous illustrations but has a long bibliography, including publications on Panoramas in the United States. It also lists Panoramas existing today, and reproduces in long foldouts photographs of some of these works.

C. W. Ceram in *Archaeology of the Cinema,* New York, 1965, discusses all the mechanical inventions of the nineteenth century that led up to the invention of movies.

P. D. Cate, *Circa 1800, The Beginning of Modern Printmaking, 1775–1885,* New Brunswick, N.J., 1981, examines the expansion of print techniques and the growth of the print as an independent artwork.

Fred Licht, *Goya: The Origins of the Modern Temper in Art,* New York, 1979, has pertinent things to say on the nature of Realism. For Géricault, see L. Eitner, *Géricault: His Life and Work,* London, 1983, and for the impact of English artists in France, Marcia Pointon, *The Bonington Circle: English Watercolour and Anglo-French Landscape 1790–1855,* Brighton, Sussex, 1985.

CHAPTER 3

The distinctions made between serious art and popular art, based on seventeenth- and eighteenth-century academic theory, have meant that there has been little art historical study of magazine and book illustration. Writers

on these subjects have come from other fields and their work has not been integrated into art history. Only recently has this situation begun to change. A few enterprising publishers have photo-reproduced books illustrated by leading graphics artists like Grandville, Doré, and Gavarni. Rabelais's *Gargantua and Pantagruel*, illustrated by Doré, and Eugène Sue's *Le Juif errant* (The Wandering Jew) by Gavarni have been issued in cheap pocketbooks by Marabout, the Belgian publisher. Dover Press in New York and Paddington Press in London have reproduced books from Bewick onwards, though sometimes the illustrations have been extracted from the text.

For a history of wood engraving and its use in magazines, see Eric de Maré, *Victorian Woodblock Illustrators*, London, 1980.

No book can do full justice to the amount of work Daumier produced in so many different media, but there are good-quality reproductions of examples in each genre in Roger Passeron's *Daumier*, Secaucus, N.J., 1981, which also lists the catalogues of Daumier's work in different media. Gavarni has been neglected by writers in English; the most substantial work remains P. Lemoisne, *Gavarni, peintre et lithographe*, Paris, 1924.

Aaron Sheon's "Parisian Social Statistics: Gavarni, Le Diable à Paris, and Early Realism," *Art Journal* (Summer 1984), pp. 58–63, offers useful information on both the artist and the book. Judith Wechsler, *A Human Comedy*, London, 1982, discusses the code of representation of gestures and expression that was used and reworked by the French graphic artists. Beatrice Farwell's *The Cult of Images*, Santa Barbara, Calif., 1977, presents a wide selection with valuable commentary of the kind of print that fascinated Baudelaire.

The Barbizon School is only gradually coming back to scholarly attention. See G. Weisberg, *Millet and the Barbizon School*, and J. Bouret, *The Barbizon School*, Greenwich, Conn., 1973; also the section on the Barbizon painters in R. Muther, *The History of Modern Painting*.

For the complicated developments in the French art world between neoclassicism and Realism, L. Rosenthal's *Du Romantisme au Réalisme*, Paris, 1914, has not been surpassed and has recently been reprinted in France.

CHAPTER 4

Something of the variety of painting at the French Salon is illustrated in J. Harding, *Artistes Pompiers: French Academic Art in the Nineteenth Century*, New York, 1979. *Great Victorian Pictures*, Arts Council of Great Britain, 1978, is particularly rewarding because each picture is discussed in detail, explaining the story and giving contemporary comments.

Aaron Scharf's *Art and Photography*, London, 1968, studies the interaction between the two art forms and is rich in information from the middle of the nineteenth century. For a discussion of the difficulties of relating photography and painting, see Kirk Varnedoe, "The Artifice of Candor: Impressionism and Photography Reconsidered," *Art in America*, January 1980, pp. 66-78. C. Hamilton Ellis reproduces a good range of prints and

paintings in *Railway Art,* London, 1977, from the point of view of a railway enthusiast.

A Victorian Canvas—The Memoirs of W. P. Frith, R.A., edited by N. Wallis, London, 1957, gives an inside view of a successful academician who pioneered with modern subjects.

CHAPTER 5

For the Pre-Raphaelites, see T. Hilton, *The Pre-Raphaelites,* London, 1970, and A. Staley, *The Pre-Raphaelite Landscape,* Oxford, 1973.

The catalogue of the Courbet centenary exhibition, Hayward Gallery, London, 1977, provides much original and essential information. For a discussion of Courbet's work in its social setting, see T. J. Clark, *Image of the People,* London, 1973. The most recent complete study is Linda Nochlin's.

R. Herbert's *Jean-François Millet,* London, 1976, is a standard work. For a useful brief study, see Griselda Pollock, *Millet,* London, 1977. *Jean-François Millet,* Boston, 1984, by Alexandra R. Murphy contains exceptionally good reproductions of the artist's pastels and drawings, and shows the brilliance of this less well known side of Millet's work.

Gabriel Weisberg and Petra Chu's *The Realist Tradition: French Painting and Drawing, 1830–1900,* Cleveland, 1980, covers Ribot and Bonvin and related French artists.

Katherine A. Lochnan's *The Etchings of James McNeill Whistler,* New Haven and London, 1984, is not only enlightening on Whistler but also relates his prints to those of the Barbizon School. Frances Spalding, *Whistler,* Oxford, 1979, reproduces the paintings in color.

Other publications on this period are J. Sloane, *French Painting Between the Past and the Present,* Princeton, N.J., 1951, and T. J. Clark, *The Absolute Bourgeois: Artists and Politics in France, 1848–1851,* London, 1973.

R. and C. Bretell, *Painters and Peasants in the Nineteenth Century,* New York, 1983, gives a wide range of illustrations. For a critique of recent writings from the point of view of a sociological art history, see Griselda Pollock, "Revising or Reviving Realism?" *Art History,* September 1984, pp. 359–68.

The admiration for Dutch seventeenth-century art is analyzed in P. Doesschate Chu, *French Realism and the Dutch Masters,* Utrecht, 1974. There is no similar work on the impact of seventeenth-century Spanish art.

CHAPTER 6

There is no book in English on Menzel, but *Menzel der Beobachter* (Menzel the Observer), Hamburg, 1982, reproduces many of his drawings and watercolors.

The Macchiaioli, Los Angeles, 1986, offers the most comprehensive account in English. The contributors see the art mainly in terms of its social and political significance.

For the Travelers, see Elizabeth Valkenier, *Russian Realist Art,* Ann

Arbor, Mich., 1977. A. Lebedev, *The Itinerants,* Leningrad, 1974, contains numerous color plates and a brief introduction giving the official Soviet viewpoint. The only book in English on Repin, *Russia on Canvas, Ilya Repin,* by F. and S. Parker, Pennsylvania State University, 1980, is brief but useful.

The Hague School, Royal Academy of Arts, London, 1983, is the major work in English.

Rodney K. Engen, *Victorian Engravings,* London, 1975, reproduces with details many engravings after Victorian paintings with a discussion of the technical developments.

CHAPTER 7

Ruskin's collected works run to thirty-nine volumes, but several anthologies are available. Kenneth Clark's *Ruskin Today,* Harmondsworth, Middlesex, 1967, covers all of Ruskin's interests and has helpful commentaries. Joan Evans, *The Lamp of Beauty,* Ithaca, N.Y., 1980, is devoted only to Ruskin's writings on art and illustrates a number of works discussed by Ruskin.

Selections from Baudelaire's writings on art have appeared in several English translations. The French Plèiade edition that contains all his writings with an excellent index is the most convenient.

The puzzling aspects of Manet's paintings have stimulated an enormous literature, but the following books provide information and a guide to the controversies: the catalogue of the centenary exhibition, *Manet: 1832– 1883,* New York, 1983; Anne Coffin Hanson, *Manet and the Modern Tradition,* New Haven, Conn., 1977; George Mauner, *Manet: Peintre-Philosophe,* University Park, Pa., 1975; Theodore Reff, *Manet and Modern Paris,* Washington, D.C., 1982. See also chapters in T. J. Clark, *The Painting of Modern Life,* Princeton, N.J., 1984. For Manet and photography, see G. Needham, "Manet, Olympia, Pornographic Photography," in *Woman as Sex Object,* New York, 1972, pp. 81–89.

CHAPTER 8

John Rewald's *History of Impressionism,* 4th revised edition, New York, 1973, remains the standard history of the movement, with a masterly organization of information and an outstanding annotated bibliography. Maria and Godfrey Blunden, *Impressionists and Impressionism,* New York, 1980, analyzes the movement well, and is rich in contemporary quotations. See also J. Leymarie, *Impressionism,* 2 vols., Geneva, 1955, and Joel Isaacson, *The Crisis of Impressionism,* Ann Arbor, Mich., 1980. For the Japanese influence on Impressionism, G. Needham, "Japanese Influence on French Painting, 1854–1910," in *Japonisme,* Cleveland, Ohio, 1975.

For a completely different approach to Impressionism from this book, see T. J. Clark, *The Painting of Modern Life,* Princeton, N.J., 1984, and Paul Tucker, *Monet at Argenteuil,* New Haven and London, 1982.

INDIVIDUAL ARTISTS

Monet: John House, *Monet, Nature into Art*, London, 1986, and J. Isaacson, *Monet, Observations and Reflections*.

Pissarro: J. Rewald, *Camille Pissarro*, New York, 1963, and *Pissarro*, Hayward Gallery, London, 1980.

Renoir: Barbara E. White, *Renoir*, New York, 1984, and *Renoir*, Hayward

Morisot: K. Adler and T. Garb, *Berthe Morisot*, Oxford, 1987.

Gallery, London, 1985.

Degas: Roy McMullen, *Degas, His Life, Times and Work*, London, 1984; T. Reff, *Degas: The Artist's Mind*, London, 1976; and J. Adhemar and F. Cachin, *Degas: The Complete Etchings, Lithographs and Monotypes*.

Cassatt: Griselda Pollock, *Mary Cassatt*, London, 1980.

CHAPTER 9

For Scandinavian art, J. Kirk Varnedoe, *Northern Light: Realism and Symbolism in Scandinavian Painting, 1880–1910*, Brooklyn, N.Y., 1982, is the main source in English, but *1880–erne i nordisk maleri* (Scandinavian Painting in the 1880s), Copenhagen, 1986, covers the Realist period in more detail and is richly illustrated. It contains English summaries of the articles.

Max Liebermann is poorly dealt with in English, but for Klinger's prints, see J. Kirk Varnedoe with Elizabeth Streicher, *Graphic Works of Max Klinger*, New York, 1977.

J. Kirk T. Varnedoe, *Gustave Caillebotte: A Retrospective Exhibition*, Houston, 1976. Both Doré's *London* and Adolphe Smith and John Thompson's *Street Life in London* have been photographically reprinted in recent years.

INDEX

Note: page numbers in *italics* refer to illustrations.